Being Watched

OCTOBER Books

George Baker, Yve-Alain Bois, Benjamin H. D. Buchloh, Leah Dickerman, Hal Foster, Denis Hollier, Rosalind Krauss, Annette Michelson, Mignon Nixon, and Malcolm Turvey, editors

For a list of books in this series, see page 349.

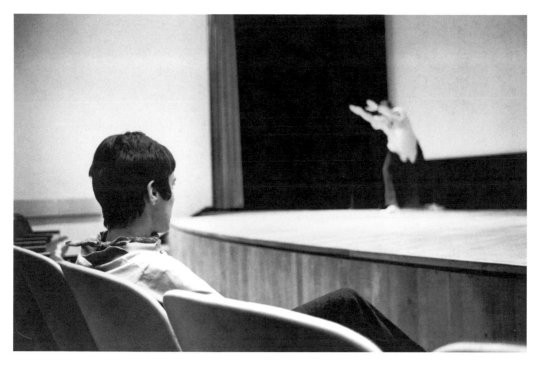

Yvonne Rainer, *Performance Demonstration,* 1968. Library of the Performing Arts, New York, 16 September 1968. Photo: Peter Moore. © Estate of Peter Moore/VAGA, New York, NY.

Being Watched

Yvonne Rainer and the 1960s

Carrie Lambert-Beatty

An OCTOBER Book

The MIT Press
Cambridge, Massachusetts
London, England

For information about special quantity discounts, please email special_sales@mitpress.mit.edu

This book was set in Bembo by Graphic Composition, Inc.

Printed and bound in the United States of America.

Library of Congress Cataloging-in-Publication Data

Lambert-Beatty, Carrie.
 Being watched : Yvonne Rainer and the 1960s / Carrie Lambert-Beatty.
 p. cm.—(October books)
 Includes bibliographical references and index.
 ISBN 978-0-262-12301-3 (hardcover : alk. paper)
 1. Rainer, Yvonne, 1934– —Criticism and interpretation. 2. Choreographers—United States.
3. Dancers—United States. 4. Modern dance. 5. Independent filmmakers—United States.
6. Experimental films. 7. Art, American—20th Century. 8. Minimal art—United States.
9. Art—Political aspects—United States—History—20th Century. I. Title.

GV1785.R25L36 2007
792.8'2092—dc22
[B]

 2007039854

10 9 8 7 6 5 4 3 2 1

My God! Can theater finally come down to the irreducible fact that one group of people is looking at another group!?

—*Yvonne Rainer, 1969*

Contents

PREFACE: CAMERA, ACTION

Two photographs from 1962 record, with almost comic precision, the play of performance and spectatorship, dance and documentation that powered Yvonne Rainer's art in the 1960s. In the first, a double exposure, Rainer is in a low squat, head down (figure P.1). One hand drapes across the back of her neck while the other hangs limply to the ground. The posture is one of exhaustion, even submission, and no wonder—her figure is dwarfed by an enormous television camera that looms above her on tripod legs, lenses aimed down as if to pin the dancer to the floor with the power of media vision. It could not hold her, though: in the second image, Rainer has risen to a straight-legged stance, stretching on tiptoe as if to gain every last inch on her mechanical partner (figure P.2). She turns away from the television camera and raises an arm slightly behind her. Her hand is out-turned and blurred; it waves. Though no doubt unintentionally, as captured in the photograph the gesture reads quite clearly. Stop looking at me, it says. I am not for you.

The images were taken by composer Warner Jepson, who served as still photographer during the rehearsal and broadcast of four solos by Rainer for a 1962 appearance on the San Francisco public television station KQED.[1] Aside from his images from that day, the program and its context are lost to history. Rainer remembers little about the circumstances of her television appearance,

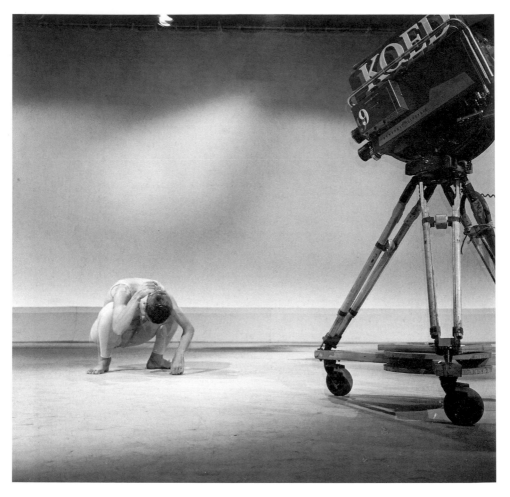

P.1 Yvonne Rainer, *Ordinary Dance,* 1962. KQED-TV studio, San Francisco, August 1962. Photo: Warner Jepson.

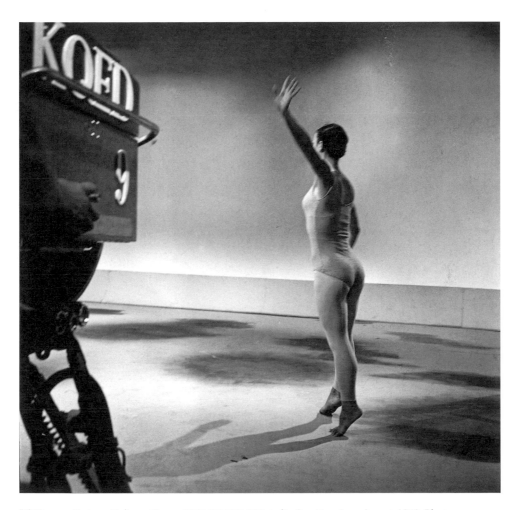

P.2 Yvonne Rainer, *Ordinary Dance,* 1962. KQED-TV studio, San Francisco, August 1962. Photo: Warner Jepson.

recalling only that the station's studio provided a great space for taking pictures. And so it did, for at least two of the images Jepson committed to film at KQED-TV give an impossibly—because accidentally—prescient glimpse of the dynamics of Rainer's work in the decade to come. In them, the camera serves as spectator extraordinaire: a surrogate for all the viewers with whose attention Rainer would work, all the gazes she would alternately, and sometimes simultaneously, submit to and defy in her performance art of the 1960s. And the television camera serves as a figure for itself: for the mass media that are always in the background of the work Rainer was involved in, shaping habits of spectatorship, conditioning our seeing of bodies offered to view. It could not be more telling for the dynamics of her work in the 1960s that in one picture Rainer folds to this gaze and in the other defies it. Nor that the images that capture these danced dialectics have been so long unseen.

ACKNOWLEDGMENTS

Yvonne Rainer was for many years an instructor in the Whitney Museum of
American Art's Independent Study Program in New York. In addition to giving
several seminars a year, she was available for meetings with program participants
to discuss their work. When I was a Critical Studies fellow in the program, I
promptly made an appointment to discuss my research and surprised her some-
what when, at our meeting, she realized that she herself was my subject. Since
that time, however, it has been my great privilege to work *with* the figure I have
been working *on*. Rainer has been open with her memories and archives, and
incredibly generous in responding to queries. Over the years, with great patience,
she has answered untold numbers of questions from me in research interviews,
casual conversations, and correspondence. She has never failed to respond to an
e-mail request for information, to sit down for an interview, or to lend me an
image for publication. And this is all the more remarkable because she does not
always wholly agree with what I say in arguments that are not primarily oriented
toward the artist's conscious intention. She has often helpfully corrected matters
of fact; she has occasionally made known her resistance to one or another of my
interpretations; she has sometimes seemed cheerfully bemused by me ("put that
in your sober art historical pipe," was one particularly memorable Rainerism),
but she has never once tried to suppress or stifle anything I have tried to say,
nor made access to her papers, memories, or even friendship conditional on

telling—or not telling—a particular story. There are sad tales out there about art historical research on living artists, and I am grateful to be able to offer a counternarrative. Rainer herself is the first person I want to thank.

After Yvonne Rainer, the list of advisers, friends, interlocutors, and supporters becomes overwhelming. I wish I had always realized, on the darker days during the long process of writing this book, how lucky I have been in this regard. I always thought I'd strive to write a tight, lean set of acknowledgments for my book, but as I consider the lushness of my blessings, leanness seems an inappropriate goal.

Though my studies with Alexander Nemerov had come to an end before my research on Rainer got under way, his teaching and writing were and remain an inspiration. In Pamela Lee, I had a dissertation adviser whose intelligence and knowledge were awe-inspiring (especially because we worked together during her first years as a teacher); they were matched only by her compassion. My adviser in the ISP was Benjamin Buchloh, who encouraged and helped me to develop my initial work on Rainer, and who has supported it as an editor at *October* and now as a senior colleague at Harvard. It is one of the luckiest aspects of my career that our paths have continued to cross. Ron Clark's support and advice were crucial; the ISP, which he has so long and lovingly directed, was the birthplace of this project, and I will always be proud of and grateful for the ways it shaped my thinking. In addition to Pamela Lee, dissertation readers Wanda Corn, Suzanne Lewis, and Thyrza Nichols Goodeve challenged me in the best possible way. Thyrza has been both a friend and a model of intellectual commitment and passion. My two years spent as managing editor at *October* felt more like an intensive seminar than a job, and I am honored that this book is appearing under its imprint. Among the *October* editors, in addition to that of Benjamin Buchloh, Annette Michelson's early support for my work on Rainer was especially encouraging; her memories of Rainer's performances as well as her probing questions about my arguments helped me a great deal, as did her own brilliant writing, quoted many times in the pages that follow. Malcolm Turvey was a close, challenging, and generous reader, and Roger Conover of the MIT Press a kind and insightful editor. Gwen Allen gave helpful feedback at a crucial moment—I still owe her one.

At Northwestern University, Hollis Clayson was a true mentor as I began my life as a teacher, as was Lyle Massey, along with other wonderful colleagues in the department of art history. Friends in Chicago and Evanston both guided and sustained me; particular thanks go to the Thursday night dinner group, Risa Brooks, Shannon Steen, and Kathy Grant—and to Kathy, Doug, Matthew, Anna (and now Angelique), family of my heart. In that category also belong three friends who happen to be art historians, whose work inspires me and whose help at various points may well have saved this book (they most definitely saved its author's sanity): Alison Matthews David, Julia Bryan-Wilson, and Sarah Adams. Claudia Zuluaga taught me about being a writer (and now, a mother). Jennifer Roberts is a newer friend, valued colleague, and intellectual model—these being categories that my two academic departments at Harvard have filled to overflowing.

I have also been fortunate in the institutions and grants that have supported work leading to this project. A Luce/ACLS Dissertation Fellowship in American Art and a Dedalus Foundation Dissertation Fellowship Award supported my initial research and writing. Funds from Northwestern University helped in the first stages of turning this work into a book. Without the Clark Fund and Tenure-Track Faculty Publication Fund at Harvard, this book would have no pictures. At Harvard I also had a summer of research assistance by Clara Masnatta, for whose diligence and persistence I'm very grateful. A year as a postdoctoral fellow at the Getty Research Institute allowed the book to take form and provided a context of support and intellectual challenge. There, Thomas Levin and Peggy Phelan became standout mentors and friends; P. Adams Sitney provided amazingly rich memories of Rainer's performances in the 1960s; and I finally had the strange and memorable experience of presenting my work on Rainer *to* Rainer. I owe thanks to all the Duration Working Group members; in addition to those mentioned above, Thomas Crow, Liz Kotz, Martha Gever, Sylvia Lavin, and Alex Potts gave especially helpful feedback. The Getty's several initiatives related to performance and the 1960s—from conferences to reconstructions of Rainer's dances—have been an important part of this project's development. Now that the Getty is the repository of Rainer's archive, its staff have been of great help, especially JoAnne Paradise and Sally McKay. I would also like to thank the editors

of the publications where parts of this book first appeared: the journals *October, Trans,* and *Art Journal;* the University of the Arts catalog *Radical Juxtapositions: Yvonne Rainer 1961–2002;* and the Vienna Museum of Modern Art publication *After the Act.* Curator and editor Sid Sachs has been a particular friend and resource, sharing his wealth of Rainerana with great generosity. Adam McEwen and David Raskin were similarly helpful with research about Donald Judd.

In the course of my work on Rainer I have been lucky enough to meet and correspond with many of the friends and colleagues who worked with her in the 1960s. It is telling of the esteem in which she is held that they were all so eager to assist me with research on her work. Those whose memories of working with and/or watching Rainer benefited this project include Frances Barth, Julie Finch, Simone Forti, Terry Fox, Sally Gross, Joanna G. Harris, Deborah Hay, Tannis Hugill, Janice Kovar, Patricia Mayer, Barbara Moore, Phill Niblock, Richard Pilkinton, Sara Rudner, P. Adams Sitney, Sarah Soffer, Elaine Summers, and Nina Yankowitz. For their exceptional generosity and patience, Pat Catterson, Barbara Dilley, Douglas Dunn, Warner Jepson, Babette Mangolte, Steve Paxton, Shirley Soffer, and Maida Withers have my special gratitude. I also want to thank all the photographers who provided images and reproduction rights. In a few cases, it proved impossible to identify and/or locate an image's photographer, for which I apologize.

Finally there's family. I'm forever grateful to Susan and Alan Lambert, who so rarely said no. Joseph Lambert is my oldest friend. My grandmother Rose Schniedman—champion nudger and believer both—gave me wise advice, support both emotional and financial, and, in her retirement community one summer, the most unusual and yet strangely efficient writing retreat I've ever heard of. I miss her every day. The Beatty family has been a joy (cracks about academia and contemporary art included).

As for the Rainer fan (and onetime Rainer performer) to whom this book is, in the end, dedicated, I'm not sure how properly to acknowledge the brilliant, steadfast, and funny partner who has been with me all through the long writing of this book, building me up, calming me down, listening, shushing, and making me laugh. For so many years of patience, insights, and cherished companionship, this is for Colin—though he may share it with John Maddock Beatty if he likes.

———

BEING WATCHED

Yvonne Rainer put it plainly: "Dance is hard to see."

She wrote these words in 1966, in the middle of the period discussed in this book, and what she meant is that as a temporal art, disappearing even as it comes into being, dance resists vision. As Rainer saw it, an artist who acknowledged this difficulty had two options. She could try to make performance less ephemeral, as she herself had done in 1961, when in her dance *The Bells* she repeated a short sequence of movements while facing in different directions, "in a sense allowing the spectator to 'walk around it,'" like an object (figure I.1).[1] Or she could exaggerate the problem of dance's disappearance, as she had just done with an elided continuum of unique movements in what would become her most famous dance. "My *Trio A* dealt with the 'seeing' difficulty," she explained, "by dint of its continual and unremitting revelation of gestural detail that did *not* repeat itself, thereby focusing on the fact that the material could not easily be encompassed" (figure I.2).[2] From *The Bells* to *Trio A,* then—from dance hyperavailable to vision, to dance resistant "to the point that it becomes almost impossible to see"—Rainer's work registered the basic, even obvious fact of performance's ephemerality *as an artistic problem:* something an artist had to work with, work around, work through.[3] As such, the difficulty of seeing performance is central to and also a paradigm for this investigation of Rainer's work. For the

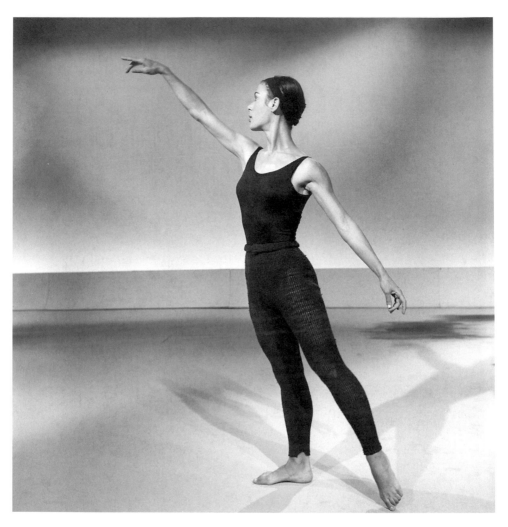

I.1 Yvonne Rainer, *The Bells,* 1961. Rehearsal at KQED-TV studio, San Francisco, August 1962. Photo: Warner Jepson.

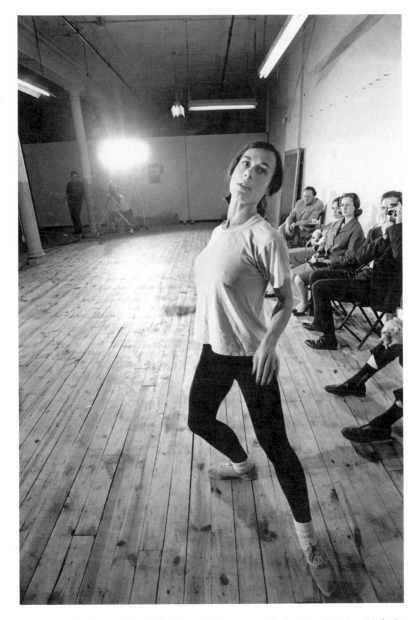

I.2 Yvonne Rainer performs *Trio A* as work in progress. Rainer's studio, New York, 26 November 1965. Photo: Peter Moore. © Estate of Peter Moore/VAGA, New York, NY.

fact that "dance is hard to see" is one of several "seeing difficulties" that this artist's work of the 1960s circled around; one of several problems of performance spectatorship through which this book will rethink Rainer's contribution to art in the United States during a watershed decade.

A founder of the performance collective Judson Dance Theater in 1962, a participant at mid-decade in the development and theorization of the tendency across the arts that came to be called minimalism, and a contributor to advanced art's turn to social content and critique around 1970, Rainer is a key figure for U.S. art of the 1960s.[4] In describing her importance, scholars have often lauded Rainer's transformation of the performing body in this period: the way she stripped it of special technique and star status, traded its costumes and leotards for T-shirts and sneakers, asked it to haul mattresses or recite texts rather than leap or spin. Yet the site of Rainer's most crucial interventions in the 1960s was not, in the end, the body of the performer. It was the eye of the viewer.[5] Or rather, it was the body *as offered to the eye,* for the status of the body as a thing to be viewed became a central and increasingly politicized problem in Rainer's work. "My God!" the artist exclaimed in 1969. "Can theater finally come down to the irreducible fact that one group of people is looking at another group!?"[6]

SEEING THE BODY

This is not to say that physicality was anything but a primary artistic concern for this artist of the body. Richard Serra, for one, has said that Rainer's performances in the 1960s offered him a way of thinking about, precisely, "the body's movement not being predicated totally on image or sight or optical awareness, but on physical awareness in relation to space, place, time, movement"[7]—giving a hint, for anyone who has experienced the sculptor's work, of how powerfully Rainer's own offered up the moving body as an entity interacting with, but not categorically different from, objects and space; of how it disclosed the "irreducible fact" of physicality itself to view. Indeed, aside from those in her New York circle, such as Steve Paxton, Simone Forti, Deborah Hay, and Trisha Brown, it is difficult to think of any artist whose work matches the literal, physical *thereness*

with which Rainer presented the moving figure in these years. In early work like *We Shall Run* (1963), whose title announces exactly what takes place in a group dance that limits its movement vocabulary to an easy jog; in the steady stream of unique motions performed without a pause for dramatic emphasis or any apparent modulation of energy that is *Trio A;* in her use of untrained dancers or onstage rehearsing and teaching within her late-1960s performances, Rainer's work presented the body as Western theatrical dance never had before: in its unadorned, physical facticity.

Along with peers like Paxton and Forti, Rainer accomplished this in part by subtraction, removing from dance performance not only story, character, and emotional expression (as her one-time teacher Merce Cunningham had done) but also everything that marked the dancer's body as extraordinary, ideal, or ethereal, beginning with its special clothing (practice garments like tights and leotards were usual in her earliest work, but even those were soon replaced by sneakers, jeans, and other street clothes). Virtuoso steps and tricks also fell away: leaps and spins were replaced with running and catching, falling and climbing. Meanwhile, Rainer rejected elegant, dancerly carriage of the body in favor of a quality of movement that she called "tasklike" and developed, in part, by having her dancers interact with objects like floppy mattresses that were heavy or awkward enough to ensure that performers manipulating them couldn't embellish or accent the activity in any way.

What was left once narrative, idealization, and conventional technique were stripped was the body as muscular fact. This she deployed in movement that was by turns quirky, athletic, and exuberant: from spastic groping of her own body in a section of *Three Seascapes* (1963), to the repeated mounting and descending of a short staircase in *Stairs* (1968, part of *The Mind Is a Muscle*, 1966–1968), to dancers' hoisting, climbing, and rolling over one another in *Continuous Project—Altered Daily* (1968). Among the many astute commentators on Rainer's treatment of the performing body, Sally Banes remains foremost: in *Trio A,* she explains, "the possibility is proposed that dance is neither perfection of technique nor of expression, but quite something else—the presentation of objects in themselves."[8] But perhaps Rainer had said it best, twelve years before.

5

"I love the body," she proclaimed, "its actual weight, mass, and unenhanced physicality."[9]

Nevertheless, to understand Rainer's art of the 1960s as only a matter of embodiment would do justice neither to the work nor to its contribution to this period's artistic culture. It would not account, for instance, for the humor (and occasional hysteria) of work in which Gertrude Stein–like dialogues, screaming fits, pornographic films, and giant sombreros were just a few of the incongruous elements featured. Even more significantly, it would not address the multimediality of performances in which still and moving projected images, sculptural objects, and recorded sound were integral aspects. It would not provide a rationale for what Bertolt Brecht would have recognized as Rainer's "literalization" of performance, with recited, read, printed, and recorded language everywhere supplementing movement activities;[10] nor for the fleeting but purposeful introduction into this supposedly abstract art of representations of sex, death, love, and emotional and physical pain. Nor would an account of Rainer's work oriented only to its emphasis on the literal, physical body give us a way to explore questions such as why still tableaux and the photographic recur within it (as in a Muybridge-like projection of dozens of sequential images of a dance in 1968); why films and film culture so suffused her aesthetic (from the imitation in *The Mind Is a Muscle* of Jean-Paul Belmondo's *Breathless* death run to the inclusion of rehearsal footage, her own short films, and Hollywood features in *Continuous Project—Altered Daily*); or, finally, why she eventually gave up live performance for filmmaking in the 1970s, returning to dance only in 1999. And, in the end, such an approach would not give us the most convincing account of why Rainer's work matters for understanding art in the 1960s.

This book tries to do so, by explaining, or at least exploring, some of these other sides of Rainer's practice. This does not mean ignoring her treatment of the physical body, of course; nor trying, perversely, to argue that she was exclusively concerned with what Serra called "image or sight or optical awareness." Rather, I see Rainer's art as structured by a peculiar tension: between showing the purely physical body and *showing* the purely physical body—between the body being, and being watched.[11]

In 1999, a film of Rainer performing *Trio A* was included (on video) in the Whitney Museum exhibition "The American Century." A friend, seeing it for the first time, remarked to me that it looked like the way someone might dance at home by herself, if no one were watching. Thinking that this was a remarkable recognition by an uninitiated viewer of one of the key aspects of *Trio A*—the way the dancer avoids making gratifying eye contact with the audience (or, in this case, camera) by averting her gaze, turning her head, and even, at one point, shutting her eyes, I passed the comment on to Rainer in the spirit of a compliment, thinking she would enjoy hearing how well the work still translated. After all, she had written in 1966 that she was trying to avoid "exhibition-like" presentation,[12] and many critics have offered versions of Roger Copeland's comment about *Trio A:* that in it Rainer "remains coolly oblivious to those watching."[13] After all, this has been the one prevalent interpretation of Rainer's dance work in terms of the politics of spectatorship—that she refused dance as spectacle—and surely the idea of "dancing alone" captured this.[14] Yet Rainer, who in previous conversations had been remarkably open to interpretations of her work (and who has continued to be so since), this time responded brusquely. She was sick, she said, of people thinking she ignored the audience.[15]

This gave me pause. While I had already developed doubts about the work's unequivocal achievement of an antispectacular mode of performance, I had rather believed that Copeland's view corresponded to Rainer's own ideal for *Trio A.* Certainly a distrust of the very idea of performing *for* an audience seemed endemic to art in the decade of this dance, as demonstrated, for instance, by Allan Kaprow's gradual removal of audiences from his Happenings until everyone involved was a participant (by the 1970s he was refusing to have most of his works documented, since a photographer would have been an outside observer). As I considered the difference between disliking exhibition-like modes of presentation and dancing as if alone, however, this exchange with Rainer began to suggest to me the space defined by her 1960s work: the space between interest in performative communication and resistance to exhibition, between body and beholder. Rainer's disapproval of the idea that *Trio A* was meant to look unperformed sent me back to certain comments by critics—particularly Annette

Michelson's 1974 suggestion that the work of Rainer and her peers "pressed for an altered relation between performer and audience,"[16] or Ann Kisselgoff's less supportive but telling identification of a seeming contradiction: "Despite what seem to be her best efforts to bore her audience, she [Rainer] only succeeds in making what she does highly interesting."[17] I returned to passages in Rainer's writings, such as her framing, in the famous 1966 essay on *Trio A*, of "the 'problem' of performance,"[18] and benefited from scholarship on Rainer and related artists such as that by Nick Kaye that explores the way work with the body in postmodern dance was also work on the situation of spectatorship.[19] I began to see that complaints by some of Rainer's contemporaneous critics about her work's relationship to the viewer, or lack thereof—for example, Don McDonagh's statement that her dance concerns were "personal and of value only to herself" or Frances Herridge's contempt in 1969 for "her nerve in taking the audience's money and then ignoring them"[20]—in fact register precisely the degree to which audiences *were* her concern; the degree to which she was working to alter the relationship between viewer and performer. And I began to suspect that the particular irritation of these critics suggested a historical (as well as an art or dance historical) nerve being struck. I realized that even *Trio A,* whose averted gaze is the most famous example of Rainer's reconfiguration of the performer's relationship to the spectator, was an attempt not to escape performance's spectatorial condition, but rather to distill it. Rainer wondered in 1967 whether, by rendering her dances into "theater-objects" that did not acknowledge the viewer, she had been able to make demands on the audience precisely by seeming to ignore it.[21] Displaying the moving body for you, without any attempt to seduce or affirm you, does not remove dance from the condition of exhibition, after all. It reduces the performance situation to the fact of display.

Rainer has often paraphrased a critic who in 1964 asked why she and her fellow avant-garde dancers were "so hell-bent on just being themselves."[22] It was only recently, however, that she made the reference in conjunction with the statement "It's impossible to behave in an everyday fashion when 100 eyes are upon you,"[23] suggesting that the emphasis in her citation of the critic belongs

not on "themselves" but on "hell-bent"—it becomes the difficulty of achieving that self-identical, simple being under conditions of spectacle that is at issue. The arguments in these pages are founded on just such a shift of emphasis; on the conviction that Rainer's area of exploration in the 1960s was not exactly "things in themselves" but things-in-themselves *to watch*. Eyeing this difference, I have come to see Rainer as not only a shaper of dances and a mover of bodies but a sculptor of spectatorship.

Seen this way, Rainer's work becomes a—perhaps the—bridge between key episodes in postwar art. For this was a period in which issues of spectatorship came to the fore everywhere, in both literal and theoretical ways. Curator Alan Solomon recognized as a matter of fact in 1965 that to make innovative art in the 1960s was to consider reception creatively as well: "except for those painters who regard their art in the purest terms, it is simply no longer possible for artists to isolate their feelings of openness and speculative adventure about their creative activity from their ways of thinking about the audience for whom they are working."[24] Two years later (and disseminated within the context of avant-garde art, in an issue of *Aspen*), Roland Barthes famously made the figure of the reader, rather than the author, the locus of textual meaning.[25] Emerging from this period, much of the best scholarship on art of the 1960s has foregrounded questions concerning the relation of viewer and artwork: in minimalism, color field painting, op art, video, multimedia performance, institutional critique: How is the viewer positioned? What kind of viewer—what model of subjectivity—is brought into being? What mode of perception is invited, what kind of experience produced, what form of connection proposed? To pursue the "irreducible fact" that spectatorship was a basic medium of Rainer's work is thus to trace a unique but central trajectory through American art in the 1960s.

Accordingly, this book follows the treatment of the viewer through overlapping but successive episodes of Rainer's career, and of the American avant-garde, as her practice connects questions of audience involvement raised in the late 1950s and early 1960s in Happenings, Fluxus, and Judson dance to the phenomenological investigation of subject-object relations in minimalism (chapters 1 and 2); links minimalism, in turn, to questions of subjectivity and intersubjectivity

in which the political implications of modes of viewing become apparent (chapters 3 and 4); articulates, at the end of the 1960s, connections between antiwar cultural politics and concerns internal to avant-garde art (chapter 5); and finally joins her 1960s artistic avant-garde to the emerging feminist discourse in which the political implications of modes of viewing were most fully elaborated in decades to come (chapter 4 and conclusion).

SEEING DIFFICULTIES

Ephemerality, presence, movement memory, documentation, attention, mediation, durational experience, involvement of the viewer ... the problems with which Rainer's work of these years grappled are intrinsic to performance in any time or place. In the 1960s, however, they presented themselves as such—as problems—in a new and significant way. Expanding the meaning of Rainer's 1966 phrase, I call these "seeing difficulties": problems that might always have been a part of experiencing art, but which at particular times, in particular places, become newly problematic, and thus newly productive for artistic work.

The theory of reception aesthetics takes as its central tenet that "the function of beholding has already been incorporated into the work itself," as Wolfgang Kemp has put it.[26] In art history, there is a tradition of investigating works of art through the kinds of spectatorship they seem to invite or require; and within this tradition, a strand of scholarship that considers modes of looking historically as well as aesthetically. For instance, just at the end of the period being considered here, Michael Baxandall's 1972 *Painting and Experience in Fifteenth-Century Italy* introduced the idea of a "period eye," arguing that ways of looking at art are historically determined and shaped by everyday skills and practices in a given culture, such as Florentine merchants' specially honed ability to evaluate visually the quantity and quality of goods.[27] Forms of spectatorship, rather than either content or style, thus become the links between artistic forms and the wider culture. The notion of the period eye is in some ways congenial to the approach I take in the chapters that follow, although of course the match between spectatorial practices in art and mainstream culture will be more complicated in this

case, under conditions of manufactured culture on the one hand and avant-garde art on the other.

For the period eye relevant for art of the 1960s is one trained not by techniques of work but by practices of leisure: by the postwar period's profusion of things to watch. As oppositional as 1960s avant-garde performance practices may have been—and as distant as avant-garde artists might have felt from the influence of Hollywood, television, and advertising—they existed in relation to a particular culture of spectatorship. The presentation of the body in Rainer's work must be understood in its tensions *and its correlations* with spectatorial situations outside the realm of art; in dialectical engagement with the effects on the sense of time, distance, and bodily reality of the culture of information and spectatorship that had developed in the postwar United States, particularly with the remarkable escalation of television culture. A key aspect of the historicity of Rainer's work is the complexity with which it engages mass media spectatorship—even though (or especially because) this was not often a consciously intended effect. We are used to recognizing how painting and sculpture of the 1960s, such as that of Warhol and Lichtenstein, engaged dialectically with mass culture. What pop did for commodified images and objects, Rainer did for commodified *experience*—for modes of observation and reception conditioned by the forms of commercialized culture. Spectatorial multitasking, submission to particular temporal patterns, objectification of bodies, and above all dialectics of distance and mediation: all of these are aspects of life in a media culture, and all structure Rainer's work with bodies being watched.

One of the ways this book differs from most studies of Rainer's work—as this interest in modes of spectatorship forged before headlines, movie screens, and TV monitors already suggests—is that I do not think either her reflexiveness or her critical stance stops at the boundaries of her medium. As an artist, Rainer emerged from and contributed specifically to dance, to be sure (though she often worked within art contexts, in collaboration, discussion, and debate with visual artists). Her work cannot be understood outside of its critical relationship to dominant models of dance modernism—and yet this does not make Rainer a medium-specific artist. Though it was through a critique of dance

that her innovations emerged, this is an artist who very quickly incorporated writing and speech, film and photographs into her art, who found her readiest audiences and sources of institutional support in the art world, and whose work was often referred to artistic categories broader than dance: Clive Barnes called her brand of performance "dance theater," Allen Hughes identified her with "avant-gardists who come from, or associate with dance" but who "are exploring theater without worrying about labels," and a *Dance Magazine* profile described her as "preoccupied with movement as a form of theatre."[28] The need to expand from a dance-specific approach to her work is made most pressing, however, by the fact that Rainer's treatment of *watching* makes sense only in relation to a wider culture in which directness of encounter, immediacy, and sheer embodiment came to be constituted in opposition to mediatic virtuality, delay, and decorporealization.

Of course, this approach presents its own difficulties. In the model of the period eye, artworks tend to correspond easily to ways of seeing developed in spheres outside of art. But in the late twentieth century the relationship between the types of spectatorship invited by artworks and their social surround is fraught. Works in an avant-garde tradition are generally assumed to have an antagonistic relation to the perceptual and attentive tendencies inculcated elsewhere in a culture. Rainer's work, however, has helped me see problems in art spectatorship as neither reflections of established ways of seeing nor resistant alternatives, but quite something else: as indicators of cultural fault lines, in this case those related to the body in a social field increasingly constituted through the exchange of images. And while an artist's stance relative to other artists tends to be clear, at least on the surface, the work's relation to such underlying cultural conditions is almost always more ambiguous.

Peggy Phelan has pointed out that the radicality of the expanded range of movement, body types, and skill level that Rainer and fellow dancers at Judson Memorial Church admitted into dance performance in the early to mid 1960s was mitigated somewhat—made to take "a stutter step," she says—by the intractable and conservative structure of the relationship between performer and audience.[29] In 1966 Rainer intervened in this relationship—which she called

"the 'problem' of performance"—with the dance *Trio A,* and especially with her decision in that work to keep the dancer's gaze from ever aiming out at the audience: coming up from a somersault facing squarely to the front, for instance, the dancer is meant to shut her eyes. By choreographing movements that keep the face and gaze turned away from the viewer, Rainer hoped to break the circuit of seduction and admiration built into the performer-viewer relationship. This has become one of the most commented-upon choreographic choices in modern dance history, and certainly the most discussed of Rainer's interventions in spectatorship. Yet one of the things that interests me about Judson-era dance, Rainer's work, and *Trio A* in particular is precisely how *little* was done here to reconfigure the spectatorial relationship. (Quantitatively little, Rainer might have said.) After all, the gesture of the averted gaze, however important in the history of dance, is a literally small intervention—coming down at times to the movement of eyelids. And it is one beset by its own contradictions. In setting out to alter the relation between a person doing and a person watching, does it not seem slightly perverse to begin with the *doer's* gaze? Further, as Phelan has provocatively suggested, in its attempt to disrupt spectatorial relations in performance, *Trio A* actually comes very close to mimicking those of a more powerful ideological machine, for the head movement of *Trio A* leaves the spectator comfortably unseen. It thus exaggerates the split between moving and viewing (as discussed in chapter 3), while also inserting "a kind of filmic voyeurism into live performance."[30] In the late 1960s Rainer did experiment with allowing viewers to move around and even through performances (this is discussed in chapter 5). Even then, however, in comparison to experiments from the Happenings and Fluxus performances to the near-bacchanals of some late-1960s experimental theater, Rainer and her peers seemed content to work—or were intent on working—within the convention of watchers, seated and silent, with moving, active performers before them. In a 1969 letter, Rainer again made herself plain: "I accept and require the 'audience-performer gulf.'"[31]

Let me be clear as well: I do not think this choice indicates any lingering conservatism on Rainer's part. Such an accusation would be inadequate to the ambiguities in Rainer's complex art, for one thing; for another, it would overlook

the contradictions, to which Rainer was clearly sensitive, plaguing experimental alternatives to the normal spectatorial arrangement. (As Kaprow put it, "to assemble people unprepared for an event and say they are 'participating' if apples are thrown at them . . . is to ask very little of the whole notion of participation.")[32] Rather, I think there was something about the conventional spectatorial situation—one group of people, largely passive, watching another, largely active—that needed to be worked through, for reasons that were historical as well as artistic. And Rainer did this in extraordinary ways. The fact that, for the most part, this work was done not at the gross level of the spectator-viewer relationship—such as seating arrangements—but within its conventions is precisely what makes it so interesting, so apposite, and finally of such continuing importance. For her choices in this regard suggest that *spectatorship as such* was the social phenomenon to be, not negated, but explored.

It is because of near-contradictions and paradoxes like those I've suggested in the case of *Trio A* that I like the slightly awkward phrase, "seeing difficulties." When "seeing" is taken as a verb and "difficulties" as its object, the phrase describes not a type of difficulty but a critical approach: the seeing of problems. And this is a strategy appropriate to a body of work full of ambiguities, of difficulties one must try to see. Too often, Rainer has been made emblematic of a particular category, such as postmodern dance, feminist art, or one or another variant of avant-garde filmmaking. This is understandable. "NO to spectacle no to virtuosity no to transformations and magic and make-believe," she famously proclaimed in 1965, "no to seduction of the spectator by the wiles of the performer no to eccentricity no to moving or being moved."[33] As this frequently quoted, manifesto-like statement suggests, Rainer occupied a central place in an avant-garde we've understood to be predicated on negation. Yet it is thus all the more important to realize that her performance practice itself—sometimes consciously, sometimes unavoidably—articulated strikingly original models not of refusal but of engagement. In Rainer's deeply dialectical art, few of the aesthetic goals announced by artists, critics, or historians are fully accomplished, few avant-garde stances completely inhabited. For every decision she made to allow her audience freedom to move around a performance space, there was

a concomitant reminder please not to interrupt the performance (chapter 5); for every effort to present the body's movement without theatrical stylization, there was an admission that unadorned, direct performance had itself to be dissimulated (chapter 3). Not for nothing did she use the language of struggle in naming such issues as "my audience problem,"[34] "the 'seeing' difficulty" or "the 'problem' of performance"! Despite a tendency by commentators to seek out the manifesto-like moments in her work and her always pithy prose, her art does its cultural work precisely in its ambiguities, and is best understood when one is attuned to compromised goals and thorny conceptual problems.

Of course, there are several such problems one could trace through Rainer's career. This book is not an exhaustive account of her art in the 1960s, still less of her life or the relationships that constituted her artistic milieu.[35] It is, rather, a critical investigation of—an attempt to see difficultly—the class of problems in her work that can themselves be described as "seeing difficulties."

SEEING 1960s PERFORMANCE

Claiming that we see differently than viewers in other times and places, the model of the period eye nevertheless supposed that past ways of looking could be accessed by historians; tried on, like a pair of spectacles, to better understand what works of art were like in their own time. Such certainty about the distinction between now and then, between when we are looking through period eyes and when through our own, is both practically impossible and theoretically undesirable in the present case. In dealing with performances, we are considering artworks that by their nature no longer exist. Like any performance historian, in order to analyze the artworks I discuss in the following pages, I have had to reconstitute them based on sparse traces, on past reconstructions by a series of viewers, critics, and historians more or less distant from the moment of performance, and on interviews and correspondence in which I tried to pin down details of dances forty years gone. On the whole I have been amazed by the vivid memories of these works among the participants and viewers I have interviewed, but blank spots, contradictions, and, no doubt, my own mistaken

impressions abound. One does not, of course, throw up one's hands and declare performance art—or its reception—inaccessible to art historical investigation because it is ephemeral; and one does not give up empirical research's place in theorizing performance simply because such research can never be complete. But, equally, one does not—or should not—pretend to be able to produce the object of study as anything other than a series of traces, shaped and serially re-shaped by the interests, desires, and ways of seeing of everyone from the artist to the photographer who documented the events to the historian herself.

The role of the photographer has special significance in discussing Rainer's work and much other avant-garde practice in New York in the 1960s, and yet it is not often enough acknowledged that we know this work now to a large degree through the images produced by one remarkably dedicated documentarian of the avant-garde. It is not much of an overstatement to say that the view we have of Rainer's art *is* the view through the lens of Peter Moore's camera. (More than half of the credited images in Rainer's book *Work 1961–73* are by Moore, for instance; he is also by far the most represented photographer in the pages that follow.) The prevalence of Moore's imagery in studies of the period is not often discussed outright, in large part, I suspect, because this photographer's choice—and his gift—was to remove his own subjectivity from the documentation as much as possible. In this way, like many of the artists he documented, Moore participated in a reaction against the cult of personality in postwar artistic culture. In this way, also, his images share in the direct, factual, or tasklike mode we associate with the art of Rainer and her peers. And in this way, it must also now be acknowledged, the images he created actively *produced* what we now understand that mode—and that art—to have been.

For, though it is obvious that the images of performance, like any photographs, texts, or reminiscences, are not transparent windows on what was but active constructions of it, the implications of this fact are often elided in the process of writing the history of performance art. Every scholar of performance develops a way of negotiating this problem, but here I have brought the process to the foreground, building arguments directly out of readings of particular documentary images and texts, discussing Moore's role and that of other pho-

tographers in shaping our understanding of past performance, and often allowing dissenting voices or contradictory traces to enter the conversation, either in notes or the main text. I do this not only to acknowledge alternatives to arguments that I recognize are sometimes interpretively adventurous, but *as* a form of argument as well. Here, a certain circularity is the very basis of investigation: the fact that my research in the traces, representations, memories, and mediations of past performance so often comes up with trace, representation, memory, and mediation as concerns of the events themselves.[36]

This circularity can be understood as a special case of a condition identified by Leo Steinberg during the period studied here. In 1967, he wrote of the need to accept "the legitimacy of retrojecting from our immediate experience to remote fields of study."[37] It was no coincidence, Steinberg insisted, that scholars of the baroque began finding evidence everywhere of artists working simultaneously in multiple distinct styles, at a time when the most prominent contemporary artists, such as Picasso, practiced precisely this kind of simultaneous stylistic divergence; nor that many-paneled medieval altarpieces became suddenly interesting to him during the mid 1960s, when split-screen projection of multiple images and "showers of visual data" became commonplace.[38] An even more relevant example, given the attention to spectatorship that artists of the 1960s and early 1970s evinced, might be Baxandall's 1972 "period eye" itself, and the approach to art history through forms of seeing rather than of making. For Steinberg, such present determination of the past did not invalidate researchers' findings. While there would always be a danger of projecting contemporary views backward (whether one admitted the role of "retrojection" openly or not), it was only in light of contemporary experience that certain previously overlooked aspects of past art could be brought into focus. In the current case, there is no doubt that my own concerns about the perceptual, psychological, and ethical effects of living in a media-saturated and spectatorship-oriented environment have affected my view of 1960s art and of Yvonne Rainer's dance. But these concerns, of course, are themselves shaped by the way such issues were addressed in the 1960s—addressed by, among many others, artists like Rainer.

Judson Dance Theater in Hindsight

"Some exercise in complex seeing is needed . . ."

—*Bertolt Brecht, "The Literalization of the Theatre (Notes to the*
Threepenny Opera*)"*

Of Dance . . . of Dance

What, who, where, when. Black capital letters and a no-frills, typewriter font. Nothing could be more straightforward than the 1962 flyer announcing "A Concert of Dance"—*a* concert, then, but to us *the* inauguration of a remarkable series presented at New York's Judson Memorial Church in the early to mid 1960s by the group of artists that came to be known as Judson Dance Theater (figure 1.1). Nothing in the black-and-white, text-only flyer that choreographer and concert participant Steve Paxton designed suggests the exhilarating, exhausting spectacle "A Concert of Dance" would be. Nothing about the data tightly compressed in the vertical poster's lower half prepares a potential audience member for a sprawling program of twenty-three individual works, in a concert that stretched to more than three hours on a sweltering July evening. Nothing indicates the event's origin in a choreographic workshop devoted to

A CONCERT
OF DANCE

BILL DAVIS, JUDITH DUNN, ROBERT DUNN, RUTH EMERSON, SALLY GROSS, ALEX HAY,
DEBORAH HAY, FRED HERKO, DAVID GORDON, GRETCHEN MACLANE, JOHN HERBERT McDOWELL,
STEVE PAXTON, RUDY PEREZ, YVONNE RAINER, CHARLES ROTMIL, CAROL SCOTHORN,
ELAINE SUMMERS, JENNIFER TIPTON

JUDSON MEMORIAL CHURCH
55 WASHINGTON SQUARE SOUTH
FRIDAY, 6 JULY 1962, 8:30 P.M.

1.1 Steve Paxton, poster for "A Concert of Dance," 1962. Courtesy of Steve Paxton.

chance techniques and convention-flouting put together for a group of young dancers and artists by a disciple of John Cage. And little—save the unranked and starless list of names—suggests the democratic, collaborative process that brought the concert into being and continued to characterize Judson Dance Theater for the next five years or more, with choreographers sharing responsibility for running the lights and taking ticket reservations (and mailing out the four hundred copies of this poster Paxton had printed up), as well as contributing whatever work they liked without censure. Certainly it is hard to find a hint in the poster for the first Judson dance concert of the radically inclusive, anything-goes spirit of the now legendary evening, whose events included one dancer wielding flashlights in the dark, one eating fruit onstage, and another singing "Second Hand Rose" in a bloody lab coat.[1]

What the poster does provide, beyond the basic facts, is a graphic representation of some tendencies in New York avant-garde movement performance of the early 1960s that have been less understood than either its collaborative ethos or its anticonventional aesthetic. The poster's upper registers are divided between a blank central space and a black strip topping the image, the latter perforated at its upper edge by a series of shapes quickly recognizable as the cut-off bottom bits of the words seen in the poster below: "of dance." This repetition emerges from the technical means for making such a poster before word processors and home printers and their easy resizing of fonts. Having typed the text, Paxton had it enlarged at a copy shop using a photographic process, likely a photostat machine, which in addition to black text in several sizes gave him a white-on-black version of each enlargement—a kind of internegative he then incorporated into the poster's design.[2]

As soon as the viewer discerns the textual echo of the event title, the top of the "Concert of Dance" announcement becomes a partial figure-ground reversal of the bottom, a negative repetition whose effect is a slight sense that the image is vertically scrolling. It is as if the black section is about to roll off the top of the page, followed by the blank space, the words "a concert," and then "of dance" once again. This virtual movement serves the design by making visual sense of the large zone of blank space at the center of the poster: once

that center is imagined in motion, the design seems less bottom-heavy, perhaps because it conjures up a virtual space below the text, not yet visible, that would balance the composition. In any case, the simple repetition of a fragmented line of text lends the poster a sense of movement—only appropriate, of course, for a document announcing a dance event. Yet, as opposed to the dynamic typography or mimetic images that could have been used to suggest *dance* motion, Paxton's choices produce a virtual movement linked not to the ephemeral, breathing art of dance but to the technologies of printing press or film strip (an impression that would have been confirmed for audience members who showed up on the night of July 6, for despite its title, "A Concert of Dance" opened with the screening of a film—a collage by Elaine Summers, John Herbert McDowell, and Gene Friedman).[3] Moreover, as "of dance" slips off the top of the poster, the repetition, negative reversal, and suggestion of scrolling repeat the reproduced status of the print itself. Despite the event title's singular article ("*a* concert") and the poster's implicitly future-tense announcement, these devices represent the singular performance event as somehow both reproducible and already partially *missed*. The concert of dance comes around, again, before it has even occurred. The text traces itself, here and gone and here again.

Now, I may well be seeing too much in a document that is, after all, a supplemental scrap of paper quite external to the event itself. Posters, and all the other "ephemera" so much more durable than events like "A Concert of Dance," have a way of gaining in importance when performances themselves fade into time, as no one knows better than artists who work in such forms. In 1974, when she prepared a book documenting her performance work of the 1960s, Yvonne Rainer commented on the limitations of the "shards" (the objects or props from her work), "papyri" (programs, essays, and texts used within performances), "hieroglyphics" (notebooks), and "those mysterious and inscrutable petroglyphs" (photographs), with which she had tried to reconstitute more than a decade's work.[4] In particular, she feared that publishing the texts that performers spoke or read aloud in her pieces alongside descriptions of the choreography might distort the record: "Being so much more synonymous with the format of a book than the physical elements of the work, these texts are more true to the spirit

of their original presentation than anything else in the book and, consequently, more lively."[5] Implicit in her musing over sources in general, and in this caveat in particular, is a recognition that the dead traces of live performance are supplemental in Jacques Derrida's sense of the term—not only adding to, but changing and partially replacing their vanished referents. Rainer knew this effect well from her immersion during the late 1950s and early 1960s in the traces of dance history; she spent long hours during this early phase of her career poring over dance books and photographs in libraries and shops.[6] Later, as she herself prepared a retrospective book, she registered the danger that the traces of her art, so amenable to reproduction, dissemination, and ex post facto interpretation, could *become* her performances as we know them, signs replacing what they signified.

And so, of course, they have. Traces are all we have to understand performance of the 1960s: the tattered programs we find in archives, the flat photographs languishing in books and files, the fragmentary descriptions in critics' accounts, or the equally worn, altered, and patchy memories of witnesses and participants. The subject of the present book, then, can really only be Rainer's 1960s performance *as we now have it,* her art as a matter of traces. My gamble, however, is that this slip of representation into the place of performance is not external and incidental to live art, but central to its workings—at least in the 1960s.

In 1967, Guy Debord lamented the diminishment of directly lived experience under the conditions of consumer capitalism and media culture that he named spectacle: "The pseudo-events that vie for attention in the spectacle's dramatization have not been lived by those who are thus informed about them. In any case they are quickly forgotten, thanks to the precipitation with which the spectacle's pulsing machinery replaces one by the next."[7] Explicit or implicit in most after-the-fact accounts of performance-oriented practices of the 1960s is the sense that they offered a counterweight to what Debord, using the American historian Daniel Boorstin's 1961 coinage, called "pseudo-events": actual occurrences (like photo-ops) that happen only in order to generate representations. For the philosopher Thomas Heyd, for example, the contribution of dancers such as Rainer, Steve Paxton, and Lucinda Childs was to make dance so much an art of the unmediated physical body that it became intrinsically resistant to

"the ever more pervasive diffusion of simulacra in contemporary industrialized societies."[8] Certainly, Judson Dance Theater emerged at a cultural moment when ideas about direct communication and unmediated interaction were brought into focus and invested with significance in a new way across a range of disciplines and contexts—as in 1963's *Behavior in Public Places,* in which sociologist Erving Goffman had to delineate as a special object of study the phenomenon of situated, embodied communication, in which people were "copresent" in time and space. Likewise, what Goffman called copresence was, at the same moment, undergirding the social vision of the emerging New Left, whose emphasis on participatory democracy as an antidote to the "remote control economy" and the "structural separation of people from power" animated the 1962 "Port Huron Statement" of Students for a Democratic Society.[9] Given this culture of copresence, it makes sense that in accounts of Judson Dance Theater such as Heyd's, and in descriptions of other important manifestations of live art in the United States in the early 1960s, such as Happenings, Fluxus, and the off-off-Broadway presentations of groups like the Living Theatre, critics and historians describe anti-pseudo-events, art dedicated to modes of being and knowing other than "being informed." They stress the haptic experience, participatory action, and unmediated contact produced through techniques of indeterminacy, spontaneity, ephemerality, and audience involvement, often in contrast with performance of the writer's own present, as when Sally Banes wrote in 1990 that "Audience participation in the '60s exploded theatrical etiquette, allowing for the unexpected," while "current audience participation . . . is a rule-game in which, like the exhibition-style dancing as well as the pithy, media-pitched sound bites of the '80s and '90s, the moves are stylized and highly codified."[10] For Banes, this change was an implicit political shift as well, as she suggested by likening the audience's involvement in performance arts of the 1960s to the era's stress on direct action and participatory politics, a linkage similar to the one she captured, in the case of Judson Dance Theater, with the resonant title of her pioneering and invaluable 1983 study of the group: *Democracy's Body.*

As this title suggests, Banes's account does not merely provide our most important source of data about the group and its activities, but also offers a strong

interpretation of the Judson group's aesthetic. In the group's inclusion of a full range of movement options beyond strictly "dance" steps and gestures, and in its use of chance and other nonhierarchical models of composition, Banes found the performance equivalent of its collaborative social structures, and she thus pictures Judson Dance Theater as a resolutely liberal and communal enterprise: "Within the Judson workshop, a commitment to democratic or collective process led on the one hand to methods that metaphorically seemed to stand for freedom (like improvisation, spontaneous determination, chance), and on the other hand to a refined consciousness of the process of choreographic choice" (*DB* xvii).

It is largely through such a lens that Judson performance has entered art history of this period. In Thomas Crow's *The Rise of the Sixties,* Judson dance becomes a crucial pivot, joining the metaphorically egalitarian formal choices of proto-minimalist art with actually egalitarian social models. "The values that were to lend a distinct character to much 1960s art-making," Crow argues, including repetition and seriality, resistance to emotional display, and nonhierarchical composition, "first came together as ethical imperatives in the conduct of the Judson circle."[11] So neat is the fit between the values demonstrated in the Judson group's social organization, the metaphors suggested by the choreographic choices the group made, and the ethics underlying the social movements of its time that it is difficult to distinguish these categories in Judson dance's reception:[12] group relations, formal decisions, social context. Not that they should be severed, of course. Yet there is a different view possible of the artistic context in which Rainer's work emerged—a view, if you will, over the shoulder of democracy's body.[13]

Mine is a way of looking at Judson dance and other performance practices of the 1960s that, while indebted to Banes's research, reads somewhat against its grain. I do so in two simultaneous and not unconnected ways: by beginning from the acknowledgment that I come to this live art as history; and by asking questions about its relation to aspects of its social surround other than the urge toward participation and egalitarianism, particularly those related to the mediated condition of everyday life in the postwar United States. It is a way of looking founded in a sense that the interest in copresence and immediacy in 1960s

discourse was a case of protesting too much—of registering in negative the encroachments of communications technology and cultures of spectatorship—and one that finds this dynamic shaping much of the period's art.

And it is a way of looking suggested by the poster for the first Judson dance concert, with its gestures toward techniques of reproduction and dissemination, repetition and trace. For, while an emphasis on the viewer's presence and real-time experience is certainly palpable in the records of this period of live art, it is also true that the contemporaneous practices closest to Rainer's in the early 1960s—Happenings, Fluxus, and above all, Judson dance—were never aligned with a single side of Debord's dichotomy of lived experience and information.[14] Rather, we might say that the pseudo-event is the bad dream of much avant-garde performance in the 1960s; which is also to say that its characteristics—delayed temporality, photograph-readiness, and informational rather than experiential reception—haunted performance events. In this way, live art of the early 1960s worked through the changed condition of something that may be as old as human history but that had become, in this time and place, peculiarly problematic: live action for audience.[15]

INVOLVING SPECTATORSHIP

How was the audience addressed in live art of the first half of the 1960s? For the present-day investigator, a starting point for this inquiry can be found packed away in the carefully labeled and bar-coded box 51 of the Carolee Schneemann archive at the Getty Research Institute, among a series of items sent to Schneemann during the 1960s and 1970s. There is a gallery announcement in the form of a small, inflated plastic bag, there is a book whose leaves are made of lead, and there is the object I went to the archive to experience, one day in 2005. Fluxus artist Ay-O's 1964 *Finger Box:* a nearly cubic paper-covered cardboard box, about three and a half inches square, its top punctured by a small round hole accompanied by one of those pointing-hand icons, so dear to Fluxus design, and three words: "put finger in" (figure 1.2). In the cool silence of the Special Collections Reading Room I followed the direction.

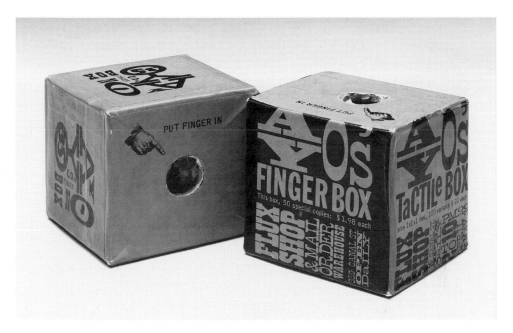

1.2 Ay-O, *Finger Boxes,* 1964. Cardboard box filled with feathers and covered on all sides with printed labels, and cardboard box filled with foam and covered on all sides with printed labels; 8.4 x 9.3 x 8.3 cm. Harvard University Art Museums, Fogg Art Museum, Barbara and Peter Moore Fluxus Collection, Margaret Fisher Fund and gift of Barbara Moore/Bound & Unbound, M26381-2. Photo: Junius Beebe © President and Fellows of Harvard College. Courtesy of the artist.

No one seemed to notice my slightly guilty grin as I probed the cube's soft innards. The Japanese artist Ay-O, then based in New York, filled boxes with various tactile treats during the 1960s—water, feathers, steel wool, Vaseline, confetti. The Getty's online catalog had disclosed in advance that this one contained foam rubber. Yet I was still taken aback by the experience set up for me some forty years earlier, for instead of the slab I had expected to encounter, my finger found bumps and folds of foam, curls and crevices to explore. It was at once sexy, clinical, and silly to wiggle around in this space—distinctly bodylike, yet obviously artificial; a funny space I could not see but now intimately know.

In this way, the box had me put my finger on what Hannah Higgins has called, appropriately enough, "the point of Fluxus": it provided an instance of haptic experience and embodied knowing specifically opposed to the relation between the subject and its object in conventional Western epistemologies, where disembodied vision is the means of knowledge, critical distance the model.[16] Nothing could illustrate more perfectly than such a box—especially one activated in the protective chill of the Reading Room—how, in Higgins's words, "the exploration of prosaic things and activities. . . . generates primary knowledge and multisensory experience," or how "the Fluxus experience, in its matter-of-factness, situates people radically within their corporeal, sensory worlds."[17] In the midst of writing a book on Yvonne Rainer's mostly vanished performance, on spectatorial effects lost to time, I enjoyed Ay-O's box as a package of such "primary experience." Rainer knew of such art (a 1964 Fluxus flyer announcing the sale of *Finger Boxes* and related work is in her files), but my exploration of the little box was really a personal bit of research. Ay-O had provided a piece of 1960s live art that I could live. For to perform *Finger Box* is to fulfill the pressing need among artists of the first part of the 1960s to involve the viewer literally, often physically, in the work.

In the case of the Fluxus performance practices that emerged in art and music contexts contemporaneously with Judson Dance Theater (beginning in Europe in 1962, and continuing after 1964 in New York), this focus on involvement took the form of a pervasive interest in spotlighting and unsettling the performer-audience relationship; in cultivating and exploring this particular

form of copresence. As Owen Smith points out, Fluxhall, the space on New York's Canal Street where Fluxus performances were presented in the mid 1960s, was arranged without a stage, and so with no structural separation of audience and performers. Much of the work performed there involved performer-audience interaction.[18] Some Fluxus artists addressed the relationship simply by acknowledging the viewers' presence, as in Lee Heflin's *First Performance:* "Performer enters, bows, then exits. This is executed once for every member of the audience."[19] Emmett Williams's 1962 work *Ten Counting Songs,* among the most often-enacted Fluxus performance pieces (and one Rainer may have known, since a Fluxus pamphlet including its score is in her files) moves from such acknowledgment to interaction.[20] The performer begins the piece by counting the members of the audience aloud, then silently. She or he then counts them aloud again, this time eating a nut or candy for each audience member; then counts them silently once more, also with treats. In keeping with Higgins's account of the prominence of nonvisual sensory experience in Fluxus works, Williams makes the count ingestible, each member of the audience signified by both the abstraction of a number and the sensation of sweet or salt. The performer then moves through the audience and touches each person as he or she is counted—engaging them tactilely—and continues with more complex exchanges, such as having each audience member autograph the performance program and then reading off the list of names, or presenting each person with a cookie or candy. The piece ends with a final count in which everyone in the audience is asked to give the performer a gift as he or she is counted.

Ten Counting Songs thus insists on the performance situation as an exchange between performer and spectator. Its raison d'être lay in the most prosaic form of such interaction—the box office—for it arose from the need for a headcount to make sure that the theater management at a 1962 Fluxus Festival in Copenhagen wasn't shortchanging the artists on their per-ticket take. But in Williams's elaborate variations on the theme of the count, the need to know how many people had purchased tickets becomes just one dimension of the circuit of gratification and admiration in the theatrical experience. Each treat eaten, each coin, pencil, or other small item received in the final count manifested what the spectator

gives the performer, rather than what the performer offers his audience. Having every audience member autograph his program, the performer turns the viewers into the stars of the show—as does *Ten Counting Songs* as a whole, of course, by taking the audience's literal presence as its very subject.

Any number of Fluxus events made quasi, or even actual, performers of their viewers. In Tomas Schmit's *Sanitas No. 165,* the "audience is seated on misnumbered seats, then are asked to correct the mistake by switching about (first row to last, etc.)."[21] In his *Cardmusic for Audience* of 1966, Ken Friedman had audience members each pick a number and come up with a sound and a gesture that could be performed from their seats. A conductor pointed to one and then to another of the ten performers on stage, who each displayed a numbered card at the cue; the audience members responded with their invented sounds and actions as their numbers appeared. It is hard to think of a more literal instance of the turn to the viewer as the focus of art in the 1960s than this transformation of audience into performers, with the onstage actors reduced to a medium with which to activate them—unless it is Friedman's other 1966 piece, *Fluxus Instant Theater.* "Rescore Fluxus events for performance by the audience," the score for this piece reads. "A conductor may conduct the audience-performers."[22]

Fluxus Instant Theater is a bit of a joke, however, because insofar as they are scored—and all the descriptions I've quoted above are scores from which performances can be generated—Fluxus events are already available for "the audience" to perform. The characteristic structure of the Fluxus event is a short textual description, or more accurately instruction, that can be activated by anyone at any time. Perhaps the most famous example is *Word Event* (1961) by the artist credited with the invention of the form, George Brecht. It consists of the single word "exit."[23] The availability of such scores and their openness to interpretation make them exemplary of the participatory, involving aesthetic we associate with art of the 1960s, and with its counterspectacular ethos. They are performances to do, not view.

Still, there is another side to the logic of the event-score. The form makes the time and space of the Fluxus event radically indeterminate. Ken Friedman has said that the score form allowed him to create work while living far away

from artistic centers: "My work had to be done at a distance, with others realizing and interpreting my pieces. . . . Scores permitted me to create work that could be realized at a distance."[24] Consider the tensions in the way Norwegian critic Per Hovdenakk more recently celebrated the event-score form: "The real Fluxus event can be performed anywhere, at any time, by anybody, alone or with other people. When you do it, you share an experience with friends you have never met, or may never see, but you know that they are there and that you have a part in something important."[25]

Any such event might be as radically embodied as *Finger Box*. Yet just as radical, in Hovdenakk's description, is the way such an experience is dispersed. Published in 1990, just prior to the flowering of the Internet, Hovdenakk's model of Fluxus collectivity seems to prefigure the disembodied, multitemporal model of community we now associate with the World Wide Web. But of course communications technologies had been inculcating such models since the invention of telegraph and telephone, while mass media, especially broadcasting, had made the experience of what is temporally or spatially distant a dominant feature of twentieth-century life, a condition given its shorthand in the Fluxus era in Marshall McLuhan's term "global village." As an organization that was both international and collaborative, Fluxus perhaps inevitably made a theme of complex variations on the here-and-now meeting the there-and-then.[26] Consider how the Danish Fluxus artist Eric Anderson imagined both dispersal and deferral in his event-score *Opera Instruction* of 1961: "December 11, 1963: Sit down from 7 PM to 8:03 PM (Danish Time) and think about the people all over the world who may be performing this."

The model of lived experience in Fluxus performance is a complex one, then, suggesting the tenuousness of this very concept under the conditions of late modernity. Even the clearest cases of sensory immediacy in Fluxus tend to have another side. If *Ten Counting Songs,* for instance, insists on the presence of the audience in vivid, multisensory, interactive terms, the very repetition of the count also hints at a certain anxiety. The counter verifies the presence of the audience repeatedly, even compulsively. And it should be noted that the immediate, tactile experience *Finger Box* provides is only one aspect of its workings. Printing

covers the box on all six sides. One bears the finger hole and instruction, the other Ay-O's return address and space for the addressee's information, postage, and postmark. One side is marked "Fragile." The remaining three sides are, essentially, advertising, announcing related projects by Ay-O—a six-foot cube on display at the Smolin Gallery, and an edition of one-foot "Tactile Boxes" that could be purchased through the Fluxshop on Canal Street in New York. *Finger Box* thus provides an experience in the here and now, but at the same time notifies its viewer about other experiences that cannot be had at the current time and place. Moreover, one side of the box is self-referential: labeled "AyO's Finger Box," it lets the reader know that fifty special copies of the box in one's hand are available for $1.98 each from the Fluxshop.[27] This box, and all its clones, thus declare their nonspecificity, bearing on themselves the marks of their multiplicity and dissemination. Even as the box offers itself to me, this day, to be performed in real time and embodied being, it tells me about forty-nine other terrains to be explored by any number of other fingers. The experience I live is paired with those I am, to use Debord's phrase, "informed about." The priority placed on the experiential becomes the flip side of an interest in the informational.

Now, any scholar of Fluxus reading this description will immediately want to remind me of a matter of authorship—that the design of the box and its salesmanship are the work not of Ay-O, but of Fluxus impresario George Maciunas, who was responsible for the Fluxus name as well as for most of its newspapers, its mail-order operations, and its shop. Maciunas was infamous for taking an artist's idea and making up his own instantiations (when Ben Vautier claimed as his art all of the world's holes, for instance, Maciunas produced and sold as Vautier's work a box full of drinking straws).[28] But the question here is not really one of authorship, since one of the things Fluxus did, precisely through these exchanges and interpretations, was to trouble the workings of what Rosalind Krauss has called "the art history of the proper name."[29] Nor is it the point that this *Finger Box,* a learning tool for embodied empiricism, is also a marketing device (Ay-O produced other boxes not so used), though it may be *to* the point that this distributional dimension of Fluxus is sometimes considered specifically American. For, even if they are Maciunas's imposition on the work or his Americanization

of it, his sales strategies—canny alternatives to the elitism of the gallery system, as the supermarket-like pricing of the box suggests—are but one dimension of the productive tension that *is* the point: a tension intrinsic to the structure of the event-score itself, and built into individual works. This is the tension between the embodied specificity of what Higgins calls "the Fluxus experience" and the way that experience was dispersed and distributed.

PERIPHERAL HAPPENINGS

Among the most dramatic examples of the turn toward the audience in Fluxus-associated performance were the events devised by Ben Vautier. One of the earliest of these demonstrated the urgency—but also the difficulty—of imagining the audience as the active element in performance. In *Police,* of 1961, "Performers disguised as police officers push the audience to the stage."[30] The next year Vautier imagined a fireman's version: "A performer sits on a chair in the center of the stage holding a fire hose and does nothing. On hearing the audience begin to complain, he shouts 'Go!' The water is turned on. The performer soaks the audience."[31] Gestures such as these distill a tendency shared with Fluxus by the Happenings taking place in the United States—the "abusive involvement of the audience" that Susan Sontag saw as central to these influential live art events, which began in 1959 and had their heyday in the very early 1960s. In the Happenings, she reported, audiences were sprinkled with water, threatened with torches, crowded uncomfortably, deafened by drums. Such treatment, which for Sontag provided "the dramatic spine of the Happening," amounted to an almost hyperbolic insistence on the aesthetic of involvement that has been crucial to most accounts of this art, then and now.[32] Trying to capture the spirit of the events in *Art News* in 1961, inventor of the term "Happening" and preeminent theorist of the genre Allan Kaprow both provided a litany of images that will recall the insistence on the nonvisual in Fluxus—amplified breathing sounds, spinach-throwing, smells of lemon juice, noxious fumes—and summarized the way Happenings stressed and revised the idea of spectatorship itself: "you come in as a spectator, and maybe discover that you're caught in it after all. . . .

[There are] long silences, when nothing happens, and you're sore because you've paid $1.50 contribution, when bang! There you are facing yourself in a mirror jammed at you. . . . You giggle because you're afraid, suffer claustrophobia, talk to some one nonchalantly, but all the time you're *there,* getting into the act."[33]

Curator Alan Solomon similarly described Happenings in 1965 as "environmental performances in which the artists participated personally, finally coming into direct and total contact with their audience." For him, Happenings and other recent developments in the legacy of Cage, Rauschenberg, and Johns were dedicated to the attempt "to find new, more appropriate forms and orders, to enlarge experience, to involve the audience more directly."[34] Nearly thirty years later, art historian Joanna Drucker similarly described the treatment of the audience in Allan Kaprow's first Happening, the 1959 *18 Happenings in 6 Parts*—whose score/program listed "visitors" as part of the cast—as "a situation in which any viewer acts, participates and thus *makes, enacts, is* the piece."[35] Kaprow's insistence on the viewer's participation diffused authorship among a collective of quasi-collaborators, and developed countercapitalist relationships lived in real time instead of mediated through things, Drucker wrote. Moreover, it made the Happenings' temporal mode an insistent presence, as "the experience was, if anything, to be of the moment—and oneself in it."[36]

Drucker also noted, however, that when Kaprow theorized Happenings in 1966, he emphasized spatial and temporal *dispersal,* valorizing those events that took place "over several widely spaced, sometimes moving and changing locales."[37] And other accounts of his early Happenings suggest that, rather than being characterized by the certainty implied in Drucker's account of relationships really experienced instead of mediated through objects, or by the plentitude of being in the moment that her view suggests, they were marked by epistemological doubt. For few Happenings could be fully perceived by the participant/spectators. In *Spring Happening,* for instance, the experience of only hearing events or of partially seeing them was orchestrated by confining viewers in a narrow, roofed corridor for most of the piece. As if in an inversion of the little drama *Finger Box* staged a few years later, the viewer of *Spring Happening* was inside the box, while the activity happened outside it. Sontag wrote that the Happenings teased their audiences as well as abusing them, that they deliberately frustrated

the viewer's desire to know what was going on. While during parts of Robert Whitman's 1963 *Flower* single events occurred slowly, to allow intense inspection, in others a camera flash was repeatedly set off in a darkened space, to make theatrical images appear and vanish more quickly than could be fully perceived.[38] In *18 Happenings,* besides breaking the collective audience into small subgroups in partially isolated chambers, Kaprow also radically dispersed each viewer-participant's attention by the overlap of events occurring proximally with those in other chambers, only glimpsed, smelled, or heard. As Gavin Butt has shown, based on the viewer-participant description of *18 Happenings* by the writer Samuel R. Delany, this format led to something quite other than an experience of plentitude and presence:

> One of the chief hermeneutic consequences of this early happening was the distracting of interpretative attention away from visually appropriable objects of knowledge towards the unruly phantasms spurred on by the ghostly images and distant sounds which emanated from the happening's multiple chambers. . . . That part of the work remained unavailable to vision served to underline the power of Kaprow's performance in foregrounding the necessarily phantasmatic and performative production of the work through the desires and curiosities elicited during the act of interpretation.[39]

Delany himself felt that this deep uncertainty within the experience of the Happening caused works in this form to be "organized very much like historical events," and Butt compellingly articulates a rhyme between the experience of primary spectators at the event and that of the historical interpreter years later.[40] This reflexive turn in Butt's argument is in line with what I hope to propose here, but first consider a slightly different slant on his (and Delany's) insight into the treatment of the audience in events like *18 Happenings.* The emphasis within these works on that which was perceived, *but just barely*—the performance within them of the peripheral and conjectured—echoes a critical problem that faced the makers of these events. Arising just at the moment that Beat and other underground cultures were reaching the attention of a novelty-seeking mainstream

press, the Happenings received an unprecedented degree of publicity. By the mid 1960s, the term "Happening" became a buzzword applied to everything from lipstick commercials to PTA meetings to the Vietnam War. All this attention led Kaprow to worry about the effect of a new notoriety on the art form and on participating artists.[41] Through such publicity, the Happenings were widely experienced secondhand, despite the makers' evident aspiration to primary experience and involved spectatorship. "Although widespread opinion has been expressed about these events, usually by those who have never seen them," Kaprow wrote early on, "they are actually little known beyond a small group of interested persons."[42] And this in turn suggests that the "ghostly images and distant sounds" of Happenings—things heard but not seen; activities viewed out of the corner of an eye or through plastic sheeting; events experienced in brief, photographic flashes; sections that one viewer might experience but that another would learn about only by comparing notes later—these can all be understood as insider experiences *of* the secondhand, outsider view. It is as if the makers could not help but work into the events themselves the structure of the Happenings' publicity problem—which is to say, the very condition for making live art in a media culture.

Avant-garde performance culture of this period was obsessed with the viewer's literal involvement, it is true; but such involvement was accompanied, often unconsciously, by an evident skepticism or anxiety about the involvement aesthetic itself and its underlying epistemology of copresence—the belief that things, events, and others are only really or best known through physical proximity, sensory engagement, and active participation. In both Happenings and Fluxus, experiential immediacy—the directly lived—was indeed a primary concern, but in both these variants of live art, the production of such immediacy seems to have been bound up with its opposites. In the early 1960s, it seemed nearly impossible to produce presence without something mitigating it: dispersal of performance time and space in the network aesthetics of Fluxus; in Happenings, the role of conjecture and peripheral perception echoing inside the works the mediated, informational experience of such an art form in the wider culture. But the tension between singular, embodied experience and something

else—which is to say, the lived, live art experience as a problem—is nowhere more evident than in the history of Judson Dance Theater.

Out of the Box

To begin to probe this history, consider another box, circa 1964: the much larger one, now, of the fifth-floor loft near Chinatown where choreographers associated with the Judson Dance Theater met that summer for a workshop. On the day it was Lucinda Childs's turn to present new work, she turned on a tape recorder, then hopped in the elevator and left the building.

On tape, her voice told the viewers that to see the dance they would have to go to the studio windows.[43] Doing so, they eventually spotted Childs in the doorway of a storefront at the far end of the strip of East Broadway visible from the studio. Watching through the windows, the audience saw her meet the dancer Tony Holder. For the next few minutes, Childs and Holder "essentially blended in with the other activity that was happening in the street."[44] Periodically they pointed to minutiae of the urban surround—to the lettering of signs, details of the buildings, the contents of store windows—and each time, in the loft above, the tape of Childs's voice described to the distant audience the details to which the dancers were pointing—the tags in an antique store display, the number to call if a certain building was burglarized, the fact that in a flea market window "two carved wooden owls face each other," and that "a white sign with red lettering beneath the window square explains that the nonautomatic sprinkler is in the basement."[45] After five or six minutes of this, Holder and Childs simply "separated and *left,*" Yvonne Rainer recalled with a laugh some forty years later.[46] They reentered the loft after a few minutes, to the audience's appreciative applause.

Street Dance—Childs's appropriately pedestrian title for this extraordinary work—is a dance about watching. Directing the viewers to details of the street scene that they could not fully perceive, it "provok[ed] an awareness of looking," as Nick Kaye argues in *Postmodernism and Performance,* an important account of Judson dance that stresses its makers' pervasive interest in the act of spectatorship

itself.[47] Beyond eschewing the conventions of dance movement, the literally pedestrian activity of *Street Dance* challenges the idea that dance is defined by anything internal to it at all. While the viewers from above watched the activity as dance, passersby at street level did not find the dancers' activity in the least remarkable, and so the work redirects the question of what counts as dance: away from specific types of movement and toward the mode or condition of its viewing. Rainer recognized something similar retrospectively, when she recalled that Childs had used the windows to frame the street as art; it was only the "literally privileged" view from above that made the performance recognizable as such. To the passerby, the dance was "invisible."[48] Dance was what was viewed as dance.

Rainer thus confirms Kaye's central argument that works like *Street Dance* were part of a broader conceptual shift in the very understanding of art (one that art historians associate with the renewed interest in the 1960s in the Duchampian readymade): from a mindset that seeks art's essence in inherent aspects of the work, to one that finds art's definition contingent upon the structuring conditions of its appearance. How an object or event is seen—under what institutional conditions? subject to what assumptions on the part of viewers? and by viewers physically and socially positioned how?—became, in this period, the crucial factor. Emphasizing not types of movement, but aspects of movement's beholding, this tendency links Judson dance to the preoccupation in Fluxus and Happenings, as well as contemporaneous criticism and theory, with audience, reader, and beholder. Further, because it asks what makes something *art,* rather than what makes it painting, or sculpture, or dance, Kaye's view of the radically contingent nature of Judson performance provides an important reminder that its reflexiveness was not always or even primarily oriented toward the medium of dance at all.

In fact, historically there was a certain tension around this question, and Judson dance is perhaps best understood as being like minimal art in Hal Foster's formulation: as a crux between the still-powerful modernist model of medium-specific thinking about art, and the context-contingent, interdisciplinary mode Kaye identifies as Judson's postmodernity.[49] While most participants, including Rainer, considered themselves dancers first and foremost (the moniker, after all was Judson Dance Theater), nondance artists were frequently involved, and there

was a strong tendency in period criticism to invent broader categorizations for the group's activities: "a theater of movement and adventure,"[50] in Arlene Croce's term, or "the Theatre of Action" in Jill Johnston's.[51] *Street Dance* embodies this sense of Judson dance as crux: its exhibition context (a dance studio, a choreography workshop) and its title take dance as a referent, even as its radical contingency and dual mode of spectatorship raise conceptual questions that exceed medium-specific thinking.

Yet even Kaye's expanded view of the dynamics of *Street Dance* does not quite get at all the cultural work being done by what Robert Dunn later recalled as "one of the most mysteriously beautiful events I have seen."[52] Perhaps it was so affecting, Dunn went on, "because of the distance and glass-separated soundlessness in which we experienced Lucinda's miniaturized physical presence, in the same moment with immediacy of her somewhat flattened but sensuous voice on the tape in the room with us" (*DB* 208–209). In this observer's description, *Street Dance* turns on distance, separation, and absence. The dancers were literally far away, and, in Rainer's recollection, had their backs to the studio window most, if not all, of the time they were performing. The sense of spontaneity that would otherwise obtain as the dancers casually pointed at things and stood talking in the street was belied by the tape-recorded descriptions with which their movements were precisely timed to coincide (the score for the 1965 version of the dance consists of a list of key words from the narration and corresponding times, broken down second by second).[53] Childs herself made clear the challenge of *Street Dance* to the aesthetics of immediacy: because of the tape, "the spectator was called upon to envision, in an imagined sort of way, information that in fact existed beyond the range of actual perception."[54]

Moreover, in *Street Dance* "actual perception" was brought into question, as sensory data was put at both a temporal and spatial remove. The dancers pointed at everyday details of the street, drawing the normally overlooked to the attention of the audience. The catch is that those details, sometimes as minute as the writing on tags hanging from individual items in store windows, could not be verified empirically by the observers several stories above. Immediacy of observation was supplemented—in effect, replaced—by the taped description of each

street-level detail. Meanwhile the tape itself, recorded at a prior moment, introduced a temporal lag into the live performance. Recall Dunn's memory of *Street Dance,* in which Childs's physical presence was "miniaturized"; in which her tape-recorded voice was present in the room with the watchers, but "flattened" by the apparatus; in which, it doesn't seem too much of a stretch to suggest, the "glass-separated" condition of spectatorship at this live performance became more than remotely televisual. One was both distanced from the event and technologically connected to it: as Childs said, the tape recording allowed viewers to "remain tuned in" to the events below, despite their physical separation from the site of viewing.[55] Some of the basic effects of broadcast media—that they distort temporality, because they can seem live when they are not; that they collapse space, by extending the senses and permitting seeing-at-a-distance (the literal meaning of tele-vision, as Samuel Weber points out);[56] but above all that they affect experience *ambiguously,* bringing events, people, and places closer to the viewer while also rendering them "glass-separated"—these phenomena of media experience were transposed into a live performance situation with astonishing economy by Childs's dance.

Broadcasting appears with unexpected frequency in Judson dance and its surrounding discourse. It was in broadcasting terms that the poet and critic Diane di Prima described David Gordon's performance in the first Judson concert: "The flow of the energy, like a good crystal set. The receiving & giving out one operation, no dichotomy there."[57] Childs's *Geranium* had as its audio component a taped broadcast of a football game.[58] In an early studio exercise, Simone Forti, Trisha Brown, and Dick Levine allowed their movements to be determined in part by the chance occurrence of certain letters or words on the radio,[59] while in William Davis's 1963 *Field,* performed at the third Judson dance concert, he and Barbara (Lloyd) Dilley[60] wore transistor radios on their belts, tuned to two of New York's most listened-to stations, WABC and WINS. Deborah Hay took this motif furthest in her 1965 dance *Victory 14,* in which the band selections and volume control by eight "musicians" manipulating radio dials determined when dancers were interrupted in their movement and tugged along the floor by ropes—giving critic Don McDonagh the impression of "a

rigid and somewhat arbitrary control of life coming from the chatter of the radio spectrum."[61]

Now, there is no evidence that broadcasting or the mass media were pressing concerns for Judson dancers in any literal way, despite these irruptions of actual mass media streams or their metaphors into Judson dance. Rather, these instances scattered throughout the work and its reception are pointers, indications of the way a culture and economy of media spectatorship, reaching a new level of elaboration at the end of the first decade of television's triumph, were at a deeper level shaping conditions for these artists' work. This is what I think we see in the pervasive, if unconscious, troubling of liveness, singularity, and ephemerality in much Judson dance—within events that were of course live, singular, and ephemeral themselves.

The performances presented under the aegis of Judson Dance Theater were widely varied, as were the concerns of the artists who made them. Nevertheless, there were overtly shared interests and strategies—such as including pedestrian or nondance movement and using chance techniques to shape performances. There were also shared concerns that were less explicit, but no less telling about cultural conditions and aesthetic choices in the first half of the 1960s. By thoroughly challenging the conventions and boundaries of dance and redefining the aesthetic event as contingent on the conditions of its being seen, Judson Dance Theater and related movement performance were negotiating a wider cultural problem. What was happening to the category of lived experience itself, as people more and more frequently experienced in the here and now events distant from them spatially, temporally, or both? In their use of strategies such as heterogeneity, stillness, slow motion, and repetition, Judson artists produced the liveness of live performance as a problem.

INCLUSION AND EXCLUSION

Classical ballet and the several schools of modern dance had applied a rigorous filtering process to the almost infinite range of human motion, each maintaining a strict and easily recognizable differentiation between dance and nondance

movement material. While this trait is most easily demonstrable for ballet, with its lexicon of established and named dance "steps," one has only to think of those sometimes-visible moments when a modern dancer crosses from the performance space into the wings, transitioning from performance to normal walking and standing, to understand how dramatic is the differentiation between most modern dance movement and ordinary human action and gesture. Even for Merce Cunningham, the most adventurous modern choreographer of the period, with whom many of the Judson dancers studied and performed, the dancing body remained upright, elegant, and extended; movement was rapid-fire, graceful, and skilled. While Judson dance often included passages of modern or balletic technique, however, one of the group's lasting contributions was to put the line between dance and ordinary behavior under erasure. Eating, talking, and even standing still were now choreographic options, as the literally pedestrian behavior of *Street Dance* so pithily demonstrates.

The young choreographers of the early 1960s were led to this radical inclusiveness by the example of John Cage, to whose techniques many of them were introduced by Robert Dunn. A composer and the accompanist for Cunningham, in the fall of 1960 Dunn began to lead a choreography workshop at the Cunningham studio, in which he encouraged participants—beginning with Paulus Berenson, Marni Mahaffay, Rainer, Forti, and Paxton, later including Ruth Allphon, Judith Dunn, Trisha Brown, Elaine Summers, Deborah and Alex Hay, and more occasionally Robert Morris, Robert Rauschenberg, Jill Johnston, and Ray Johnson—to apply Cage techniques such as chance procedures, rule structures, and scores to movement composition.[62] When the artists in this workshop had accumulated enough material, they began to look for performance venues, leading to their discovery of the Judson Memorial Church and to "A Concert of Dance" in 1962. Cage's inclusiveness was crucial to the work they presented there. Where Cage taught that all sounds—even the absence of sound—could be used as musical options, Dunn encouraged the use of any type of movement, "whether it's a cough, a sniffle, or natural movement," remembered Mahaffay (*DB* 8). This approach opened movement performance to artists who were not trained in dance (musician Phillip Corner and visual

artists Robert Rauschenberg, Robert Morris, Carolee Schneemann, and Alex Hay were all relatively regular Judson presenters) and allowed professional dancers to question the traditional limits of their art. Steve Paxton was the one who pushed hardest on this idea of anything goes: "The work that I did there was first of all to flush out all my 'why-nots,' to go through my 'why not' circles as far as I could until getting bored with the question. 'Why not' was a catch-word at that time" (*DB* 9).

One telling example of this tendency is Elaine Summers's *Daily Wake* (1962). Also called *Newspaper Dance,* the work itself started with a paper: Summers generated the score for the work from a copy of the *Daily News.*[63] Her basic operation was to treat the newspaper as a map, establishing a one-to-one correspondence between the layout of the page and the floor space on which the dancers were arranged. She then used the paper in various ways to shape the performance. The number of paragraphs and incidence of headlines became systems for cuing dance phrases, for instance, while dancers performed abstractions of the action words within the stories, and used the *Daily News'* photographs as templates for still poses, all the while staying within assigned "columns," or areas of the floor corresponding to the location on the page of the story or photograph being enacted.[64] Exemplifying the "why not" school of dance experimentation, Summers says that she turned to the newspaper while seeking a resource for dance composition that hadn't yet been explored. The text, images, and layout gave her a ready-made source of material with which to escape restrictive traditions of dance movement (a source that was literally quotidian), and the resulting work must have been a perfect example of the inclusiveness and leveling in Judson choreography as a whole. The still poses alone ranged from the Twist to Rockefeller, soldiers to brides.

The Daily Wake suggests another parallel, too: between the anything-goes heterogeneity of Judson dance and that of the mass media. Summers has indicated that the newspaper was at once a handy way to get beyond accepted dance vocabulary and structure *and* a way to work through her feelings about "how much information we were getting."[65] In this way *The Daily Wake*—and with it, Judson dance overall—recalls work of the same period like Robert

Rauschenberg's silkscreen paintings. In importing onto the flat modernist picture plane a seemingly limitless range of materials and images, since the 1950s Rauschenberg had, in Leo Steinberg's words, "let the world in again." However, the world let into both Rauschenberg's and and Summers's work was what Steinberg described as "the world of men who turn knobs to hear a taped message, 'precipitation probability ten percent tonight,' electronically transmitted from some windowless booth."[66] That is, it was the world about which one is *informed*—not landscape but mediascape. Or so the critic famously argued for Rauschenberg, whose key operation was to transform the Western idea of the picture from something through which one looks to see the world, to something on which one arranges existing images of it.

Steinberg's arguments about what he called the flatbed picture plane were specific to the genre of painting, but if he had expanded his view to the realm of performance—in which Rauschenberg himself participated in these years—he would have found examples readily in Judson dance, beginning with Summers's mapping of the newspaper space onto the dance floor: a remarkable moment in which the physical space of bodies is structured by the virtual, printed space of image and text.[67] He also could have drawn on aspects of the work of Steve Paxton, whose procedure for making some of the scores for *Proxy* was a literally flatbed method in which he held photographs above a sheet of paper placed on the floor, let them fall where they would, then secured them to the page and asked his dancers to read their way through the sequence of poses. (Paxton also made a photograph-based 1964 dance titled *Flat*.)[68] Or, albeit with less emphasis on the move from a vertical to horizontal imagination (though one could make a case for the perspective *down* on the street that characterized it), the argument for a specifically media-oriented rethinking of live performance could be made by looking again at Lucinda Childs's *Street Dance*—itself a kind of report from a booth, if a windowed one. In this 1964 piece, as we've seen, Childs drew attention to details of the urban environment—signage, letters, antique animals—that are strikingly similar to the images and objects that adhere to Rauschenberg's flatbed pictures (and in fact Childs once performed the work at, or below, Rauschenberg's studio).[69] In putting them behind glass, moreover—

at a physical distance and at a temporal remove, via the tape-recorded description—she performed an operation similar to the one Steinberg recognized in the work of Rauschenberg, Warhol, and other artists of this time and place, in which any experience could be admitted into a painting, but always "as the matter of representation."[70] And the same is true of *The Daily Wake,* whose quirky range of movement and poses and anticonventional arrangement of dance space and sequence reflected a newspaper's heterogeneous informational array.

STILLS

Consider standing still. Surely there is no more literal way to put to the test the boundaries between dance and not-dance than to stop moving. In one Dunn workshop experiment, Paulus Berenson punctuated a solo with long periods of stillness, claiming that the dance's "climax" was the longest period in which nothing at all happened. Steve Paxton stood still, alternating tense and relaxed poses, during parts of his solo *Transit* (1962), and in *Flat* (1964) he periodically posed in stances taken from sports photographs (figure 1.3). Rainer and Trisha Brown posed in the style of pinup girls in the *Duet Section* of Rainer's evening-length work *Terrain* (1963). In another section, called *Stance,* dancers were allowed to stand still in comfortable rest positions, returning to these positions and other moments of stillness in *Bach,* the dance's final segment. Rainer, Simone Forti, and Ruth Allphon alternated between unison movement, an empty stage, and stillness in their 1961 collaboration *Stove Pack Opus.* In choreographing her 1962 solo *Timepiece,* performed at the first Judson concert, Ruth Emerson used a chart and chance techniques to combine elements of timing, movement quality, direction, and use of space, and was at first horrified when the procedure she was using mandated that the dance begin with a long, still pause: "I had to get over the fact that I could start a piece with forty seconds of stillness. One of the reasons I like the piece was that I learned I could do that" (*DB* 43). Robert Morris had a surrogate enact even longer periods of stillness in *Column* (1960), which was at once his performance debut, his first sculpture, and an initiating event for minimal art. It consisted of a six-foot-tall gray wooden box that stood

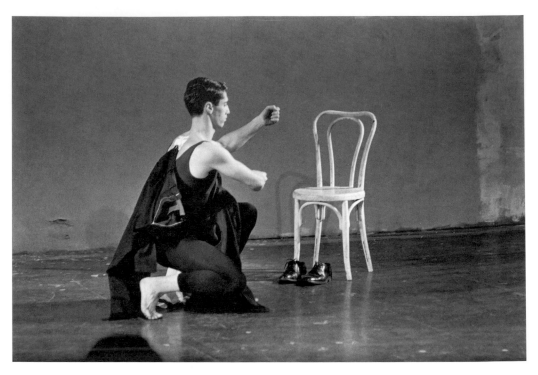

1.3 Steve Paxton, *Flat,* 1964. Performed 9 February 1964. Photo: Peter Moore. © Estate of Peter Moore/VAGA, New York, NY.

center-stage before an audience at the Living Theater for three and a half min-utes, then abruptly toppled and lay still on its side for an equal period of time.[71] Later, in his 1965 piece *Check,* he used a strobe light to render a running per-former into a series of static images.[72] *Take Your Alligator with You* (1963), choreo-graphed by Rudy Perez and performed at the seventh Judson concert, turned images from advertising into still poses and juxtaposed them with short move-ment phrases and speech.[73]

Perhaps it is not surprising that stillness punctuates the cumulative his-tory of Judson movement performance, given the currency of Cage's ideas in the Dunn workshop and among Judson participants. In *4'33"* a pianist sits at his instrument for the period of time designated in the title, but never touches the keys, his only action opening and later closing the keyboard to indicate the beginning and ending of the work's three "movements." With this, Cage had demonstrated that silence is part of the continuum of sound, and thus is an equally valid element of musical composition; the Judson dancers reasoned by the same logic that stillness is part of the dance spectrum, as valid for dance as movement is. Or so Banes explains it (*DB* 8), interpreting Cage's use of silence as a sign of radical inclusiveness. In an egalitarianism of form, hierarchies between compositional elements are dismantled, with the potential of a metaphorical extension of these aesthetic models to social ones.

It is not entirely clear, however, how strong the parallel is between Cage's silence and Judson dance's stillness—nor on what terms it is constructed. One way of understanding Cage's use of silence in musical composition is as a tech-nique for activating the audience's awareness of the *impossibility* of silence, of the world's constant audio backdrop. He often reiterated that "there is no such thing as silence," writing in the lecture "45' for a Speaker" that "something is always happening that makes a sound,"[74] and in *4'33"* forcing the audience to listen to themselves—their rustles and coughs, the noises around them. Stillness could certainly have had a similar effect in dance, and a decade later Rainer would use the close-up power of the film camera to expose the impossibility of hold-ing completely still poses. But nothing indicates that Judson dance stillness was

intended to activate the audience's awareness of ambient *movement* (their feet impatiently bouncing, perhaps, as they waited for Ruth Emerson's forty seconds of stillness to end). More relevant to the Judson extension of Cage's silence into physical activity is a second way of thinking Cage's silence: as a temporal exercise. Centering its auditors in their own living bodies, effectively amplifying the everyday sounds and sensations of the moment, one purpose of the silence of *4'33"* is to force the audience into a radical awareness of present tense experience. The name *Timepiece* already indicates that the Judson use of stillness was a specifically temporal experiment. The question is whether it, too, directs the viewer toward an awareness of the present. Does the parallel between Cage's silence and Judson stillness hold at the level of temporality? Yes, of course; and of course, no. For, as opposed to Cage's here and now, Judson stillness often looked elsewhere—and else-when.

For his *Flat,* and for *Proxy,* another major work of the period, Steve Paxton made collaged, photo-based scores. Two of the four scores comprising *Proxy* were constructed by pasting cartoon images, sports photographs, and photographs of pedestrians onto large sheets of paper, then asking the performers to strike the poses of the figures in the images. Notations on the score indicated the number of times each dancer would take each pose, and in what order, while the transition from one position to the next was left up to the performers. Performing this section of the dance was thus a matter of choosing an image to start from, embodying it, and then working through the score, proceeding image to image, moving pose to pose. Rainer, who throughout this period was "devouring" dance books and photographs,[75] later used a photograph of Nijinsky that she had studied in the Dance Collection of the New York Public Library as a repeating position struck by dancers in a section of *The Mind Is a Muscle* (1966–1968). She had also turned photographs into still positions at least as early as the pinup girl poses in *Duet Section.* In all of these cases, stillness meant quotation. Poses not only arrested onstage action, but also embodied a previous, photographic stoppage, as Banes suggests in calling these still poses "freeze-frames" (*DB* 54).

In Banes's account, the recourse to photographic source material represents the egalitarian aspect of the Judson aesthetic: using photographs to mediate

between choreographer and dancers is a renunciation of choreographic control (*DB* 58)—following the model of Jasper Johns's flags or targets, perhaps, in which found designs, rather than artist's whim, dictate composition. This is surely part of the function of photographic sources for Judson dance: a way of looking outside the traditions of dance for ways to arrange and move the body, as Summers's use of still poses taken from the newspaper in *The Daily Wake* had been. But in including stop-action poses, these artists also imported into live performance the special temporality of photographs; the way, in the manner Roland Barthes calls the "that-has-been," they materially bear something of the past into the present moment, asserting the existence of the past while rendering its absence ("it has been absolutely, irrefutably present, and yet already deferred").[76] This temporality of representation suggests a complicating factor for understanding Judson dance in relation to many prevailing theories of performance.

It is a truism that a sense of the lived moment—instantaneity or spontaneity—is the sine qua non of performance in general, for performance is limited, by its very nature, to the present tense. Peggy Phelan stated this definitively in *Unmarked: The Politics of Performance:* "Performance's only life is in the present. Performance cannot be saved, recorded, documented, or otherwise participate in the circulations of representations *of* representations; once it does so, it becomes something other than performance."[77] For many critics, this essential presence—constituted by disappearance—gives live performance a special purchase on the political. This is especially true when the performers are visual artists, in which case performance can be construed as an alternative to making saleable objects. In a 1994 exhibition catalog, for instance, Robyn Brentano asserted that "artists' performances have assumed a confrontational and iconoclastic role in relation to institutional art-world practices, aesthetic traditions, and social norms." Thus she objected to the way "the commodification of some [performance] artists' work in other media such as photography, video, compact disks, film, and television . . . [has removed] performance art from its earlier, radical focus on creating unmarketable work."[78]

The Judson dancers, of course, never made a penny on performance documentation, instead paying photographers for prints. And for photographers of

avant-garde performance like the tireless Peter Moore, documentation was also a labor of love and not a significant source of income. It is not only their literal marketability, however, that causes such representations to threaten performance's status. As Susan Sontag put it, "through photographs, we . . . have a consumer's relation to events, both to events which are part of our experience and to those which are not."[79] Even when not literally purchasing photographs, we are like consumers when we engage with them, insofar as photography makes experience *available,* stocking the shelves with experiences to choose from (shelves the Judson dancers raided when they used photographs to shape the action or poses of their dancers). Photographs of performance, unlike performances themselves, can be reproduced, circulated, and endlessly gazed upon. As Sontag suggests, through them we can participate in events we did not experience; in Debord's terms, we can be informed about performances rather than living them. Photographs make performance available and *visible* in a way that it is not when it is live. And it is this aspect that is at the heart of Phelan's exclusion of performance-in-documentation from performance proper. Like Brentano, she argues that performance betrays its promise "to the degree that performance attempts to enter the economy of reproduction,"[80] but in her subtler argument this promise lies not in any supposed opposition to the art market, but in resistance to "the ideology of the visible." In Phelan's view, the equation across our cultural spectrum of that which is seen and that which is real has negative consequences: being seen, or entering into representation, means being an object for the gaze, being other, and being subject to phallocentric power; it means reproduction, the generation of sameness, and control by surveillance. While she acknowledges that there is also a price in refusing visual representation, a main project of *Unmarked* is to reinvest invisibility with value in the face of an identity politics staked on being seen. In this argument, which has been both influential and hotly debated, the ephemerality of performance, its constant vanishing, makes it always at least potentially resistant to the operations of power in a visually oriented social, cultural, and economic order.[81]

There are, then, a range of associations between performance's evanescence and forms of dissent, making it no wonder that an emphasis on the present-tense

condition of performance—especially as demonstrated in improvisation, indeterminacy, and other techniques of spontaneity—is one of the key attributes of Judson's democratic version of dance performance according to Banes. In *Democracy's Body,* she points to "more immediacy, more 'presentness,' more concrete experience" as imperatives of the larger art culture of the late 1950s and early '60s out of which the Judson aesthetic emerged (*DB* xvi), and includes "the coveted performing value of spontaneity" among the most important aspects of the Judson aesthetic (*DB* 48). This may well have been a desired value among the choreographers. But given the negative place that photography holds in the theory of evanescence-as-dissent, it's difficult to understand within this model the proclivity for still poses in Judson dance, the interest in photo-derived and photolike positioning. What is needed is an account that recognizes the tension in this work between the spontaneous and ephemeral and the mediated and fixed. As Phelan recently acknowledged about Rainer in particular, "it is as if [she] understood, and feared, the drive toward 'the still life' in dance itself."[82]

JUDSON MEMORIES

One might think that using a newspaper to structure a dance—as opposed to relying on decades or centuries of tradition—would have been about seeking the new; about waking to a new day, welcoming in the world hot off the presses. Yet, in making *The Daily Wake,* Summers was interested in precisely the opposite. "What they have reported is already dead and finished, so it has a wake-like quality," she explained, reiterating decades later that her interest was in "something that had already happened."[83] For her, the very dailiness of the paper made it a marker of time past, a sort of daily memorial.[84] As in Childs's use of tape-recorded descriptions of a present-tense scene in *Street Dance,* what is normally understood as present—performance time, the daily news—turns and grabs the past. This turn is important for Judson dance in general, and for understanding the interest among its choreographers in still poses, in particular. *Daily Wake* helps us see all the photo-based and photolike stilling in Judson dance as a strategy for dancing yesterday.

In cases like *Flat,* where the still poses come from sports photographs, the specificity of the positions suggests to the viewer a source in preexisting images, even though in a performance the photographs are not available.[85] More powerfully, however, the very act of freezing in a particular position—of making the moving body a still image—is a photolike effect and thus evocative of prior sources, of photography's ability to record moments of the past. Moreover, still poses could also be understood as literally mnemonic. The relaxed poses dancers were allowed to take in Rainer's *Stance* or *Transit* suggest how stillness offered the dancer a chance to recover, but according to at least one participant in these early 1960s experiments, stillness also provided the viewer opportunities for the other kind of recovery: recall. Asked about her use of stillness by Sally Banes, Marni Mahaffay remembered: "When you roll the dice and get stillness, *suddenly you are given an image of what preceded that moment*—and that creates a kind of meditation on the movement" (*DB* 8; italics mine). A meditation on the movement just ended; a moving memory of the motion now ceased. As if suddenly the still body acted not just as an image but as a screen, triggering the memory to act as a projector: to replay a dance action that had been, it seems, recorded.[86]

This comment suggests that the past-tense nature of the still pose extends from the specifically photograph-based images of *Flat, Proxy,* or *Daily Wake* to the instances in which there is no media source for a pose—as with the relaxed positions taken in Rainer's *Stance* and Paxton's *Transit,* or the forty seconds of stillness in *Timepiece.* A casual statement, made by a dancer who was an original member of the Dunn workshops but did not participate in the later Judson concerts, Mahaffay's description of the effect of stillness in dance is nevertheless extremely suggestive, for it intimates that in special cases of live performance, one might at times be perceiving not presence but memory. If this is so, Judson stillness clicks us into a register quite different from Banes's models of inclusiveness or convention-testing, one oddly situated relative to Phelan's linkage of presence with the ability to resist a hegemonic visual regime, and one, finally, that intriguingly parallels that in which the performance historian operates—looking *back*

at Judson dance. In this register the issues at stake are visibility and temporality, image and time: hindsight.

In this light it is interesting to look back at a famous dance by Trisha Brown. *Homemade* (1965–1966) is a long string of movements taken from her own experience, many of them quotidian gestures such as making a phone call and casting a fishing line. In this way, it is already a dance about and based in memory. But *Homemade* explores memory as a spectatorial problem, not just as a choreographer's or performer's issue. For Brown enacted her remembered movements in reduced versions, not at the full energy level or bodily extension of the actual tasks.[87] In performances of the solo by Mikhail Baryshnikov during his White Oak Dance Project's revivals of Judson dance in 2000, it was striking how close the slightly slowed or shrunken gestures were to recognizable movements, but how thoroughly they resisted identification nevertheless. They existed on the cusp of recognition. Moreover, because the motions were performed on such a small scale, straining to *see* movement was linked with the desire to *recognize* it—to tie it to one's own experience and memory.

The dynamics of recognition in *Homemade* are further complicated by an innovation Brown added to her dance in 1966, when, incorporating the solo into a new series of three works, she performed its gestures with a film projector strapped to her back playing a film of herself performing *Homemade* (figure 1.4). With this prosthesis, Brown's dancing body became a projector of movement into the theater space—punning, perhaps, on the conventionally valued ability of a performer to "project" her voice, presence, or movement out to the audience (which of course the dancer of the miniaturized and unemotive *Homemade* pointedly did not do). A dance film is a captured, remembered version of performance. Film does our remembering of movement for us. Projected in a theater, the large scale of the filmic image promises precisely the visibility and the ability to recognize that the live performance of *Homemade* withholds. Of course, it doesn't work quite that simply. Juxtaposed with the live dance, splitting the viewer's attention between mediated and unmediated, live and recorded, and skipping and jumping around the room as the dancer's performance jiggles and

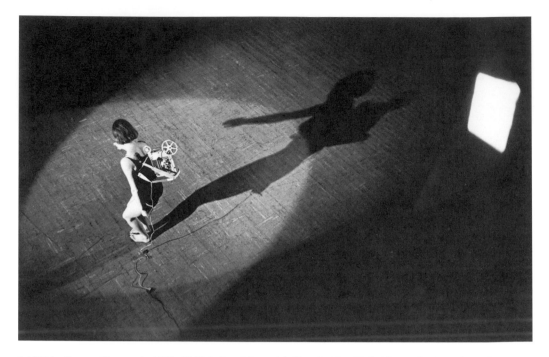

1.4 Trisha Brown, *Homemade,* 1965–1966. Judson Memorial Church, New York, 30 March 1966. Photo: Peter Moore. © Estate of Peter Moore/VAGA, New York, NY.

rotates the projector, the mnemonic capacity of film and the pleasures of its larger-than-life visualization are both signaled and undercut. As if to illustrate the dynamic of desire this effects in the spectator, at the final performance of this version of the dance in 1966 Brown had a partner dash around the space holding a movie screen: a surrogate for the viewer, trying literally to capture the moving image.[88]

The centrality of memory to dance perception—a basic condition for movement performance, suddenly figured as problematic—was also explored in the two-part work *Pop #1* and *Pop #2* of 1963, presented at successive Judson concerts by the gymnastically talented dancer Eddie Barton. Each was a brief event. In *Pop #1,* Barton unfurled a mat on the floor, then blew up a balloon and placed it on the mat. After some careful preparation he then performed a backward flip, popping the balloon as he landed on his back on the mat. *Pop #2* was performed the following night. It looked at first to be an exact repetition of the first dance, only this time, when he did the flip, Barton missed his mark and landed on his back on the floor. He then flopped over onto the mat, bursting the balloon with the front of his body.[89] The two *Pops* surely pun on the then very current art world buzzword, perhaps paying tribute to the flatness of the pictures in pop art, or its affinity for serial structures (or maybe even bursting its bubble). They also play, however, on the role of memory in performance.

For those who had been present for *Pop #1,* the miss and delayed balloon pop of the second evening's performance would have been quite funny, while the smiles or laughter of the knowing audience members would have been mystifying to those who had missed the first event. Both experiences would thus affirm, albeit one in negative, that remembering is part of the way performance meaning is made. For those who came to both performances, Barton's piece essentially stretched out over successive evenings the logic of repetition and variation that is basic to dance composition and dance spectatorship (in traditional theatrical dance such as ballet, repetition of certain steps or phrasing is the ground against which variations can then be perceived). But the viewer who only saw the second evening's event might have received an even better sense of what was at stake in Barton's ridiculous extension of that pattern, because for

her the recognition of one movement's relation to a past one would have been produced only as something to be longed for. All dance spectatorship relies on memory: not only the educated viewer's memory of previous versions of a work, or of the related dances to which a choreographer refers, but at a more basic level any spectator's ability to hold the just-past in mind long enough to make connections across the ephemeral art form's temporal unfurling. In the Judson work that deals with recall, however, this persistence of the past in perception somehow couldn't be left alone; it had to be signaled or triggered by specific techniques—stillness, simultaneous film projection, stagings of our need to recall in order to see. This recourse to special past-inducing practices suggests a perceived need to forcibly activate memory-in-presence, and indicates that in the 1960s—at least in the spectatorial situation of live performance—the ordinary persistence of the past could no longer be assumed.

Making (More) Visible

Later, in the early 1970s, Trisha Brown developed a series of works called *Accumulation Pieces,* each of which starts with a single gesture. The gesture is repeated, then another added on. Both are repeated, and another is added, then another and another. These works test the dancer's memory (eventually, when she realized she had become a virtuoso in remembering such dance movements, Brown had to increase the challenge by adding spoken phrases). What they do for the viewer of the work, however, is even more interesting: they effectively compensate for, even mitigate, dance's ephemerality, as if, again, to exaggerate or forcibly call into being the dependence of present perception on memory.[90] Where *Homemade* multiplied familiar movements, but teased the viewer by making them just-unrecognizable and by splitting the viewer's attention between the body filmed and live, this later work gives the viewer all the visibility she needs, and more. The movement doesn't vanish in the way a normal dance phrase does; or it does, only to reliably return. Movement recurs, even stutters.

It stutters not unlike the way the words "of dance" did on the poster for the first Judson dance concert some ten years before. Even then, thinking

through in practice problems of ephemerality, perception, and memory had been important for the work produced by artists in Brown's circle, particularly Rainer. Paxton remembers that the dance Rainer showed the Reverend Al Carmines, in the presentation that won the young performers the opportunity to perform at Judson Memorial Church, was one "in which she had excerpted or put into it a pose from a Gauguin painting which repeated several times, in order, as she put it in a class one night, to establish it in memory by repetition."[91] Around this time she wrote of her dance *Three Satie Spoons,* "I became involved with repetition thru a concern that each movement might be seen as more than a fleeting form, much as one can observe a piece of sculpture for one minute or many minutes."[92] That is, in contrast to the value theorists have placed on the ephemerality of performance, Rainer wanted to give it some durability. As she wrote in 1965: "In the early work I remember thinking that dance was at a disadvantage in relation to sculpture in that the spectator could spend as much time as he required to examine a sculpture, walk around it, etc., but a dance movement—because it happened in time—vanished as soon as it was executed."[93]

R ecent work in dance theory has recognized both the prevalence and the historical nature of Rainer's lament that dance "vanished as soon as it was executed." André Lepecki finds the emergence of the mournful rhetoric of dance as ever-disappearing in Noverre in the later eighteenth century, and sketches its path through the long history in twentieth-century dance theory, criticism, and notational practices of what he calls the "documental tradition"—a dedication to dance's capture and preservation—which takes a turn in recent theory, like Phelan's, that reverses the terms and valorizes precisely the evanescence of performance.[94] The concern of Rainer and other Judson dancers with the resistance of their temporal art form to vision also resonates, however, with what Pamela Lee calls the pervasive "chronophobia" of the 1960s—"an almost obsessional uneasiness with time and its measure . . . an insistent struggle with time, the will of both artist and critics either to master its passage, to still its acceleration, or to give form to its changing conditions."[95] Lee has shown how this concern in the artistic realm both reflects and critiques social and cultural developments in the 1960s that also centered on temporality, prime among them computer

technology and attendant theoretical work in cybernetics and systems theory. Without referring Judson dance to that particular techno-philosophical constellation, Lee's study of the period-specificity of such concerns can help in thinking historically (rather than only dance historically) the temporal "uneasiness" of this art—registered in the fact that it itself was ambiguously "documental."

Consider, in this light, Rainer's early solo *The Bells* (1961) (figure 1.5). In it, she repeated for eight minutes a short sequence of idiosyncratic movements—twiddling her fingers before her face, having her right hand "collide" with her nose, turning about with fingers flitting "like insects" about her head, and speaking the words "I told you everything would be all right, Harry."[96] ("It wasn't," grumbled a critic in the *Herald Tribune*.)[97] Rainer reiterated the movements in different parts of the space and facing different directions, thus systematically presenting the same movements to the audience from different points of view and repeating them until they might stick for the viewer (or at least begin to "ring a bell"). The idea that the viewer of movement performance should have something like the multidimensional perspective available to the viewer of sculpture recalls the innovations of Rainer's sometime studio-mate and collaborator Simone Forti in her 1961 event at Yoko Ono's loft titled "Five Dance Constructions + Some Other Things." There, dance works were performed in various parts of the loft. Viewers could circulate and see them from different perspectives—in Forti's words, the dances were "placed like a sculpture in a gallery space."[98] In *The Bells,* Rainer stuck with the convention of the seated audience and moving performer, but her rotating repetition of the movement sequence choreographs the viewer's perception as thoroughly as it does the dancer's action, effectively substituting for the movement around an artwork that the conventions of performance spectatorship disallowed. Several years later Robert Morris, in his "Notes on Sculpture," articulated the significance to the new minimalist art of the viewer's circulation around it in space.[99] In Forti's and Rainer's early work, however, one sees by 1961 the need to emphasize the simultaneously spatial and temporal relationship between spectator and work; indeed, to define art in terms of this kind of embodied experience. While in its "theatricality" minimalist art is often described in terms of performance, here we

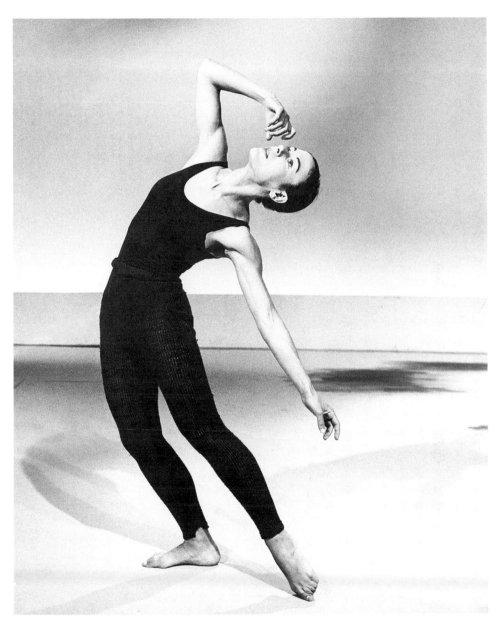

1.5 Yvonne Rainer, *The Bells,* 1961. Rehearsal at KQED-TV studio, San Francisco, August 1962. Photo: Warner Jepson.

see performance aspiring to the condition of sculpture. In Rainer's dance in particular, repetition and rotation combine to mitigate—if also, of course, thereby to emphasize—performance's disappearance.

SLOW MOTION

In an interview looking back at the period of Judson Dance Theater (during which time he was also a member of Merce Cunningham's company), Steve Paxton comments on the slow pace of his own choreography: "It didn't move . . . fast. It moved at a pedestrian pace. It didn't surprise anybody. There were no surprises in it. It was all very ordinary. In fact, that was maybe the surprise and the humor of it, was how ordinary it was in the face of the glamour of Cunningham and the speed and the pacing and the Rauschenberg costumes and the Cernovitch lighting and, you know, all the sparkle that could be generated."[100] Here the much-valued ordinariness of Judson choreography—the replacement of special, theatrical movement and performance style with the quotidian—becomes a matter of pace. Indeed, Paxton generated *Flat* in part out of the instruction to himself to "do things too long."[101]

He wasn't alone. A section of Rainer's *Terrain* was called *Slow,* and in it dancers moved in slow motion from one tableau or group pose to another.[102] Reviewing Arlene Rothlein's dance *Another Letter to the Sun (for Charles Ives),* performed at the eighth Judson dance concert, Jill Johnston mentions "a slow classical tableau," and groups moving "with slow baroque expression."[103] Judith Dunn's *Acapulco* involved a woman seated in a chair, who rose in slow motion to stand upon it, then rotated her torso, again in slow motion, until she fell into the waiting arms of a male dancer. In the sixth Judson dance concert in May of 1963, Elaine Summers performed a solo called *Dance for Carola* that consisted of one simple movement: she took nearly ten minutes to crouch down and stand back up. In the next concert, her *Dance for Lots of People* had fifteen performers move very slowly through a series of clustered and clumped configurations, then rise from the floor to standing and sink back down in slow motion before beginning a series of vibrating, quicker movements (*DB* 146). Trisha Brown's *Part of a Target*

(1963) consisted of the dancer posing in ballet's fourth position, saying the words "oh no!" and falling sideways as slowly as possible.[104] David Gordon's *Mannequin Dance* (1962) took up no more room than the bathtub in which it was composed, as Gordon rotated his body and bent down to lie on the floor, taking a full nine minutes to complete the action, singing "Second Hand Rose" and "Get Married Shirley" all the while (*DB* 54–55).[105]

On the one hand, these long, slow exposures simply relished in displaying the human body in motion. On the other, they did so using a technique related to what Walter Benjamin famously called "unconscious optics"[106]—the aspects of the world revealed when technologies of vision such as close-up photography or slow-motion film exceed perception rooted in the body and in time's normal flow—suggesting, again, how perception was artificially prodded or jump-started in much of the dance work presented at Judson church in the early 1960s. Banes indicates as much when she mentions that the use of still poses in Judson dance made it seem "almost as if the choreographers wished to appropriate the filmmaker's ability to slow down a film and watch it frame by frame" (*DB* 54).[107]

The use of slow motion further suggests how the ephemerality of performance was marked—and marked in some way as a problem—by the dance-makers associated with Judson. Phelan has written that "Performance's being . . . becomes itself through disappearance."[108] The Judson works I have been discussing do not escape that condition, of course—they remained ephemeral and unique performances—but they seem internally to have resisted it. What Paxton said of his work's pace in general in this period was made programmatic in the super-slow sections of other Judson dance works: this was movement made tediously *visible,* refusing to meet what would seem to be a basic requirement of theatrical dance: that it be ephemeral, that it glint in and out of visibility, that it *sparkle.* Perhaps the language of some of Paxton's comments on the function of performance in general is not, then, as surprising as it might otherwise be:

I think performing helps solidify those ideas because of the power of performance and the inevitability of what you've done once it's

been seen by a group of people. The sort of karmic union that you all have establishes in the flux and flow of event and time a moment that you can return to, at least, you can relocate in some kind of, as some kind of gesture, there's some reference to it in the group that you're with, and have the idea . . . jelled for a group of people. And then, in some way, that frees you a little bit from the karma of that, that's finished, and you can then go on and continue the flow.[109]

With performance that solidifies ideas, with performance that congeals or jells, and most of all with performance as "a moment that you can return to," Paxton's account of the sociality and historicity of performed works suggests a view of live art as something altogether more solid and enduring than performance theory tends to allow.

REPETITION

Such a view correlates with Paxton's own work of this period, where the inherent fleetingness of performance was played off against strategies dealing with memory and repetition. One section of *Proxy* featured a curtain around which the dancers walked, then walked again; passing in front of and parallel to the fabric, circling around behind it, and repeating the circuit seven times. Like many artists in his milieu, Paxton was intrigued by the chronophotographic studies of Eadweard Muybridge,[110] and *Proxy's* repeating marches against the flat backdrop can be understood as live-action versions of those nineteenth-century images. They also recall the scrolling effect of the flyer he had designed for the concert in which this work was first performed. As he has said of his use of a repeating phrase in *Transit,* another Judson-era dance, Paxton wanted the audience to have several "chances to recognize it."[111]

Rainer did the same—working on or around the fact that dance "vanished as soon as it was executed"[112]—in her *Room Service* (1963). This was part of a collaboration between the Judson choreographers and the sculptor Charles Ross at the thirteenth Judson Concert of Dance, in November 1963. In it the dancers

invented a series of interactions with an "environment" the artist constructed for them—a grown-up jungle gym of steel pipe, plywood, and rubber tires. Rainer's contribution divided a large company of performers into teams, each with a leader and two followers (figure 1.6). The leaders improvised activities involving Ross's sculpture—crawling over the top of the structure on all fours and then jumping off, for example—and the followers did their best to exactly repeat the leader's movement. Earlier that year, in June, Judson participant Joseph Schlichter had similarly combined improvisation and repetition using the game structure of follow-the-leader. In *Association (Improvisations)* one dancer improvised a movement and three other performers copied and varied it each in turn, as in a game of telephone, with the role of "leader" constantly alternating among the four (*DB* 139–140). Because the followers could intentionally vary the action, Schlichter's version of follow-the-leader played back the improvised movement less literally than Rainer's. However, both would have offered viewers something like the opportunity to remember that still poses could provide— only here, the review was provided for them. Thirty years before, Bertolt Brecht had written of his attempts to replace the singular flow of drama that "carried away" the spectator with something more like the looping temporal experience of reading and rereading. The sequential repetitions in the work of Rainer and others at Judson are very much in this spirit, as if they thought dance viewers, like Brecht's theater-goers, should be provided some version of "footnotes, and the habit of turning back in order to check a point."[113] In 1965 Rainer wrote of her dance *Parts of Some Sextets* that moments of repetition made "the eye jump back and forth in time."[114]

In this way, the view of the dancing body that has emerged in recent dance theory, with its investigation of the absence that always haunts the presence of the moving performer, was embodied in the dance art of the 1960s. Lepecki characterizes this conceptualization as one in which the "dancing body releases layers of memory-affects, photographic contact, digital depth, and choreo/graphing."[115] For this reason, it is significant that in both *Room Service* and *Association (Improvisations)* the initial gesture—that of the leader—was improvised: unpredictable, unpremeditated, done on the spot. As Sally Banes argues, "improvisation

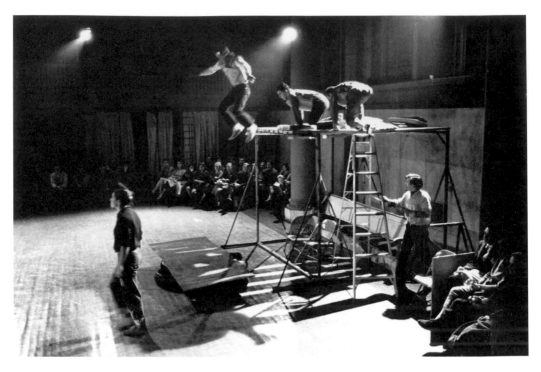

1.6 Yvonne Rainer, *Room Service,* 1963. Sculptural environment by Charles Ross. Judson Memorial Church, 20 November 1963. Photo: Peter Moore. © Estate of Peter Moore/VAGA, New York, NY.

emphasizes that evanescence [of all dance] to the point that the identity of the dance is attenuated, leaving few traces" (*DB* 195). Improvisation would seem to be the form of choreography *least* oriented toward memory, least invested in the phenomenology of recall, and most committed to an idea of live performance as direct and unmediated. However, in these cases the followers' mimicry was an attempt briefly to capture this spontaneous, ephemeral movement; to have it leave brief traces—or tracers—in the visual field. The sloughing off of images that Lepecki characterizes as inherent was instead purposefully, almost mechanically produced. Like the instantaneous photography that fascinated Benjamin, or like replays in sports or news broadcasting, such dance repetitions enhance vision, interceding in the ephemeral's disappearance (several years later, Don McDonagh commented that the use of similar repetition and mirroring in the work of Twyla Tharp recalled "television's use of 'instant replay'").[116] With the repetition of the danced phrase, what was barely perceptible is apprehended.

Still other aspects of Judson dance seem also to manipulate the flow of performance time—among them, one of the most foundational for Judson experimentation. When the Judson dancers used chance procedures like dice throwing to determine the order, location, and direction in which movements were to be performed, choreographic control was given up for improvisatory techniques, and structuring from above was made to give way to the flow of probability and chance. Not surprisingly, this giving up and giving way has been aligned with the idea of democracy and freedom as the underlying theme and contribution of Judson dance. The singular authority of the choreographic genius was, after all, being replaced by decisions made in the moment and governed by the neutral, objective laws of chance. Banes suggests something a bit different, however, when she reports of Simone Forti that "chance methods became meaningful to her not so much as a repudiation of personal control—she did not mind having control over the work—but as a technique of invoking a past experience—the moment of composition—in present performance" (*DB* 11). Chance could thus signify the *opposite* of instantaneity. It could mean showing within a present performance the prior work that structured it.

Later, Rainer experimented a great deal with this particular kind of temporal switch, in which the work of rehearsal and teaching was displaced into the live performance event.[117] There were instances of such experimentation even in Judson days, though, as in Paxton's *Transit*. Paxton opened the piece by performing a ballet phrase. Then he repeated the entire phrase, but this time "marking" the movement. Marking is to dancing what humming is to singing: a glossing over or gliding through, a half-dancing in which all the steps are indicated but none fully executed. Informal and pedestrian, high points flattened out and technical tricks eliminated, marking shares many of the characteristics of Judson dance itself—including a fixation on remembering. For marking is what a dancer does in class, during rehearsal, or just before a performance to cement a series of movements in kinetic memory and, later, to return to active memory the sequence that the body knows. Just as it may be difficult to recall a tune without humming it, to bring a dance to memory dancers need to move their bodies, because they remember movement sequences physically.

And we viewers do not. Paxton's repetition of the dance gave the audience several "chances to recognize it": those second and third opportunities to perceive the movement that regular repetition, slow motion, and even stillness provided elsewhere in Judson dance. While the term suggests the leaving of a visual trace, *marking* this repetition insists upon a kind of knowledge categorically unavailable to those seated in the audience. Muscle memory is the vanishing point of dance visibility—a kinetic phenomenon that spectators cannot share. As such, it is at the heart of the issue posed by the temporality of the Judson Dance Theater. All the techniques that help viewers to apprehend dance, to hold a picture of movement in the mind's eye, negotiate between a physical epistemology and a visual one: between a performer's and a spectator's way of knowing movement.

While any number of 1960s art events tacked together the sides of this divide, attempting to make audience members participants rather than viewers, Judson dancers were less eager to seal the scar. They found a myriad of ways to engage spectatorship—and all the techniques discussed are engaging in this

sense—but, given the artistic context of the early 1960s, where Happenings had been offering immersive and participatory experiences and Fluxus artists were having audiences perform, it is notable that Judson dance performances made no sustained attempt *literally* to involve the spectator. In 1970 McDonagh noted for readers of the *New York Times* that one effect of watching Rainer's piece *Continuous Project—Altered Daily* "was the frustration of not being able to participate except vicariously in something that appeared to be fun."[118] Even seven years earlier, on the heels of the Happenings, Judson choreographers were apt to confront what were, after all, the more normal conditions of spectatorship in the 1960s as well as today—conditions that render the living, breathing body of the performer an image; conditions that keep the rest of us in our seats.

In this way Judson choreography makes evident complexities in the period's fascination with "live" performance. The use of forms of repetition and slowness as quasi-mechanical enhancements of vision, the fascination with photography and photographic effects: these aspects of Judson dance complicate any tendency to view it as committed to immediacy, instantaneousness, and presence. Likewise, in its resistance to forms of literal participation by viewers, the art of the Judson participants represents an alternative to the outright affirmation of participation and copresence in much 1960s culture—for instance to that of Guy Debord, whose writing, Anselm Jappe points out, "especially in its condemnation of 'contemplation' and 'non-participation,' is characterized by a vigorous activism that sees any occasion when the subject is not shaping his world as an abdication."[119] Consider, in this regard, Yvonne Rainer's decision in her 1963 *Terrain* to have the dancers who were not performing in a given section of the dance remain in the onstage area, in front of the audience yet conspicuously not performing (figure 1.7). Gathered around a police department street barricade Rainer had provided for the purpose (and, in Peter Moore's photographs, looking for all the world like Degas ballerinas languidly leaning on a barre), these viewers within the work represent an inversion of the tendency elsewhere toward audience involvement. Instead of making spectators into performers, Rainer made her performers *watch*.[120]

1.7 Yvonne Rainer, *Terrain,* 1963. Judson Memorial Church, New York, 28 or 29 April 1963. Pictured: William Davis, Steve Paxton, Albert Reid. Photo: Al Giese. Reproduced by permission of the Estate of Al Giese.

Flash Forward

Alex and Deborah Hay closed the first Judson concert with *Rafladan,* a collaboration with musician Charles Rotmil performed almost entirely in the dark. *Rafladan* anticipates the use of flash bulbs, Day-Glo, and light projection in the public parties of the slightly later 1960s—the Acid Tests, sponsored by Ken Kesey, the Trips Festival and the Awareness Festival produced by Stewart Brand, not to mention Andy Warhol's multimedia events with the Velvet Underground. These classic counterculture manifestations would experiment with a range of light and vision effects in the interest of an expanded perception. And the possibilities of perception were precisely at issue in *Rafladan*'s darkness. Deborah Hay danced on, invisible, while Alex Hay "did things with little pinlights, flew them around" (*DB* 68). Paxton recalled that the dancers "wrote things in the air with flashlights, leaving afterimages" (*DB* 68). On the one hand, there was no visibility at all; on the other, an afterimage inscription: writing movement in the air, on the eye, and in the short-term memory. For to see a line of light "drawn" in the darkness is to see a trace of where the light has been—like looking at a distant star, it is to perceive the light's past in the present.

The use of lights in *Rafladan* is thus a more explicit example of the dual effect of still poses in Judson dance. Whether triggered by a sudden arrest of motion or inscribed with light, the image not only artificially suspends the past in the present, but cuts into the flow of performance time. Like repetition, which reproduces the movement until it can be properly apprehended, or for that matter like the newspaper that reports events that are over and gone, the afterimage opens a window on the just-past. Dance is viewed in these cases in a kind of momentary hindsight. The effect of such temporal/visual experimentation is clear in Jill Johnston's description of the piece called *Flares* that composer and musician Philip Corner presented at the Judson Dance Theater's eighth concert. Corner began working on this piece with written scores, which he then translated into both sound and movement. The scores were made visible within the performance, projected on the walls of the sanctuary. But nothing in *Flares* was

unambiguously available for vision, for it was conducted, as the title suggests, in bursts of activity separated by blackouts. As Johnston describes it, this piece by a musician becomes a kind of coda for the perceptual experiments of Judson dance, with their vacillation between too much performance perceptibility and too little: "Everybody was hot and tired, so the interminable alternation of activity and blackouts became unbearable. . . . The short span of each scattered assemblage really did flare up and die off like scenes lit by lightning in partially unknown places. But the blackout intervals were at least eleven seconds long, and since there were about 35 of them, the pleasurable sensation of not knowing exactly what you've just seen turned into an intense desire to be sure of something, just once."[121] In this last line of her review, Johnston channeled with typically casual brilliance the "seeing difficulty" that charged so much of this period's performance experimentation: an alternating current of pleasure in and resistance to dance's inaccessibility to vision.

In 1964, Steve Paxton presented at Judson Church a dance called *Rialto* that involved both leaving the stage for long periods of time and hiding within a tower of cardboard boxes, thus exploring different ways of making the act of watching performance a thwarted effort to perceive the performer's body. Notably, the dance also included a moment in which Paxton raised a camera and snapped photographs of his viewers. "I took pictures of the audience instead of the audience taking in a picture," he explained (*DB* 195). This gesture anticipated both the device of using a camera within performance and the reversal of subject and object of the gaze that Vito Acconci elaborated in 1968 with his *12 Pictures,* a piece that consisted of the artist crossing a stage while taking Instamatic snapshots of the audience. As Anne Wagner has shown, much video and performance like Acconci's circa 1970 centered around viewing—around "eye contact and evasion"—in the service of fundamental questions about the status of artist, artwork, and audience in the age of technological culture and spectacle: "How can a work make itself public? Can object and viewer still continue to be so efficiently *present* to each other, so mutually absorbed? Will the artist's apostrophe go unheeded? Will it fail to conjure a viewer into life and presence and connection with its chosen forms? Can the old requirement—art's

need for witnesses—continue to be sustained? And, if so, with what measure of vividness and veracity? Does confidence in the directness of vision really survive translation and reproduction by technological media?"[122] Wagner historicizes the tendency to denaturalize artist-spectator relationships in this period, viewing it as a function of an increasingly televised, image-driven culture. The work she describes—like Acconci onstage taking pictures, interrupting the audience's view of him and changing the relation of viewer and viewed, or Dan Graham in a gallery before a seated audience, describing his viewers to themselves, then himself to them—testifies that simple presence and communion between artist and viewer, via the artwork, could no longer be assumed. These artists had to dramatize and make problematic, to present and represent, the relation of artist and viewer, and this urge makes historical sense in relation to the increasing omnipresence of media in the cultural surround.

Though performance itself implies the necessity of presence—"you had to be there"—an earlier stage of the same crisis of copresence is intimated in the work of the Judson Dance Theater. Just where directness of experience seems most available, "being informed" sneaks in, also or instead. This seems to happen, for example, in Diane di Prima's review of David Gordon's *Mannequin Dance* (the slow-motion dance in which he sang "Second Hand Rose"). The critic wrote of the unusual effect of Gordon's ability to link performance and reception: "the receiving and giving out one operation, no dichotomy there." This instantaneity of experience of viewer and performer was "terribly moving," di Prima writes. And one wonders whether the emotional affect might have had something to do with the rareness of that copresent union of performer and audience in "receiving and giving out," or with nostalgia for a time when such exchanges were perceived as more commonplace. For "giving out and receiving" are double entendres in di Prima's review, in which she uses metaphors of broadcasting in describing Gordon's performance.

The struggle to resist the culture of representation is at stake in Phelan's argument in *Unmarked* that performance is ontologically limited to the present tense, and at issue in her segregation of performance from documentation. What the present account of Judson dance should have indicated, however, is that for

these particular performance artists such a distinction between action and image, performance and photograph, could not quite hold. It is no accident that scores made of newspapers and photographs mediated between choreographer and performer in much Judson dance. With its frequent complication of performance's present tense, Judson Dance Theater can be understood to have addressed—albeit for the most part at a level other than conscious intention—a condition of mediation. Their antihierarchical and democratic impulses supplemented by a deep-running concern with the visibility of movement performance and its reliance on memory, Paxton and the other Judson choreographers join Acconci, Graham, and other artists who found their practices embroiled in rather than separated from a mediated, image-flooded milieu.

Debord described the way a culture defined by spectacle transforms human life: "it arrogates to itself everything that in human activity exists in a fluid state so as to possess it in a congealed form—as things that, being the *negative* expression of living value, have become exclusively abstract value. In these signs we recognize our old enemy the commodity."[123] It is more than a similarity of metaphors that links the Judson tendency toward objectified, or "jelled" performance to Debord's description of the "congealed" activity of a spectacular system. This is not to say, of course, that Judson performances became commodities. Rather, it is to insist on the complexity of the ways Judson dance engaged the conditions of its time. If the group's aesthetic project is to be written into social histories of the period, it must be as an engagement with spectacular visuality as well as a battle for democratic ethics.

This is to read Judson Dance Theater in hindsight, of course, for it is to align its experiments of the early to mid 1960s with ideas and aesthetics fully elaborated only later. As several of these dances themselves demonstrated, however, looking back is precisely the project we necessarily undertake in any study of performance art—even the most contemporary. There are methodological difficulties involved in studying the performance art of the past, but these choreographers recognized that there were also problems inherent in seeing it in the present. Witness Paxton's two *Rialto* snapshots—focusing on the audience, they also instantiate a delay tactic that has everything to do with the questions of per-

formance visibility and performance time at stake in Judson dance. I don't know if Paxton used a flash for those two snapshots, but I hope he did, because it was a suspension of the audience's ability to see that was at issue. The photograph, which can't be seen until later, implies a delayed temporality, instantly shuttling consciousness to the time when the performance moment would be, not lived, but recalled. With the click of the shutter, the focus of the performance has become invisible to the audience, a matter of future mediation. It is what he sees through that lens that matters, and that vision is unavailable to his viewers—or, more specifically, it is splintered off from the tense of ordinary performance time. It is unavailable for *now*.

RETURNING TO JUDSON

Backward. That's how Yvonne Rainer recently chose to begin her first concert of dance at Judson Memorial Church in almost thirty years—with Pat Catterson dancing Rainer's 1966 *Trio A* in reverse.[124] The 1999 debut of *Trio A Pressured*— as Rainer's first dance composition after decades of working exclusively in film was called—began with Catterson in *Trio A*'s final toe-tapped, arm-wrapped position, and proceeded with the dance's unraveling. Dancers call this kind of reversal doing a dance "in retrograde"—a choreographic exercise in which the dancer reverses both the sequence of movements and the motions themselves. The dance is effectively played in reverse, like a film rewinding.

Quite a trick for a dancer to accomplish, retrograded dance also makes certain demands on the viewer of performance. In *Trio A Pressured* these demands varied according to the viewer's relation to *Trio A*. If, like many in the audience that night, you knew the dance already—from memories of its many incarnations in the 1960s and '70s when Rainer repeatedly incorporated the five-minute dance into her performance events, or from the film produced by dance historian Sally Banes in 1978—then the retrograde version might have been disorienting. You found your eyes straining to recognize remembered movements, your memory taxed as you tried to anticipate which head shake or foot shuffle or somersault was coming next—that is, before.

If on the other hand you didn't know *Trio A,* you might not have recognized the reversal at all. The piece works almost as well in retrograde, its trademark evenness of tempo and tone intact, the performer's always-averted gaze still enacting a perceptible disruption of the normal performer-audience relation.[125] Even for an uninitiated viewer, though, the retrograde version in the 1999 concert would have triggered a memory test, because the rest of Rainer's new piece consisted of *Trio A* presented four more times, all in the forward direction.[126] This repetition of the dance in its original condition made you reflect on that first, slightly off-kilter presentation. It asked you to remember what was different. It asked you to remember.

Trio A Pressured was also Rainer's homecoming to Judson Memorial Church. Appropriately enough for such a return, Rainer initiated the 1999 concert by rewinding her most famous piece of choreography before our eyes. In light of this chapter's investigation of problems of spectatorship in the earlier breakthrough performances of Rainer and her cohort at Judson—in particular, the way certain techniques in Judson dance seemed designed to activate spectatorial practices of rewinding and review—I find it fitting that, returning to dance and to Judson in 1999, Rainer cast the viewer's experience of her re-debut as an act of recollection, prompting us to look backward at her dance.

Sections and Chunks: Serial Time

Parts of Some Histories

In one particularly wonderful photograph by Peter Moore of Yvonne Rainer's *Parts of Some Sextets* (1965), the stage of the Wadsworth Atheneum in Hartford, Connecticut, becomes a bright box thickly framed in black (figure 2.1). Dark margins on all four sides focus attention into the image's central space, where ten people dressed in jeans, sweats, and T-shirts are caught in the midst of activities ranging from the dancelike (a couple downstage center looks almost ballroom-ready), through the banal (a woman paces the back of the stage in an ordinary, sidewalk stride), to the worklike (a man wedges both arms under a mattress to heave it off a pile of its mates). Half a dozen more mattresses, splayed flat or folded in loose curls, snake along the midline of the stage.

Moore's image corresponds closely to a particular kind of demand often placed on photographs of live performance. In 1974, the theater scholar Ronald Argelander gave a powerful example of this tendency when he argued in the pages of *The Drama Review: TDR* for a genre of "photo-documentation," as distinguished from creative theatrical photography. He deemed Moore the pioneer of this photographic mode, devoted to "capturing as much of the total visual experience of an actual performance as possible and getting it from the point

2.1 Yvonne Rainer, *Parts of Some Sextets,* 1965. Wadsworth Atheneum, Hartford, Connecticut, 7 March 1965. Pictured: Deborah Hay, Yvonne Rainer, Steve Paxton, Tony Holder, Lucinda Childs, Sally Gross, Judith Dunn, Robert Rauschenberg, Robert Morris, Joseph Schlichter. Photo: Peter Moore. © Estate of Peter Moore/VAGA, New York, NY.

of view of the audience."[1] What was to be documented was less the work as a thing in itself than the *experience of viewing it.* To suggest this opening onto the situated condition of performance, it was crucial for the photographer to forgo the temptation of the close-up and to provide visual information that would "establish" the shot. The unusually thick margins around the stage space in Moore's photograph of *Parts of Some Sextets* serve this function. A visual guarantee, this framing assures us that no selective zooming or cropping has occurred, while the especially broad stretch of mostly illegible darkness below the stage signifies the all-important "point of view of the audience." Argelander's article also helps to explain a noticeable skewing in the Moore photograph, a misregistration of stage space and frame. Conveying information about the depth of the stage, the angle also gives us the coordinates of the camera. This specificity, together with the slight tilt of the whole image, provides the photograph's viewer with a sense of contingency that maps onto that of the live event: we are seeing the performance as it would have appeared to someone sitting toward the back of the house and slightly stage left, that night in Hartford.

Now, everyone knows that we are doing no such thing, at least not in any simple way. Yet Argelander's insistence that the proper documentary image is the one that most transparently transmits the audience's visual experience is not a case of media naïveté; rather, it is evidence of his place in a particular intellectual history. His interest in the audience's experience links his view of performance to that broad tendency in thinking since the 1960s that stresses spectatorship; more specifically, his article dates from the moment of the emergence of the field of performance studies, and was published in one of its mouthpieces. The interdisciplinary endeavor of performance studies was shaped in part by the imperative to take drama back from literature, and influenced strongly by the involvement of many of its founders in avant-garde performance in the 1960s. (Michael Kirby, one editor of *TDR,* wrote the first book on Happenings in 1965; another, Richard Schechner, directed the avant-garde troupe The Performance Group later in the decade.)[2] Accordingly, the new approach privileged theater in its performative rather than textual dimension, as a temporal event rather than a literary object. Hence Argelander's repeated emphasis on the audience

and its experience, for these factors of copresence were overlooked when theater remained a province of literature, but were valorized in the rhetoric—if complicated in the execution—of Happenings and other 1960s art practices. This relationship to performance studies also explains Argelander's very practical underlying project of addressing the "lack of reliable or accurate visual material to work with,"[3] which is to say, the need to build an archive for an emerging field of scholarship.

Practical as this need might be, we should not overlook the structuring tensions, even contradictions, in a project based on the need to preserve what is valued precisely because it vanishes; one whose investment in the situated, particular point of view is matched only by its desire for a total record. These tensions are important clues to a larger history that Argelander's views on performance documentation fit into—along with Moore's photograph *and* the dance by Rainer that it depicts. All of these participate in a long history of attempts to cope with the profound transformation of temporal experience in modernity. The question at hand is how, in the mid 1960s, this transformation became a seeing difficulty: a productive problem for art and art spectatorship.

The performance scholar's fantasy of a representation that would open onto the actual, situated moment of live performance *while also* preserving it in a convenient and accessible package is, but for its date, a perfect example of the conflicted relationship to contingency that Mary Ann Doane has teased out of the dense history of photography, cinema, and modern philosophy at the turn of the twentieth century.[4] Of course, there are many accounts of the period when it seems every intellectual, inventor, engineer, and artist in the industrialized world became obsessed with the problem of time, as industry's demands for standardization and efficiency and capitalism's ever-more-pervasive equation of time and value spread into the domain of lived experience (this was the era of Greenwich Mean Time, the time-motion study, the efficiency expert, and, of course, the cinema).[5] Most studies also emphasize the intellectual countermeasures that emerged—the valorization of chance, accident, and immediacy of impression, or the obsession with temporal continuity in the work of philosophers like Henri Bergson. But Doane's *The Emergence of Cinematic Time: Modernity,*

Contingency, the Archive is particularly useful for its insistence on thinking modern temporality through the interdependence of two dimensions: on the one hand, generalizing, rationalizing structure; on the other, contingency, or that which is particular, undetermined, ephemeral, resistant to system.[6] Doane argues that there is a reason these two temporal complexes intertwine in period texts and practices, from those of Bergson or Charles Sanders Peirce to Thomas A. Edison and Étienne-Jules Marey. In modernity, "chance and the contingent are given the crucial *ideological* role of representing an outside, of suggesting that time is still allied with the free and indeterminable."[7] Experiences and representations of the contingent make the constraints of standardization tolerable. At the same time, contingency itself is always approached with some anxiety, as it verges into meaninglessness—absolute individuality, failure of causality, the "riot of details" Charles Baudelaire feared would be let loose in an unmoored modernity.[8]

Doane's central proposition is that the visual technologies of photography and especially cinema performed a crucial role in this context by representing, *but thus also managing and containing* the contingent. In modernity's still and moving images, "contingency and ephemerality are produced as graspable and representable, but nevertheless antisystematic."[9] Something similar is at stake in Rainer's mid-1960s performance. For art like Rainer's did for audiences of the 1960s what photography and film did for theirs in the period of their emergence: it produced a socially resonant, deeply dialectical management of time.[10]

Argelander's desire in 1974 for the situated but also the systematic in the document of live performance, the contingent but also the total, is an expression of the paradoxical needs Doane describes. But the persistence of her problematic into the later twentieth century—and as we will see, its transformation—is also hinted at by an interesting dimension of the Moore photograph of Rainer's dance. Even as it exemplifies performance photography as token of the contingent, the image captures more than its own split second of time. This is evident as soon as one turns one's attention from the dancing bodies to the mattresses strewn among them. What we see in this picture is not an arrangement, but a sequence of mattresses. The posture of the man on the pile—it happens to be the artist Robert Rauschenberg—in combination with the way the bend in

the mattress he curls is repeated by others in the array, allows us to reconstruct a series of events. Each mattress has been "peeled" off the stack and left to fall as it may; each has then been nudged and displaced by the mattress that had been beneath it, as it, in turn, was peeled. The mattresses in the photograph are collectively legible as the record of a specifically serial action. In this they are not dissimilar to the waves of hardened lead that Richard Serra pulled along the floor a few years later in *Casting* (1969), whose most famous photographs are also by Peter Moore. In Serra's piece, which involved flinging molten metal, allowing it to cool, dragging out the resulting form, and then repeating the process, the further one looks from the seam of wall and floor, the older is the trace of action. Likewise, in the photograph of *Parts of Some Sextets,* the further one looks from the man doing the peeling, the further back one sees in time. While as a whole the photograph cuts into the performance's timeline, the mattress pile slices along it. Moore's instantaneous photograph thus contains its own small archive of previous moments of the dance.

Another way to put this is to say that Rainer made a dance that let the still image do more than it is supposed to. Its photograph documents not only a single moment of a dance, and not only a swath of that dance's temporal extension, but in addition the quality of that dance that this chapter will draw out: its historically specific dialectic between two conflicting but interconnected attitudes toward time. As we proceed, it will help to remember that, in addition to the image's cut into time and the temporal sequence that nevertheless unfolds there, there is a third vector in Moore's image of Rainer's dance: our attention, so carefully directed into the depicted theatrical space.

The Emergence of the Ordinary

Parts of Some Sextets was built of thirty-one distinct activities—bits of what the choreographer referred to as "movement material." Each had a name, and these themselves suggest the work's range: from "Human Fly" to "Vague movement"; "Solo beginning with shifting of weight" to "Crawl thru below top mattress." Even though the actions designated by some of the names have been lost to

history, it is clear that there were at least four types of activity in this work. There were relatively elaborate, choreographed phrases (what Rainer called "the 'dancey' stuff"); passages of walking and running; static formations; and tasks, usually to do with manipulations of the mattresses, like the one called "peel one at a time" that Rauschenberg is performing in the full-stage photograph.[11] This wide range of material made it possible to work with a human spectrum as well—a combination of highly skilled dancers and untrained performers. The activities sometimes occurred singly, but more often, as the Moore full-stage photograph suggests, a number of them were performed at once, and actions recurred again and again as the dance went on, moving, as it were, from one performer to another. The effect has been described as orchestrated, contrapuntal, complex.[12] To watch a performance of *Parts of Some Sextets* was to see a dense coordination of action: not just dancing but lifting and throwing, walking and running, working and posing, grouping and regrouping. A surprisingly large swath of this spectrum of activity is captured in the full-stage photograph.[13]

Despite all this variety, there is something interestingly uniform about the bodies depicted in Moore's image. The poses in which they are captured share a particular quality—call it a middling aesthetic. Nobody (except for the seated person whose head is just visible behind the stack of mattresses) is at rest, but nobody is at an extreme of bodily extension, either.[14] Arms, if extended, are not quite stretched, legs are only narrowly scissored open. Bodily positions are more or less closed. Postures are erect, stable, pedestrian.

It's not that there was no physical exuberance *in Parts of Some Sextets*—in fact the work is often remembered as especially playful, many of the activities were distinctly athletic, and the dance was the occasion for some of the photographs that best convey the joyous liveliness of postmodern dance, as seen in Moore's image of Steve Paxton doing the action called "Fling" at the Judson Memorial Church performance later that month (figure 2.2). The full-stage photograph at hand is particularly helpful, however, because it offers visual equivalents for one of the most significant aspects of *Parts of Some Sextets*: the quality of performance that unified its range of activities. This was a style or mode of moving oriented away from the dancerly or theatrical and toward ordinary behavior.

2.2 Yvonne Rainer, "Fling," from *Parts of Some Sextets,* 1965. Performed by Steve Paxton at Judson Memorial Church, New York, March 1965. Photo: Phil MacMullen.

Rainer described it this way in 1965: "no rhythm, no emphasis, no tension, no relaxation. You just do it, with the coordination of a pro and the non-definition of an amateur."[15] Describing a section of *Parts of Some Sextets* performed at Judson in 1965, Robert Morris captured this quality, calling it "a low pressure, non-dancer work," that seemed to "operate between skilled dance requirements for movement and the kind of non-dance movement generated by task situations or rules."[16] In its representation of ordinary actions, like walking, dancing, and working, the photograph thus evokes a quality of movement performance, often characterized as tasklike, that distinguished *Parts of Some Sextets,* and that came to be deeply associated with Rainer's art.

Although activities as quotidian as eating a pear, walking, or running were part of the choreographic repertoire of Rainer and her peers in the early 1960s, and even though a distinctly nontheatrical bodily carriage was typical in the work of most artists in this circle, the tasklike movement in *Parts of Some Sextets* marks a turn in Rainer's work—one with significant art historical resonance. *Parts of Some Sextets* was first performed at the Wadsworth on 6 and 7 March 1965. In an essay published later that year, Rainer described the struggle leading up to the new dance: "It was necessary to find a different way to move."[17] She felt she had exhausted one tendency in her work, "the 'imitations-from-life' kind of eccentric movement that someone once described as 'goofy glamour,'" and she seems exhausted herself when she reports no longer being able to "call on the energy and hard-attack impulses that had characterized my work previously." This crisis may have been a personal matter (we are talking about the end of her twenties, for one thing). But she was also participating in an art historical shift, as the youthful abandon, the anything-goes and why-not attitudes that had given New York-based avant-garde art its energy since at least the late 1950s came to seem unsatisfactory. Certain other tendencies, while present all along, were now emergent—a linked set of concerns that included modular or serial structure, and neutral or impersonal presentation. The quotidian quality in dance-based performance was part of this transition. It received new prominence in *Parts of Some Sextets,* in part because in this work Rainer was renouncing the very different type of dance activity for which her early work had

become known: the quirky, oddball, silly, or grotesque material inspired, as she put it, by the loony bin and the New York City subways—like that in her early dance *The Bells,* where her hands flitted like insects about her face. As she explained in a 1965 *Dance Magazine* profile, her work had already been "concerned with the anti-heroic and anti-theatrical"; she was now working to "eliminate the bizarre or expressive elements in favor of a more abstract non-associative dance idiom."[18] In the absence of screaming fits and spastic groping, funny faces and imitations of erotic sculpture, a certain workliness came into focus.

The mattresses were crucial to this transition. In Rainer's *Room Service* of 1963, a collaboration with the sculptor Charles Ross, "prop men" had set objects and obstacles in the way of dancers, who then improvised with these, using a follow-the-leader format. Rainer found one incident especially intriguing: "2 of us carrying a mattress up an aisle, out the rear exit, around and in again thru a side exit. Something ludicrous and satisfying about lugging that bulky object around, removing it from the scene and re-introducing it. No stylization needed. It seemed to be so self-contained an act as to require no artistic tampering or justification."[19] Hauling the weighty, awkward mattresses allowed Rainer to isolate the simple but crucial operation that she then showcased in *Parts of Some Sextets*—the move Michael Kirby (who had seen *Parts* in Hartford) described at the end of the 1960s as foundational for avant-garde dance in that decade: "'danciness' has been replaced by the muscular dynamics of everyday life."[20]

There are two important ways the ordinary quality of movement brought forth in *Parts of Some Sextets* has been theorized since the 1960s. One has to do with time: it holds that ordinary movement performance restored to dance an intrinsic temporality—things done in the time it took to do them. The other has to do with attention, proposing that this kind of dancing brought the focus back to the overlooked marvel of the ordinary working, moving body. Both are right, I believe, but both also miss something that the dance itself can tell us—even if only with, or maybe especially through, its residue. *Parts of Some Sextets* is its own theory of ordinary movement performance, offering a corrective to the shared assumption of both the temporal and the attentional models of what ordinary motion is about. In both modes, naturally enough, we tend to

look at this ordinary movement performance in relation to nonordinary activity—to the special kind of movement in conventional dancing. While there is no doubt that a revolution in dance aesthetics was the immediate aim and consequence of the innovation, a different, more historical understanding of what was at stake in the quotidian mode of movement performance is possible if this artistic development is placed in relation to the type of temporal structure through which Rainer presented it and the kind of spectatorial experience this work occasioned. Both of these relationships point less to the generational negation of modern dance than to a period-specific grappling with the realities of modernity in their late-twentieth-century forms.

TASK TIME

It is easy to understand ordinary movement performance in its found-object mode: actions like walking, eating, or talking displaced onto the dance stage. It is a bit harder to characterize tasklike performance—a mode of behavior, a type of execution, that has the *quality* of these unself-conscious, everyday actions even if it is invented, unusual, or dancelike. One way people have defined this type of movement since the 1960s is to emphasize its temporality. Rainer described the tasklike movement quality of her 1966 dance *Trio A* as "a control that seems geared to the actual time it takes the actual weight of the body to go through the prescribed motions, rather than an adherence to an imposed ordering of time."[21] Annette Michelson echoed this idea in 1969, explaining that recent avant-garde dance had been "predicated on the distinction between a time one might call virtual as against a time that is operational, the time of experience, of our actions in the world."[22] In the mid 1960s, according to Michelson, Rainer and her peers had "install[ed] within the dance situation a real or operational time, redefining it as a situation within which an action *may take the time it takes to perform that action*."[23]

Art historians are used to this concept of experiential time in discussions of the 1960s, in part because Rosalind Krauss applied Michelson's notion so productively in her writing on the theatricality—the time-based situatedness—of

1960s sculpture. Specifically referencing Rainer as a source, and reproducing an image of *Parts of Some Sextets* as a marker of the trend, Krauss argued in *Passages in Modern Sculpture* that the most important sculpture of the 1960s—from Robert Morris's minimalist plinths to George Segal's tableaux to Richard Serra's precarious props—was, like theater, constituted and experienced in duration, in the time it takes to see it. Krauss valorized this quality in opposition to Michael Fried's commitment to work that "one experiences . . . as though if only one were infinitely more acute, a single infinitely brief instant would be long enough to see everything, to experience the work in all its depth and fullness, to be forever convinced by it."[24] Through the debates over sculptural theatricality, real or experiential time in 1960s art has been understood by means of a contrast with a high-modernist abstraction of pure presentness.[25]

New York artists were not the only intellectuals in the industrialized world becoming interested in Michelson's "operational" time in the 1960s, however—and modernist timelessness was not the only temporality against which operational time was being defined. The temporality of tasklike performance as it emerged in the 1960s is remarkably similar to a way of using and experiencing time that ethnographers, historians, and social critics, as well as development experts and social engineers were just then identifying as the norm in societies organized according to nonindustrial modes of production. Consider the following examples: an interval of time called "a rice cooking," an egg boiled for as long as it takes to say a Hail Mary, or (my personal favorite) a period of time designated by the phrase "a pissing while." They could not come from more varied contexts—twentieth-century Madagascar, colonial Chile, and early modern England, respectively—but when held up against the treatment of time in Euro-American modernity, as they suddenly were in the 1960s, they appear to share an approach to temporality. Instead of measured time being used to structure tasks, in all of these cases activities or tasks are used to measure time. All are examples given in a now classic 1967 paper by the British cultural historian E. P. Thompson, who traced the shifts in time sense effected by the demands and incentives of industrial capitalism, whether in eighteenth-century England or contemporary Mexico, using the sociologist Wilbert Moore's phrase "task-orientation" to

describe the temporal system typical in nonindustrial societies.[26] Approaching the problem as a historian, Thompson was nevertheless acutely conscious that his was a contemporary concern, for time sense was a real site of conflict with the imperatives of the emerging global economy, as "development" introduced capitalist incentives and discipline throughout the third world in the second half of the twentieth century.

In presenting activities that "took the time it takes" to perform them, Rainer and her peers were, like Thompson, isolating, abstracting, and presenting a task-oriented temporality. But in *Parts of Some Sextets,* as in Thompson's study, task-oriented time could be identified and experienced only against the ground of—or even within the context of—a precisely opposite temporal model. Thompson noted that "one recurrent form of revolt within Western industrial capitalism, whether bohemian or beatnik, has often taken the form of flouting the urgency of respectable time-values."[27] If *Parts of Some Sextets* did nothing but create in dance a space for the practice of operational or task-oriented time, it might fall into this countercultural model.[28] However, remembering that this is the dance in which Rainer gave up, or at least downplayed, the appeal to the marginal, improper, or shocking, it will make sense that *Parts of Some Sextets* was built, instead, on a deep tension between the task-oriented temporality of its movement and the time structure of the performance into which this movement time was slotted.

TIME STRUCTURE

Rainer created the dance using a long chart—two large pieces of graph paper taped together—whose vertical axis represented the thirty-one choices of movement material, and whose eighty-four horizontal units corresponded to consecutive, thirty-second intervals of time (figure 2.3). Partially randomly, but, she admits, with some sense of the order in which she wanted things to happen, she scattered points on the chart. Each mark was thus at the crossing of an action and a time unit, and so determined when along the timeline of the dance each activity would be performed. Since more than one mark might be made

2.4 Yvonne Rainer, *Parts of Some Sextets,* 1965. Robert Morris looks at the score during a rehearsal. Photo: Al Giese. Reproduced by permission of the Estate of Al Giese.

through detailed looks at phenomena from the dissemination of pocket watches to Puritan moral tracts to contemporary guides for capitalists in developing countries—time divided, measured, standardized, objectified; the kind of time that can be used to regulate the performance of tasks.

Rainer's compositional process meant that there was a dialectic in *Parts of Some Sextets* between the task-oriented time of its movement and the time of the performance as a whole, time which was not something generated by activity, but something to be filled with it. In this approach to performance time, *Parts of Some Sextets* is an example of a tendency in art, music, and dance from the 1950s on that Liz Kotz has done much to clarify through her discussions of the seminal early work of John Cage, particularly *4'33"* (1952)—whose title designates a temporal unit, subdivided by the composer, then filled and refilled in every performance—and *Williams Mix* (1952)—in which lengths of reel-to-reel tape were complexly spliced together.[35] In works like these, as in *Parts of Some Sextets,* time is conceived as a strip or a linear container—time, in McLuhan's terms, "mechanically or visually enclosed, divided, and filled."[36] Building on the arguments of Friedrich Kittler and others, and on her reconstruction of Cage's classes in New York in the late 1950s, Kotz argues that despite Cage's later disavowal of interest in recorded music, this way of conceiving performance in terms of predetermined units of duration corresponds to the ubiquity of recording technologies in the postwar era, and particularly to the introduction following World War II of magnetic tape (a form much explored in German experimental music and music theory, especially that expounded in the journal *Die Reihe,* which stressed quantitative method and technology such as loudspeaker and tape recorder, and which Cage's students and other artists in New York in the early 1960s read in English translation). Such a way of thinking time was pervasive in the 1960s—think of Andy Warhol's *Screen Tests* and the many other experiments throughout this period determined by the linear/temporal limits of a reel of film or videotape—but it would also have reached Rainer fairly directly. For Robert Dunn, who attended Cage's New School classes from 1958 to 1960,[37] passed on to the choreographers in his early-1960s workshops, alongside the composer's often-discussed lessons on inclusiveness and indeterminacy, his technologically

91

influenced way of thinking time as structure. Steve Paxton remembered as a key contribution of those classes that they taught participants to think in terms of sections and structure: "When you listen to a piece of music, you listen to intervals, sections, and structures. You aren't involved with personality and states of presence. So Dunn got us into that."[38] It thus seems worth emphasizing here one lesson to be drawn from Kotz's research: that the artists who conceptualized time as linear, and as a container to be filled, were engaging recording media not as mere conveniences for preserving and disseminating performances after the fact, but as what amounts to *the technological condition for time-based art in this period*. The spatialized temporal systems designed to store and manage time were now being used to generate it, as live performance figured forth the ribbon of time that is film or magnetic tape.

There was just such a temporal ribbon in *Parts of Some Sextets*: a reel-to-reel recording of Rainer's voice reading the late-eighteenth-century diary of William Bentley, a New England minister.[39] And crucially, this tape functioned as both the soundtrack of the dance and its timing device. Rainer taught the dance to her performers using a rehearsal tape that simply marked out thirty-second intervals, each one indicated by her voice saying "change." Once the dancers had learned the sequence of activities—particularly challenging because no inherent or internal logic governed their order—she switched to the tape of her reading of Bentley's diary, having determined which phrases from the text occurred at the thirty-second marks. Phrases like "The last fear," or "twenty years ago I," replaced the word "change" as signals for the dancers to switch activities.

Of course, these particular phrases were arbitrary. They had no special meaning, and were not privileged within the text—they just happened to be the words voiced as the second hand on Rainer's watch hit the thirty-second mark. The rhythm of the dance was tied to the text while being independent of the breaks between diary entries, or indeed of any internal structure—paragraphs, sentences, or even number of words. This is very different from the ways other dancers have used text to structure dance temporality. For instance, the choreographer Sally Gross, one of the original performers of *Parts of Some Sextets,* continues to use live and recorded speech both in the choreographic process and in

actual performances. For her, the point is the way the rhythm of speech informs the movement's pulse and structure. The beat, duration, and sounds of speech direct the dancing, cuing her transitions from one movement to the next.[40] Rainer's use of text in 1965 was radically different—the rhythm of speech was subjected to the temporality of the stopwatch, and it was this that, through arbitrary markers in the text, signaled changes in the dancing. In effect, the time of the tape technology overwrote both textual and lived time, as Bentley's language and the quotidian sequence of his days were processed through the standardized time identified in the 1960s as the time of capitalist modernity.

Perhaps I am putting too much pressure on this device. A dance needs a temporal structure, after all, and for an artist not working in terms of organic flow or intuition, and not using musical accompaniment, the clock is the most convenient way to divide up time. Still, Johnston's review suggests that there was something recognizably rigid and specifically rationalized about the time of *Parts of Some Sextets*. "Everything began to look and feel like it was happening in a large experimental cage for conditioned responses of some sort," she reported. Moreover, it was the tension between the dance movement's own temporality and the time structure of the work that bothered her. In line with Doane's contention that "contingency appears to offer a vast reservoir of freedom and free play, irreducible to the systematic structuring of 'leisure time,'"[41] Johnston felt "there is something even slightly grotesque about playground activity subjected to signal commands at regular intervals."[42]

MACHINERY OF AMUSEMENT

Slightly grotesque, yes, but surely also slightly familiar. Though she might not have realized it, Johnston's image of regulated freedom, of standardized play, is a powerful picture of the stage in the industrialization of time that she was living through. That is, the dance critic evinces an anxiety about the extension of industrial time sense from the sphere of production into the time we think of as free; an anxiety corresponding to the particular form that the generalized modern concern about rationalized time took on in the 1960s. McLuhan a few years

earlier had written that any true "leisure excludes times [*sic*] as a container,"[43] and the political philosopher Sebastian de Grazia made the case in 1962 that the very concept of "free time" was the mirror image of the industrial model of labor: "Being considered the opposite of work, and work being now calculated by time, leisure too must be figured the same way.... [L]eisure is counted off in quantities of time."[44] Johnston's discomfort with *Parts of Some Sextets* may have arisen from seeing in this dance a picture of the condition in which *all* kinds of behavior are fitted into temporal containers; certainly her image of the dance's ordinary movement "strangled by a rigid time structure" recalls de Grazia's nearly contemporaneous description of Americans in the 1960s: they were, he wrote, "cooped up in time."[45]

Thompson closed his essay on the spread and enforcement of rationalized versus task time with a meditation on present and future conditions in developed capitalist nations in the 1960s, where automation held out the promise of diminishing work hours and increasing time for leisure. He allowed himself to imagine the possibility that even as their industrial time sense was being exported to newly industrializing areas of the world, citizens of the already capitalist ones might, in their expanded leisure time, "re-learn some of the arts of living lost in the industrial revolution."[46] He clearly hoped that studies like his of the transformation of temporal experience under capitalism might lead to this rediscovery. Perhaps the task-oriented time of 1960s ordinary movement performance could likewise be construed as a temporal tutorial for postindustrial Americans. But Thompson also recognized that as long as industrial time sense was simply extended to the hours freed up in the "automated future," there would be no gain at all—liberated time would simply be exploited by the growing industries of leisure in the same way labor hours were consumed by traditional industry. And this was precisely the threat already apparent. The popular 1963 collection of the writings of C. Wright Mills included his 1953 essay on work and leisure, in which the sociologist announced that "the machinery of amusement" was destroying the time freed up by "the machinery of production."[47]

Several of the activities in *Parts of Some Sextets* are characterized by a kind of industrial playfulness. I'm thinking of the repetitive heaving of the mattresses

we see Rauschenberg doing in the full-stage image, and of the activity in which one dancer wormed her way over the other dancers' bent arms, which appear like rollers on a bodily conveyor belt (figure 2.5). In both cases tasklike activity takes on a specifically linear, repetitive, and unidirectional form that seems to flirt with the imagery of mechanical processes, with assembly line and conveyor belt, much as minimal sculpture, with its modular repetition or seriality, its logic of one thing after another, gestures toward the logic of industrial production (figure 2.6). While minimal sculpture's likeness to industry always seems faintly anachronistic—prompting us to ask why art should be compelled to turn to industrial models in the first flush of the Information Age, just as those models were losing their hold on the cultural imagination, if not their actual role in the organization of the economy—the dance's rendering of *playful* activity along industrial lines speaks to the particular anxieties around the rationalization of leisure in this late capitalist moment.

Still, any morphological reference that this dance makes to industrial modes is less important, in terms of the dance's relationship to its historical period, than the logic of its temporal system. And here it seems significant that the choice of the thirty-second-interval structure was the one blind spot in Rainer's remarkably lucid account of the genesis of *Parts of Some Sextets:* "How I decided upon the system that I ultimately used is now not too clear to me," she wrote.[48] If the dance's structural tension between movement performed in task time and performance organized by clock time works through a period preoccupation with capitalism's structuring of the very leisure its technology promised to provide, then this lacuna might be explained as a product of the historical rather than personal unconscious. What appears is a correspondence, however unconsciously created, between Rainer's organization of performance and the most powerful way time was being exploited by industry in the 1960s.

It was in broadcasting, and especially commercial television, that the problem of free time and structure was most effectively engineered. Leisure was contained, rationalized, and made productive by television's ability to break the day into sixty- and thirty-minute units, and to sell watching time, or the attention of viewers, in thirty-second increments. That there is an echo of TV time in

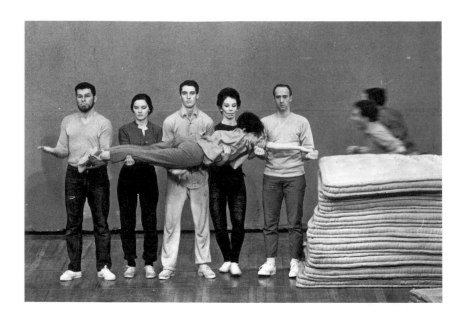

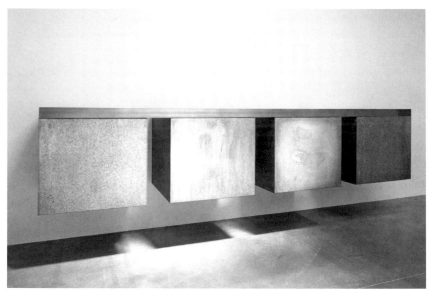

2.5 Yvonne Rainer, *Parts of Some Sextets,* 1965. Wadsworth Atheneum, Hartford, Connecticut, 7 March 1965. Pictured: Deborah Hay (horizontal), Tony Holder, Robert Rauschenberg (in background), Joseph Schlichter, Sally Gross, Steve Paxton, Judith Dunn, Robert Morris. Photo: Peter Moore. © Estate of Peter Moore/VAGA, New York, NY.

2.6 Donald Judd, *Untitled,* 1966. Galvanized iron and painted aluminum, 40 x 190 x 40 in. (101.6 x 482.6 x 101.6 cm). Norton Simon Museum. Gift of Mr. and Mrs. Robert A. Rowan. Art © Judd Foundation. Licensed by VAGA, New York, NY.

the 1965 *Parts of Some Sextets* can only be speculation, or course. (In the course of expressing her disinterest during the 1960s in new, technological media, and her suspicion of their enthusiasts, Rainer recently noted that she was not even exposed to television until she was thirty years old—which would mean that television entered her personal visual experience around 1964.)[49] But the possibility makes it all the more important to turn, next, to the work Rainer did in this dance with the attention of her viewers. We can begin with the fact that, though her original vision of the work had been of a totally regular series of intervals, when the dance was enacted—offered to spectatorship—she discovered something about duration and attention: "I did not realize until later that a given duration can *seem* long or short according to what is put into it." She explains: "my scheme [of thirty-second intervals] . . . did not really produce the insistent regularity I had thought it might. However, by the time I made this basic discovery I had begun to like the irregularities of the piece."[50]

The dual or even triple temporality of *Parts of Some Sextets*—with its task-oriented movement time, its overall temporal structure of regular, exchangeable intervals, and the irruption of perceived irregularity within that structure—performs both Thompson's warning and his hope: the hope that in the postwar period advanced capitalism might actually provide the opportunity to recover ways of living time freed from capitalist imperatives; the warning that leisure industries like television were already absorbing nonwork time into industrial logics and economies. As it works through, not the opposition of task time and the abstraction of presentness, but a dialectic of unregulated temporality and capitalist time sense, *Parts of Some Sextets* suggests that ordinary movement performance was not just a reaction against the exclusivity of the physical vocabulary in conventional dance, but an episode in the long history of dealing with what modernity in general and capitalism in particular had done to the experience of time, one particularly appropriate to the intensive rationalization of leisure that was the later phase of that history. And this dialectic means we must attend to at least two ways of understanding the subjective time experience Rainer discovered in her dance despite the stringencies of its standardized structure. While on the one hand the modulation of the dance's "insistent regularity"

in its actual performance signals the irruption of contingency, even subjectivity, within the ordering system, it suggests at the same time the sophisticated and functionally necessary way leisure industries deploy the rhythms of entertainment to mask, at the level of spectatorial experience, the standardization of their market in lived time.[51]

DISENGAGING ORDINARY MOVEMENT

The modular time of *Parts of Some Sextets* will recall, for anyone familiar with the visual art of Rainer's milieu, the compositional logic Donald Judd identified that same year: "the order is not rationalistic and underlying but is simply order, like that of continuity, one thing after another."[52] While we are very used to thinking about what "one thing after another" meant in terms of composition—the ways repetition and seriality challenged conventional ideas about the role of the artist, downplaying personal taste, intuitive decision-making, and corresponding models of expressiveness—we could do more to think what serial structure in 1960s art meant from the point of view of spectatorship. *Parts of Some Sextets* provides a clue, since Rainer turned to the modular, regular system in order to create a dance that was "completely visible at all times, *but also very difficult to follow and get involved with.*"[53] And this is precisely how Jill Johnston experienced the finished work: *Parts of Some Sextets,* she said, "was an ambitious and impressive work with a structural flaw that might be construed as a daring assault on the tolerance-attention of any audience."[54] The perceived flaw was the temporal systematicity of the dance, as we've seen. But why did Johnston read that structure as a challenge to attentiveness? One way to begin to understand this dimension of the work is to listen more carefully to *Parts of Some Sextets.*[55]

Rainer spent five weeks in November and December of 1964—five weeks of the crucial transitional period during which she began to develop her much-lauded mode of tasklike performance—in the New York Public Library. The object of her attention was not dance history, not aesthetics, neither histories of the avant-garde nor philosophies of the everyday. Rather she pored over the diary of William Bentley, D.D., the minister whose near-daily observations about

life in Salem, Massachusetts, between 1784 and 1819 had recently been reissued in a four-volume set.

On the face of it, Reverend Bentley would hardly have been less out of place in Rainer's work if he had appeared in it in person—all five-foot-five and two hundred pounds of him, in knee britches. Early Americana seldom comes to mind as a source of inspiration for the avant-garde of the later twentieth century. Yet Rainer, and thus her viewers, had a fairly sustained engagement with Bentley's diary in the mid 1960s. She first came across the text in September of 1963, when the *New York Times Book Review* ran a feature about the newly republished diary along with several brief excerpts.[56] Rainer recited one of these, Bentley's 1797 description of an elephant, during a solo dance called *At My Body's House* in early 1964. Returning to Bentley nearly a year later, she transcribed page after page from the diary, material she then read into a tape recorder. The forty-three-minute tape that resulted became the soundtrack of *Parts of Some Sextets*.

Bentley's diary was not a space for self-examination. Unlike the *Autobiography* of Benjamin Franklin, the author was not concerned to advise his reader; nor was he prone to moral reflection. Instead, the diary is a quotidian record of Bentley's activities and those of his parishioners. An entry on the price of salmon is followed by two entries on a trip to Newburyport for the laying of the cornerstone of a new church, after which comes a description of the manufacturing of nails.[57] The diary's question is not "what matters?" or "who am I?" but "what happened?" It tells us who died, what building burned, where Bentley strolled, with whom he ate, who came to him for counsel, who owed him money, to whom he owed. In Bentley's diary Rainer had a veritable catalog of the everyday.

The text corresponded beautifully with her new emphasis on the quotidian—on the "muscular dynamics of everyday life," in Kirby's phrase—as Johnston recognized when she wrote of *Parts of Some Sextets* that "dance and tape together, the work is a tour de force of factual information."[58] Each entry in Bentley's diary could be described in the terms Rainer had used to explain the appeal of lugging mattresses around on stage: "No stylization needed. It seemed to be so self-contained an act as to require no artistic tampering or justification."

Johnston even used a movement-oriented metaphor in describing Bentley's "pedestrian observations."[59]

In Sally Banes's many writings on the quotidian in dance of this period, an underlying argument has been that by leveling the refined and the humble, the recourse to the aesthetically ordinary by dancers like Rainer corresponds to an egalitarian ethic.[60] For Noël Carroll, in a slightly different way, to bring the ordinary into perception is also to revalorize it: the performance of truly everyday movement like jogging or of dance movement performed in an undramatic, tasklike style constitutes not merely a presentation but a *celebration* of what Rainer described in 1968 as the body's "actual weight, mass, and unenhanced physicality."[61] Here is Carroll in a recent article about Rainer, again with reference to the two "mattress pieces":

> instead of graceful airs, the viewer is invited to savor the intelligence of human bodies in action as the dancers negotiate moving a heavy and unwieldy object through space. Given this opportunity, framed as it was as a performance, one could only begin to marvel at the precision and subtlety, the bodily savoir faire of the human mechanism, which, once defamiliarized by Rainer, finally showed itself forth in a way that reminded us that these very amazements are everywhere around us in the everyday hustle and bustle of the world, where every street is, in effect, a concert hall.[62]

For Carroll, here, and often for Banes, the presentation of ordinary motion in 1960s art is a kind of recovery operation (his essay is titled "Yvonne Rainer and the Recuperation of Everyday Life"). In this model, the attention of the artist, and through her, the viewer, restores value to the overlooked.

While the opportunity "to savor the intelligence of human bodies in action" is a crucial aspect of Rainer's artistic project in the 1960s, it was one that she rarely offered without qualification. Whenever we begin to examine the work in depth, it becomes clear that however real and however valuable was the desire

simply to present the marvels of the human mechanism, this moving, working physicality-as-such appeared as a difficulty or problem for art in the 1960s. In *Parts of Some Sextets,* it had to do with the simultaneous desirability and impossibility of a task-oriented time sense in the mid 1960s. It also had to do with the type of attention Carroll assumes the viewer of *Parts of Some Sextets* gave to the working bodies it displayed. The idea is that by giving seemingly banal material the special frame of artistic re-presentation, its inherent interest was revealed to the viewer. But in *Parts of Some Sextets,* the seemingly banal thing is represented banal*ly,* to be met not with a wonder-filled spectatorship of revelation, but with a rather more sanguine kind of attention. Rainer stated with equanimity that she had made the dance as she had "at the risk of losing the audience before it was half over."[63] And Jill Johnston reported in the *Village Voice* that she had been to four performances of *Parts of Some Sextets,* "and the audience never failed to settle into a pall by the 30-minute mark if not sooner."[64]

For Carroll, the recuperative celebration of the everyday in *Parts of Some Sextets* and other works puts Rainer in a lineage that reaches through John Cage, whom we know to have been a direct and indirect inspiration for Rainer, to the celebration of the natural world underfoot in the poetry of Wordsworth and, especially, the nature writing of Ralph Waldo Emerson. Rainer's New England bard of choice was no Emerson, however. Here is the 1797 entry from Bentley's diary that first drew her to his writing:

> Went to the Market House to see the elephant. The crowd of spectators forbad me any but a general and superficial view of him. He was 6 feet 4 inches high. Of large Volume, his skin black, as tho lately oiled. A short hair was on every part, but not sufficient for covering. His tail hung 1/3 of his height, but without any long hairs at the end of it. His legs were still at command at the joints, but he could not be persuaded to lie down. The Keeper repeatedly mounted him but he resisted in shaking him off. Bread and hay were given him and he took bread out of the pockets of the spectators. He also

drank porter and drew the cork, conveying the liquor from his trunk into his throat. His Tusks were just to be seen beyond the flesh, and it was said had been broken. We say "his" because the Common language. It is a female and teats appeared just behind the forelegs.[65]

Bentley delivers the narrative elements in what is, after all, an account of an alcohol-drinking, rider-tossing, pocket-picking pachyderm in exactly the same choppy, declarative sentences as he does observations like the amount of hair it had and the color of the animal's skin. The whole description becomes, though not entirely unamusing, certainly "difficult to get involved with."

Johnston found the diary reading deadly boring, and critic Jack Anderson recalled it as "a droning recitation"[66]—even though Rainer had actually selected many of its most dramatic passages. Disfiguring cancers, deaths and births, elephants and sea serpents all popped up in her taped narration. Bentley's text, as I've said, is an inventory of the quotidian, but this is not to say of the dull: reports of deaths and illnesses are the diary's bread and butter, salted with experiences as simple as a long walk in the New England spring, or as spectacular as the elephant viewing that tickled Rainer's fancy. Yet what intrigued her was the detachment that nevertheless characterized his accounts. Bentley's diary is full of everyday wonders, but in his treatment, everything becomes less exalted, less marvelous, not more so. As the one literary critic to devote an essay to Bentley somewhat apologetically admits, "the quality of the objective style reduces all to a rather numb egalitarian presentation."[67] And here, of course, was precisely the source of the text's appeal to an avant-garde artist in the 1960s. Rainer told Jerry Tallmer in a *New York Post* article in 1966 that she was attracted to the diarist's "completely unemotional, unhysterical way of dealing with these situations, playing down calamity, not showing an attitude toward the subject matter."[68]

This was the new aesthetic Rainer was then helping to extract from the limitless range of activities characterizing art in early-1960s, avant-garde New York. How did one get from the anything-goes inclusiveness of Judson dance, the overall overkill of collagist Happenings, or the naughty and poetic play of Fluxus, to what we recognize now as minimalism? The Reverend Bentley may

seem an odd source, but to Rainer, the minister's detachment "seems to be a part of a lot of what I've observed the past five years or so in the arts."[69] Here, of course, Rainer was referring to the much-discussed retreat from expressionism and personality in pop and what would come to be called minimalism, but also to that in her own work and the work of her peers in dance. A significant element in the heterogeneous mix of approaches to movement performance at Judson had been the exploration of a range of affective styles—from the exaggeratedly theatrical (Rainer threw a hysterical screaming fit in *Three Seascapes*) to an increasingly prevalent mode sometimes called the "Judson stoneface"—an inward, almost glazed look that was an alternative to the convention of theatrical "projection."[70] This disengaged self-presentation is of course reminiscent of Andy Warhol's carefully produced persona, and indeed what Rainer found in Bentley's text is strikingly similar to the modes then available in both contemporary art and its surrounding theater of artistic self-presentation. In the diary, the effect that Rainer called "deadpan" (using a Judson-associated term) is produced through emotionless description, of course, but also through a structure of repetition and parataxis. By placing one thing after another without making emotional connections, Bentley helped Rainer recognize the nonexpressive tendency in the art of her milieu that she would pull out and develop in *Parts of Some Sextets*. Moreover, his diary seems to have helped her create a specific *attentive* structure for her work: a spectatorship neither of pleasure nor of revulsion, but of noninvolvement.

If we cherish the model of recuperative attention—attention given to the pedestrian and ordinary in order to restore or reveal its value—we must also accept the effort to hedge any such investment. There is one particular strategy in *Parts of Some Sextets* that illuminates its work with spectatorial attention. In the full-stage Wadsworth photograph, the dark margins surrounding the bright stage funnel attention into the performance area, a photographic effect replicating the conventional condition for theatrical performance—darkened house, illuminated stage. As historians of theater explain, this format was an invention of the later nineteenth century and is particularly associated with Richard Wagner, who darkened the house as part of his effort to create an experience

of intense, collective absorption with the spectacle onstage. What Moore's photograph doesn't show is how Rainer foiled this lingering legacy. At intervals throughout *Parts of Some Sextets* the house lights were turned up, then down, then up again. The effect would have been to open up, restore, and widen again the audience's focus. Think of Bentley and his elephant, and the crowd that "forbad" him "any but a general and superficial view." Or listen to Rainer describing the period she spent working in Germany leading up to *Parts of Some Sextets,* when she was struggling to develop an alternative to the "goofy glamour" of her earlier work: "I went every day to a tiny 6th-floor walk-up ballet studio in the Altstadt; I could see the Rhine beyond the old roof-tops. One day there was a fire in the next block. Much smoke and scurrying around. I felt like a cuckoo in a Swiss clock observing an intricate mechanized toy go thru its paces. All those little firemen and townsfolk seemed wound up. And in the distance that flat river and green-washed Rhinemeadow. The whole scene was decidedly depressing."[71] Her image of the street scene as "an intricate mechanized toy" and of the whole thing imagined specifically as clockwork (with herself as the cuckoo—observer, but also announcer of intervals) recalls both Johnston's description of *Parts of Some Sextets* appearing as if "it was happening in a large experimental cage for conditioned responses," and the dance's structure by clock time. But Rainer's image of herself watching with disengagement the complex, coordinated human activity outside the studio window is also an alternative model for the mode of spectatorship involved in ordinary movement performance like her own. Neither an enlightening Buddhist disinterest, nor an energizing Brechtian alienation, this noninvolvement is a strangely mechanical way of watching.

DURATION OF STOPS

Nothing could contrast more clearly with Rainer's desultory view of Düsseldorf than the urban spectatorial experience described by Jill Johnston in the opening of her essay on *Parts of Some Sextets.* In midtown Manhattan, having forgotten that it was St. Patrick's Day, the critic stumbled upon a parade. She

walked delightedly alongside the bagpipers for a block, then "ran back to the subway entrance" before the procession of "a group of nurses or old veterans or something" diminished the pleasure of the experience. She then jumps to a description of riding the subway: "I often glance around fast at the people in my half of the car to position myself with respect to whomever I think will best sustain my interest for the duration of stops."[72]

There is something cinematic about these descriptions, perhaps because of the linear, sequential nature of the two experiences that Johnston chooses—parade and subway—but due also to her emphasis on rapidity: *running* away from the parade after her favorite section had passed, looking around *fast* to pick someone to watch on the subway. To keep herself interested and engaged, she effectively created jump cuts between experiences, evoking herself as an editor of city life, selecting and splicing interesting clips of the human spectacle and leaving the rest on the cutting room floor.

Compare this with Johnston's description of the spectatorial experience provided by *Parts of Some Sextets:*

> At some point the success of the dance considered from any norm of desire for the maintenance of tension with a certain time span (how much of what? and how long?) was out of the question. Just so the tape. How long would you listen to the Reverend Bentley's pedestrian observations before you flaked out or began to daydream or excused yourself or told the good man to take a powder? On the other hand, why not, and why not look at the interior decoration which is a polka-dot expanse outside important trips from bed to icebox? Existentially, why not anything? Nothing matters, not too much anyway, because everything matters, equally. I can tell you how and when my bed or my icebox is more important to me than my wallpaper, and I can tell you how I might love my wallpaper if it were better looking, and I can imagine how important wallpaper must be to those who manufacture it, and I could go on and on about the personal nature of entertainment, but I'll agree with

anyone who tells me that the diary of an obscure minister is just as momentous as the diary of another obscure minister.[73]

Johnston's mobile, speedy transfer between entertaining images on street and subway is just the opposite of the experience she felt *Parts of Some Sextets* provided: instead of quickly cutting between interesting elements (bed, icebox), the dance lingered on the banality in between (wallpaper). Similarly, she complained that the loud volume at which Rainer played Bentley's "drone of dry facts" did not allow her to "tune in when I felt like it."[74] Thus, the dance's investment in "factual information"—in the quotidian—is figured, in its contrast with Johnston's own brisk editing of urban experience, as a "curious slack in its structure."[75]

The idea that what was missing from *Parts of Some Sextets* was the *edit* is reminiscent of film scholars' accounts of the move early in the history of film from "actualities," or short depictions of single events (like the Lumière brothers' famous image of workers leaving a factory), to narratives produced through montage. Although in fact most actualities are more edited than they first appear, the impression they foster is that the time of the film is the real time of the contingent event. In essence, actualities are task-oriented—things take the time it takes to do them—as opposed to the radically synthetic time of later cinematic narrative. For Doane, the move toward the latter mode reflects a need to manage the anxiety that the contingent—however attractive as the figure of antisystematicity—produces in modern thought about time. Synthetic, edited cinematic time was a way of ameliorating the worry produced by photography and the photographic element of film—the fear of the blizzard of images these continuous, inclusive representational technologies could produce.[76] And this is the very fear that Johnston reiterated in 1965 when she complained that in *Parts of Some Sextets*, "Nothing matters, not too much anyway, because everything matters, equally."

The attentional structure of *Parts of Some Sextets* depends on this: that though full of cuts, it was without montage. Its regular breaks only brought the viewer back to more of the same. Its principles were interruption—movements

cut off on the thirty-second cue—and repetition—the same movement recurring, time and again, on different bodies. Rainer explained that the effect was "a 'chunky' continuity, repetition making the eye jump back and forth in time," with interruption precluding "prolonged engagement with any one image."[77] *Parts of Some Sextets* did not flow, but neither did it leap. It had no correlate for the editorial process that allows film to go beyond the "real time" of the moving bodies or scenes it depicts, but it did stack those actualities together in a sequence. Not surprisingly, when Rainer began experimenting with film a year or so after *Parts of Some Sextets,* she recapitulated this logic in *Volleyball* (1967), a sequence of shots of the corner of a room. A ball rolls slowly into the frame, tracked by the camera. Someone, visible from the knees down, walks up to the ball and lets it hit her feet. When the ball comes to a stop, the camera cuts to another image of the corner, with the ball reentering the frame. Many shots, many cuts, much stopping, but no leaping, no splicing, no connecting—and no narrative, no relationship, no meaning. As Johnston noted, the athletic theme of *Volleyball* contrasted the idea of "goal" with the ball's specifically aimless travels.[78] Just so *Parts of Some Sextets,* which for all its variety and intricacy had a similar structure: it was built on continuous stopping.

EADWEARD MUYBRIDGE, CHOREOGRAPHER

In this, *Parts of Some Sextets* was less cinematic than chronophotographic. One way to view the Judson dance in which Rainer's work was so central is as a collective attempt to work through an inherent aspect of dance performance that seems to have become rather suddenly problematic: the difficulty of seeing and understanding an ephemeral art that moved through time. While this was rarely their declared intention, it is striking how often Judson choreographers either made movement more difficult to see—by dancing in the dark, for instance—or made it *too* visible—stretching it out in slow motion or stilling it in virtual photographs or ready-made memory images.

This latter tendency, to resist ephemerality with strategies of slowing or stoppage, is strikingly reminiscent of attempts nearly a century earlier to expose

the motion of bodies in time. Take, for example, Judith Dunn's Judson-era dance *Acapulco,* a slow-motion depiction of a woman approaching a seated girl to brush her hair. In its subject matter, its eroticism, and, crucially, its aim of presenting to vision a movement event in more detail than one could normally take in, this dance could be taken right out of Eadweard Muybridge's late-nineteenth-century studies of "human locomotion." Indeed, for artists working on untheatricalized or tasklike motion in the 1960s Muybridge was an important referent. Simone Forti has said that her dance *Huddle,* a prime example of task-based 1960s performance, was inspired by his human locomotion studies (figure 2.7).[79] First presented at Yoko Ono's loft in 1961, *Huddle* is what Forti termed a "dance construction," based on a task rather than a choreographed sequence. It begins with a group of half a dozen performers facing inward in a cluster, arms wrapped around one another's waists or shoulders. One at a time, a performer separates from the group just enough to begin to scale the bodies of her fellows, climbing up and over the clump. The effect is of the mass slowly seething, the cluster constantly involuting. Forti recalls that at the time she made the dance she was particularly moved by the Muybridge series showing a man chopping wood, in which the images reveal each successive phase of the motion from the raised arm to the reverberation of the axe in the final frame. Struck by the effect of being able to see exactly how the body performs such an action, she thought of *Huddle* as a dance "where you can see people climb."[80] This revelation of the inspiration for *Huddle* allows us to view it in a new way. Rather than focusing on the dancers' experience—their freedom from imposed choreography, their physical intelligence as they figure out the surfaces and weights of the body, their modeling of an interactive social unit—we can approach the piece, as Forti seems to, from the spectator's point of view. Despite the inward orientation of its cluster of performers and the tangled, roiling effect of the human structure it produces, *Huddle* offers moving bodies to perception as surely as did Muybridge's orderly arrays.

A 1955 Dover edition of Muybridge's photographs of human locomotion was reprinted and available throughout the 1960s. Rainer remembers having had a copy.[81] Paxton, we've seen, found inspiration in these images and created

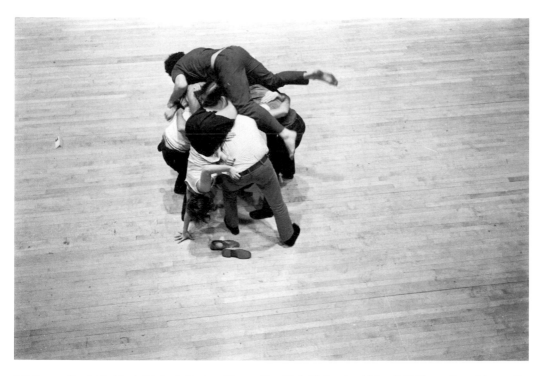

2.7 Simone Forti, *Huddle,* 1961. Loeb Student Center, New York University, 4 May 1969. Photo: Peter Moore. ©
Estate of Peter Moore/VAGA, New York, NY.

a movement version of their effects in *Proxy*. In the mid 1950s, Sol LeWitt famously found a Muybridge book left behind by the former tenant of his apartment; he claimed that this happenstance led to the discovery of the serial method that would come to characterize his work, and that of so many others, for thirty years or more.[82] A major, well-illustrated article on Muybridge and other nineteenth-century experimenters in time-motion imaging was published in *Art Quarterly* in 1963.[83] And between 1961 and 1974—bracketing the years of Rainer's performance career—Muybridge appeared as an influence, subject, or reference in the work of Mel Bochner, LeWitt, Robert Morris, Elaine Sturtevant, and Hollis Frampton, as well as in that of Rainer's onetime studio-mate Forti, her collaborator Paxton, and Rainer herself (figure 2.8).[84]

Recall here the 1963 piece *Room Service* that was a source for Rainer's elaboration of ordinary movement performance in *Parts of Some Sextets*. As we've seen, it was based on a follow-the-leader structure, in which one dancer improvised and two others trailed behind, trying to replicate her actions, and producing an afterimage effect for the viewer of the dance. In photographs, this effect becomes distinctly chronophotographic: three staggered figures demonstrating three successive phases of a movement (fig. 1.6). Something similar occurs in the full-stage image of *Parts of Some Sextets* by Peter Moore, in which the lateral spread and depiction of a range of human bodies in action are vaguely Muybridgean. The cluster at the left, three figures in slightly different versions of the same position, is even more so (and it doesn't hurt that Rainer's mattresses are dead ringers for those Muybridge put to use in the 1880s). In fact, insofar as Muybridge was involved in staging a vast range of human activity specifically to expose "the muscular dynamics of everyday life," he can come to seem a postmodern choreographer *avant la lettre*.[85]

As with Forti's *Huddle,* Rainer's impulse in *Room Service* to make unstylized physical activity more than usually visible links this example of ordinary movement performance of the 1960s with the nineteenth-century photographic precedent. But Forti's knot of constantly moving and collaboratively improvising bodies suggests an investment in notions of continuity that does not seem part of Rainer's experiment. Whereas Forti's live movement restored flow to

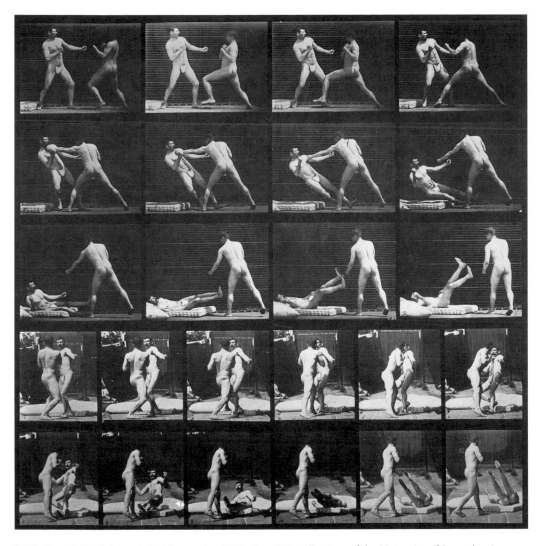

2.8 Eadweard Muybridge, *Animal Locomotion,* 1887, plate 333. Collections of the University of Pennsylvania Archives.

Muybridge's series of stops, Rainer's version imported the Muybridgean stutter into the flow of live performance. While each dancer in *Room Service* moved continuously, they spread the improvised action across three bodies. They drew it out into space and lagged it in time in a manner distinctly chronophotographic, adding spatialized repetition and variation into the moving image.

"You will always experience the disappointment," wrote Henri Bergson in 1907, "of the child who tries by clapping his hands together to crush the smoke."[86] With this image the philosopher expressed his disagreement with what he called the "cinematographical" habit of mind, in which we think of time as if it were a series of individual moments and of movement as a series of positions. His concept of duration, or true time—that fleeting smoke—was specifically opposed to the temporality embedded in the relatively new technology of cinema, made visible for him in the late-nineteenth-century chronophotography of his contemporary and colleague at the Collège de France, Étienne-Jules Marey, and Marey's Anglo-American counterpart, Muybridge. As these serial images of movement divided time into a sequence of still images, they epitomized for Bergson modernity's relentless transformation of experiential, integrated flow, or *durée,* into the spatialized time of measurement and timekeeping.[87] The philosopher's chief example of the transformation from a classical experience of time to the rationalized temporality of his own day was his contrast between the artful representation of motion in the marble horses of the Parthenon frieze and the analytic array of the famous, then-novel horse photographs of Marey and Muybridge, in which he saw the historical loss of an experience of duration and flux. While both are static representations of motion and thus, to Bergson, philosophically incorrect, Phidias's creation condenses an entire motion into one enormously significant moment, representative of the whole. The chronophotographs, on the other hand, replace duration and flow with positivist, quantified abstraction.[88] It is, then, to Muybridge's still, spatialized images of movement that Gilles Deleuze refers when he identifies a modern, scientific worldview characterized by motion understood as "immanent material elements" and the analytic mode he calls "any-instant-whatever."[89] "Any-instant-whatever" thinking conceives time as the unidirectional, mechanical succession

of instants: the very model of time we have seen *Parts of Some Sextets* both engage and evade.

A technological innovation in imaging based on imposing homogeneity and order, Muybridge's process was inescapably intertwined with social developments of the turn of the century. It is well known that his analyses of movement were crucial to the studies of laborers' motion by engineer F. W. Taylor and later to Frank B. Gilbraith, who used chronophotography to break down and streamline the motions of industrial tasks. Jonathan Crary further argues that Muybridge's project, which was tied to industrial capitalism through the patronage of California railroad magnate Leland Stanford, also coincided with its directives at another level. For, as Stanford's railroad fortune attested, capitalism of the late nineteenth century was premised on the increasing speed at which goods could move and information travel. Muybridge's segmented presentation of motion enabled, or produced, a visual experience uprooted from stabilities of both space and time. In viewing a Muybridge sequence, we are able to see a whole movement in a glance, on a single page (reminiscent, perhaps, of the detached, overall type of visuality Rainer evokes with the memory of her Düsseldorf window view during the making of *Parts*). Sometimes we see the movement from two points of view simultaneously, and we always see each frame from a hovering viewpoint that remains at a fixed angle and distance from the figure even as he or she travels, and that is thus freed of such material inconveniences as an embodied point of view. Crary perhaps presses the point, but certainly captures this aspect of the innovation, when he claims that Muybridge's work "announces a vision compatible with the smooth surfaces of a global marketplace and its new pathways of exchange."[90]

However, Crary dares to counter all the implications of Muybridge's project for an increasingly dominating capitalism by invoking the photographs' quasi-liberatory potential. The same dispersal, objectification, and condensation of space and time that could so efficiently pave the way for capital could also operate otherwise: as chronophotography disrupted the continuity of time and disintegrated the autonomous image, "it posed plural scatterings of attention and the possibility of unforeseen perceptual syntheses outside of any disciplinary imperatives."[91]

Crary does not provide examples of such liberating applications of the images in Muybridge's own time; certainly such counterdisciplinary, experiential usages are by their nature all but impossible to trace. They may also be deferred in Crary's account because the Muybridge he proposes—one whose images open up, within an orderly, regularized form, opportunities for antidisciplinary modes of perception—may well belong less to the 1890s than to the 1960s.

To Dan Graham, for instance. In his magazine piece "Muybridge Moments," which appeared in *Arts* in 1967 and featured a Muybridge photograph sequence of a woman on a ramp, the artist stresses the discontinuity of the photographer's sequences.[92] "Things are separated from other things," he writes. And, echoing Judd describing an emerging minimal art circa 1965 and Johnston on *Parts of Some Sextets* and the Bentley diary, "no thing is more important than any other thing." Graham does not emphasize the detailed representation of *motion* that made Muybridge photos so exciting and so useful in the 1890s, but rather a quality of *suspension* that seems to have been their attraction in the 1960s. He stresses the futility of the tasks—that bucket of water will slake no one's thirst—over the usefulness of the images: "The model isn't going anywhere. Her task isn't completed—no work is done." And, perhaps most interestingly, he finds in Muybridge's stuttering sequences a striking alternative to the idea of temporal flow. He writes that in these images "things don't 'happen'; they merely replace themselves in space."

These issues had been played out in the realm of performance a few years earlier, with Robert Morris's 1964 *Waterman Switch.* The most famous image of this performance is of Morris and Rainer inching along two long tracks in tiny steps, face-to-face, clutching each other, naked (figure 2.9). This sequence was only part of the dance, however.[93] Much of the rest of the performance was a kind of geological ode—Styrofoam boulders, recordings of the sound of rocks bouncing, a taped reading of Leonardo's notes on erosion, and finally a series of slides of a man lifting a stone and throwing it (figure 2.10). These last images were studies of human motion made by Muybridge, whom Morris also evoked in the running sequence of his 1965 dance piece *Check,* in which a performer was illuminated by a strobe light because "it gives a static image."[94]

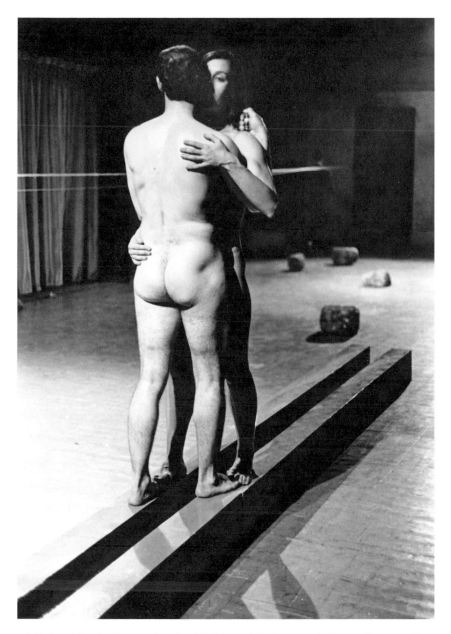

2.9 Robert Morris, *Waterman Switch,* 1964. Pictured: Robert Morris, Yvonne Rainer. Judson Memorial Church, 25 March 1965. Photo: Peter Moore. © Estate of Peter Moore/VAGA, New York, NY.

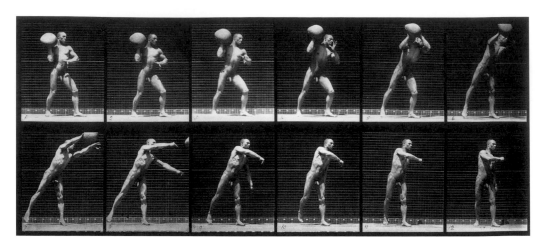

2.10 Eadweard Muybridge, *Animal Locomotion,* 1887, plate 311. Collections of the University of Pennsylvania Archives.

One of the most salient aspects of *Waterman Switch* was its play with time; with anticipation and recollection. Early in the piece, as Morris ran in circles, the audience heard a tape recording of his voice: "I hope eventually to have slides made of this dance. Perhaps if anyone is photographing now they will let me know later. I will then show the slides of this section, for example, near the beginning . . . " and so on. In prompting the viewer to imagine future documentation of the present event, the text splices a new temporality—the future pastness of the dance—into the performance. It reminds us that such time was likely *always* on the fringe of audience and performer awareness, with photographers like Peter Moore and Al Giese working to document avant-garde dance and performance in the 1960s (or artists like Acconci or Paxton taking up cameras themselves within performances). What André Lepecki calls the "documental urge" in dance history and theory was practically and experientially enacted at performances in this period—so much so that Don McDonagh remarked that "avant-garde dancers would rather be seen nude—and often are—than be caught without their avant-garde cameraman in dutiful attendance."[95] In his discussion within the dance of the future use of slides of *Waterman Switch,* Morris both acknowledged this documental impulse and performed its complication of performance time. On tape, he discussed an entire future version of the performance—both sections that had occurred when the tape was played and those that were to follow—and how it would look with the added presence of photographs not yet taken. When the stage darkened and the Muybridge slides appeared, then, they both fulfilled a prophecy of what would be and rolled time back toward a historical precedent.

Like Morris's earlier, self-descriptive *Box with the Sound of Its Own Making,* this performance is dedicated to relays between perceptual present and past, or displacement of the present into other registers of time. Simple linear temporality—like that path of the figures on the tracks—seems as perpetually and perceptually impossible as the mythic hermaphroditic union. Indeed, the dual figure of Morris and Rainer clapped together as they inched along the tracks, making a "beast with two backs" (which is to say, no front), might be an image of just the reversibility or lack of directionality that the performance as a whole

imputes to time, and that the Muybridge images, despite themselves, make visual. Jill Johnston reported: "At the end of the sequence [of Muybridge slides] the nude Morris appeared for an instant against the white rectangle of a 'blank,' moving across it holding a rock aloft—illustrating the slides which illustrated him."[96] Again, the Muybridge sequences figure as representations not of movement in time, but of a stuttering suspension. One thinks of Sisyphus and his boulder, of purposeless labor and loops of repetition; one thinks of Pamela Lee's evocation of the problem of endlessness in art of the 1960s, particularly her argument that the belaboring of the present in Andy Warhol's films and On Kawara's practice constitutes a critical comment on the discourse of futurity in the 1960s.[97] And this in turn is crucial for understanding the appeal of the chronophotographic in this period.

Rainer had written of *Parts of Some Sextets* that she was interested in the "effect of nothing happening," as if, like Graham two years later, she wanted to replace *happening*—with all that word's links to the recent history of performance art—with something more hesitant.[98] Recall that Johnston criticized the dance's *static* time structure. Not surprisingly then, it was in terms of thwarted progress that Rainer described *Parts of Some Sextets*' effect: "the dance 'went nowhere,' did not develop, progressed as though on a treadmill or like a 10-ton-truck stuck on a hill: it shifts gears, groans, sweats, farts, but doesn't move an inch."[99] Muybridge's images may be, as Crary proposes, the visual correlate of capitalism's accelerating economics of transport. Rainer's stalled and sputtering truck, then, is a powerful counterimage: efficiency ground to a halt.[100]

This image of the broken-down machine helps to explain the odd historical synapse by which nineteenth-century modes for representation of time and movement—and with them, seemingly industrial-age concerns like the spatialization and rationalization of time—gained currency among advanced artists in the 1960s. It suggests that chronophotography, the model of time it made visible, and even, therefore, the temporal structure of *Parts of Some Sextets* all had value for mid-1960s artists less because of their link to the structures of temporality in modernity *than because of their obsolescence in late or postmodernity*. Lee demonstrates how "the rise of the Information Age and its emphasis on speed and accelerated

models of communication serve as the cultural index against which many artists and critics gestured" in their work of the 1960s.[101] The mechanical model of temporal representation was of interest because of its resistance to—rather than, as Crary's model suggests, its prefiguring of—the smooth and instantaneous systems of later, global capitalism. Similarly, and relatedly, Rainer's interest in noninvolvement might be understood as a counterposition to that of Marshall McLuhan (to whose techno-utopianism she was always allergic).[102] For to him the characteristic spectatorial experience of the electric age was that typical of television: involvement in depth.[103]

An early draft of her well-known essay on *Parts of Some Sextets* includes a section in which Rainer promises to describe "an area of concern ... [that] might be called 'nothing happens.'" What follows, though, is a paragraph dealing not with what does or doesn't happen on the stage—not with the lateral axis of Muybridge's images—but with what occurs along the axis between audience and performer:

> Theatre is still based on—& people still go to the theatre with—the old Aristotelean notions. If not actual catharsis or purging thru fear and terror, it is a "losing of oneself" that one is supposed to experience. One judges a theatrical event according to the degree to which one became "involved" with it. Yes I know all about Brecht & "alienation" & Ionesco & the absurdities & how they have supposedly changed all that. But it just ain't so. Theatre is as concerned as it ever was with magic, transformations, transcendencies, if not outright ascendancies and various & sundrie [*sic*] forms of seduction to assure the "drawing in" of the spectator. I am not opposed to seduction. It can be a source of sport & pleasure & enlightenment. I am simply wondering out loud if there is not another alternative that has not been attempted.[104]

In this passage, the question of what "doesn't happen" shifts. What is stopped—quasi-photographically arrested—is not so much the dance flowing forward in

time, as the viewer being "drawn into" its spectacle. Although Rainer did not include this passage in the final version of her essay, the evidence of *Parts of Some Sextets* suggests it was worth the risk of coming off as a behaviorist or a drill instructor—worth even unleashing the period anxiety about standardized and rationalized leisure time—to break up continuity, because with continuity went models of continuous, synchronic involvement.

WHAT WE'RE AFTER

In 1968, Peter Moore took a photograph of a section of Rainer's piece *Performance Demonstration* (figure 2.11). Like many of his other photographs of Rainer's work, and like the image of *Parts of Some Sextets* with which I began, it shows clusters of individuals in street clothes, absorbed in their idiosyncratic actions. Like the first image, it gives us a luminous stage in a darkened space, here with the lower edge scalloped by the silhouetted heads of front-row viewers, securing even more firmly our sense that, as Argelander would wish it, the image "captur[es] as much of the total visual experience of an actual performance as possible and get[s] it from the point of view of the audience."

In time, however, we notice certain details of the photograph. The murky shadows dividing the sets of performers. The way the floor, on closer inspection, seems to recede to separate vanishing points behind each of the three staircases. And, finally, among the similarly round, shadowed shapes of the audience members' heads, those forms—so unmistakable, if now nostalgic, to the art historical eye—of three carousel-bearing slide projectors. In lieu of a live performance on stairs, we come to see, we have a trio of photographs on slides. Rather than nine moving dancers stilled in one photographed moment, three photographed performers have been thrice frozen. The image is not of live performers at all, but of projected photographs.

This image takes time. It unfolds temporally, in the sense that it takes a moment to recognize its trompe l'oeil. And it simultaneously extends the time pictured within the frame, for with our recognition of images within the image, the single depicted moment unfolds, as if it had been pleated, to display

2.11 Yvonne Rainer, *Performance Demonstration,* 1968. Library of the Performing Arts, New York, 16 September 1968. Photo: Peter Moore. © Estate of Peter Moore/VAGA, New York, NY.

three separate instants of a dance. Like the photograph of *Parts of Some Sextets* with which I began, in this image photographic instantaneity and indexicality are matched to the contingency of situated, ephemeral performance so that the image opens into the poetics of the live, of being there. At the same time this image, like the other, does a bit more than a purely instantaneous photo ought to do to meet the demand for a total and systematic record of the resistant, contingent event. What looks like performance documentation oriented toward the live moment of viewing turns out also to open onto the practice of performance documentation itself.

The photographs projected during *Performance Demonstration* show a dance called *Stairs,* a section of the final, 1968 version of *The Mind Is a Muscle* involving a series of repetitive but inventive interactions between three performers, a short, moveable staircase, and a sheet of foam. *Stairs* was not performed live in *Performance Demonstration;* only a sequence of photographs, specially shot by Peter Moore at Rainer's request and projected three-by-three, inserted it into the performance. With their midrange focus, their black-and-white film stock, and their neutral point of view, the images are typical of Moore's deadpan or workmanlike images of dance, demonstrating the minimization of interpretive framing that endeared his work to Argelander. They go even further than most of his photographs, however, toward the elimination of the photographer's personal taste. Not only spatial but *temporal* selection were eliminated from their production, per Rainer's instructions. In asking Moore to take this series of images, the choreographer replaced the photographer's search for the telling moment with an assigned task: one image every few seconds, which Moore accomplished by motorizing the shutter of his camera.[105] It clicked at preset intervals, an ideal of indifference, snapping whether the performers were gloriously midair, blandly midstep, or awkwardly mid-butt bump. Further stripping away aesthetic taste from the documentary project, Rainer gave up her own "director's cut." Whereas most of Moore's contact sheets are marked in wax pencil with his or the artist's selection of images, the sheets of *Stairs* images are untouched. This is because Rainer kept every image from the shoot, later presenting the entire series, in sequence, as the slide show that constituted the

section of *Performance Demonstration* documented by the tripartite photograph. As in the system for the making of *Parts of Some Sextets,* chance meets totalizing structure. Distinctly chronophotographic, the images that Rainer, in a notebook entry, referred to as her "Muybridge slides" bring together the temporal management of tasklike performance and that of performance documentation (figure 2.12).[106]

Moore's full-stage 1965 photograph of *Parts of Some Sextets* manages time better than it should because the dance was about such management. By 1968, the management becomes explicit, but also more ambiguous. While Rainer and Moore used a mechanized timer to photograph *Stairs,* it wasn't a rapid-fire mechanism, and so there's something strange about the intervals between the shots. One-one thousand, two-one-thousand: a lot happens in a few seconds of a dance. Not surprisingly, the image of the projected *Stairs* slides is like a poem that scans but does not make sense. Even looking carefully at the details of hair and clothing, it is difficult to be sure that the figure who hops off the staircase in the image on the left is the same person who comes around it in the central image; is the dancer who approaches the two seated performers in the rightmost image the same as the walking figure in the central picture? It is possible that entire rounds of the game have fallen between the three sequential, but temporally separated images; fallen into a gap given visual form in the image by that cloudy darkness between the photographs—that smoke, Bergson might say. The Muybridgean visual method, tied to an epistemology of certitude, here becomes a means for manufacturing doubt.[107]

Interestingly, there is also some uncertainty about how long the interval actually was between images. In her 1974 book *Work 1961–73,* Rainer says it was twenty seconds. Reviewing the Moore contact sheets more recently, however, she began to doubt that twenty-second figure—it seems that there might be an error in her book, and she now thinks the interval between images could have been as short as five seconds, or even two.[108] The fact that the pictures were taken at regular intervals but that the interval is all but impossible to reconstruct is exactly to the point. Imprecision is imprinted in the photographic record— or, rather, haunts the spaces between its images. Such uncertainty irrupting in

2.12 Eadweard Muybridge, *Animal Locomotion,* 1887, plate 103. Collections of the University of Pennsylvania Archives.

the most totalized, systematic documentation possible is reminiscent of the way Muybridge's work has recently been figured in research that highlights the often unscientific manipulation of images in his sequences.[109] But in the current context it recalls nothing so much as *Parts of Some Sextets* itself—whose title, after all, is both inaccurate (there were ten rather than six dancers) and suggestive of a resistance to totalization (of what are the presented activities *parts*?).

The sequence of *Stairs* slides and the photograph of their projection in *Performance Demonstration* intervene in both performance and performance photography—and, in retrospect, in performance history as well. For across its images, through Muybridge, butt-bumping from moment to moment and leaping back, these images playfully thwart one driving and one enabling assumption in the kind of discussion of performance and its documentation seen earlier, with Argelander. Revealed as a photograph of photographs, rather than of live dancers, the Moore image of slide projections tweaks the presumption that performance's ephemerality and contingency are the qualities we ought to be after, when we approach performance after the fact. Then, as with its gaps and missing moments the project fails to testify as a systematic record of a movement event, it upsets the matching fiction that photographs of performance offer access to the events they represent.

The venue of *Performance Demonstration,* and thus the setting for this remarkable image of images, was a stage at New York's Library of the Performing Arts. I think it is no accident that this demonstration of some of the complexities of performance time and representation took place there. Where else to slip performance away from its present tense and reveal it split and suspended—and where else, at the same time, to demonstrate the resistance of the live to the need to manage it—than in an archive of performance, a library dedicated to the temporally tangled activity of preserving for now the live art of what-has-been; a space for the paradox of embodied, contingent experience, ordered, archived, and preserved.

MEDIATING *TRIO A*

For one to whom the real world becomes real images, mere images
are transformed into real beings—tangible figments which are the
efficient motor of trancelike behavior.

—*Guy Debord,* The Society of the Spectacle

Approached through its photographs, Yvonne Rainer's *Trio A* is a spectacular
dance. While in some previously unpublished images the dancing body appears
in ungainly positions (see figure I.2), most published period photos give us *Trio
A* as a dance of physical expansiveness, of dramatic and athletic display (figures
3.1, 3.2, 3.3).[1] Though these photographs are spare and gray, though they de-
pict the bare stages and street clothes that signaled Rainer's departure from the
conventions of theatrical dance, the muted images are animated by her perform-
ers' articulate bodies. Dancers stretch their spread-eagled figures. They lean into
graceful arabesques. They trace dynamic shapes across their pictorial fields, so
that even when they hold themselves with less than balletic poise, the performers
are stilled in moments of physical drama.

This is the case even though nothing could be further from Rainer's de-
clared interest in the 1960s than images of spectacular dance effects. "NO to

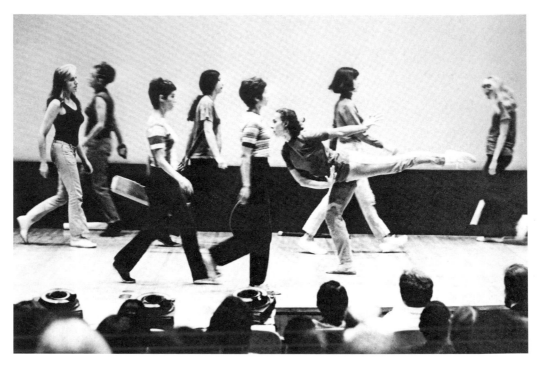

3.1 Yvonne Rainer, *Trio A,* 1966, in *Performance Demonstration.* While a group of people walks across the stage, Rainer, outside the frame, teaches Becky Arnold the dance. Library of the Performing Arts, New York, 16 September 1968. Photo: Peter Moore. © Estate of Peter Moore/VAGA, New York, NY.

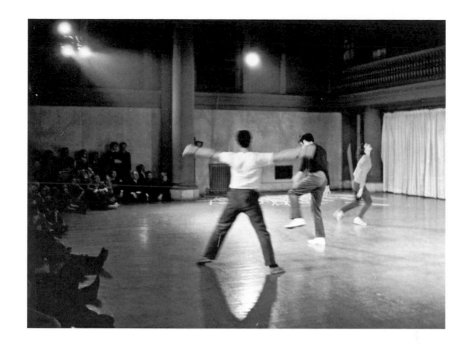

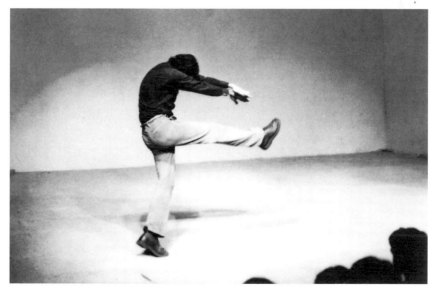

3.2 Yvonne Rainer, *Trio A (The Mind Is a Muscle, Part I)*, 1966. Debut performance, Judson Memorial Church, New York, 10 January 1966. Pictured: Steve Paxton, David Gordon, Yvonne Rainer. Photo: Peter Moore. © Estate of Peter Moore/VAGA, New York, NY.

3.3 Yvonne Rainer, *Trio A*, 1966. Performed by John Erdman in Rainer's *This Is the Story of a Woman Who . . .*, 1973. Photo attributed to Babette Mangolte. Research Library, The Getty Research Institute, Los Angeles (2006.M24).

spectacle no to virtuosity no to transformations and magic and make-believe
. . ." she famously proclaimed in 1965, in the wake of her work on *Parts of Some
Sextets* and during the period of *Trio A*'s invention.[2] An accordingly antispec-
tacular impulse characterizes the film of *Trio A* that dance historian Sally Banes
produced more than a decade later, in which a stationary camera frames a bare
space where Rainer performs at a deliberate pace and with quiet concentra-
tion.[3] *Trio A* chugs along like a well-running, if slightly quirky machine. The
movement is inventive—body parts seem to move out of sync, like separately
functioning mechanisms—but there are no special effects, kinetic or emotional.
Instead, a rocking, tick-tock motion permeates the dance. Arms rotate in their
sockets; feet tap out neat, rhythmic circles; a half turn to the right is tidily undone
by a rotation to the left. These back-and-forth movements within *Trio A* become
metonymic for the work as a whole. A danced summation of 1960s aesthetics, it
beats on, funky but determined clockwork.

The dance's refusal to dazzle has always been key to its reception. Critics
at the time of its debut described this brief dance as "a blissfully boring dance
number" and "a sort of boring continuum," with one reviewer going so far as to
single it out as "possibly the most stultifying dance I have ever seen." Even an en-
thusiastic Jill Johnston likened *Trio A* to "woolen underwear."[4] While witnesses
of the original performances of *Trio A* remember the excitement that attended
Rainer's new choreography, and though plenty of viewers (myself included)
find even the filmed version of *Trio A* fascinating and strangely beautiful, there is
some justice in Johnston's image. The dance was both serviceable and scratchy—
utilitarian in feel and for this, irritating to traditional sensibilities. Indeed, *Trio A*'s
frustration of expectations has been key for the scholars who have been in ac-
cord in identifying the work as a crux in dance history. Mark Franko proposes
that a negation of prior theatrical dance is basic to its very structure, which he
thinks of as "the formalization of negated options as a procedure."[5] Banes says
that *Trio A* goes beyond any previous choreography in proposing that "dance is
neither perfection of technique nor of expression, but quite something else—
the presence of objects in themselves. It is not simply a new style of dance, but a
new meaning and function, a new definition of dance, that has appeared."[6]

Nevertheless, fixed within those plain photographs, those bodies so elegantly extended and poised: might they not so much misrepresent a woolly, difficult, antispectacular *Trio A,* as point us to something else about it?

To ask this question—to follow the hint made by the dance's documentation—is not to question the radicality of *Trio A*'s aesthetic relative to the mainstream modern dance of its time, but to clear the ground for a different sort of story: one about the difficulty, rather than the achievement, of oppositional culture; about the problems that faced so-called postmodern dance when it encountered the features of a postmodern social order; and about how Rainer's treatment of spectatorship works through these questions.[7] For *Trio A*'s meaning and historical significance come not solely from its relation to previous dance, but also from its entwinement with the visual art of its time—particularly minimalism—and the technologies of representation—photography, film, and television—by which it was surrounded. Start with the photographs and the focus shifts: from a dance's relation to dance as an art form, to the relation between a dance and its images. Or, better: to the relation between bodies and pictures, in the context of a changing culture of mediation.

Trio A was developed, debuted, positioned, and repositioned by Rainer in the years 1965 to 1968. This was the relatively brief period between her early work's boundary-testing exuberance and her invention of a variable, evolving, and increasingly collective performance art in the later 1960s. It was the time between the first work on *Trio A* and the final presentation of the larger performance, *The Mind Is a Muscle,* of which it was part.[8] It was the period during which minimalism came to dominate the visual arts in the United States. And it was the time when media representations of the Vietnam War began to foreground and complicate, in the register of mass media and widespread cultural experience, a three-way relation between spectatorship, representation, and embodiment on which Rainer's avant-gardist work was also staked. Placed in this context, the model of dance performance *Trio A* provides cannot be quite Banes's triumphant "presentation of objects in themselves." Indeed, such presentation turns out to be a problem for performance—a historical seeing difficulty addressed by the dialectics of *Trio A*. Rainer's single most famous piece

of choreography gives us performance as a place to question what happens to the very idea of an ahistorical, baseline presentation of the body under specific historical conditions.

OF FREEZING AND FLOW

Faced with the surprisingly dynamic poses in the images of *Trio A,* most dance historians would shrug. It is no wonder the images of the dance don't correspond to the intentions and effects of the dance itself. Dance is an art of time and motion; photography, of the temporal and spatial freeze. Images of dance *never* capture the energy, dynamism, or power of a live performance. They are pale representations, at best, of an inherently ephemeral art. Any dance photographer would remind us that the inherent incompatibility of performance and photograph is the structuring condition of his or her practice. William Ewing catalogs the incongruities: "Dance is the movement of bodies through space and time. Dance is fluidity and continuity. Dance connects, dance unfolds. Dance envelops us; it enters through the eye and the ear. Photography imprisons in two dimensions. Photography flattens and shrinks. Photography can tell the ear nothing. It fragments time and fractures space."[9] Yet, as we've seen, Rainer and other Judson choreographers frequently produced dance that eschewed "fluidity and continuity," often specifically by reaching for elements of the photographic. As discussed in previous chapters, in the first half of the 1960s Steve Paxton, for one, made dances based on photographs, froze in positions taken from sports photography, and even picked up a camera and snapped photographs during a dance. Rainer, meanwhile, was one of many artists in her circle who played with still poses in the midst of dance, and further challenged the idea of dance as flow by using rigid repetition in an effort to make dance movements linger for the viewer, such that "each movement might be seen as more than a fleeting form, much as one can observe a piece of sculpture for one minute or many minutes."[10]

Nevertheless, it would seem that Rainer designed what would become her most famous individual dance specifically to counter still, photographic effects.

In an essay written in the same year as *Trio A*'s debut, she contrasted its structure to that of dances based on phrases, or sets of linked steps. In the typical dance phrase, "there is always maximal output or 'attack' at the beginning of a phrase, recovery at the end, with energy often arrested somewhere in the middle."[11] This convention is the formal structure that supports the exhibition- and display-oriented dance that was anathema to her aesthetic, and that she conceptualized in specifically pictorial terms. When dances are founded on the conventional formula of attack, suspension, and recovery, "one part of the phrase—usually the part that is most still—becomes *the focus of attention.*" These central moments are, she writes, "*framed*": they are "*focal moments,*" and dances oriented to them become exercises in "getting from one point of *still 'registration'* to another." As if this language of focus, framing, and stills didn't make the metaphor clear, she zooms in: the unmoving center of the dance phrase seems frozen before the viewer's eyes, "registering like a photograph or suspended moment of climax."

To avoid this quasi-photographic tendency—to eliminate the structure identified with dance spectacle—Rainer devised a dance with a prime directive of constant motion. She purposefully sought ways to exaggerate in *Trio A* the fact that "dance is hard to see." To understand a dance, the viewer must be able to recognize its component parts, to "focus on the structural organization of the dance, first by deducing its basic moves and then by learning how these moves are put together," as Susan Leigh Foster has explained it.[12] However, in *Trio A* "basic moves" are nearly impossible to locate, dispersed into a phraseless continuum of movement. Just as eliminating the pauses between words would make spoken language unintelligible, the suppression of phrasing in *Trio A* makes the dance difficult to apprehend. Jean Nuchtern, writing about Rainer for the *Soho Weekly News* in 1976, was moved to recreate the effect for her readers in typographical terms:

thereisnopartofthisarticlethatisanymoreimportantthananyotherpart
eachwordsentenceparagraphcarriesthesameweightasanyotherandits
smoothnessliesnotonlyintheequalweightednessofeachwordsentence

andparagraphbutinthejuxtapositionofoneparagraphtoanotherwhich
causesthereadertoreacttothearticleasawholeratherthanassegments.[13]

Likewise, *Trio A*'s syntax is purposefully slurred. A dance of constant transition
from one movement to the next, it is a sort of run-on sentence testing the role
of phrasing in the production of meaning. *Trio A* does not so much counter
normative dance, as dissolve it.

As the text of Nuchtern's paragraph suggests, to remove breaks between
units is also to level their relative value. *Trio A* thus makes a double attack on the
dance phrase: it suppresses both differentiation (the ability to discern phrases)
and difference (the differential value of the phrases' parts). As Jill Johnston noted
at the time, the normal dance phrase "is, in microcosm . . . an expression of the
whole hierarchical structure of traditional dance."[14] *Trio A* disarticulates phrases
and their internal hierarchies with the result that, as Rainer put it, in this dance
"no one thing is any more important than any other."[15] Even gravity is not al-
lowed to accelerate the body's motion or heighten the dance's drama. When the
performer of *Trio A* falls to the floor, she does so in stages, so that what might
be a thrilling collapse instead maintains the dance's uniform rhythm. The dance
is thus not unlike the regulated fields and all-over structures of contemporary
paintings and drawings, like those by Agnes Martin or Eva Hesse, that limited
compositional incident and artistic decision making to the confines of the con-
tinuous, predetermined structure of the grid (figure 3.4). Johnston suggested
something similar when she described *Trio A* as "all-over" and "de-focused,"[16]
and Rainer briefly literalized the parallel with nonhierarchical visual form when
she had a huge wooden grid descend during a section of *The Mind Is a Muscle*
in which she was dancing an embellished version of *Trio A* (figure 3.5).[17] The
leveling effect is also built into the movement tasks *Trio A* requires. Very often
some body part—a foot, a shoulder—must begin a new movement before the
rest of the body has finished the first. This internal staggering ensures that no
composed bodily picture is ever produced.

A taxonomy of dance forms could be devised according to the degree
to which they value actual or virtual stillness. Call it the "suspended moment"

3.4 Eva Hesse, *Untitled,* 1966. Ink on paper, 12 7/8 x 9 7/16 in. Collection of Maxine and Stuart Frankel, Bloomfield Hills, Michigan. Photo: Tim Thayer.

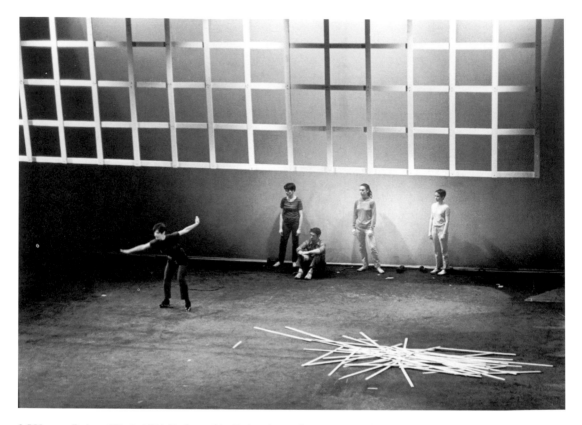

3.5 Yvonne Rainer, *Trio A,* 1966. Performed by Rainer in tap shoes as *Lecture* in *The Mind Is a Muscle,* 1966–1968. Anderson Theater, New York, 11 April 1968. Photo: Peter Moore. © Estate of Peter Moore/VAGA, New York, NY.

quotient. *Trio A* would be on one end of its spectrum; classical ballet, with its affinity for picturesque poses, on the other (a measure of a ballet dancer's talent is his or her *ballon,* or ability to seem momentarily suspended at the top of a leap). Dance historian Ann Daly points out that in the very early twentieth century, ballet—whose artistic legitimacy in the United States was still limited by the perceived sexual availability of the "ballet girl"—shared its pictorial quality with the "skirt dances" and strip shows of the period's burlesque revues. The performers in all these forms were what Daly calls step dancers: "they operated in a pictorial mode, striking pose after pose or performing trick after trick."[18] The pictorial quality of their dancing was reflected in the popularity of actual still images of the dancers, with "ballet girls," vaudeville dancers, and burlesque performers becoming the first to populate the genre of the pinup. Daly suggests that historians may have overlooked the significance of this shared image affinity in turn-of-the-century dance, for she argues that it was in part to distinguish herself from step-dancing counterparts, whether in tutus or pasties, that Isadora Duncan developed a choreographic style characterized by lilting flow and constant motion.[19]

If Duncan is considered to have initiated the modernist dance tradition, Rainer and her peers are often credited with announcing its end. So it is interesting that some fifty years later, but three years before the debut of *Trio A,* Rainer made a danced argument similar to Duncan's.[20] In *Terrain,* of 1963, a dance called *Duet Section* brought Trisha Brown onstage in a black bra to perform a hip-thrusting burlesque number, while Rainer, in a matching costume, danced an adagio combination from ballet class. Then, lest the audience miss the point that classical and peephole dance are equally directed at the sexualized pleasure of the viewer, Rainer and Brown together ran through a series of still stances.[21] "Focus out—coy over r. shoulder and l. hand," said the directions for one such pose; "head up, mouth open . . . r. hand under l. tit," read another.[22] The instructions for what Rainer referred to as the "cheesecake postures" of course conjure the displayed female bodies of pinup photographs.[23] *Duet Section,* then, sent up treasured distinctions between classical ballet and peephole dance; it introduced

the problem of the dancing body as object of the sexualized gaze; and it did all of this by performing dance's affinity with still images.

FREEZING AND FLOW, CONTINUED

David Parsons first thrilled audiences with his dance *Caught* in 1982. Carrying the control to a strobe light in his hand, the performer of this trademark work leaps around a darkened stage, activating single flashes of light only when he is at the height of a jump. The effect is dramatic, to say the least. He is both in motion and frozen. He seems to fly around the stage in jerks and stops, a literal showstopper arresting motion right before our eyes. The strobe allowed Parsons to make a dance that is *nothing but* climactic moments, the anti-*Trio A*. *Caught* epitomizes dance conceived as purely spectacular display, and, with its flash freezes, it confirms the suggestion made by Rainer in *Duet Section,* in the *Trio A* essay, and, in negative, in *Trio A* itself that such dance-spectacle is tied to the photographic. It's no surprise to learn that *Caught* was thought up during a session with dance photographer Lois Greenfield, or that Parsons himself studied photography.[24] "[H]e didn't just keep moving and dancing," celebrity photographer Annie Leibovitz recalls of a session with the choreographer. "The photograph is about moments, a specific split second, and he gave me split seconds rather than continuous motion."[25]

Caught blurs the binary opposition of frozen photographs and flowing dance, but does so as a kind of parlor trick that leaves the binary's enabling assumptions intact. A decade before, *Duet Section* had interrogated the terms more self-critically, and presciently: besides raising far in advance the key issues of feminist dance theory, the dance provided a surprisingly early precedent for the interrogation of photography, posing, and masquerade that became central to much feminist art in the late 1970s and 1980s, as Craig Owens did most to explain.[26] *Duet Section* also shared the inherent problem of much of this art, however, as the dancers' self-display rehearsed as well as critiqued the mode of dancer-as-pinup: however ironically, its bra-clad preening made use of the spectacle of beautiful women, scantily clad and provocatively displayed. *Trio A* might be understood as an attempt, a few years later, to pose again the question of pictorial dance.

In doing so, it submerges the gender politics of the problem, but the tradeoff is a thorough frustration of the dualisms on which most discussions of dance photography, as well as *Caught, Duet Section,* and even Duncan's choreography, were based.[27] For though phraselessness and noninflection preclude quasi-photographic moments in dance performance, they do not add up to the organic model Duncan favored, but to an intriguingly inorganic continuity—one that does not so much leave behind as incorporate the fracturing effect both of pictorial dance and of photography.

I've had recourse to the metaphor of clockwork in describing *Trio A,* but it was also granted a mechanical character by at least one contemporary observer, Jerry Tallmer, who in 1966 announced quite as if it were a matter of fact that the dance was an imitation of the displays at "the old Museum of Science and Industry at Rockefeller Center."[28] For Tallmer, a longtime *Village Voice* theater critic and supporter of off-off-Broadway theater who believed the contribution of the current generation of artists was characterized by "a seeking for the joyous" and "a seeking for pain,"[29] this may have been a negative assessment, but Johnston used similar rhetoric in a glowing account of *Trio A* as a dance whose "pieces articulate like well oiled joints."[30] Later, Rainer recalled that she often had to correct dancers who were using mythical or natural imagery to guide themselves through the dance. When she heard that one of them was doing a particular movement in *Trio A* by thinking of himself as a faun, she told him to try thinking of himself as a barrel instead. When another dancer described a movement as "bird-like," Rainer retaught it to her as "airplane-like."[31] Decades later, she clarified one of *Trio A*'s more unusual movements to a group of young dancers by explaining that "you're making a machine to flap your ears,"[32] calling to mind Tallmer's description of the dance, more than thirty years previously, as "a simulation of cogs-and-gears, cams-and-levers."[33]

It is more than the images in her own and the critics' rhetoric that suggest *Trio A*'s antiorganic character, however. Conceived from the beginning as the first section of a longer work, the dance had its debut under the title *The Mind Is a Muscle, Part 1* at a concert shared by Rainer, Steve Paxton, and David Gordon at Judson Memorial Church on 10 January 1966.[34] Seated in folding chairs or

cross-legged on the floor, the audience watched the three dancers spread out and stand at their ease, all facing stage left. Together, the three dancers bent their knees in a shallow, parallel *plié* and began the dance's first motion, twisting the upper torso from side to side so that their loosely hanging arms swung from the shoulders, behind their backs, then in front. As the dancers moved, yard-long, unpainted wooden slats began to drop in rhythmic succession from the choir loft down onto the stage area (they are visible, piled up in a heap, in figure 3.2). Rainer considered these slats the musical accompaniment of the dance, and used them in several performances of *Trio A* and its variants. She valued them for what she called their "metronome-like regularity," an invariable rhythm corresponding to the dance's unusual uniformity.[35] Still, however continuously they came, it's hard to imagine that each impact of wooden slat on hard floor would not have given the audience a small start. Or that, even if one could grow accustomed to the rhythmic dropping, those clattering slats would not have acted as so many physicalized punctuation marks, breaking/up/*Trio A*'s/run-on/continuity.

If so, the falling slats might have drawn attention to the fact that, despite all the talk of *Trio A*'s consistency, a certain kind of stoppage, or cutting off, is fundamental to the dance as well. There is a particular movement—a running step forward followed by a hop on the opposite foot—that in a recent rehearsal Rainer had an especially hard time coaxing from the dancers. "The jump doesn't go forward even though the preparation does," she explained, trying to get them used to interrupting their own momentum.[36] The slats as well as this kind of internal braking remind us that, while its constant motion might have countered the punctuated quality of "step dancing," Rainer's solution was less Duncan's flow than a special variation on what Annette Michelson identified early on as the paratactic structure of much avant-garde dance of the 1960s: less flowing stream than laundry list, or assembly line.[37] Johnston might write of *Trio A*'s integrative wholeness that "one could view the entire solo as a single phrase"—but in the very same paragraph she had already noted its structure of "innumerable discrete parts or phases."[38]

This structural discreteness reveals the kinship of *Trio A* with the serial and repetitive impulses then pervasive in sculpture and painting. Donald Judd's es-

chewal of dynamic composition in his stacks, for instance, demonstrates the order he attributed to the most important new art of the mid-1960s: "one thing after another" (figure 3.6).[39] Rainer credits Cage and Cunningham and the influence of Simone Forti for her discovery of this compositional mode: in early work, Forti "made no effort to connect the events thematically in any way . . . one thing followed another. Whenever I am in doubt I think of that. One thing follows another."[40] Of course, whereas a Judd stack piece is characterized by the regularized array of objects in space, *Trio A*'s parataxis, like Forti's, concerns arrangements of events in time. This much is obvious (though it bears mentioning that the temporal quality of Judd's "after"—not "next to," "in front of," or "behind"—is as good an indication as any of how inextricable are the spatial and temporal, the plastic and theatrical, in minimal art). The more significant difference between the two versions of mid-1960s parataxis is that *Trio A*'s series is profoundly ambiguous. Sequence or stream, string of details or unitary whole: it is undecidable, both particle and wave.[41]

It is this quality, which Rainer expressed in the term "continuum," that makes *Trio A* significant for the ongoing discussion in art history about minimal sculpture's likeness to both the look of industrial products and the paratactic logic of their production. Specifically, it suggests how *Trio A* might contribute to a previously mentioned problem: even if we accept that the industrial aesthetic of minimal art was just that, the question remains as to why, at the very moment the special place of factory production in the cultural imagination was rapidly slipping—when the transition of capitalist Western nations to a service and information economy became conventional wisdom (which is to say, as industrial production began to be diverted to "developing" nations)—such forms became so central to art in the United States.[42]

The most pervasive (and least critical) articulation of this belief was published in 1964. Marshall McLuhan's *Understanding Media* popularized its author's conviction that the mechanical age, typified by the printing press and culminating in the assembly line, had passed. At least in developed Western nations, the central "Gutenberg fact" of "uniform, continuous, and indefinitely repeatable bits"[43] had given way to the patterns of integration and simultaneity encouraged

3.6 Donald Judd, *Large Stack*, 1968. Stainless steel and amber Plexiglas (10 units), 185 x 5 x 40 in. (469.9 x 101.6 x 78.7 cm). The Nelson-Atkins Museum of Art, Kansas City, Missouri. Gift of the Friends of Art, F76-41. Photo: Louis Meluso. Art © Judd Foundation. Licensed by VAGA, New York, NY.

by electric media, epitomized by television. The tipping point between these two modes was embodied, McLuhan argued, in film, which was both a sequence of discrete images and an involving whole: "Mechanization was never so vividly fragmented or sequential as in the birth of the movies, the moment that translated us beyond mechanism into the world of growth and organic interrelation." As if describing *Trio A*'s strange continuum between series and stream he goes on: "The movie, by sheer speeding up the mechanical, carried us from the world of sequence and connections into the world of creative configuration and structure. The message of the movie medium is that of transition from lineal connections to configurations."[44]

Embodying at once both flow and mechanical sequence, *Trio A*'s continuum gave form to some of the contradictions of a period when the features of late capitalism were in emergence. McLuhan's schema is notoriously crude, and Rainer herself was resistant to his ideas.[45] But one need not believe that the industrial order of production really had been superseded, or that technologies of communication determine historical change, to find it significant that *Trio A* motivates, at the same moment as McLuhan, terms so similar to his. Perhaps it is a stretch to suggest that the consequence of the dance's deconstruction of the photograph/dance and freezing/flow binaries is that *Trio A* also works on the opposition between modernity and postmodernity. But if so, it would surely be telling that while Tallmer thought *Trio A* looked like an industrial demonstration, Johnston added a specifically McLuhanesque term to the conversation. She described *Trio A* in 1966 as "well-oiled," but also as a liquid "mosaic"—McLuhan's favorite metaphor for the medium of television.

THE SHOT

Illness, convalescence, and travel led to two years' elapsed time between *Trio A*'s debut at Judson and performances of the completed *Mind Is a Muscle,* of which it was the first part.[46] As they entered the Anderson Theater on the nights of 11, 14, and 15 April 1968, members of the audience who had come to see

this work, Rainer's first full-length New York concert in more than two years, each received a program giving them a run-down of the various sections of the piece and its performers. On the next page, under the deadpan title "Statement" and a characteristic disclaimer ("it is not necessary to read this statement prior to observation"), Rainer printed a brief but extraordinary essay explaining the physicality she wished to foreground. The statement begins with a complaint against dance as sexualized display, recalling the feminist protest of *Duet Section,* while heading off accusations that this aversion was anything like a distaste for the body as such: "The choices in my work are predicated on my own particular resources—obsessions of imagination, you might say—and also on an ongoing argument with, love of, and contempt for dancing. If my rage at the impoverishment of ideas, narcissism, and disguised sexual exhibitionism of most dancing can be considered puritan moralizing, it is also true that I love the body—its actual weight, mass, and unenhanced physicality."[47]

Rainer thus began her artist's statement by announcing her devotion to the brute simplicity of the body as a thing in the world. Her intent, as she put it in the next paragraph, was "to weight the quality of the human body toward that of objects."[48] This emphasis on the actual, present, and physical body participates in the prevalent minimalist aesthetic: the opaque physicality of Donald Judd's or Robert Morris's works were meant to hold viewers in a real-time experience of both the objects' materiality and their own physical location as they viewed them. As Michelson and others have suggested, the advanced dance of the 1960s was in large part what showed artists such as Morris the way to an art of the body in space and time.[49] In Rainer's case, however, this experience was mounted as a counteroffensive. She implies as much in the statement's conclusion:

> The condition for the making of my stuff lies in the continuation of my interest and energy. Just as ideological issues have no bearing on the nature of the work, neither does the tenor of current political and social conditions have any bearing on its execution. The world disintegrates around me. My connection to the world in crisis remains tenuous and remote. I can foresee a time when this remote-

ness must necessarily end, though I cannot foresee exactly when or how the relationship will change, or what circumstances will incite me to a different kind of action. Perhaps nothing short of universal female military conscription will affect my function (The ipso facto physical fitness of dancers will make them the first victims.); or a call for a world-wide cessation of individual functions, to include the termination of genocide. This statement is not an apology. It is a reflection of a state of mind that reacts with horror and disbelief upon seeing a Vietnamese shot dead on TV—not at the sight of death, however, but at the fact that the TV can be shut off afterwards as after a bad Western. My body remains the enduring reality.[50]

In her earlier essay on *Trio A,* "A Quasi Survey," Rainer had contrasted the virtually photographic effect produced in conventional dance with *Trio A*'s radical continuity. Two years later, as she countered a dance of seductive display with one of pure materiality, and the fleeting televised body with her own enduring one, Rainer set up another opposition between the realm of pictures and that of performance, but this time her rhetorical poles are different: image and corporeal substance. Before, it was elision as opposed to hypervisibility that might save her art from spectacle. Now it was materiality as opposed to virtuality. And while Rainer's paragraph starts out declaring her dedication to an art apart from politics—"ideological issues have no bearing on the nature of the work"—through its very insistence on the materiality of the body she ends up implying the opposite: that the lack of manifest content in her dance—its "remoteness," its reluctance to address the events of a world in a state of emergency—is actually bound up with pressing social and political conditions. In the clip of implicit narrative she gives us here, the artist turns *away* from the body on TV news *to* the body as "enduring reality"—to a physical facticity, the love of which she declared at the top of the "Statement" to underlie her work's form and concept.[51] The insistence on the materiality of the body that drives Rainer's work in this period is here articulated in dialectical relation with other bodies, precisely immaterial, flickering on the screens of American television.

———

Below the one-page essay, Rainer printed her name and the date the statement was composed: March 1968. This time stamp allows us to specify her references. Though she meant her statement to respond to the Vietnam War in general,[52] "a Vietnamese shot dead on TV" would have had particular resonance at the time. In Saigon on 1 February of that year, South Vietnam's chief of police General Nguyen Ngoc Loan raised a revolver and shot a prisoner in the head. That evening, U.S. television networks aired still images of the very moment of the execution; the next day newspapers prominently featured the prisoner's death in Eddie Adams's now-famous photograph, while NBC broadcast film footage of the event, giving viewers what remains among the most graphic and vividly remembered instances of "a Vietnamese shot dead on TV" (figure 3.7).

Shot at once ballistically and photographically,[53] broadcast on television to twenty million viewers and captured in Adams's Pulitzer-winning photograph for millions more, the summary execution on that street has become an emblem of the American media's powerful and powerfully ambiguous role in the Vietnam war.[54] Depicting the bodily cost of the war in stark, visual terms, as well as revealing dishonorable behavior by the United States and its allies, still and moving images like this one are commonly claimed to have turned public opinion against the government and the military.[55] Television in particular is felt to have played the pivotal role, transforming the experience of a nation in what is so often called the first "living-room war." As Richard Nixon complained: "More than ever before, television showed the terrible human suffering and sacrifice of war. Whatever the intention behind such relentless and literal reporting of the war, the result was a serious demoralization of the home front."[56] While scholars have questioned this view, the Tet offensive of the winter of 1968 is generally recognized as a turning point when the media coverage of the war indeed became more critical, and increasingly violent images on television began to motivate dissent. The Loan execution, committed in the aftermath of the An Quang Pagoda battle of the Tet offensive and widely, even spectacularly disseminated in the press, is the classic case. Within a week of its broadcast and publication, Secretary of State Dean Rusk was asking a specially assembled cadre of journalists, "Whose side are you on?"[57]

3.7 Eddie Adams, South Vietnamese National Police Chief Brig. Gen. Nguyen Ngoc Loan executes a Viet Cong officer with a single pistol shot in the head, Saigon, 1 February 1968. AP / Wide World Photos.

The image's impact is the stark fact of a body whipped from life to death; it conveys war, not as strategy or politics or statistics, but as a matter of bodies, and the discussions it engendered at the time focused on the wrenching display of violence rather than the event's meaning in the context of this particular war.[58] Yet despite the brutality with which this picture, both still and moving, approached the bodily baseline of the conflict, it was also immediately apparent that the incident was chillingly contained, limited, and transformed by its context as media image. In a *Life* magazine column that, like Rainer's "Statement," dates from March 1968, Shana Alexander summarized the television broadcast of the film: "the skinny captive, hands tied, face beaten, is marched between husky guards to the waiting policeman. Sudden bang. Commercial."[59]

Rainer's selection of the image of "a Vietnamese shot dead on TV" is thus telling. Out of all the millions of killings in Vietnam, and from all the shocking events of the "world in crisis" in 1968, her phrase evokes an incident that, in terms that relate to the issues of spectatorship and embodied physicality her dance work was raising, remains a focal point for the special intertwining of representation and bodily reality in the later 1960s. The shooting on that street, broadcast and photographed, is a central image for this historical moment in that it instantiated the key question of whether the media, and especially the newly ubiquitous form of the national television news,[60] were heightening and extending Americans' experience of reality, collapsing the distance between civilian spectators and combatants far away, or were instead detracting from war's reality to Americans at home, distancing and numbing a society of spectators.

"Television *overcomes* distance and separation; but it can do so only because it also *becomes* separation."[61] These are the words of philosopher Samuel Weber from the 1990s, but they could well have been written in the context of the Vietnam War by a critic like Michael Arlen. As television critic for the *New Yorker*, Arlen wrote extensively on the media's coverage of Vietnam, coining in the title of his 1966 essay, "Living-Room War," the phrase that has come to stand for the idea that TV gave Americans an experience of combat more immediate and therefore more incendiary than anything previously available. What has been less well remembered is that Arlen intended this phrase to have a double meaning.

With television, the fighting was taking place right in your living room (shock, outrage), but then, it was taking place in the *living room* (comfort, containment). "I can't say I completely agree with people who think that when battle scenes are brought into the living room the hazards of war are necessarily made 'real' to the civilian audience," he wrote. "It seems to me that by the same process they are also made less 'real'—diminished, in part, by the physical size of the television screen, which, for all the industry's advances, still shows one a picture of men three inches tall shooting at other men three inches tall, and trivialized, or at least tamed, by the enveloping cozy alarums of the household."[62]

Shrunken and contained by domestic fixtures, the bodies on the television set are stripped of their reality, even as that reality is beamed back in a newly direct way to the audiences at home. This is the same effect that artist Martha Rosler countered between 1967 and 1972 in a series of now well-known photomontages, originally published in antiwar publications and collectively entitled *Bringing the War Home: House Beautiful* (figure 3.8). Combining home décor photo spreads from decorating or architectural magazines with images of Vietnam from *Life,* Rosler almost seamlessly inserted minesweepers, weeping mothers, and dead soldiers into the "cozy alarums" of picture-perfect households.[63] Her title is telling, for "bringing the war home" is both a cliché standing for the newly vivid effect of a televised war and a phrase that radical groups, especially the Weathermen, used for attacks intended to bring conflict literally to the streets of the United States. Both meanings of the phrase apply to Rosler's images. Deploying the visual violence of photomontage, they picture the Vietnam War brought home physically rather than televisually. They register in negative the paradoxical diminishment and distancing effected by war "as seen on TV."

Remember that in her "Statement" Rainer called her connection to world events "tenuous and remote," and speculated as to when "this remoteness" would end. She thus established a relation of distance between her art and the war. Weber reminds us that in its literal translation, the word "television" means "seeing-at-a-distance." The distance between a Saigon street and a New York living room is not simply elided, as McLuhan would have it, but is telescoped: both magnified and collapsed.[64] Television journalism does make the war closer and

3.8 Martha Rosler, *Balloons,* 1967–1972. Photomontage, 24 x 20 in. © Martha Rosler,
courtesy of Mitchell-Innes & Nash, New York.

more real, but it also pushes it further away and makes it more illusory. It is no wonder, then, that Rainer was moved *while proclaiming her devotion to a baseline human physicality* to mention the televisual presentation of the war in Vietnam. For television, and in particular the period's broadcasting of violent conflict, forces a connection (however "tenuous and remote") between the period preoccupation with the reality effect of bodies seen from far away and the attempt in her work to discover and disclose the simple physicality of the body closest at hand.

"My body remains the enduring reality." In the system of meanings that informed *Trio A* by 1968, the body's obdurate physicality acts as ballast in a "disintegrating" world of insubstantial images. To make this connection, however, is also to open up doubts about the status of the physicality she evokes. Rainer writes that the horror of her time is not the sight of death on television but "the fact that the TV can be shut off afterwards as after a bad Western." Less horrible than seeing the corporeal reality of death, she seems to be saying, is seeing it incorporated into the televisual, such that it can be viewed, or not, with detachment.[65] Likewise, in March 1968, Alexander wondered about the television viewers of the Loan shooting: "Do we somehow hold the subliminal notion that the figure in the plaid shirt will get up and walk away during the commercial?"[66] Like Rainer when she turns off the TV "as after a bad Western," Alexander saw that the horror is in the way television trains us to see—or not to.[67] And that is to "see-at-a-distance," spatially but also emotionally. The crisis Rainer evokes is one of empathy; the problem is not horror alone, but "horror and disbelief."

Turning off the TV is thus not the solution in Rainer's text, but the problem. To it she contrasts her affirmation of her own body's enduring reality—the fact that it can't be turned off—but this is also in part an acknowledgment that asserting one's own physical reality in 1968 *depends on* the faded signal of that other corporeality. They are bound together: bodies on television seem both more real (brought home) and less real (interrupted for commercial).[68] What Rainer tells us is that the body in front of the television is not unaffected by that ambiguity. Such a condition is at the heart of Weber's argument about

television. He proposes that what television transmits is not images so much as vision itself: the difference is that the latter decisively and uncannily separates the TV watcher's senses from her own physical time and place. Television "transmits the power to see at a distance. But in so doing, it necessarily detaches the power of seeing from our experience as individuals who are situated in bodies. What television does is to allow us to participate in an experience of seeing that is not subject to the spatial-temporal limitations of the individual body."[69] The complex phenomenology of television means that the body on TV is both really there and, in some felt sense, really *here,* and because of this—because the medium promises something that it can never quite deliver—the viewer's own body is both really here and in some felt sense split, seeing *there.* Weber states this effect of television decisively: "It overcomes spatial distance but only by splitting the unity of place and with it the unity of everything that defines its identity with respect to place: events, bodies, subjects."[70] Or, as Vito Acconci would put it, TV is "a rehearsal for a time when human beings no longer have bodies."[71] In other words, television is felt precisely to unsettle the fundamental principle of what Rainer called the body's "weight, mass, and unenhanced physicality": one body, firmly and exclusively occupying one place at one time. By making distant bodies more present *and* rendering them mere representations, television, especially in the context of the Vietnam War, is both expression and mechanism of a profound and consequential ambiguity—an ambiguity instantiated, also, by Rainer's most famous dance.

ACTUAL APPEARANCE

> What is seen is a control that seems geared to the *actual* time it takes the *actual* weight of the body to go through the prescribed motions. . . . [T]he demands made on the body's (actual) energy resources appear to be commensurate with the task—be it getting up from the floor, raising an arm, tilting the pelvis, etc.
>
> —*Yvonne Rainer, "A Quasi Survey . . ."*

"What is seen" in *Trio A* is a factual quality that is the essence of Rainer's 1960s dance theory—the source of what she called "tasklike dance." Later she corrected an interviewer who thought the concept of task had provided a way for her to organize movement. "No," she said, "it was an attitude about performance."[72] Rainer was interested in dance that is like a task in its very quality of movement. And this ideal meant an equation between the dancer's *apparent* expenditure of energy and the *actual* requirements of the motion being performed—between the moving body seen and lived. In this equation, the "unenhanced physicality" that Rainer loved about the body finds its performance manifestation; each perceived motion directly expresses the action of the body itself.

This ideal of a one-to-one relation is a resistance to indirect correspondences—to dissimulation, illusion, code. In her 1974 essay on Rainer, Annette Michelson evoked *Trio A*'s "refusal to inflect motion," calling attention to its "evenness of utterance" and "revision of choreographic grammar."[73] I have also turned to metaphors of language in my description of *Trio A*—referring to its syntax, dubbing it a run-on sentence—but Rainer's discussion of the relation between the feel of the dance and its look makes clear that, despite the temptation of grammatical metaphors, what *Trio A* aims for in its peculiar, slurred version of parataxis is a specifically nonlinguistic art. Think of the idea she and critic Jill Johnston both insisted on: no "phrases." Or, perhaps even more to the point, a year earlier: "no to transformation." There was to be no excess movement (none of the frills of balletic carriage, of decorative body placement); there were to be no gratuitous modulations of energy (the pauses that offset a dramatic move), and in this way, ideally at least, the character of the movement seen was to be the direct outcome of the requirements of the movement produced.

It's tempting to conceptualize this as the utter fusion of actual and apparent, as if *Trio A* demonstrated the inseparability of lived and observed experience, or the inherence of the felt *in* the seen.[74] But Rainer won't quite let us. For one thing, the movement of *Trio A,* however inventive and unusual, is haunted by images of dances past. Here, the ghost of an arabesque or a *rond-de-jambe,* there something that looks suspiciously like a Graham contraction or a Cunningham quirk of the leg. As Rainer has confirmed, she inscribed *Trio A* with the traces

of the very dance conventions she was working to displace.[75] Whether these elided but perceptible quotations are taken as ironic send-ups of previous dance, as statements of mastery in the anxiety-of-influence vein, or as cues signaling the oppositional stance of *Trio A,* they cut into the perception of the dance as tautological, self-generating, in and of the performative moment.[76] They freight *Trio A* with reference.

The tracing of *Trio A* goes farther, however: to the dance's very structure and mode of performance. Rainer readily admitted that the direct display of physicality proposed by this dance was only a quality of "the look" of *Trio A.* "In order to achieve this look [of tasklike movement] in a continuity of separate phrases that does not allow for pauses, accents, or stillness," she wrote, "one must bring to bear many different degrees of effort just in getting from one thing to another."[77] In order to create the phraseless continuum, the dancer must actually modulate her energy and suppress aspects of her effort—even while striving for the *effect* of a direct relay between bodily effort and visual appearance. Stripped-down, tasklike presentation testifies to the "unenhanced physicality" of the dancer's body in *Trio A;* but the differential expenditure of energy needed to create such a direct display actually *erases* that very order of simple signification. In other words, to create the appearance of unmediated energy, the dancer dissimulates—effectively replacing the real economy of effort with its own image. Presentation yields to representation; the "actual" to what only "appears."

Much of the avant-garde dance of the 1960s worked to strip away the layers of signification that attend the moving, performing human body in other forms of dance: the miming where dance becomes storytelling, the expressionism where movement represents emotional states, and the performative signifying of Western theatrical dance in general, where the dancing body means perfectibility, transcendence, and the ideal. Rainer's dance work, and *Trio A* in particular, are often thought to be dedicated to presentation rather than representation. But her work can better be described as working the conceptual fold between them. This is the work of an artist who could both think about the body's "actual energy resources" and speak of the dancing body as a "purveyor of

information."[78] It is between the uncoded and the linguistic, the presentational and the representational, that *Trio A* plays.[79]

Dance Photography

Remember that Rainer's word for the relation between the body felt and seen is "geared": what the audience perceives "seems geared to the actual time it takes the actual weight of the body to go through the prescribed motions."[80] Tooth in groove, the qualities of the body in motion materially affect the appearance of the movement—not as if they were the same, but as if one were the imprint of the other. For, while the gearlike correspondence of the dance's mode of meaning may be an attempt to escape symbolic or coded communication, *Trio A* does not evade a representational order. And it is in this that Rainer's dance becomes a special case for considering the relation between dance and photography.

What does it mean to say a dance is photographic? "Step dancing"—and Rainer's critical take on it in *Duet Section*—offers the pleasure of looking at bodies stilled as if for photographs, in attractive or sexually solicitous poses. Bodies act like images. Parsons's *Caught,* on the other hand, uses a strobe light to make it the spectator's vision that is photograph-like, mobilizing the power of stop-action photography in a series of spectacular flashes. There is a third model for thinking the question of a photograph-like dance, however: not in terms of whether it has quasi-photographic moments within it, not in terms of whether it is punctuated with stillness, but in terms of how it makes meaning.

This approach was suggested in 1977 by Rosalind Krauss, when she opened the second of two major essays on contemporary art by describing a recent performance by Deborah Hay, Rainer's contemporary, who had been a participant in the Dunn workshop and Judson performances in the previous decade.[81] In this piece, Hay stood before an audience and announced that instead of making visible movements, she was going to speak. She proceeded to discuss her body, her awareness of its inner couraings, and its presence before

the audience. She explained that her goal was to arrive at a state of attentiveness to her body's every cell. In this work, movement—the basic currency of dance communication—was shifted from steps and gestures apparent to the audience to the movement of blood, cells, and organs within the body: what Krauss called "a kind of Brownian motion of the self."[82] Hay's dance centered on—was nearly reduced to—the presence of the body before the audience. And in this, Krauss saw a rupture of the systems by which dance normally produces signs.

In dance understood as a system of meaning, signs are a matter of visible motion—the perceptible actions of the moving body constitute dance signifiers, operative in relation to one another and to the tradition or lexicon from which they are drawn.[83] To Krauss, Hay's dance was therefore, like Barthes's description of the photograph, "a message without a code." Because of the radicality of such a mode of direct communication of its message ("I am here"), speech had to be appended, in a parallel to the supplemental texts that tend to accompany mutely indexical signs like photographs. Krauss understood Hay's speech as a caption, and the still dance as an example of the preeminence of the semiotic category of the index in art of the 1970s.[84] Thus, while its goal may have been a direct relay of the performer's bodily presence to the audience, Krauss's analysis suggests that this *presentation* was in fact *representation,* albeit of a particular sort. A special, more direct mode of signification—the index—had appeared, and the photographic had become the structural model for abstract art.

However, while Hay's piece would seem intended to overwhelm any distinction between inner and outer, embodied and viewed, the dance whose only outward manifestation is speech in fact shines a spotlight on the problem of their difference, leaving us with a body that remains asemiotic, and a mode of signification that is wholly coded. *Trio A,* on the other hand, in its attempt to make embodied and viewed movement correspond—and in its demonstration of the impossibility of such an achievement—invites even more speculation about the applicability to dance of the kind of sign Krauss was interested in (the index) and the example of such a sign most relevant to Krauss (the photograph).

An index, according to Charles Sanders Peirce, "refers to the Object that it denotes by virtue of being really affected by that Object."[85] A system of material cause and effect is embedded in the concept—a system that is not inherent to language, but *is* neatly appropriate to Rainer's conception of the body in *Trio A.* Whereas Hay says, "i dance like a deer," Rainer moves "like an airplane." Rainer wants to dance as a "neutral purveyor of information"; Hay says, "i am dancing breath."[86] Indeed, if Rainer, like Hay, concerns herself with energy as the basic medium of dance, she mechanizes the metaphor. Hay, in the 1970s, talks about energy flow, but Rainer's 1960s rhetoric is about an economy: she is concerned with the body's "energy resources," with "conserving (actual) energy."[87] Rainer seems to conceptualize the body in terms of muscles and tendons, mechanical forces—the "cogs-and-gears, cams-and-levers" of the flesh.[88]

The model of the body underwriting *Trio A* thus complements its "geared" mode of signification.[89] In 1961, five years before the debut of *Trio A,* Roland Barthes arrived at the idea of the photograph as "the message without a code" by pointing out that in photographic communication "it is in no way necessary to divide up . . . reality into units and to constitute these units as signs."[90] This is another way of describing the photograph's indexicality: unlike other kinds of representation, a photograph does not involve a coding of reality into preexisting signs. Photography's mechanical representation *automatically* transfers the whole of the visual field to the surface of the image: "the photographic message is a *continuous* message."[91] Just as the idea of direct, mechanical cause and effect in photographic signification echoes Rainer's body-concept, Barthes's evocation of indexicality via the lack of division has a special resonance with *Trio A,* in which, as we have seen, the suppression of individual phrases is the structural foundation of the dance's mode of meaning. It might be said, then, that the special continuity of motion allows a direct, imprintlike or even indexlike relation between danced signifier and bodily signified in *Trio A.*

And yet, just as we've seen that *Trio A*'s paradoxical continuity also incorporates a quasi-photographic stoppage, so, performing traces of previous dance, itself tracing the bodily facts it makes present, *Trio A* is characterized by a mode

of signification suspended at that point at which indexical directness flips over into mediation. And it is in this that it may be, in the end, most intimately wed not to the indexical in general but to the photographic specifically. Compared to linguistic representation, photographs offer a mode of startling immediacy. In contrast to live performance, however, even indexical images are secondary and mediating artifacts—the residue that necessarily inflects any approach to the performance art of the past. *Trio A*'s own involvement with photographic modes centers around this duality. As *Trio A* engages it, the photographic is both that which makes present and that which mediates; to use Denis Hollier's terms, it is both performative and descriptive.[92] The felt body of the dancer is both intensely present in *Trio A* and already a trace—and it is this quality that makes the dance profoundly historical. Rainer's writing on the media's representation of the Vietnam War is only the most obvious manifestation of the currency of this issue: that indexical technologies which bring distant events and people into shocking presence also displace those events and people to the spectacular, spectral realm of the merely represented.

Composed in late 1965 and debuted in 1966, *Trio A* obviously cannot be considered a response to the precise conditions Rainer decried in the months of the Tet offensive. Rather, the dance she invented and the terms in which she framed it in 1965 to 1966 manifest a certain "seeing difficulty" with cultural relevance in the mid 1960s, one that emerged by the time of her presentation of the final version of *The Mind Is a Muscle*. The pictured violence Rainer evoked in her 1968 statement is among its most powerful examples. As such scenes are replayed, reproduced, and reused, they lose some of their power of directness. With all the honors Adams received for the photograph of the Loan shooting, for instance, it came in many contexts to signify his skill. As it became a standard in illustrated histories of the Vietnam War, catalogs of war photography, and the canon of documentary photography generally, the image stood for both excellence in photography and the medium's uncanny and politically powerful ability to capture the split second between life and death. Widely reproduced following Loan's death in exile in California in 1998, and accompanying most of Adams's 2004 obituaries, the photograph has most recently come to signify

the difficulties, on both sides, of being forever linked to such an image. That is, the Adams photograph is a particularly clear case of how the indexical image can be made symbolic.

Trio A is Rainer's most reproduced and reproducible dance. Early on she stipulated that anyone who wanted to learn it could, and anyone who wanted to teach it to others was welcome.[93] In this reproducibility, the work again parallels the photographic. But what has happened is that due to the sanctioned reproduction of *Trio A* by others, due to the film version made in 1978, and especially due to Rainer's own frequent reuse of the dance in later performance works, it has come to be something of a signature piece. You can sense this tendency in the narration of a public television program that calls the work a "mini masterpiece," in the scholarly discussions that recognize it as a key work for the whole of postmodern dance, and in the recent cases, from its restaging at a Judson Memorial Church benefit to its reframing as *Trio A Pressured,* where it became the centerpiece of Rainer's return to performance circa 2000. As she somewhat ruefully allows, it has become "my trademark work."[94] *Trio A* cannot simply point to the felt body, if ever it could, because it now signifies postmodern dance, Rainer's choreography, or Rainer herself. In this way, too, *Trio A*'s immediacy is mediated, presentation overwritten as representation.

Rainer's decision to raise problems of body and image and of abstract art and political relevance in the 1968 program notes of *The Mind Is a Muscle* underscores the fragility of the distinction between the categories at play: dance and spectacle. Later in the year, Frederick Castle chose to quote the final paragraph of Rainer's "Statement" in full in an *Art News* article.[95] It's tempting to think that he included the passage because he recognized the wide relevance to the art world of its message: in 1968, the world-in-crisis *was* a world of representation. As it holds together the felt and the seen, but nevertheless always registers their division, Rainer's danced manifesto embodies just this conjuncture. The dance opposes what Weber calls television's splitting of "events, bodies, subjects," its prying away of the body seen from the body felt, but only by replacing this splitting and prying with a mode of signification that is itself ambiguous: the indexical, both moored to the real and slipping into the stream of representation.

And so we can think of the term "dance photography" differently in light of *Trio A:* as a dance that dips into something called the photographic for its means of structure and operation. The photographic returns to *Trio A* not as actual image, but as structuring paradox.

Tracings

It begins to make a bit more sense, then, that a dance as carefully unspectacular as *Trio A* produces such dramatic photographs, and also that many images of *Trio A* and pictures of more conventional dance approach one another in striking ways. The most often reproduced photographs of *Trio A*—with their high contrast, broad fields, and grainy quality—rely on conventions of documentary, but the bodies in these images seem to return *Trio A* to the world of conventional dance, and to edge its images toward the conventions of dance photography. If the disparities between these images and typical pictures of dancers are obvious, their similarities are thus all the more striking—the way a bare-chested Steve Paxton strikes a graceful *attitude;* the way David Gordon, even in the midst of performing *Trio A* as a protest dance, seems possessed by a balletic *ballon* (figures 3.9, 3.10, 3.11, 3.12).[96] We might now, however, understand this visual convergence as less a betrayal of *Trio A*'s oppositionality than a clue to the conditions of the dance's operation.

More than Judd's or Morris's writings, it was Barbara Rose's 1965 "ABC Art" that Rainer used to articulate the parallels between *Trio A* and the visual arts of the mid 1960s. There she would have read a quotation from Merce Cunningham, writing a decade earlier: "since our lives, both by nature and by the newspapers, are so full of crisis that one is no longer aware of it, then it is clear that life goes on regardless, and further that each thing can be and is separate from each and every other, viz: the continuity of the newspaper headlines."[97] Substitute "photos" for "headlines" and you have a description of the kind of paradoxical continuum *Trio A* establishes; replace Cunningham's naturalizing equanimity with Rainer's critical consciousness, and you have a suggestion of the relevance of that continuum to dance in a society increasingly organized

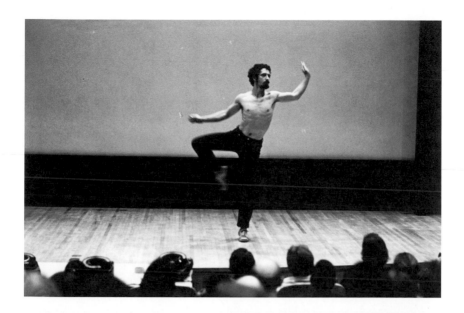

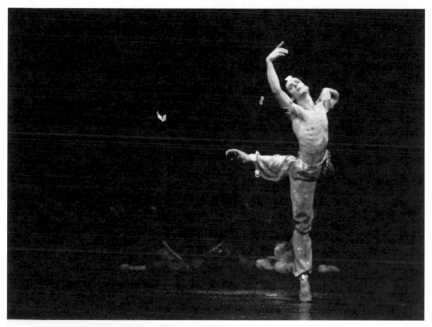

3.9 Yvonne Rainer, *Trio A,* 1966. Performed by Steve Paxton in Rainer's *Performance Demonstration*. Library of the Performing Arts, New York, 16 September 1968. Photo: Peter Moore. © Estate of Peter Moore/VAGA, New York, NY.

3.10 Angel Corella as Ali the Slave in *Le Corsaire,* choreography 1962 by Rudolf Nureyev, after the 1856 original by Joseph Mazilier as revised by Marius Petipa. Photo: MIRA.

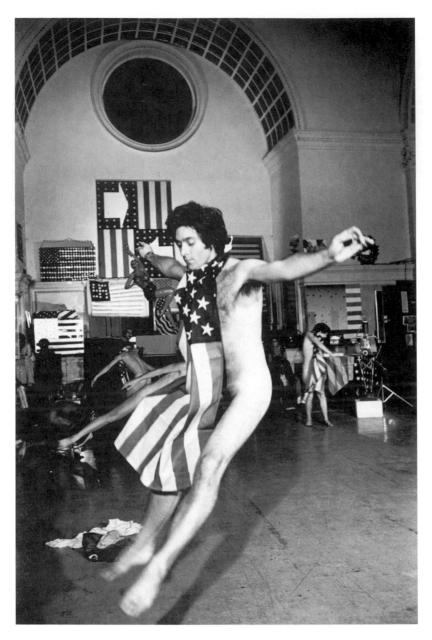

3.11 Yvonne Rainer, *Trio A with Flags*, 1970. Judson Memorial Church, "People's Flag Show," New York, 9 November 1970. Pictured: David Gordon. Photo: Peter Moore. © Estate of Peter Moore/VAGA, New York, NY.

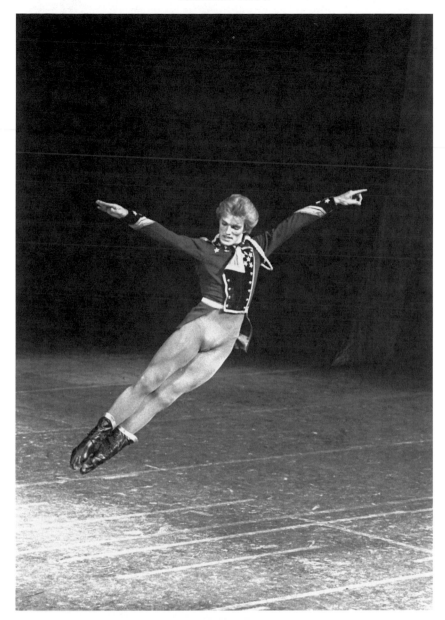

3.12 George Balanchine, *Stars and Stripes,* 1958. Performed by Peter Martins. Photo ©
Martha Swope.

through mass media and spectacle. *Trio A,* we've seen, has no differentiation between phrases, no (visible) modulation of energy. It is all transition—but this is to say, it is also all climax. And if this logic is built into *Trio A,* then it is no wonder at all that the dance produces such beautiful pictures. For *Trio A* might now be understood as one continuous photogenic moment. In 1968 Jill Johnston evoked *Trio A*'s effect for readers of the *New York Times* as "a sense of the dance being at rest, static, even as it constantly moved."[98] The camera does not so much freeze *Trio A* as distill it.

So it becomes necessary, finally, to reconsider the statement that I have fixed upon in this chapter: Rainer's passing fancy that conventional modern dance was phrased so as to "register like a photograph." The artist has since looked back on the 1966 essay in which she made this tendentious claim, and recognized the particularly youthful haste with which she had deconstructed her dance ancestors. Perhaps she would not have been so quick with her critique, she admits, if she had seen more of this classical modern dance in person. And here I have a start of recognition, for Rainer herself provides a precedent for my latter-day approach to her dance through its photographs. "Just as young dancers of the '90s can only follow '60s dance from so many removes," she writes, her generation could approach the performance work of thirty years earlier only through technologies of mediation: "a book, some photos, a scrap of film."[99]

That should be the end of the chapter. But I keep coming back to the pictures. And I can no longer help noticing that in almost all the photographs of *Trio A,* one small part of the performer's body tends to be out of focus (figure 3.13). Hands, feet—they blur out sections of the images, as if making snow angels in the photographic emulsion. It could be argued that this blurring is itself a conventional visual sign for motion "too quick for the camera to see." If so, however, *Trio A*'s own dialectics demand that we also view these passages as miniature acts of rebellion within the photographs themselves. It is almost as if the dancers of *Trio A* are rubbing out the photographic surfaces; almost as if the frozen bodies are resisting their photographic status, still.

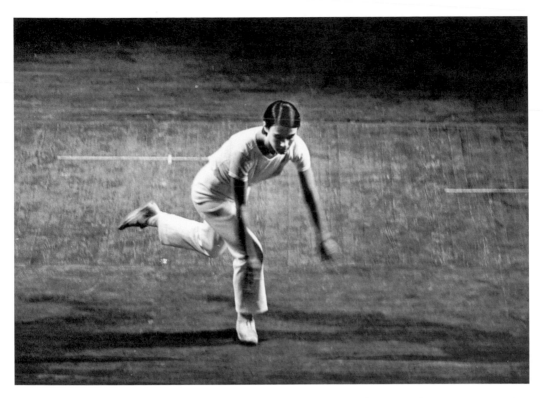

3.13 Yvonne Rainer, *Convalescent Dance* (*Trio A* performed by Rainer in convalescent condition), 1967. Angry Arts Week, Hunter Playhouse, New York, 2 February1967. Photo: Peter Moore. © Estate of Peter Moore/VAGA, New York, NY.

OTHER SOLUTIONS

How to use the performer as a medium rather than persona? Is a 'ballet mechanique' the only solution?[1]

—*Yvonne Rainer, "Miscellaneous Notes" on* The Mind Is a Muscle

As a choreographer, Yvonne Rainer was interested in the objective nature of the human body—its status as a physical thing. So critics have told us, and so Rainer has amply demonstrated, in words and in work. Witness her desire to get "away from the personal psychological confrontation with the performer";[2] her concern to "weight the quality of the human body toward that of objects and away from the super-stylization of the dancer";[3] the recurrence, in her famous dance *Trio A,* of moments in which "one part of the body becomes an object for another part of the body to lift";[4] her acknowledgment that in her work "people may become object-like in the way they are manipulated";[5] her interest in the idea that "objects and bodies could be interchangeable."[6] Consider her contrast between the "imperial balletic body" of conventional theatrical dance and the way "the body is an object" in her dance of the 1960s;[7] think of her request to be treated like a thing herself when, lying down across the laps of several audience members, she asked them to "please pass me along the row."[8]

Take a look at the 1969 image of *Continuous Project—Altered Daily* where Becky Arnold becomes a pallet for the conveyance of a cardboard box (figure 4.1). Or remember Rainer's entreaty to one of her dancers, circa 1966: "Try thinking of yourself as a barrel."[9]

In the last chapter, "image" was the crucial term for understanding Rainer's interrogation of the body presented to vision. Now I want to turn to another dimension of the problem, one whose central term is "object." Rainer's conceptualization of the object-body in the mid to late 1960s is a particularly revealing form of 1960s artistic antihumanism—the pervasive interest among artists of her generation in upsetting interpretive modes of spectatorship and the conceptualizations of art and personhood that underwrote them. In particular, Rainer's gestures toward treating the human body like any other object paralleled, exaggerated, and offered subtle correctives to the other art of the period for which "object" was a central concern: that produced by the visual artists in her New York milieu who were then becoming labeled minimalists. Artists like Donald Judd, Carl Andre, and Robert Morris imagined an art so specific and situated that it would preclude metaphorical, metaphysical, or psychological interpretation. As these other artists so often did, Rainer's art of the mid to late 1960s reminds us at every turn that the object is always an object *of* spectatorship. What she adds to this view is a typically problematic recognition: that its spectators are (only) human.

SPEAKING OF ANTIHUMANISM

In 1964 Herbert Marcuse commented on the condition of art in a world where humanist themes were deployed and dissolved in the consumer culture stream of images and information, where "the music of the soul is also the music of salesmanship."[10] Minimal art and postmodern choreography together took part in a widespread period attempt to counter assumptions inherent in the idea of an art "of the soul." According to these assumptions, even in abstraction art ought to transcend the merely material, revealing the subjectivity of its creator, expressing universal values, or addressing the essence of the human condition. Such beliefs

4.1 Yvonne Rainer, *Continuous Project—Altered Daily,* 1969. Performed in *Connecticut Composite,* Connecticut College, New London, Connecticut, 19 July 1969. Pictured: Becky Arnold (top), David Gordon, Douglas Dunn, Yvonne Rainer, Barbara Dilley. Photo: Ellen Levene. Research Library, The Getty Research Institute, Los Angeles (2006.M24).

Rainer's peers often labeled "humanist" and associated, in a broad way, with the rejected inheritance of the New York School in painting and Martha Graham in dance. It was in this mode that, in early 1964, Frank Stella famously complained about "the humanistic values" that old-fashioned viewers insisted on finding in art, "asserting that there is something there besides the paint on the canvas. My painting is based on the fact that only what can be seen there is there. It really is an object."[11]

There were at least two dimensions of the antihumanist artistic stance as it was discussed in the U.S. context in the mid 1960s. First was a precept about art spectatorship: Stella's prohibition of interpretive projection, or expecting works to "speak to you," which was given its most famous form in late 1964 by Susan Sontag's call in "Against Interpretation" for a spectatorship based in sensory experience rather than interpretation of content—an "erotics" rather than a hermeneutics of art.[12] Sally Banes registers this impulse in Judson dance when she identifies "a refusal to capitulate to the requirements of 'communication' and 'meaning'" in the art of Rainer and her performance peers at Judson Memorial Church.[13] The second dimension of antihumanism was a thesis about the changing understanding of the human self. Largely due to the 1970s writings of Rosalind Krauss, it has become well understood that the development of an art based on a nonhumanist model of subjectivity was part of minimalism's accomplishment. The idea is implicit in Krauss's early writing on minimal art, such as her 1966 essay "Allusion and Illusion in Donald Judd," where references to Merleau-Ponty hint at the appropriateness of an intersubjective and temporal model of the subject to this art, a proposition she went on to make plain in her essays of the early 1970s and to drive home most influentially in *Passages in Modern Sculpture* of 1977.[14] But for a sense of how the problem, if not the solution, presented itself earlier in the 1960s, listen to Brian O'Doherty in the *New York Times* just a month before Stella's famous comment, struggling to explain the dimensions of the change implied by the "excess of objectivity" that turned Stella's "pictures into mere objects": "His new paintings are unimportant. What is important is that they announce that a new kind of human animal is around, a new response to living life—one that is anti-emotion, anti-human, anti-art (by transgressing

its limits of expression or non-expression) and that is even anti-anti."[15] As if the paper's layout designer wanted to emphasize his point, O'Doherty's unillustrated review appeared adjacent to a photograph of Jackson Pollock in the act of "action painting"—what contrast could illustrate more clearly the passage from one mode of art, artmaking, and underlying model of "human animal" to another?

O'Doherty's intuition matches that made in musicologist Leonard B. Meyer's "The End of the Renaissance?" of 1963, an essay of currency great enough for that premier pulse-taker of American culture, Andy Warhol, to mention it to his *Art News* interviewer the same year.[16] Centrally concerned with Cage and other composers, but touching on abstract painting and sculpture as well, Meyer argued that the new art using chance procedures or radical abstraction to redirect audiences toward "what is really there to be perceived" arose from a coherent philosophical foundation. "*The Renaissance is over,*" he imagined artists to be saying: "Man is no longer to be the measure of all things, the center of the universe. He has been measured and found to be an undistinguished bit of matter different in no essential way from bacteria, stones and trees."[17] By 1966, responding to minimal art's major public debut in the Jewish Museum's "Primary Structures" exhibition, Mel Bochner could put the two sides of the problem together: the new art was "dumb in the sense that it does not 'speak to you,' yet subversive in that it points to the probable end of all Renaissance values."[18]

Perhaps necessarily, however, the two sides of artistic antihumanism coexisted uncomfortably. In finding the paintings themselves less important than the philosophical shift they "announced," O'Doherty reprised precisely the move from work to idea that the "anti-anti" aesthetic should have disallowed—the one Sontag would have bemoaned as "reducing the art to its content and then interpreting *that.*"[19] A similar problem was registered by Bochner's conjunction in the sentence I have quoted: the new work of art does not speak, *yet* it points; it bespeaks the end of humanist values by not speaking at all. This tension was palpable in the mid 1960s. To some writers, like Annette Michelson, the problem seemed to be other critics' inability to shake idealist habits of mind when confronted with art like Morris's.[20] Certainly the nihilistic vision O'Doherty imputes to Stella appears to be an error of this kind. The lesson of Rainer's work

of this period is slightly different, however: it is that we might take as the very object of consideration the incompleteness of the match between art, critical language, and philosophical models during this period; that this difficulty itself might be understood to constitute the field of artistic investigation. For, in working with the body-as-object, at once person and art, Rainer set herself up precisely at the strained center of the emerging artistic antihumanism.

The problems that necessarily arose from this position, and the value of her "other solutions" to them, are nowhere more evident than in five short films she made between 1966 and 1969. Predating her transformation from choreographer to feature-length, narrative filmmaker in the 1970s, these experiments were screened privately for artist friends such as Deborah and Alex Hay and Richard Serra and were shown publicly as elements of multimedia performances like *The Mind Is a Muscle* and *Performance Demonstration*. The last of the films, *Line,* was screened for art audiences when Hollis Frampton and Michael Snow selected it for a program at the Paula Cooper Gallery in 1969. After that, aside from isolated screenings for individuals who were able to borrow the films directly from Rainer, the shorts went unseen until her 2003 retrospective at the Rosenwald-Wolf Gallery of the University of the Arts in Philadelphia.[21] Happily, they have since become more much accessible, with their release on DVD by the Video Data Bank.

For the 2003 Philadelphia show, Rainer gave the films the collective title *Five Easy Pieces.* It is a borrowing befitting her claim that these are not quite full-blown artworks, but exercises of a kind.[22] Yet "easy," like dumb, silent, or boring (and Rainer also likes to call these her "short boring films"), is a word that tends to turn over into its opposite when it comes to art of the 1960s. The silent, 8 or 16mm films in Rainer's celluloid sketchbook are indeed modest, but also complex and telling. They are animated by a tension not unlike that of O'Doherty's interpretation of the anti-anti, or Bochner's "yet." Each of the film shorts equates bodies and things; each approaches the condition of *ballet mécanique* that Rainer mused about in the line from her notebook that is the epigraph of this chapter. Yet each ultimately refuses this condition, and the films' resulting ambiguities constitute a historically important critique of the period's antihumanist aesthetic from within.

ON THE ONE HAND

Against a pale gray ground, the back of a hand. Its fingertips graze the top of the frame, its wrist bone the bottom edge (figures 4.2, 4.3). For the next five minutes it is hand and nothing but hand for the viewer of Rainer's first film: hand moving, hand turning, hand filling the field of vision. The first two knuckles of the middle finger bend and straighten. The fingertip bobs between unmoving mates, and a tendon pops in and out of relief, demonstrating the hand's mechanics. The fingers rub against one another, bend forward, lean apart. The hand rotates on its vertical axis to show its palm. The fingers keep up their exploratory wiggling, each discovering how far it can reach and in which directions it can move, each discerning the shape and feel of the others. *Hand Movie* is a dance performed by fingers, tendons, palm, wrist, and thumb.

The black-and-white 8mm film, the low level of contrast, and the even lighting combine with the visual isolation of the hand—from its body, from its mate—to create a vaguely clinical mood (as opposed, for instance, to the atmosphere that might surround the animated but disembodied hand's horror film kin). This mode of studied neutrality, so typical of the artistic moment, comes in large part from the anonymity of the appendage onscreen. The hand belongs to someone, and we presume it to be Rainer's, but its attachment to a person seems beside the point. The hand is neither an old hand nor a child's; it is not immediately identifiable as either male or female; it bears no identifying—signifying—markers (no nail polish, wristwatch, rings).[23] The neutral mode of the film is also a function of its avoidance of all other kinds of signification: not one of the hand's gestures, even in passing, resembles a conventional sign (no spreading of index and middle finger to signal victory or peace, no "A-OK" circle of index finger and thumb). As Bochner would say, it does not "speak to you." Or perhaps it speaks an uninterpretable language. It is at once articulate and dumb.

This is all the more notable because, culturally, the human hand holds together the two things that artists in Rainer's milieu were most eager to drop from art circa 1966: individual personality and interpretable signification. Think of the "artist's hand," classic metaphor for the inherence of individual personality in the art object; or of the long history of attempts to link the seeming arbitrariness

4.2 Yvonne Rainer, still from *Hand Movie,* 1966. 8mm black-and-white film, silent, 5 min. Cinematographer: William Davis. © Yvonne Rainer.

4.3 Yvonne Rainer, still from *Hand Movie,* 1966. 8mm black-and-white film, silent, 5 min. Cinematographer: William Davis. © Yvonne Rainer.

of linguistic signs to the supposedly natural language of gesture; or think of the hands' ability in sign language to convey both linguistic meaning and emotional inflection. The hand—particularly the artist's own—is in all these ways the ideal medium to embody the tendencies Rainer and her generation were most concerned to evacuate from their art: interpretability, personality, transcendence. It is, then, in a virtuoso demonstration of minimalist restraint that *Hand Movie* refuses all of these, prying gesture from metaphor, hand from human self.

And yet, characteristically, what Rainer accomplishes with one hand she cuts into with the other. For, if it is a carefully cultureless hand, the very fact that the viewer recognizes it as such calls attention to the process that the film carefully stymies. That is, the film enacts—or it causes us to enact—our inability *not* to inventory and decode the cultural and biological data of a hand offered to our view. And while the hand may not convey information—it does not sign—the way we use our hands as information gatherers is everywhere implied by the exploratory movements of the fingers. That it is self-exploration, more than a little onanistic, only adds to the possibility for strangely psychological drama and comedy that undercuts the neutrality of the film (whose title Rainer admits was a partial pun on "hand job").[24] The hand's very verticality in the image gives it a humanoid presence, and as the fingers move they become ersatz figures as well. They even acquire personalities (isn't that middle finger the most adventurous and witty, the thumb a slightly dull hanger-on?) and have little digital dramas (isn't there something less than wholesome about the way the index finger gropes for the ring finger's fleshy pad?).

Now, it might be objected that to find such play in the film is to depart from a properly minimalist appreciation for the literal, physical thing—in this case, for the strictly physiognomic intelligence of the moving body, or body part. The encounter with minimalism, however, was never so pure, as no one noted better than Rainer herself. In a 1967 essay in *Arts Magazine,* the artist gave a wonderfully functionalist description of what was elsewhere referred to as the objecthood and literalism of sculpture by Robert Morris: his works are "stolid, intrepid entities that keep the floor down."[25] Rainer linked this quality to the explicitly antihumanist polemic of Alain Robbe-Grillet, whose *For a New Novel*

was "kind of a bible" for her in the 1960s, and whose aphorism became a pull quote for the article: "Man looks at the world, but the world does not look back."[26] The year before, Bochner too had cited Robbe-Grillet to help specify the challenge of the new art to prevailing aesthetics, finding in *For a New Novel* the epigraph for his review: "there is nothing behind these surfaces, no inside, no hidden motive."[27] Rainer, however, found it impossible to experience the minimalist objects as if they had nothing inside; as if they did not "look back." On this point she turned again to the French author: "One is drawn into a situation of 'complicity' with the object, to borrow a term from Robbe-Grillet. Its flatness and grayness are transposed anthropomorphically into inertness and retreat. Its simplicity becomes 'noncommunicative,' or 'noncommittal.'"[28]

This "complicity," which might also be described as imaginative projection or anthropomorphism, is an example of what I have been calling a seeing difficulty—a problem that is arguably always a part of art spectatorship, but which at a particular time and place becomes both newly problematic and newly productive for artistic work. Many commentators on minimal art, in the 1960s and since, have mentioned the paradoxical anthropomorphism of its blank, geometric forms.[29] Rainer was thoroughly involved in exploring this issue in the mid to late 1960s, and her work helps us see how integral it was to the central problem of the "object" in American art of this period. She took the inquiry in two directions, working with mere objects saturated with cultural associations, and with human bodies in their material objectness. Her notes indicate her interest in using "Objects that in themselves have a 'load' of associations (e.g., the mattress—sleep, dreams, sickness, unconsciousness, sex) but which can be exploited strictly as neutral 'objects.'"[30] She sounds fairly confident that such exploitation can be achieved, yet her interest in the associational "load" of objects, like her 1967 writing on Morris, indicates that the source of fascination was in fact the precariousness of objects' neutrality.[31] Slightly later, writing of "the body as a moving, thinking, decision- and action-making entity and the body as an inert entity, object-like," she hints at the significance of this instability. "The object can only symbolize those polarities," she wrote, "it cannot be motivated, only activated. Yet oddly, the body can become objectlike, the human being can be treated as an ob-

ject, dealt with as an entity without feeling or desire."[32] There is a drop of ambiguity—and a world of meaning—in that single word "oddly." Here we see Rainer's fascination with the fact that corporeal materiality can be separated from psychological reality; and here we get a hint of the problematic nature of that fact.

This is the evidence, too, of *Hand Movie,* and of most of her short films, where projection inevitably complicates the fit with assumptions about the period's artistic antihumanism. In his use of the term "complicity," Robbe-Grillet was lambasting the specifically humanist tendency to anthropomorphize the physical world, then hold it as a "crime against humanity" when contemporary artists like himself acknowledged instead the alien quality, the utter indifference, of inanimate matter.[33] In contrast, Rainer, in describing her experience of "transposing" physical qualities into characterological ones, recognizes and accepts such complicity as part of the act of looking. She is no reactionary—it is not *criminal* to remove the comforts of anthropomorphism. She is a realist—it is impossible to do so. The hand may not "speak to us," but we cannot help but speak to it. A body may become an object, but does so "oddly."

That same year, Rosalind Krauss wrote against a certain overkill, even literalism, in critical responses to "object-art." In her essay "Allusion and Illusion in Donald Judd," the critic detailed the phenomenological experience of one of Judd's horizontal wall pieces in a tour de force of critical description, explaining how the supposedly obdurate object actually shifts and changes relative to the position of the moving viewer who encounters it. In doing so, Krauss crucially reframed the minimal artwork-as-object as, instead, object-of-perception.[34] *Hand Movie,* and indeed in different ways all of Rainer's short films, make an argument not dissimilar to Krauss's, albeit in a different manner and with different ends. The differences have to do with the kind of perception the object is object of—phenomenological, psychological, or both at once. If treated as mere visual facts, the body objects in Rainer's visual essays would surely reinforce the view of cool, objective, and antihumanist treatment of things and bodies in 1960s art. When the work of spectatorship is reinserted, however, the antihumanism of the body-object idea becomes odd—which is to say, dialectical, active, and productive. And even, gradually, political.

Rainer began her experiments with the medium of film under extraordinary circumstances. *Hand Movie* was made in the hospital while she recovered from a life-threatening illness and major surgery in 1966. Her friend, dancer William Davis, brought a Super 8 camera to the hospital and filmed Rainer moving her hand: a way to dance when her body couldn't.[35] *Hand Movie* thus participates in the testing by Rainer's generation of the necessity of the link between dance and the ideal of a body beautiful, youthful, and well. She continued this investigation not long afterward when, following another bout of illness, she performed a shaky, weakened version of *Trio A* under the title *Convalescent Dance*. Beyond testing dance conventions, however, Rainer's work with dance and infirmity addressed fundamental questions about the status of the human body. Just as for writers like Meyer or Sontag, O'Doherty or Bochner, the old-fashioned, interpretive tendency in art spectatorship went hand in hand with particular assumptions about humanity itself, Rainer's film of a hand that isn't and is interpretable, that is both nothing but itself *and* a vehicle of psychology, raises questions about subjectivity. A hospital bed, after all, gives special vantage on the degree to which the body is a thing, the degree to which the body is a self, and the validity of that distinction. From this, then, Rainer's first film: a lesson, on the one hand, in physiological mechanics; on the other, in imagination.

IN RAINER'S CORNER

The meeting of mechanics and projective imagination also defined Rainer's next filmic venture. *Volleyball* (1967) is a series of shots, each a variation on the same basic scenario. The knee-level camera (operated by Bud Wirtschafter) is aimed down toward a wooden floor and into a corner. A ball rolls slowly into the frame, its impetus unseen. The camera moves slightly to track it. The ball bumps into one of the walls. Someone—of whom we can see only smooth, bare calves, white bobby socks, and a worn pair of Keds—walks toward the ball, slowly but purposefully (figures 4.4, 4.5). The feet meet the ball, touch it, or wait for it to touch them. When the ball settles into place, so does the camera. Cut. Repeat.

4.4 Yvonne Rainer, still from *Volleyball,* 1967. 16mm black-and-white film, silent, 10 min. Cinematographer: Bud Wirtschafter. © Yvonne Rainer.

4.5 Yvonne Rainer, still from *Volleyball,* 1967. 16mm black-and-white film, silent, 10 min. Cinematographer: Bud Wirtschafter. © Yvonne Rainer.

The ball's travel is based on high school physics. It is a body in motion, an equation of force, mass, and momentum. But here these factors are endlessly complicated by the incidentals no textbook asks a student to consider. The volleyball, which we think of as round, is of course far from it, its surface a pattern of deep grooves between strips of white leather. And this not-round body is put in contact with a floor that is as far from the physics book's frictionless plane as can be—a collection of warped and uneven floorboards, all gaps and snags. The combination of these specific topographies is all it takes to produce motion in endless variation, eccentric paths in which the ball doubles back or stops before it seems it should, takes a sudden jog left or right, or gives an animated little wiggle as it settles into place. The first few times, it is just a ball rolling, but the unexpected changes in momentum and motion grow increasingly engrossing, even endearing, as the scenario is repeated. We anthropomorphize once again; we are soon "complicit." Meanwhile, the feet take their few steps over and over, and details like the style of the socks and the holes worn in the sneakers are duly noted. There's no doubt who the star of this movie is, however: by the end, the ball seems as lively as a rambunctious child, the legs as wooden as the floor.

The dynamics of *Volleyball* become clearest if we look at the film as Rainer's answer to certain more canonical works of the 1960s. In one corner, picture the untitled 1964 piece by her then-companion Robert Morris: a giant plywood wedge wheeled into the corner of a gallery, altering the shape of the room (figure 4.6). In another, imagine Joseph Beuys's 1960 *Fat Corner,* filling the corner and thus the space with the German artist's particular brand of physicality-as-meaning (figure 4.7).[36] The slice that Morris's piece takes out of the room calls attention to the literal physicality of the altered architectural container and to that of the human viewer contained along with it.[37] The corner piece by Beuys saturates that physicality with meaning. Built on the contrast of architectural structure and formless fat, depending on the organic material's evocative fleshiness and on its role in the artist's personal myth of death and rebirth, *Fat Corner* works by setting off a series of symbols, more literary than literal.[38]

Volleyball, Rainer's corner piece, claims neither the neutral physicality of Morris's corner nor the mystical energy of Beuys's. Yet with its modest means it

4.6 Robert Morris, *Untitled (Corner Piece)*, 1964. Painted plywood, 70 x 108 in. (198.1 x 274.3 cm). Solomon R. Guggenheim Museum, New York, Panza Collection, 1991 (91.3791). © 2007 Robert Morris / Artists Rights Society (ARS), New York. Photo: David Heald. © The Solomon R. Guggenheim Foundation, New York.

4.7 Joseph Beuys, *Fat Corner*, 1960. Lard, dimensions variable. © 2007 Artists Rights Society (ARS), New York / VG Bild-Kunst, Bonn.

gives the viewer something of both. Like Morris's sculpture, the film insists on the relation between artwork and viewer. But where the minimalist wedge addresses us as physical entities whose primary determinants are spatial and kinetic, it is, again, the psychological propensity for anthropomorphic projection that Rainer's film causes us to acknowledge. Filmic time and motion allow Rainer to do what minimalism was supposed to avoid doing at all costs—to infuse the physical with something like personality—while her absurdly limited means and nakedly quotidian objects keep any hint of metaphysics at bay. The merely physical bodies and forces in combination with the irrepressible imagination of the viewer become wondrous *enough*—an alternative both to the demystifying recalcitrance of minimalist literalism and to Beuys's compensatory remystification of the physical world. In fact, Rainer's film requires us to look again at the other corner pieces—to note the situated materiality of the Beuys (that seepage into the room's walls) and the suggestive illusionism of the Morris (it hovers).

A few years later, Rainer encouraged her students (and the readers of *Aspen* magazine, in which her teaching text was published) to look at the human bodies sharing the dance studio in the same way as they viewed inanimate objects arrayed there. "Our bodies, despite the difference that lies in the fact of our volition, can be looked at in the same manner. We occupy space, when one of us moves out of that space he leaves room for another to enter, or for an inanimate object to be placed there. This place is chock-full of redistributable material."[39] Surely it's hard to imagine a more antihumanist imaginative exercise than the mental squint that would let one see that performers, objects strewn about, and audience members all take up space and can be moved, and in this sense can be considered interchangeable. Crucially, however, Rainer did not allow her lesson to be in the *simple* reduction of the human to the status of thing. She rounded the corner: "Inanimate bodies," she explains, "are also imbued with a basic dignity of presence."[40]

BALLET ORGANIQUE

In 1968 Rainer made two films that suggested, in very different ways, the beginning of the end of the neutral, objectlike performer she and her peers had been

exploring, and for which the stolid feet in *Volleyball* are a synecdoche. The first of these films, *Rhode Island Red,* creates as an alternative to the *ballet mécanique* an organic version—using animals rather than either human actors or inanimate objects. Shot by Roy Levin at a poultry farm where Rainer had stopped to buy eggs during a residency at Goddard College, it consists of two long shots, seven and five minutes long, of a barn full of chickens. Hundreds of pecking heads bob up and down. Occasionally, a bird fluffs feathers and wings in a short flight before returning to the field of perpetual avian motion. In the first shot, light streams in from the side, washing out the back wall of the barn and making the size of the space impossible to gauge. In the second shot, the camera has been relocated, closer to the chickens, and with the space behind them closed off by a row of their roosts (figures 4.8, 4.9).

The film is effective at closing off signification as well. None of the poultry-related metaphors (pecking order? henhouse?) give any entrée into the meaning of what is going on in this film, with its setting so seemingly distant from the urban lofts, basements, and gymnasiums that are normally the staging ground of Rainer's art. Nor is there any kind of commentary on farming practices or animal rights, though hundreds, maybe thousands, of chickens are packed together on the floor of the barn. Rather, *Rhode Island Red* is all but abstract: a massive, moving, all-over painting on film. It might even seem aestheticizing, if its monotonous temporal extension, like one of Bruce Nauman's deadpan, repetitive films of the same period, weren't such a test of the viewer's attention, and if the total effect of the incessant motion of these living creatures were less like television static.

The kind of movement with which Rainer fills the screen in *Rhode Island Red* is distinctly inhuman; no dancer could recreate the stuttering precision with which the pecking birds jerk from position to position. With its dancer-less field of motion, this short film comes closest of the five to *ballet mécanique,* and you can see why Rainer would describe it as both funny and bitter.[41] And yet this is also the film that pulls back most sharply from performance voided of human subjectivity—at least for a moment. For there is incident in the film after all: the cut from the first shot to the second, certainly, but also the entrance halfway through the first shot of a distant human figure at the far end of the

4.8 Yvonne Rainer, still from *Rhode Island Red,* 1968. 16mm black-and-white film, silent, 12 min. Cinematographer: Roy Levin. ©Yvonne Rainer.

4.9 Yvonne Rainer, still from *Rhode Island Red,* 1968. 16mm black-and-white film, silent, 12 min. Cinematographer: Roy Levin. ©Yvonne Rainer.

coop, methodically gathering eggs (figure 4.10). A small, faint silhouette almost lost in the bright light and nearly hidden behind a support beam, visible only for a few minutes if it is noticed at all, this wraithlike figure changes everything. The film becomes, not a purposefully boring temporal exercise nor a wry statement about the possibilities for postmodern dance, but a hesitant dialectic of the mundane and the transcendent—one that begins to reframe the kind of dance Rainer was known for inventing. The choreographer wrote in 1966 that what she was aiming for in her dances was a quality of movement resembling the way "one would get out of a chair, reach for a high shelf, or walk down stairs."[42] It was this prosaic quality that characterized the "movement-as-task or movement-as-object" with which her work of the minimalist moment brought the dancing body back to literal, physical, fact. In the chicken coop, Rainer discovered a found-object version of this kind of activity in the literally quotidian task of the egg gatherer. Now, though, in 1968, contrasted with the inhuman movement of the chickens and wrapped in radiance, this tasklike motion becomes, against all expectations, lyrical. It *is* the music of the soul—albeit for a world that may not have one. The man performs his workaday human movement: plain, uneventful, and unaccountably touching. And then Rainer cuts to another shot of chickens in the coop.

BALLS

The second film of 1968 takes place in a space as unlike the chicken farm as can be imagined—a white-on-white, fashionably minimalist living room—and no amount of critical projection could lend it the elegiac tone I find in *Rhode Island Red.* Perhaps the best period record we have of the sensibility of Rainer's performance, the film finds its way out of a strict objectivism through humor rather than transcendence.

Shot by Phill Niblock, featuring dancers Steve Paxton and Becky Arnold and an enormous white balloon, *Trio Film* is the first of Rainer's movies to include human figures who are both whole and fully visible (figures 4.11, 4.12). Yet this difference does not lend the film any more drama than found in

4.10 Yvonne Rainer, still from *Rhode Island Red,* 1968. 16mm black-and-white film, silent, 12 min. Cinematographer: Roy Levin. ©Yvonne Rainer.

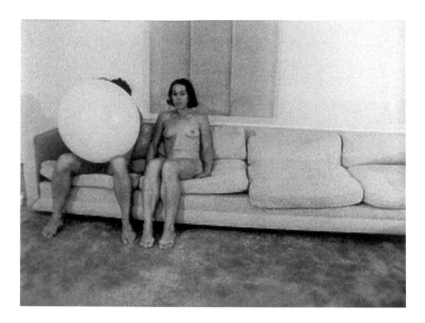

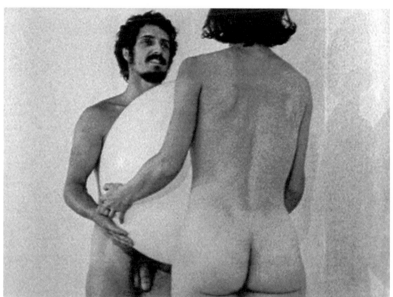

4.11 Yvonne Rainer, still from *Trio Film,* 1968. 16 mm black-and-white film, silent, 13 min. Cinematographer: Phill Niblock. Performers: Steve Paxton and Becky Arnold. ©Yvonne Rainer.

4.12 Yvonne Rainer, still from *Trio Film,* 1968. 16 mm black-and-white film, silent, 13 min. Cinematographer: Phill Niblock. Performers: Steve Paxton and Becky Arnold. ©Yvonne Rainer.

the earlier works. Clive Barnes described it as "singularly boring: nothing but a naked man and a naked woman throwing an enormous balloon one to the other."[43] In fact, the performers' behavior includes calm, inaudible chatting on a couch and performing back somersaults over it, passing the balloon back and forth and seating it next to them, tossing it between them and walking to and fro with its weightless body pressed between their bellies. Niblock's camera plays along, sometimes tracking the travel of the balloon, sometimes that of a person, sometimes lingering on an empty seat cushion until the balloon is placed there. Rainer called the carriage of the performers in *Trio Film* "decorous," and everything is indeed done with a calm detachment, all the more notable because both performers are nude. Rainer has referred to *Trio Film* as her *Déjeuner sur l'herbe:* it is comparable to Manet's painting in the conjunction of civilized, social behavior and matter-of-fact nakedness.[44]

The conceit of the film is the likeness of the three entities within it. At two and a half feet in diameter, the white balloon has a certain bulk. It is near-weightless, of course, but like Claes Oldenburg's outsized, soft typewriters or toothpaste tubes (figure 4.13), the balloon has bodylike qualities. These do not include the fleshiness or weight of the human figure, of course. The balloon is a body in the way a planet is a celestial body or a swallowed coin a foreign one: the concept *body* separated from *human* or even *animal*. At the same time, like the volleyball in Rainer's earlier film or the hand in her first, the balloon is an object that attracts projection. As it bounces into the scene or takes a seat beside the dancers, it becomes a performer in its own right. Whether to recognize this is to anthropomorphize the balloon or to depersonify the performers is crucially and delightfully undecidable: either the balloon has as much personality as the affectless dancers, or they have as little as it does. Rainer's title doesn't distinguish between human and nonhuman members of the "trio."

Here, Rainer again exemplifies the vaunted neutrality of the 1960s avant-garde. Filmed in 1968, *Trio Film* was made at the height of minimalism's ascendancy in the visual arts. By then, minimal art had become an -ism, had been featured in several major museum exhibitions, and was on tour in Europe as the latest officially certified American contemporary art.[45] Rainer's own theorization of

4.13 Hans Hammarskiöld, *Claes Oldenburg, London, 1966,* 1966. Gelatin silver print, 11 7/8 x 9 3/8 in. (30.2 x 23.8 cm). © Hans Hammarskiöld.

minimal aesthetics in dance appeared in Gregory Battcock's movement-defining anthology *Minimal Art* that same year. It happens that the apartment in which *Trio Film* was shot belonged to Virginia Dwan, the dealer whose gallery—with exhibitions such as "10" featuring Carl Andre, Jo Baer, Dan Flavin, Judd, Morris, and others—was at the time "the hot bed of 'cool' art" (in the words of Lucy Lippard).[46] One needn't know the apartment's owner to identify the sleek, low, white furniture against white walls and on white carpet as the latest in minimal chic, however; nor to recognize the film as a gentle poke at the seriousness of minimalist art.

Imbued all along with something like what a viewer once astutely called Rainer's "goofy glamour,"[47] it is fitting that *Trio Film* ends in laughter. Arnold tries and fails to keep a straight face, as Paxton, visible only from the waist down and holding the ball to his abdomen, jumps up and down on the cushion next to her, causing his penis and testicles and her breasts to bounce like so many white balloons (figure 4.14). The film ends, in Rainer's words, when Arnold's "professional detachment" crumbles into "unabashed glee."[48] It is as if the whole exercise had been a test: How long can you keep pretending your nude body is neutral—that your physicality is the same as that of a white balloon, or that sexual difference can be stripped from human bodies as easily as clothes? *Trio Film* happily undercuts the physical neutrality it so carefully establishes.

After seeing *Trio Film* projected onstage opposite a pornographic film in Rainer's performance piece *Rose Fractions,* Carl Andre wrote her an admiring letter, musing that "making love looks like the blue movie but feels like the balloon movie."[49] The aesthetic of "object-art" had been transformed by *Trio Film*—for Andre, into a visual metaphor of subjective experience itself. The film remains the document of a period attempt to think the human body as part of the physical world, an object among objects. However, its pleasures—for us and for the performers—turn on the disparity among objects inanimate and animate, male and female. The likeness of breasts, balls, and balloons is funny precisely because, in the world outside the white-on-white enclosure, they are so significantly different. *Trio Film* is unlike minimalist sculpture (more like Oldenburg's, perhaps, or Hesse's) in that it registers the potential absurdity of its premise.

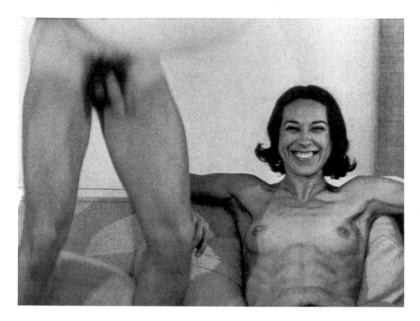

4.14 Yvonne Rainer, still from *Trio Film,* 1968. 16 mm black-and-white film, silent, 13 min. Cinematographer: Phill Niblock. Performers: Steve Paxton and Becky Arnold. © Yvonne Rainer.

Even as it jokes, however, *Trio Film* evinces historical shifts. Introducing sexual difference into the equation of bodies and things, it moves toward yet another "seeing difficulty," one around which Rainer and so many other artists, filmmakers, and critics would soon organize their cultural politics.

A LINE CROSSED

Like *Volleyball* and *Trio Film,* Rainer's last short film, *Line,* includes a round object whose source of movement is not shown. Shot by Niblock in 1969, the film begins with a black ball emerging from the lower left corner of a blank, white frame, moving slowly on the diagonal toward the upper right (figure 4.15). Unlike the volleyball that rolls and the balloon that floats into Rainer's images, the black circle moves at a constant, slow pace and is not subject to gravity or momentum. There is nothing in the image to give us a sense of scale—the ball could be large and distant or tiny and close to the camera, and the white space around or behind infinitely deep or minutely shallow—until a pair of legs, clad in white trousers, steps into the frame. The legs are followed by the rest of the body of a young woman with blond hair and heavily made-up eyes, who lies down on her stomach, facing away from the viewer. This performer, Susan Marshall, holds a pen and seems to write on a vertical white surface before her. Although we can't see the text she produces, her gesture causes this plane to "appear" in a space whose shape and size are now defined in relation to her body (figure 4.16).

This film centers on the three-way relation of object, human body, and space—which is to say, on the defining triad of minimal art. Within this minimalist situation, however, Rainer dissolves the literalness, the grounding in the physical world on which minimalist art (including her own) insisted, and undercuts the very understanding of the human body that this art had put in place. First, *Line* reveals itself as an experiment in the camera's capacity to distort distance and scale. We are never quite sure of the size of the black bead or its location, even once the body of the woman gives us a clue to the spatial dimensions

4.15 Yvonne Rainer, still from *Line,* 1969. 16mm black-and-white film, silent, 10 min. Cinematographer: Phill Niblock. © Yvonne Rainer.

of the shot. When viewers encounter minimalist objects like Morris's, the relationship of body and thing is meant to ground both artwork and viewer in their irreducible physicality. In a neat reversal, Rainer here stages a similar encounter, but as a filmic trick, a special effect.[50] The viewer is now unequivocally a spectator, outside the scene of the encounter, disembodied and ungrounded.

But the film's revision of minimalist presence goes further. It seems no coincidence that it is with writing—language, code—that the woman shapes the space around her. In this film, materiality gives way to a reality that is cultural rather than physical. As the ball continues to crawl on its diagonal path,[51] the woman squirms around in the nowhere space. Sometimes she crouches, so that her bottom fills the frame. She periodically leans on her elbow and looks over her shoulder at the camera, speaks (though we can't hear her), bats her eyelashes, and flashes flirtatious grins (figure 4.17). These smiles are a far cry from the irrepressible laughter of Becky Arnold in *Trio Film*, just as Marshall's behavior is the precise opposite of the tasklike movement in the earlier experiment, and in so much of Rainer's performance. Here, instead, is self-display filtered through millions of media images. Indeed, Rainer described Marshall's expressions as "classic toothpaste-ad" smiles.[52] With this film, the social meaning of the equation of human and thing has entered the picture.

Line is thus significant as an instance of the breakdown of minimalism's neutral mode of embodiment—its tendency "to position artist and viewer alike not only as historically innocent, but as sexually indifferent," as Hal Foster has put it.[53] Foster credits the mid-1970s feminist art of Mary Kelly, Barbara Kruger, and others with the critique of this aspect of minimalism, and Rainer's later, more overtly feminist films could well be listed among these interventions. Her set of short filmic experiments, however, is an important place to look for the critique's prior historical emergence. In these, the asexual, cultureless body of minimalism gradually becomes unsustainable. Though Rainer continued to explore the relations and likenesses of bodies and objects in her performance work and films, something crucial happens in *Line*. Object becomes objectification. If in Rainer's dance work it was productive to liken the treatment of bodies and the treatment of objects, and if in *Trio Film* bodies and objects were equivocally and

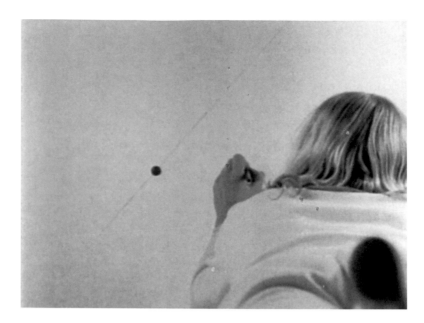

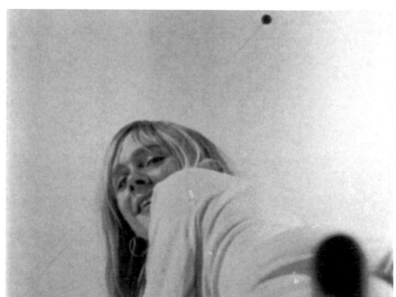

4.16 Yvonne Rainer, still from *Line,* 1969. 16mm black-and-white film, silent, 10 min. Cinematographer: Phill Niblock. Performer: Susan Marshall. ©Yvonne Rainer.

4.17 Yvonne Rainer, still from *Line,* 1969. 16mm black-and-white film, silent, 10 min. Cinematographer: Phill Niblock. Performer: Susan Marshall. ©Yvonne Rainer.

cheerfully equated, in *Line* that equation takes a nasty turn. It does so in a direction that seems strikingly prescient, given the lines of inquiry followed in the feminist film theory that emerged in the following decade. For the meaning of "object" has shifted: no longer that material, physical, and situated thing-in-itself, stripped of interpretable content, it is now object as in "object of the gaze."

Avant-Garde and Counterculture

"We oppose the depersonalization that reduces human beings to the status of things."[54] In this simple sentence from the Port Huron Statement, the founders of Students for a Democratic Society articulated the model of subjectivity that backed the political and cultural revolution augured by their 1962 document—and the model was unapologetically humanist. To read this sentence in the context of a discussion of advanced art of the 1960s—and in particular Rainer's work with the human body as thing—is to wonder about the line between aesthetic antihumanism and the dehumanization whose pervasive critique drove dissent in other arenas. And, no matter how accepted the art of the minimalist moment has become, at a time in which "dehumanization" remains a rallying point for those protesting U.S. antiterrorism policy,[55] and when the U.S. president characterizes the nameless, faceless enemies from whom the Patriot Act is meant to protect us as "people who have no soul,"[56] it is not difficult to make strange the artistic moment when treating human beings as things seemed a worthwhile aesthetic goal.

Scholars have given us several ways to understand the discrepancy between avant-garde and counterculture, Greenwich Village and Port Huron. One can, with some art historians, see artists like Stella or Judd to have been more or less wrapped up in the technocratic project of mainstream society in the cold war era.[57] One can, as structuralist and poststructuralist critics would, understand artists to have gone much further philosophically than did the optimistic leaders of youth movements, early in their own project. One can posit a shift between 1962 and 1966. Or one can question whether the object-art aesthetic ever really *was*.

The play with objects and bodies in Rainer's *Five Easy Pieces* is tonic against any tendency to think of antihumanism in 1960s art as fixed, accomplished, or achieved—as a position an artist could occupy, a characteristic she could have, or a philosophy to which she could subscribe. Instead, such play implies that antihumanism was something more like a process in which an artist might engage, something for which we might use all the bobbing and nodding and bouncing in the films as metaphor: antihumanism only, ever, in motion. Despite the manifesto-like claims of the critics, despite the influence of Robbe-Grillet, Rainer's work suggests that artistic antihumanism was always a pole in a dialectical formation; always both attraction and absurdity. And it was as rocked between these poles that the body-object idea developed its value. While it is sometimes difficult now to see how treating a human body like a thing could seem like a good idea, it is also easier now to see why such treatment was a crucial, historical problem for art to try out, play with, undercut, and transform. To see that human beings could be treated like things, but to see it "oddly." How to acknowledge dehumanizing conditions without becoming part of them? How to imagine a way out of those conditions without becoming their disguise? An answer to the double problem of art in late modernity is a lot to ask of a hand, a volleyball, and some chickens. But present chicken, ball, or hand to a viewer, play the complex cultural work of looking against the object nature of the viewed thing, and other solutions begin to develop.

Performance Demonstration

Why Are We in Vietnam?

This question hung over Yvonne Rainer's artistic practice circa 1970. Or so I will be arguing here, proposing that such an inquiry was in the air of her performances in the late 1960s and early 1970s, even when not being explicitly addressed; and suggesting that the quality of its suspension there is crucial for characterizing the kind of political art she was then developing. So it seems fitting to begin with a moment when the question hung over Rainer's practice quite literally: in the form of a twelve-foot-long, handwritten banner she placed in the gym at George Washington University, where she taught as artist-in-residence in June 1970.[1] When her class went out of doors, so did the sign. And not to the nearest grassy spot, but to the Ellipse, some seven blocks away, directly across from the White House. As the dancers went about exercises called "war games" that Rainer was developing at the time—crawling, rolling, and walking in line formation; charging at and tumbling over one another; converging, dispersing, and collapsing[2]—her question hung in the Washington air. Or rather, it hung on a park fence, in full view of White House guards and of visitors queued up for tours of the presidential mansion.

This action was not a dance performance, exactly, and Rainer does not list it in any of the published chronologies of her work. Nor was it, relatively speaking, a terribly bold piece of political theater—not for the summer of 1970, only a few months after the bombing of Cambodia, the shootings at Kent State and Jackson State universities, and the nationwide demonstrations that followed. As Rainer remembers it, she and her students did not display the sign as they walked along the streets to the Ellipse, and they removed it promptly when asked to by White House guards. Likewise, the question on the banner is almost conciliatory by protest sign standards: not the strident imperative of "fuck the draft," not even the insistence of "peace now," but a gentle, if pointed inquiry.

Nevertheless, the sign hanging was not done casually. Rainer was prepared to give up the carefully arranged, prestigious, and financially helpful summer gig if the university did not let her display the banner in the gym for the length of her stay, which she did, even though in a compromise worked out with the university's physical education department, which had jurisdiction over the gym and put up great resistance to her plan, she had to take down the banner after and rehang it before each of her classes.[3] And while Rainer's account of the Ellipse episode makes it sound fairly nonconfrontational, the location was a charged one: the Ellipse had been the scene of a major antiwar demonstration that May in the wake of the Kent State shootings, fueling a debate over whether regulations should be put in place to forbid political gatherings in the parks surrounding the White House.[4] In the memory of Washington-based choreographer Maida Withers, who participated in Rainer's Ellipse class, the guards sat on horseback tensely overseeing the dancers' activity, the dancers refused to take down the sign, and the White House tourists booed loudly throughout the event.[5]

Even if it *were* a modest act of political dissent, however, the story of the Washington banner would remain remarkably telling. Telling about changes in Rainer's practice, and in the world of advanced art she was a part of, at the height of the Vietnam War. Telling about the question of presence, so foundational for the study of performance, for the art history of the 1960s, and for this investigation of Rainer's work. And telling about what we think political art is—or should be—able to do. I hope the ways the episode of the sign begins

to tell all this will be evident by the end of the chapter. For now, let me just note something obvious: that although Rainer has said she chose the inquisitive mode for her banner because she thought a political question would be more acceptable than a confrontational assertion to nervous university powers that be, her banner was not *less* than a political statement but *more* than one.[6] It was an action. To hang this banner in 1970 was to cause anyone who saw it to perform a check of conscience. To read it was to consider the reasons for the war, however briefly; even to dismiss the question as unnecessary was to affirm your certainty that "we" should be there.[7] And of course that "we" matters a great deal, as does the present-tense verb "are." The Washington dancers who were the primary addressees of the sign in the gym, and the White House guards and tourists who were their audience in the Ellipse, were obviously not in Vietnam, but the statement spoke to them as if they were. It matters both for the history of performance and for the history of antiwar cultural politics that Rainer's sign interpolated these performers and audiences not only as dancing and viewing bodies copresent in an immediate time and place, but as members of a body politic occupying territory elsewhere.

Performance Demonstration

The title of this chapter and this section is the name of a work that Rainer first presented at the Performing Arts Library in New York in September 1968. *Performance Demonstration* was not explicitly political, yet its title, however unintentionally, is a pun that draws together the form of art in which Rainer was engaged in the late 1960s and early 1970s and the wave of political dissent with which it coincided historically. Though not addressing political issues explicitly, as the sign in Washington would two years later, *Performance Demonstration* inaugurated a period of experimentation in dance form and content, and in modes of spectatorship and their politics, of which the banner incident is part.[8]

In the later 1960s, Rainer moved from tightly structured programs of minimalism-linked dance like *Parts of Some Sextets* to increasingly diffuse, flexibly structured, and multimedia movement performances. *The Mind Is a Muscle* of

1966–1968, built in sections and gradually developed with additions over a number of performances, was in a sense a transition to this mode of performance, but even with its several units and mixed media it remained a discrete, evening-length work. Rainer referred to *Performance Demonstration,* on the other hand, as not a dance but a *format,*[9] a designation that already suggests the nature of her new performance concept: contingent, changeable, and responsive. In a 1968 letter to the organizer of a performance at the University of Illinois, she explained that she could no longer think in terms of discrete dances. Rather, she was working with "blocks or units of material that can be combined or separated in various ways (including sound, film, slides, speech) to fill various time situations."[10] Two years later, she wrote to Withers, who was also trying to organize a Rainer performance, that she was "no longer making 'pieces,'" or even, as she used to, "evening-long works with clearly delineated 'episodes' or units": "What seems to happen is that I work (and think) fairly continuously with a cut-off point being a performance date rather than an idea of 'completion.' Thus the nature of the performance is strongly determined by each particular situation *at the moment of performance.*"[11] In keeping with this emphasis on contingency (and against the tendency to look to titles for clues to the work's internal subject matter or meaning), the names Rainer bestowed on these events changed depending on the venue: *Performance Demonstration* at the Library of Performing Arts; *Rose Fractions* at the Billy Rose Theater in New York; *Performance Fractions for the West Coast* for Los Angeles, Oakland, and Vancouver performances; and *Connecticut Composite* at the American Dance Festival, then held at Connecticut College.[12]

The *Performance Demonstration* "format" was in effect a mutable collage, combining sequentially and in juxtaposition a grab bag of material selected and ordered depending on the time available and the nature of the space. Attending a given performance in this mode, an audience member might have heard Rainer's voice reading a priggish lecture about the need to purify dance from the emotional contamination of musical accompaniment—immediately undercut by Steve Paxton's dancing *Trio A* to the Chambers Brothers' stirring rock-soul version of "In the Midnight Hour." This highly skilled performance would have been followed by an iteration of *Trio A* by someone with no prior dance train-

ing, or by an onstage tutorial, with Rainer teaching the dance to someone who had never done it before, interrupted at irregular intervals by a horde of twenty people rushing across the stage (see figure 3.1).[13] At a concert like this, all live dancing could be replaced for extended periods by a series of slides documenting one of two previous dance performances;[14] or performers might line up in long rows called "People Walls" while Rainer's *Trio Film* or *Hand Movie* played above their heads (figure 5.1). A viewer might experience the house lights coming up and down precipitously and for no apparent reason, watch a porno film, or be treated to Rainer's rendition of a Lenny Bruce monologue on snot.

The order of events in these performances was variable but always determined in advance, with carefully plotted cue sheets orchestrating sequence and overlap. In the spring of 1969, however, Rainer began including in her "format" performances a flexibly structured dance for which she borrowed the title of a Robert Morris process piece of that same year: *Continuous Project—Altered Daily,* a title that perfectly expressed the ethos of contingency and constant experimentation she, too, was developing. First performed at the University of Illinois, Urbana-Champaign, on 8 May 1969, *Continuous Project* was itself a mini-format piece—a set of interchangeable and rearrangeable solos and group dances—but the order of its elements was left up to the participants and improvised during the performance itself. It would eventually incorporate a range of props both quotidian and quixotic: cardboard boxes and a giant set of strap-on wings; sheets of paper and a stuffed object with a dangling leg; a bolt of pink fabric, an unwieldy white screen, several pillows, and a sombrero some five feet in diameter (figures 5.2, 5.3).

A silent film by Michael Fajans of an early rehearsal of *Continuous Project—Altered Daily* elements shows the dancers engaged in a spirited, sometimes hilarious, and occasionally lyrical series of experiments with one another and some of these props.[15] They lope around the room in a floppy, skipping gait; they catch one another at the waist and gently fold the captured body forward or back. They practice slapstick timing as they drop pillows to the ground, then quickly stomp them with a foot as if to keep them from floating up again, or as they unexpectedly boot them at another dancer's face. In a kindlier mode,

5.1 Yvonne Rainer, *Rose Fractions,* 1969. Rehearsal, Billy Rose Theater, New York, 6 February 1969. Photo: Peter Moore. © Estate of Peter Moore/VAGA, New York, NY.

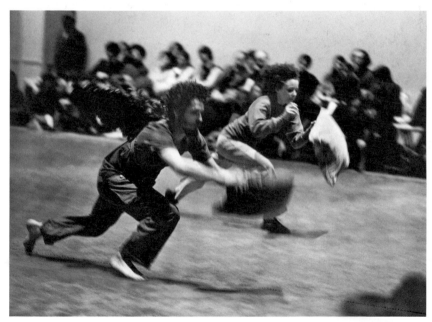

5.2 Yvonne Rainer, *Continuous Project—Altered Daily,* 1969. Whitney Museum of American Art, 1 April 1970. Photo: Peter Moore. © Estate of Peter Moore/VAGA, New York, NY.

5.3 Yvonne Rainer, *Continuous Project—Altered Daily,* 1969. Whitney Museum of American Art, 1 April 1970. Pictured: Steve Paxton, Barbara Dilley. Photo: Peter Moore. © Estate of Peter Moore/VAGA, New York, NY.

dancers use the same pillows to cushion the sideward fall of partners who seem suddenly like oversized infants being put down for a nap. Stiffened figures are transported, either above the heads of a row of dancers as if on a bier, or lying across the backs of two partners who crawl on their hands and knees, then stretch out and roll along the ground. The group works on a maneuver in which one dancer, launched off the arms of partners on either side of her, can leap from a seated position on the floor to a brief suspension high above the others' heads in a single, slightly scary swoop. None of these activities are virtuosic, but all are hard to do. None have specific content, yet several evoke themes like mutual help and trust. A handful of images of love, friendship, and death emerge, only to dissolve again into the series of playlike tasks.

Originally a section of the *Performance Demonstration* or format pieces, *Continuous Project* soon engulfed them, eventually lasting from one and a half to two hours and becoming its own evolving format. It reached what Rainer considered a definitive version at the Whitney Museum on 31 March and 1 and 2 April 1970, where it was billed as an evening-length accumulation of the heterogeneous "materials" that had occupied her for the last year, "such as movement problems, objects, film, and also the range of situations that normally occur prior to performance: teaching, social interaction, working out of new material, conversation, and other rehearsal-like situations."[16] But "definitive" is of course an incongruous term to use for an always evolving work (even the Whitney performances contained "material that we had learned the day before"),[17] and especially for a work that the dancers themselves, and not just the choreographer, had started to alter. By the time of the Whitney performances, the dancers involved in *Continuous Project—Altered Daily* had begun to want to add their own components to the repertoire of solos and group activities Rainer had provided. After some struggle with the idea, she acquiesced—so that, in a series of short but crucial steps between 1968 and 1970, Rainer completely upended what she called "the old conventions of directorship."[18]

If Judson Dance Theater of the early 1960s was "democracy's body," in Sally Banes's phrase; if it was the site where formal devices such as nonhierarchi-

cal composition, equality of parts, and anonymous surface "first came together as ethical imperatives," in that of Thomas Crow, it was in Rainer's work of the late 1960s and early 1970s that the movement performance avant-garde made good on the political promise of that earlier work. Around 1970, Rainer later wrote, it came to seem "a moral imperative to form a democratic social structure."[19] Concerts were being collectively organized, but, more radically, the choreographer's labor itself was being transformed into a collaborative enterprise, even as the very idea of "a dance" gave way to an improvisational series of encounters that were both physical and social. In 1968, invited to present a concert at a Broadway theater, Rainer gave over part of her evening to the debut of a dance by another artist, Deborah Hay.[20] In the following year, as she worked with Becky Arnold, Trisha Brown, Barbara Dilley, Douglas Dunn, David Gordon, Nancy Green, and Steve Paxton on *Continuous Project—Altered Daily,* she found herself exploring, in performances and outside of them, the complexities of group dynamics and in particular her own role as choreographer-director, both of which were attenuated by the semi-improvisational structure of the work. Once teaching and rehearsal were happening within performance, issues such as the way one performer held back and watched, helped another, asked for help, and offered praise (or failed to) became part of the work. Meanwhile, Rainer had to respond to the dancers' desire not merely to sequence events and decide how to respond to them, but to alter sections, drop them, or add new material.

In November 1969, following a performance of *Continuous Project* in Kansas City, Rainer wrote to her performers with a new set of guidelines for "freedom and limits," essentially trying to find a formula that would allow flexibility in behavior while maintaining her vision of the performance:

> At this moment I have trepidations about allowing people to 'alter' my material or introduce their own, BUT (concurrent with my trepidations) I give permission to you all to do either of these *at your own risk:* that is, you will risk incurring the veto power of me or other members of the group, *in performance* (I do not want to know about

your intentions prior to performance). In short, I reserve the right—and I confer upon all of you the same right—to be true to my/your responses in performance—be they enthusiastic or negative—bearing in mind the *natural precedence and priority of my material.*[21]

In this brief paragraph—at once expressing fears about the dancers' desire to alter the work, allowing them that freedom, and reserving her own rights—we see the process Rainer later described as "both fascinating and painful, and not only for me, as I vacillated between opening up options and closing them down."[22] Gradually, however, she seems to have overcome her misgivings. In January of 1970, Rainer was continuing to elaborate rules for altering the order of events and the material itself, but was also allowing her dancers "one chance per person per performance" to introduce their own elements.[23] Soon the dancers were adding music, importing props, and inserting their own material into *Continuous Project—Altered Daily* while eliminating some of Rainer's.[24] Finally, Rainer relinquished directorship of the project entirely. Beginning in the fall of 1970, she and the group had their events billed as the work of an entity called The Grand Union, whose performances quickly became completely improvisatory. Rainer continued to work with the group for several years, gradually separating by 1973.[25]

As her borrowing of the title "Continuous Project" already indicates, in this slightly later phase, as earlier in the decade, Rainer shared in the preoccupations of her artistic generation. While her earlier work was allied with minimalism in the visual arts, the format work of 1968 to 1970 evinces the imperatives to surrender control and embrace change, and corresponding formal devices of looseness, mutability, and sprawl, that characterized antiform, scatter, and process pieces by peers like Eva Hesse, Richard Serra, and of course Robert Morris.[26] But unlike most other experiments in this vein, aside from those of Morris, Rainer's explosion of imposed form and hierarchy was social as well as aesthetic. Its commitment to alternative means of organization was apparent in its structure and look, but also in the social relations that constituted it.[27] Even more than in the case of Judson dance, it makes sense to think of this as a deeply political art.

WHAT IS POLITICAL ART?

This is the title of a 1997 essay by Susan Buck-Morss. But perhaps the better question (and the one she more compellingly answers) is: What does political art do? Her essay suggests at least two models. One, perhaps most often associated with social-documentary photography, but reworked in the 1990s in certain site-specific interventions, is typified for Buck-Morss in the shanty constructed by Marcos Ramirez "ERRE" in 1994 in Tijuana's official cultural center. A dense work keyed to the debates then raging about NAFTA, Ramirez's displacement of a tidy but impoverished slum dwelling into the city's showcase of a public plaza hits at the corporate interests driving changes in trade policy *and* their likely effects in the future with its canny title: *Century 21.* Yet Buck-Morss probably is correct in her assessment of the gut-level impact of the shack for the lunch-time users of the plaza who were its primary audience: "this art insinuates social criticism into the experience of the everyday. . . . *If successful, it leaves viewers with a bad conscience.* This is the source, but also the limit of its political effect."[28] It's important to emphasize that this is not a negative assessment: bad conscience, for Buck-Morss, implies a sense of responsibility, and therefore agency and the possibility of change.[29] But she nevertheless implicitly opposes bad conscience to a second potential political effect of art, which she names "avant-garde experience." Triggered by breaks from convention, and characterized by interruption to the orderly progression of time, avant-garde experience is a form of embodied cognition that "break[s] the routine of living," allying itself "with our better side, our bodily side that *senses* the order of things is not as it should be, or as it could be."[30] Some political art has this effect—Fred Wilson's *Mining the Museum* is one of her examples—but Buck-Morss's category is intended to be broader than art itself. Another case she identifies is that of Elvis Presley, whose music she understands to have challenged the divide between black and white American culture, and whose performance style ruptured the "repressive sexual order" of the 1950s.[31]

Bad conscience: guilt or shame about the contrast between one's own well-being and the suffering of others. Avant-garde experience: rapturous, or at least deeply compelling episodes of breakthrough, where the possibilities for other

ways of being and living are revealed. Between these two political effects—but therefore also against the distinction between them—lie the operations of Yvonne Rainer's relatively unknown and decidedly political art of the period 1968 to 1970.

In this work, dancers dashed about joyously and launched one another into the air; flopped over, falling, and caught each other, supporting. They did nothing if not exalt in the experience of their "bodily side." Often performed to rock and folk music of the day, this work was exuberant and free-flowing enough that at least one critic likened the performers to flower children;[32] liberatory enough to allow another to connect it to "Norman O. Brown and the apostles of sensory reawakening";[33] and for a viewer of *Connecticut Composite* simply to tell Rainer that "the whole 'ensemble' was a turn-on."[34] The expansive format of the dances allowed improvisatory interaction—one kind of liberation—while by including porn, nudity, and Lenny Bruce, Rainer seemed to taunt, with another, the guardians of whatever remnants of a "repressive sexual order" Elvis's pelvis had not managed to dislodge.

Something of this spirit can be seen in one of Rainer's most overtly political yet characteristically complex and irreducible interventions of the period. On 9 November 1970, Rainer along with David Gordon, Nancy Green, Barbara Dilley, and Lincoln Scott entered the sanctuary of Judson Memorial Church, which had been given over to the "People's Flag Show" to protest flag desecration laws and was already bedecked with dozens of American flags in inflammatory paintings, sculptures, and installations. Rainer's group proceeded to tie American flags around their necks like bibs, strip off all their clothing, and perform *Trio A* twice each (figure 5.4).[35]

I had a chance to see this version of *Trio A,* which Rainer calls *Trio A with Flags,* performed at Judson Memorial Church by a different group of dancers in 1999.[36] Of course it is impossible to say whether my experience was anything like that a viewer would have had nearly thirty years before, but for me the striking thing was not how *shocking,* but how *touching* was the dancers' nudity—something palpable also in many of Peter Moore's beautiful photographs of the first performance, in which the seriousness and calm of the dancers' expression

5.4 Yvonne Rainer, *Trio A with Flags,* 1970. Judson Memorial Church, "People's Flag Show," New York, 9 November 1970. Pictured: Yvonne Rainer. Photo: Peter Moore. © Estate of Peter Moore / VAGA, New York, NY.

and physical carriage balances out the potentially histrionic or even funny use of the flag as an awkward and ineffective garment (figure 5.5). In fact, there was tremendous poignancy in seeing the flag, with its connotations of invulnerability and triumphalism—"our flag was still there"—rendered inadequate cover for the raw delicacy of flesh and skin. Buck-Morss's terms are helpful here again, for this piece's motivation of the "bodily side" seems aimed precisely at questions of how things should or could be: at the freedom of expression, with flag or body, that should be acceptable but isn't.

A similar contrast between "should be" and "is," enacted physically, was at the core of a political reading of Rainer's work at this time by Deborah Jowitt in the *New York Times*. For Jowitt, while performance in 1970 didn't provide the overt political messages of earlier modern dance ("in which three thin girls represented the Hungry Masses and one fat girl the Fascist Threat"), there was a politics to Rainer's work nevertheless, as in the recurring instances in *Continuous Project—Altered Daily* when one body caught or supported another, or one dancer gently cushioned another's descent. These instances of intense, unadorned physicality and contact Jowitt understood as replies to the virtual connectivity of the media environment, in which television "may have created a global village, but . . . a village that cannot actually be smelled or touched or tasted."[37] The actual connection between performers within Rainer's work served for Jowitt as a counter or corrective to the false connection of mediatic communication.[38]

We can access the "avant-garde experience" provided by Rainer's work of the late 1960s in still other ways. The shift of teaching from the studio to the stage and of rehearsal from before to during the performance, for instance, recalls Buck-Morss's description of avant-garde experience as an interruption in time and displacement in space.[39] Moreover, Rainer's experiments of this period fit the spirit of that concept in their demonstrable ability to effect personal transformation. Some viewers of Rainer's work in this period called it a life-changing experience,[40] but it was still more so for the works' participants. Shirley Soffer saw her first Rainer performance in 1968, joined an open dance workshop Rainer began in 1970, and went on to participate in many of her performance works and films in the 1970s.[41] She credits both viewing and participating in

5.5 Yvonne Rainer, *Trio A with Flags,* 1970. Judson Memorial Church, "People's Flag Show," New York, 9 November 1970. Pictured: Steve Paxton. Photo: Peter Moore. © Estate of Peter Moore/VAGA, New York, NY.

Rainer's work with literally transforming her—the physical freedom, collaborative process, and new social world she encountered were factors in the emergence of her independence and will, ultimately creating profound changes in her personal life.[42] Other participants in Rainer's work of this time certainly felt they were part of a simultaneously personal, social, and aesthetic experiment, even if, like Douglas Dunn, they now consider it only indirectly political.[43] In a 1972 essay on Grand Union, Steve Paxton described the group's demands on performers as the antidote to the "voluntary slavery" that he felt characterized both American life and theatrical art, for an objective of Grand Union's work was for participants "to be emancipated without confining or restricting others."[44] Barbara Dilley wrote to Rainer in 1969 that "the magnitude of humans relating to one another seems available to me through aspects of your work (you)."[45] That same year, in a letter to the performers who would soon become Grand Union, and whose behavior in *Continuous Project—Altered Daily* was less and less under her control, Rainer beautifully acknowledged something like this kind of potential: "The words I keep thinking of to describe [the piece] come perilously close to current psychotherapeutic clichés: reality of encounter, responsible interaction, truthful response. I got a glimpse of human behavior that my dreams for a better life are based on—real, complex, constantly in flux, rich, concrete, funny, focused, immediate, specific, intense, serious at times to the point of religiosity, light, diaphanous, silly, and many leveled at any particular moment."[46]

I'm tempted to stop there: certainly I can't think of a better example of "avant-garde experience" than the "glimpse of a better life" that Rainer received as a viewer of her own liberated performers. And yet with the Washington banner we have already seen that something much more like the art of bad conscience could also inflect her practice. In Rainer's work circa 1970, there is always more.

AND MORE

Rainer described the experience of one of her late-1960s pieces as "the sprawling shuffle"—a phrase that begins to get at a special kind of excessiveness that

characterized them.[47] In early 1968, she had designed an event for dance students at New York University called *Untitled Work for 40 People,* in which activities were performed in two adjacent rooms, including some from the still in-progress *The Mind Is a Muscle.*[48] At around the same time, she added to *The Mind Is a Muscle* a section called *Act,* featuring performers taking turns instructing one another to lie down on a mattress, sit on a swing, or stand beside it, in a series of slow tableaux (figure 5.6). While this somewhat excruciating antispectacle went on stage left, at stage right a hired performer named Harry de Dio did juggling and sleight of hand. The viewer of *Act* was thus asked to continuously choose between austere arrangements on one side of the stage and entertainments, literally diverting, on the other.

With this, Rainer began to explore a split-screen performance mode: an aesthetics of performance concurrence. In some ways this form of spectatorial experience, developed between 1968 and 1970, could be considered a rethinking of the models provided in her artistic milieu of a decade earlier: from Fluxus, a combination of intense experience and distributive or informational knowing; from the Happenings, an awareness of the borders of perception, of the sights and sounds just beyond one's immediate experience. In Rainer's work of the late 1960s these models returned in the controlled production of a particular "seeing difficulty": situations in which the spectator could not view all of what was going on, but in which she was aware of what she could not see. On hearing of a new performance facility at the University of Illinois, for example, Rainer allowed herself to imagine "4 simultaneous dance concerts going—one in each theater—with both performers and audience running back and forth between. Gee whiz."[49] Though as it turned out this building wasn't ready in time to realize her vision, in July 1969 Rainer's *Connecticut Composite* involved five distinct performance spaces at Connecticut College. Overlapping events included a looplike version of the five-minute dance *Trio A* performed in relay by thirty students for over an hour, and a dance performed in chairs called *Audience Piece* to encourage viewers to sit among the dancers and view the performance from within (figure 5.7). *Continuous Project* at the Whitney Museum in 1970 was similarly multitrack. In the main gallery space, Rainer, Paxton, Gordon, Dilley,

5.6 Yvonne Rainer, *Act,* 1968. Performed in *The Mind Is a Muscle,* 1966–1968. Anderson Theater, New York, 11 April 1968. Pictured: Harry de Dio, Becky Arnold, Barbara Dilley, Gay deLange, David Gordon, Steve Paxton, William Davis, Yvonne Rainer. Photo: Peter Moore. © Estate of Peter Moore/VAGA, New York, NY.

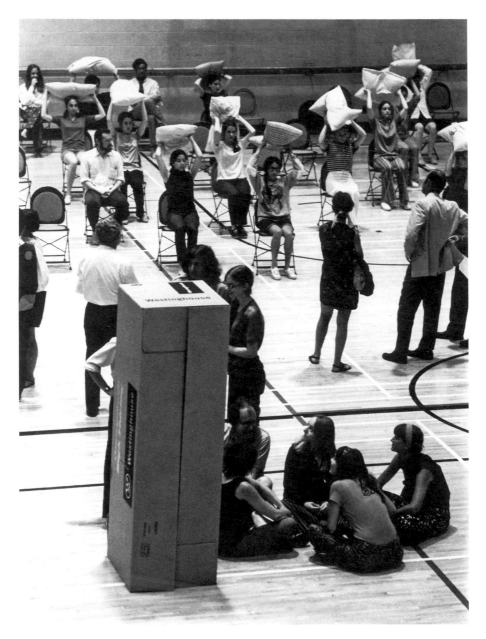

5.7 Yvonne Rainer, *Audience Piece (Chair/Pillow),* 1969. Performed in *Connecticut Composite,* Connecticut College, New London, Connecticut, 19 July 1969. Photo: Ellen Levene. Research Library, The Getty Research Institute, Los Angeles (2006.M24).

Arnold, and Dunn performed their improvisations. But there was also a station set up with a microphone, where a series of speakers stood to quote from movie stars and directors,[50] and adjacent spaces for the projection of films, including Rainer's own *Line,* a Hollywood feature stripped of its soundtrack,[51] and Fajans's film of a rehearsal of the very material being concurrently performed. In some of Peter Moore's photographs of this event, the distinctions between live action and film, and between one space and another—even, when viewed on a contact sheet, between one photograph and the next—can become difficult to determine (figure 5.8). These images thus give visual form to the diffusion of attention Rainer's performance required.

Tellingly, Moore's images of this performance document the efforts of viewers to position themselves at thresholds where they might be able to view more than one event at once.[52] But spectatorial multitasking at such performances could go only so far. Here the fact that Rainer stripped the Hollywood films of their sound is crucial, for it means that hearing could not be used to compensate for the gaps experienced as one looked from film to live performance and back. Just as for performers of such work the prechoreographed dance had given way to a set of choices, for the viewer the singular performance had been replaced by a manageable yet mutually exclusive set of options. Nothing demonstrates this more clearly than the program for *Connecticut Composite,* which provided audiences with a timetable to use in choosing between simultaneous, ongoing events, and a map in order to facilitate walking from one to the other (figures 5.9, 5.10).

Putting her audiences on the move, Rainer in some ways allied her work with broad tendencies in avant-garde theater, for performance concurrence meant literalizing the avant-garde desideratum of the "active" viewer, at just the moment the idea of activating the audience had become a priority—to an almost hysterical degree—in experimental theater. In 1968–1969 alone, American audiences were asked to sing, dance, and potentially be made love to in *Dionysus in 69;* to be carried around by performers and to lie in bed between actors playing lovers in *Changes;* to hug the recovering drug addicts who asked each member of the audience of *The Concept,* "Do you love me?"[53] Even on Broadway,

5.8 Yvonne Rainer, *Continuous Project—Altered Daily,* 1969. Whitney Museum of American Art, 1 April 1970.
Photo: Peter Moore. © Estate of Peter Moore/VAGA, New York, NY.

CONNECTICUT COMPOSITE
by
Yvonne Rainer
at the
Crozier-Williams Center of Connecticut College 7/19/69

featuring
Becky Arnold, Douglas Dunn, David Gordon, Barbara Lloyd, Yvonne Rainer
with 80 performers from Connecticut College American Dance Festival

	EAST GYM	WEST GYM	EAST GYM	WEST STUDIO	LOUNGE
8:45		Continuous Project	Trio A	Lecture	
9:00	Audience Piece	People Plan			Films
9:15	" "				
9:30	" "	" "			
9:45	Audience Piece and People Plan	Continuous Project			

The audience is invited to sit in any available seats at any time. They are requested not to move the chairs, the exact positioning of which is important to the structure of the evening.

5.9 Program for *Connecticut Composite.* Connecticut College, New London, Connecticut, 19 July 1969. Research Library, The Getty Research Institute, Los Angeles (2006.M24).

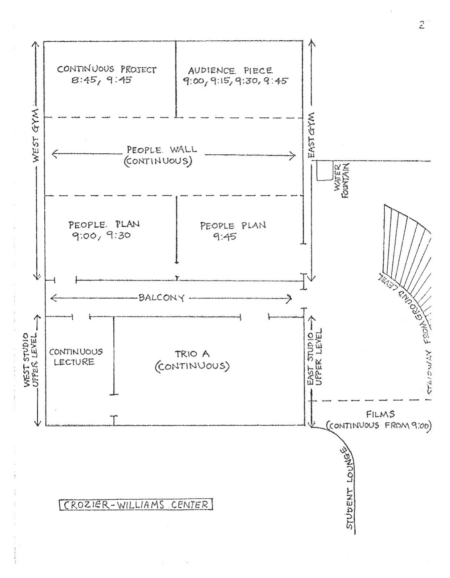

5.10 Program for *Connecticut Composite.* Connecticut College, New London, Connecticut, 19 July 1969. Research Library, The Getty Research Institute, Los Angeles (2006.M24).

they could converse with the performers of *Tom Paine* onstage at intermission and receive flowers handed out by the actors in *Hair*. In what Elenore Lester in the *Times* called "a perfect frenzy of involvement"[54]—which she and other commentators understood as the late flowering of the Happenings of a decade earlier—viewers were everywhere being invited up out of their seats and made a part of the performance.[55] The simple fact that "performers and the audience are in the same space" had gone from being an utterly unremarkable theatrical fact to what Richard Schechner in 1969 called "the most sophisticated and difficult thing facing the new theater."[56]

At least one program from Rainer's performance work of this period rather lukewarmly specifies that "responsible audience participation is O.K."[57] And there were occasional instances of renegade viewers joining in Rainer's work—Soffer's seven-year-old daughter Sarah made an impromptu intervention in a Grand Union performance at NYU in 1970, for example (figure 5.11). But for the most part, just as she and other Judson choreographers had resisted the tendency toward audience involvement in the earlier 1960s, Rainer's later work also "activated" the audience only in carefully controlled ways. In the program for *Continuous Project—Altered Daily* at the Whitney, she laid out the terms: "the audience is invited to go to any of the three performance areas at any time. However, please *do not walk across* the main performing area, but proceed around the periphery or along the walls to get from one place to another."[58] Her *Audience Piece* at Connecticut College similarly and rather hilariously deflated the whole idea of including the spectator in the performance, as the viewer, now literally immersed in the dance, nevertheless remained stuck with the role of sitting and watching—indeed, watching a rousing but rigorously synchronized dance in chairs that could itself be considered an ode to mass seatedness (figure 5.7). Here again audiences were both given freedoms and reminded of their limits. "The audience is invited to sit in any available seats at any time," read a note on the Connecticut College program, immediately followed by the request "not to move the chairs, the exact positioning of which is important to the structure of the evening."[59] Don McDonagh wrote of the Whitney *Continuous Project* that it was frustrating "not being able to participate except vicariously in something

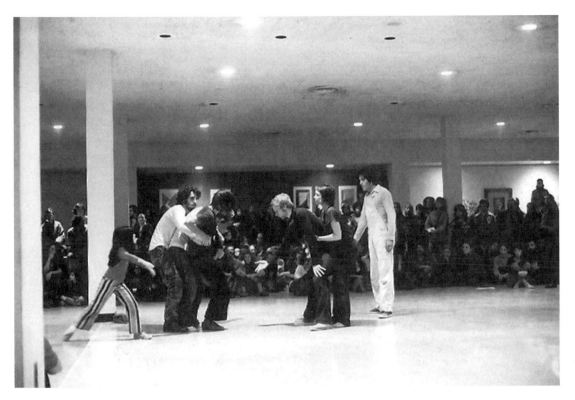

5.11 Grand Union performance. Loeb Student Center, New York University, 22 November 1970. Pictured: Sarah Soffer, Steve Paxton, Nancy Green, Yvonne Rainer, Douglas Dunn, Barbara Dilley, David Gordon. Photographer unknown. Research Library, The Getty Research Institute, Los Angeles (2006.M24).

that appeared to be fun,"[60] and this vicariousness is key: compared to the stripping, singing, dancing, and embracing undertaken by the viewer-participants in what Benjamin DeMott called the "tickle-touch body-contact school of dramatic production,"[61] the rather tame activities allowed the viewer of Rainer's work circa 1970 ("to converse, move around, even to leave and watch a film being shown in another room," as a *Washington Post* dance critic enthusiastically listed them)[62] represent a simple but carefully crafted alternative to both conventional modern, Western audience behavior and its negation in avant-garde theater. Moreover, they represent a particular kind of cultural politics, given that the wave of more ribald and unrestrained audience participation elsewhere in the avant-garde was understood at the time to reflect "the socio/political development of the past couple of years," from love-ins to campus occupations,[63] and to be the very expression of artists' disgust "with the political social and artistic life of their nations."[64]

In 1967, Robert Morris had written to Rainer about her treatment of the audience, wondering whether she wanted to "upgrade" and make more flexible the normal, "rigid audience situation." He reminded her of his own 1965 work, *Check,* in which many simultaneous events, some occurring unseen by the audience, made absorbed, focused attention impossible: "There must be other possibilities more suitable to seeing your work. Then again, perhaps this is not an issue. Perhaps the audience must accommodate itself rather than being accommodated."[65] Rainer did indeed create more flexible situations for viewers in her late-1960s work, but they were specifically situations in which viewers had to "accommodate" themselves; that is, work within their positioning as members of the audience. For the freedoms Rainer provided were strictly spectatorial. Even as they walked about and had conversations—even, like the child visible in some images of the Whitney *Continuous Project* performances, when they lay down for a rest during performances—the viewers of Rainer's work remained just that: viewers. In April 1969 an *Oakland Tribune* arts writer reported that Rainer responded to the vogue for audience participation with perplexity, stating "a bit defiantly" that "my work is not therapeutic; I don't try to 'help' anybody. I use performers as materials."[66] She made her commitment to this principle clear later

that year in a letter to McDonagh: "I accept and require the 'audience-performer gulf.' I do not wish the audience to participate in my thing; neither do I wish them to focus on themselves, but rather on arbitrary and carefully focused situations external to themselves within clearly delineated social areas. If I make them mobile it is only to avoid their being 'captive,' not to narrow the separation—either physical or psychic—between audience and performer."[67] After attending a performance by Batya Zamir in late 1969, Rainer similarly expressed the "gulf" between performer and audience as a desired condition rather than something to be overcome, writing to the choreographer that the large room in which the work had taken place was far better than a small space Zamir had previously used, not only for the expansiveness it allowed the performers "but also the distance of audience from performance. Proper physical distance produces psychic distance that I (as audience) find extremely important. Perhaps this is my problem, but seeing these two concerts has clarified my audience problem."[68]

Rainer's work of this period provided images or models of real connection, of an ideal sociality between its performers—one that Deborah Jowitt even contrasted with the virtual connection offered by television (its ability to let a viewer "see-at-a-distance," in Weber's phrasing). So why, when it came to the viewing of her work, would Rainer insist on *preserving* distance? Why, at a cultural moment that would seem ripe for blurring roles and bridging gaps—and even as she worked against the conventional audience's 'captivity'—would Rainer continue to insist on the "audience-performer gulf"? What exactly was her "audience problem" in 1969?

An answer to these questions begins with the particular paradoxes of that theater of the late 1960s that tried to negate the conventional separation of audience and performers. Richard Shepard noted half-facetiously in the *Times* that some older theater patrons "would like to buy some sort of pre-show insurance against molestation by the cast,"[69] while Benjamin DeMott summed up the problem in his plaintive article title from 1969: "Can't I Just Watch?"[70] Even Joseph Chaikin, founder of the Open Theater and a leader in the participatory performance movement, admitted that he disliked being approached by performers

when he was in the audience. ("I'm offended because I know that the actor knows what's coming. I don't.")[71] The kind of participation involved in *Dionysus in 69* or *Paradise Now,* in other words, was likely also to be experienced as compulsion, while Rainer's choose-your-own performance mode was genuinely noncoercive. And, as DeMott argued in 1969, the assumption that a "traditional" audience member was inherently passive, rather than actively engaged in co-constructing the meaning and experience of the work, is a dubious one.[72] Rainer presumably also felt a need to distinguish her project from that of artists whose work, like hers, could be described in terms of "loosely structured scripts, enacted by vigorous young performers who are more concerned with physical agility and self-expression than traditional acting techniques,"[73] but whose goal was something close to ritual (the example likely nearest to her mind being Anna Halprin, though the idea of avant-garde theater as ritual was pervasive at the time).[74] Certainly Rainer's interest in preserving distance in contrast to these other 1960s experiments in ritualistic involvement could be understood through the opposition between Brecht and Artaud as models for avant-garde performance.[75]

Brechtian she certainly was. But mapping Rainer's distance onto that of the German playwright risks moving too quickly to a model in which the effect of distance is critical consciousness on the part of the audience. Rainer strenuously objected to precisely this move a few years later: "how can we say which type of film will make 'people' think, or make them active, and which will not?"[76] The modesty of her hopes for the efficaciousness of her work is part of what must be preserved about it. And though the influence of Brecht and Brechtian ideas on Rainer's work is more than apparent, referring her interest in the "gulf" directly to his precedent also risks losing some of the specificity of her modes of distancing circa 1970.

Consider this instead: that the most fundamental aspect of Rainer's "audience problem" of the late 1960s and early 1970s might be, simply, that she felt she had one. The most obvious aspect of her acceptance of the audience-performer gulf was that, in maintaining the difference between performers and viewers, Rainer was insisting on *watching something "external"*—on spectatorship—as the social condition with which she wanted to work. In this regard, it makes sense

that within these same performances Rainer's lifelong interest in film and film culture became ever more apparent. She had been making her own filmic studies since 1966. *The Mind Is a Muscle,* in both the 1966 and 1968 versions, opened with a recorded dialog section in which a man and a woman discuss a movie, and included a section called *Film* in which the live dancers' bodies were dwarfed by the giant, projected feet of *Volleyball,* with which they shared a stage. As I've mentioned, in *Continuous Project— Altered Daily* Rainer included projections of her own films as well as Hollywood features; at the Whitney, she had performers recite quotations from the likes of W. C. Fields and Buster Keaton. *Continuous Project* also involved the white screen—made from shiny material rather than canvas, because it "should look like a movie screen rather than a painting"[77]—an object that was in some ways the apotheosis of the dialectic between physicality and image in her work (figure 5.12). Like the mattresses of *Parts of Some Sextets,* the screen was large and awkward enough that dancey or artful movement was impossible while manipulating it; but at the same time this explicitly filmic prop framed her performers as moving pictures. While her later work in feature filmmaking would explore in great depth the specificities of film and film spectatorship, what seems to have been compelling at this moment was simply making the filmic a part of the experience of dance.

Within a context of live performance tied to this mass medium, moreover, it becomes impossible to ignore the fact that with her use of performance concurrence—which is to say, in her resistance to the binary opposition between "captive" spectator and putatively liberated viewer-participant—Rainer created an audience whose freedom was *the freedom to choose what to watch*. And that is to say that she was working with, perhaps working through, precisely the experience to which the conjunction of consumerism and spectatorship reduces so much of mass-mediated living. While the physical and literal interaction of performers in her dances could be understood by Jowitt as alternatives to television's "false intimacy,"[78] Rainer's maps and especially her timetable are reminiscent of aids published to manage media consumption—a kind of live *TV Guide*. As Richard Schechner would note of similarly diffuse situations staged by Robert Wilson a few years later, choosing when to pay attention and to what were habits

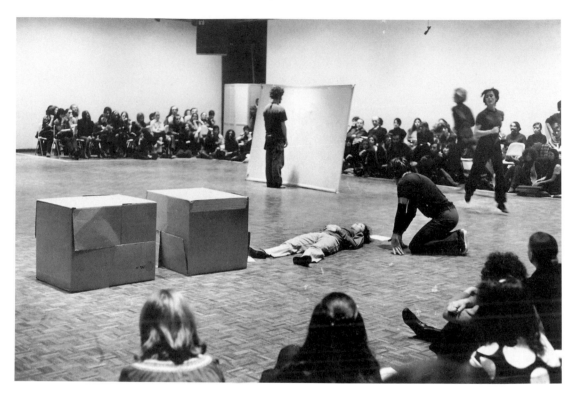

5.12 Yvonne Rainer, *Continuous Project—Altered Daily,* 1969. Whitney Museum of American Art, 1 April 1970. Photo: Peter Moore. © Estate of Peter Moore/VAGA, New York, NY.

"trained by television . . . or by the radio and phonograph which also encourage selective inattention."[79] Rainer provided representations of physical, emotional, and social connectivity that countered the "false intimacy" of the mass media, but did so framed within a spectatorial structure of selective viewing that mimics mass media's basic modes.

If the multichannel format Rainer developed is underwritten by mass-media habits of spectatorship, however, this is not the end of its politics. In fact, given the condition of an ongoing—or overhanging—foreign war, it may be their beginning. It is significant that the most dramatic instance of Rainer's deployment of performance concurrence came in 1970 with her addition to three performances by the newly named Grand Union of simultaneous enactments, in separate spaces, of a piece she called *WAR*.

Infiltrate / Unite / Subvert

In 1970 Rainer compiled a list of verbs, an activity art historians will recognize as typical of this moment. As practiced by Richard Serra in 1968–1969, Lawrence Weiner in 1970, or Mel Bochner in reference to Eva Hesse's work in 1966, listing verbs makes clear the period interest in process that binds these visual artists' work to Rainer's: sculpture is described as action or potential action, operation rather than object.[80] Rainer's slightly later catalog of actions differs from those of the visual artists, however. Despite the ever-present possibility of lifting off into metaphorical meaning, their verbs remain directed toward the physicality and materiality of sculpture making. But even a quick comparison of Rainer's "infiltrate / unite / subvert . . ." with Serra's "to tear / to chip / to split . . ." or Bochner/Hesse's "wrap en–wrap cover . . ." suggests how Rainer's action words hover on a peculiar brink between physical, artistic possibilities and specific, topical references. Hers are war words.

She culled them from newspaper descriptions of the war in Vietnam, supplemented by readings on military tactics from the Peloponnesian War to the Chinese Revolution. Then, in what amounts to an elaborate pun on the term "avant-garde" so frequently applied to her practice, she used these warfare terms

to inspire a set of maneuvers, group formations, and gamelike tasks enacted in improvised order by a group of thirty performers, most of them nondancers, divided into two teams. This process began in Washington, D.C., in June of 1970: the "war games" enacted by her workshop students in George Washington University's gym as well as across from the White House were preparations for *WAR*'s maneuvers.[81] She continued to develop these activities in a workshop and a series of rehearsals in New York that fall. Rainer's *WAR* lasted about forty minutes and was performed three times in November of 1970, at Douglass College (part of Rutgers University) in New Jersey, the Smithsonian Institution's Museum of History and Technology in Washington, and the Loeb Student Center at New York University (figure 5.13).

Physical, improvised, and yet rule-based, the work was in some ways reminiscent of Rainer's fondly remembered childhood games of capture the flag, and involved both an American flag in the official colors—always respectfully kept from touching the ground, usually by placing it on a large piece of fake grass on top of a black overcoat—and one in green, black, and orange, made by Donald Judd, probably after the design by Jasper Johns, which itself had been used in a 1969 antiwar poster as well as in earlier paintings and prints.[82] The activities of the performers, who were divided into the neutrally named Teams A and B, did not mime warlike activity. They did tend to deal with antagonism and relationships of power, however—sometimes quite humorously, as when a line of people had to position themselves in pairs, like ballroom dancers, but with pillows placed between their two bodies and instructions to insist on "doing your own steps without regard for what your partner was doing, resulting in a struggle for domination."[83] In general, however, there wasn't much struggle; people willingly gave up their bodies and their territory according to a set of arbitrary rules. In this "ass-backwards war," one group could "occupy" another simply by standing among members of the other group. "Scouts" circling an opposing team gave signals if they decided they would like to be "captured." A "prisoner" could be "rescued" from the opposing team simply by touching two of its members and shouting "rescue": the team members would then obligingly form themselves into a column, hoist the "prisoner" overhead, and pass him or her along until

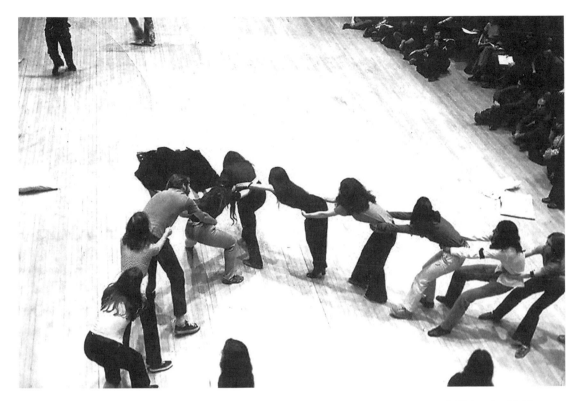

5.13 Yvonne Rainer, *WAR,* 1970, showing "Wedge" formation. Loeb Student Center, New York University, 22 November 1970. Photographer unknown. Research Library, The Getty Research Institute, Los Angeles (2006.M24).

she reached the end of the line and was "free." In one formation, performers crawled through the legs of their teammates, who slowly edged forward while rotating their torsos and raised arms. The rules dictated that a team advancing in this manner could "nudge through" an opposing team or clump. Similarly, "Wedge" formation, a V shape with participants holding on to one another's waists and the point person leaning far forward, protected a group and allowed it to escape.

Performers in *WAR* share enjoyable memories of the sheer physicality of the activity, and of a strong sense of comradeship with the other performers.[84] And in some ways, this dance represented a return to the joyful, rule-governed play Rainer and others had explored back in Judson days. In her 1963 *Terrain*, in particular, dancers similarly called out signals for various actions, grouped and regrouped, and improvised the order of events according to a complex and arbitrary system of rules. But *Terrain*'s six performers had been free-roaming, independent agents. They were not assigned to teams, and they had no goal, however nominal. Pat Catterson recalls of *WAR*, on the other hand, that while there was pleasure in the performance and options for the performers, it was a strictly structured experience, "never just, move how you feel."[85] And there was no equivalent in *Terrain* to the narrator of *WAR*, who at one-minute intervals throughout the performance read short quotations from the texts Rainer had found on actual wars, past and present.

These ranged from brief phrases ("the truce expired") to dry historical descriptions ("at the end of February 1415 the negotiations in Paris were broken off"), but also included disturbing, contemporaneous accounts: "'Get out of your villages or else . . .' was the threat contained in the air-dropped leaflets— sometimes before the bombs and napalm rained down, more often later—to warn villagers not to try and set up houses elsewhere."[86] On the one hand, these texts ensured that the referent—actual war—would hang over the performances despite the arbitrariness and abstraction of the signifiers on view, and the playfulness of the "ass-backwards" war games. As Catterson remembers, "it was war times" and no one forgot it, no matter how much pleasure might have been involved in the physical activity and gamelike structure of the dance. Although

"we were having fun," there was no denying "the serious purpose underneath."[87] On the other hand, the relationship of the words to the dancing might be understood in the opposite way: instead of text anchoring the movement's referent, the physicality of the moving bodies could restore to words about war precisely the ability *to refer* that endless repetition in news accounts can drain. Indeed, it is in this two-way play between words and actions—which had everything and nothing to do with one another—and in the doubling of modality it ensured, that the text and dance in *WAR* would have brought to a high point the tensions about advanced art's relevance to contemporary events with which Rainer was then struggling.

"I Am Going thru Hard Times"

Rainer had made this announcement the previous spring, in a statement, written for the Museum of Modern Art exhibition "Information," that offers a stunningly candid view of what it was like to be both an artist committed to an abstract idiom and a person of conscience at this particular historical moment. As we have seen, she had been publicly struggling with this conflict since at least March 1968, when in the program for *The Mind Is a Muscle* she confidently (if somewhat defensively) acknowledged her work's "remoteness" from "a world in crisis."[88] By the time of the MoMA statement, dated 11 May 1970, however, the gap between her work and world events had made her doubt the value of her practice: "In the shadow of real recent converging, passing, pressing, milling, swarming, pulsing, changing in this country, formalized choreographic gestures seem trivial."[89]

Notably, this statement came a day or two *after* Rainer had made what seems a remarkable attempt to reconcile "formalized" and "real" movements of bodies. Outraged first by Nixon's 30 April announcement of the American invasion of Cambodia, and then by the 4 May attack by the National Guard on protesting students at Kent State University, in which four students were shot to death and nine wounded, Rainer took to the street. The event she would come to call *Street Action* coincided with a weekend festival of art events and open studios sponsored by the Soho Artists Association (then battling for loft

laws and to protect the district's distinctive buildings from high-rise development plans). Planned as a straightforward, boosterish event, the festival came to embody precisely the problems of artistic versus political commitments and local versus global attention that one can sense Rainer wrestling with in her 11 May statement. In the days after Kent State, some participants in the Soho event began urging cancellation of the festival. Eventually, the Association decided, instead, to use the 9 and 10 May event, which had long been in the works and promised to gather a large audience, to deliver a dual—or split—message: on the one hand about the value of artists' contribution to the city, and on the other of opposition to the war. The Association issued a statement saying it was impossible to celebrate in light of recent events and added black bunting to the colored crepe decorations festooning the Greene Street Cooperative buildings, but most events went off as planned.[90]

Rainer's intervention began by gathering students, friends, and acquaintances in front of her loft at 137 Greene Street. A group that started some forty strong tied on black armbands and lined up in a three-column formation. They then began to move in a gait called "M-Walk" that Rainer had used in *The Mind Is a Muscle* (figures 5.14, 5.15). A slow, swaying lockstep on straight legs, with head down-turned, it was based on the motion of the dronelike workers in Fritz Lang's 1927 film *Metropolis* (figure 5.16). In this manner Rainer's group proceeded down the center of the street, south on Greene, west on Prince, south on Wooster, east on Spring, and north on Greene: marking off the heart of the newly defined art district while attempting to square the culture of this artistic enclave with the tragic tenor of international and national events.

To begin to understand the character of Rainer's gesture, it is helpful to compare it with two instances of guerrilla theater enacted blocks away, within a week of Rainer's event, in response to the same tragedy.[91] On 5 May, the morning after the Kent State shootings, a group of NYU students were tied together in groups of four and were marched through the streets of Greenwich Village by fellow students dressed in army uniforms and bearing fake rifles. Calling them "Commie bums" and "fucking student trash," the soldiers kicked their

5.14 Yvonne Rainer, *Street Action,* 9 or 10 May 1970. Yvonne
Rainer, Douglas Dunn, Sarah Rudner in first row. Photographer
unknown. Research Library, The Getty Research Institute, Los
Angeles (2006.M24).

5.15 Yvonne Rainer, *Street Action,* 9 or 10 May 1970. Yvonne
Rainer, Douglas Dunn, Sarah Rudner in first row. Photographer
unknown. Research Library, The Getty Research Institute, Los
Angeles (2006.M24).

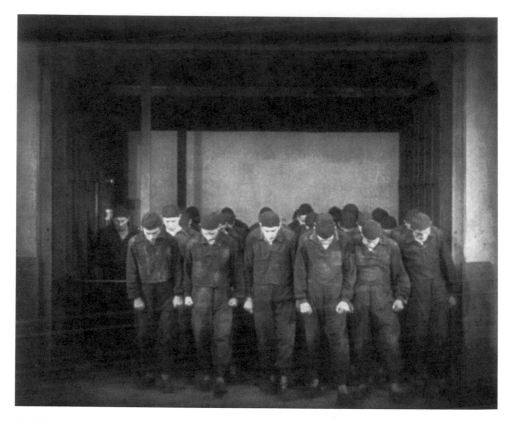

5.16 Fritz Lang, still from *Metropolis,* 1927. Print from the collection of the Harvard Film Archive, Cambridge, Massachusetts.

"captives" and hit them with rifle butts, dragged hecklers and protestors from the crowd in with the bound students, and finally pretended to shoot their "prisoners"; the students "died" in slow agonies, soaked in animal blood thrown by the "shooters," and tossing up animal entrails and organs they had concealed in their clothes.[92] On 14 May, some dozen NYU School of Education students goose-stepped down the street singing "God Bless America," surrounding a group of three bound students labeled "Nigger," "Gook," and "Bum." At a busy corner one of the goose-stepping students explained to the crowd that the government had given his patriotic group permission to allow ordinary Americans a chance to participate in the violence their taxes paid for, by killing for themselves a Vietcong, a black militant, and a Communist agitator. A planted volunteer stepped forward and "shot" the captives with his outstretched arm. The rest of the group broke into the national anthem, ending with a repetition of the phrase "bombs bursting in air," before giving a Nazi salute and continuing their march down the street.[93]

With their blood and guts, salutes and screams, their high-pitched rhetoric and transparent symbols, these spectacles seem far removed from Rainer's slow, silent, procession. Thirty years on, their metaphors and means may sound overblown, slightly hysterical, especially in contrast to the artistic and physical restraint of the M-Walk—whose contrast with the period's culture of protest may have been part of the point, as Douglas Dunn suggests in remembering how distinctly *calm* the participants in Rainer's group remained.[94] On the other hand, the abstraction of Rainer's dance may seem overly circumspect for a demonstration at a moment of political emergency. The contrast between the actions could surely be used to dramatize one of the perennial debates about committed art: whether artistic values need to be sacrificed for political effectiveness. But before leaping to such questions, consider how the procession, among the oldest forms of nonviolent political expression, was common to Rainer's protest *and* much of the students' guerrilla theater; think also how the goose-stepping and tied-up captives exaggerate and push into a realm of overt signification some of the dynamics of Rainer's minimal march.

In the few snapshots that are the only known documentation of the event, Rainer is visible at the front of the three-column formation, next to Dunn—a frequent performer in Rainer's work at this time and fellow member of the emerging Grand Union—and the dancer Sara Rudner, then a performer with Twyla Tharp. The varying heights of the group's members and their differing clothes and accessories lend them a certain casual quality, but hardly the colorful variety we tend to associate with Vietnam-era political protests. Likewise the variety of gender, size, and age among the group's members is belied by their nearly uniform bodily position. Indeed, for a choreographer's first overtly political work—an instance of movement performance finally intersecting The Movement—it is striking how little sense of motion is in these images. In the more tightly cropped photo in particular, the three front figures seem to stand solidly on their feet, almost as if, rather than leading a forward surge, they were trying to restrain one. And this posture corresponds to the felt experience of the event—Rudner's strongest memory of the piece remains a sense of restriction. This impression of constraint was created by Rainer's insistence that the walkers maintain a downward gaze throughout the march (a directive whose difficulty is indexed in negative in the pictures by the straying eyes of the young, bearded man directly behind Rudner) and by the almost unbearable slowness of the procession. To Rudner it seemed to move no more than two feet in ten minutes—an exaggeration, but not much of one, since Rainer reports that it took at least an hour to progress around the block. The strictures on movement were difficult for everyone (by the end of the hour, the group had dwindled to only five, according to Rainer), but for Rudner, then deeply involved with Tharp's exuberant, lightning-quick choreography, the constraint Rainer imposed was a kind of minimal mortification: a small "sacrifice" of physical freedom and expression that was appropriate "because people were killing and dying."[95]

The Soho M-Walk was an extremely simple action, with exceedingly complex significations. In it, Rainer took elements of art—Fritz Lang's and her own—and recoded them for a particular context. For instance, deviating from both the original *Metropolis* workers' procession and her earlier use of it in *The Mind Is a Muscle,* where the arms hung down listlessly at the sides, here she had

the participants link arms, transforming the movement from dronelike submission to mournful solidarity. Likewise, the aversion of the eyes, a device which in *Trio A* was used to disrupt the performers' gratifying relationship with the audience, here became an image of prayerful remembrance, or as Dunn suggests, an expression of shame for U.S. actions.[96] When a policeman stopped the group for blocking traffic and the dancers refused to look up or stop swaying, the downturned gaze also became a powerful signifier of defiance—indeed, a form of momentary civil disobedience. The police eventually stood back as the walkers continued (moving, however, to the sidewalk).[97]

At least in retrospect, *Street Action* seems a remarkable piece of political expression, at once forceful and multivalent. Yet it was *after* this experience that Rainer dated her statement about the problem of triviality—about the difficulty of reconciling the relationship between "formalized" maneuvering of bodies in art and "real" versions on campuses, battlefields, and streets. Perhaps she did not realize how powerful a gesture *Street Action* had been; or perhaps *Street Action* had done its work too well. For *WAR* of five months later seems a step back from its eloquent solution to the problem. Instead of making art behaviors into political activity, Rainer would bring the difference between them to a head.

"Coolly Horrific"

Rainer next used M-Walk within *WAR* (figures 5.17, 5.18). But now the fraternal linking of arms was dropped, and individuals rocking in formation could choose to extend the swaying motion, cantilevering themselves out, with the help of the others in their row, until they met the ground and lay still on their sides. M-Walk thus became one of several activities that littered the field of *WAR* with prone bodies. Describing the dance recently as "coolly horrific,"[98] Rainer has said that it "was all about battlefields strewn with bodies, or masses of people."[99] In one activity a "prisoner" was moved, constantly collapsing and leaning from one couple to another, down a corridor of captors; at the Smithsonian, performers gently placed one another on the ground, creating a circle of unmoving figures, like minutes on a clock (figure 5.19).[100] In a letter to Rainer

5.17 Yvonne Rainer, *WAR,* 1970, showing M-Walk. Douglass College, Rutgers University, New Brunswick, New Jersey, 6 November 1970. Photographer unknown. Research Library, The Getty Research Institute, Los Angeles (2006.M24).

5.18 Yvonne Rainer, *WAR,* 1970, showing M-Walk. Douglass College, Rutgers University, New Brunswick, New Jersey, 6 November 1970. Photographer unknown. Research Library, The Getty Research Institute, Los Angeles (2006.M24).

5.19 Yvonne Rainer, *WAR,* 1970. Museum of History and Technology, Smithsonian Institution, 19 November 1970. Photo by Gerald Martineau, as published in the *Washington Post,* 20 November 1970. Research Library, The Getty Research Institute, Los Angeles (2006.M24).

about a 1970 rehearsal of the dance, Catterson described "a mass fall-out—a people pile of A's and B's in layers, perpendiculars."[101] Photographs of *WAR* are crosshatched by these fallen figures, which the patterns of the dance laid out in neat parallels and right angles (figure 5.20).

These bodies have none of the horrible torque, the brokenness of the dead and injured figures in photographs of real wars. Nevertheless, the most famous photograph of a battlefield—Timothy O'Sullivan's 1863 *Harvest of Death, Gettysburg*—with its field stretching out into the distance, and its combination of vertical and horizontal figures, seems to haunt some of Peter Moore's images of *WAR* (figure 5.21). What makes *Harvest of Death* so stunning an image is its commingling of three modes: the drastic realism of the arched, stiffening corpses on the ground; the lyricism of the foggy beyond; and a third thing. A serial thing: the chilling overneatness of the array of corpses, parallel on the field and extending into the distance. They might have been arranged this way by the burial detail about to take them up, but it's also possible that they were moved into place by the photographer to make a better picture. Either way, this third element of the famous photograph is in some ways all there is in Rainer's *WAR* as a rendering of military conflict. Hers was war stripped of both the romance *and* the realism, the mist and the grit. Having her performers "infiltrate," "rescue," and take flags from one another, having them "captured" and having them "die" while a narrator read fragments of texts about war, she purposefully schematized and abstracted this heavily, painfully charged vocabulary.

Rainer herself retrospectively describes *WAR* as "a formalized 'vision' or 'impression' of war," one in which she was interested in "cooling down the horror vis a vis these formal configurations."[102] One participant recalls it as a "chilling" dance, an image of seeming freedom within programmed constraints.[103] Indeed, the strange thing about this work, as an antiwar piece from 1970, is that its main operation seems to have been to put war imagery on rhetorical ice. Taking vocabulary from the language of newspaper reports (and specifically not from visual images, either from photojournalism or TV), Rainer seems to have been actively seeking that Brechtian desideratum, distance. This goal is precisely in opposition to that of other projects of the time, which were steeped in a particular version of the art of bad conscience. In the guerrilla theater troupe's offer to

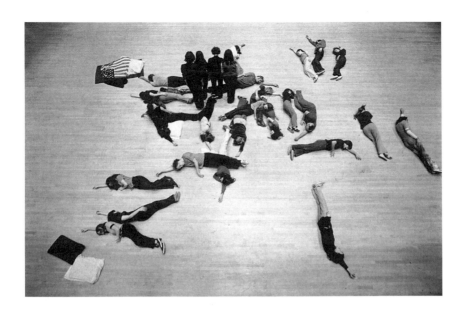

5.20 Yvonne Rainer, *WAR,* 1970. Loeb Student Center, New York University, 22 November 1970. Photo: Peter Moore. © Estate of Peter Moore/VAGA, New York, NY.

5.21 Timothy O'Sullivan, *A Harvest of Death, Gettysburg, Pennsylvania,* 1863. Albumen print by Alexander Gardner. Library of Congress Prints and Photographs Division, Washington, D.C.

let American taxpayers shoot their victims themselves, or, in a more dialectical way, in Martha Rosler's deployment of the visual violence of montage to force together images of wealthy American homes and scenes from the war in Vietnam, the presumed apathy of the American populace was meant to be countered by "bringing the war home"—by virtually closing the gap between here and there, between our luxurious good fortune and the violence being perpetrated in our name. In *WAR,* Rainer seems rather to have actively sought out ways to insert distance in her engagement with Vietnam: temporal distance, in her use of ancient war descriptions; distance by generalization, in making it about "war" rather than only the one in Southeast Asia; distance by emotional withdrawal in contrast with the fevered urgency of actions like those of the NYU students; and the distance of formalism, in her rendering of descriptions of battle into neutral configurations and patterns.

Rainer considered this an explicitly antiwar artwork.[104] But why, with this goal, in 1970, would one create a "formalized vision" of war? What sense would it make to chill and distance the representation of conflict? It isn't that Rainer didn't perceive the situation in 1970 as one of crisis (it was around this time that she took the stage at a meeting of the Art Workers' Coalition and shouted that if they didn't get their act together, in five years the government would have them in concentration camps).[105] Rather, hers was a strategy responding to an emergent situation, but casting that emergency in different terms.

The dance *WAR,* like much of Rainer's work of this moment, participated in an aesthetic of concurrence. Each of the three times it was performed in November 1970, Grand Union was simultaneously performing. At Douglass College, both performances took place in the Lorre gymnasium complex, with *WAR* in what was called the auxiliary gym and Grand Union in the dance studio;[106] at the Smithsonian, *WAR* was in the first-floor pendulum hall of the Museum of History and Technology, while Grand Union performed in the flag area on the second floor; and at the Loeb Student Center at NYU, the performers of *WAR* enacted their formations and mock battles in the upstairs auditorium, while Grand Union performed in the more informal surround of the downstairs lobby. Rainer was always with Grand Union while *WAR* went on.

As a result, like Fluxus artist Ken Friedman, who used scores to produce per-
formances long-distance, Rainer had choreographed a dance that she never got
to see performed. More importantly, the simultaneous performances meant that
audiences, invited to "change location at any time,"[107] had to choose between
WAR, with its mostly nonprofessional dancers and its intermittent accompani-
ment of dry readings from military textbooks, and Grand Union, with its terrific
and by then very well-known performers; with its rock music, improvisation, and
exuberant play. An extreme version of the multichannel mode Rainer explored
in other performances of this period, the strategy of double-booking here be-
comes a choice between something like a political art of bad conscience and one
of avant-garde experience. Of course, *WAR* was also improvisatory and enjoy-
able to perform, and Grand Union could be serious and sometimes political (I
read Paxton's camouflage pants, for instance, as no innocent sartorial selection).
But most important is the fact that Rainer's aesthetic of concurrence meant that,
no matter what you were watching, you were aware of what you were not see-
ing—of the thing coincident in time but distant in space.

Immediacy and spontaneity were constantly mitigated by experiences of
repetition, rewinding, and remembering in Rainer's early 1960s art and in the
work of her peers in Judson Dance Theater. By contrast, her development of
the format works and eventually the innovations of Grand Union in the late
1960s and early 1970s seem far less ambiguously dedicated to the fleeting *now.*
"Improvisation is not historical (not even a second ago),"[108] wrote Steve Paxton
in reference to Grand Union in 1972, while Rainer's program notes to some of
the same Grand Union/*WAR* performances I've been describing explain that
"a performance is a convergence of people and a particular time and a particular
space. . . . What you will see is something in flux."[109] Yet she set up a situation
in which the "particular space" was multiple and fractured. This suggests to me
that, by the late 1960s, it was "here" rather than "now" that was a problem; that
temporality was less relevant a seeing difficulty in 1970 than the physical distance
between contemporaneous events.

Though I discussed it in an earlier chapter, it was in 1968, for the final
performances of *The Mind Is a Muscle,* just prior to the format works and the

transition to Grand Union, that Rainer wrote the statement that includes the sentence, "My connection to the world in crisis remains tenuous and remote." She could sense then that a time would come when this remoteness would end, "though I cannot foresee exactly when or how the relationship will change, or what circumstances will incite me to a different kind of action."[110] It would be possible to argue that Nixon's bombing of Cambodia and the shooting of protesting students on U.S. campuses were these circumstances; certainly it was in spring, summer, and fall of 1970 that Rainer first made explicitly political art. But by that time, I have been trying to show, distance itself had become the spectatorial condition with which she felt it compelling to work. This was a kind of crisis, and I'm not sure it was one the work ever resolved. It has also been difficult to think through as a critic and historian—at least, as a critic/historian of a generation steeped in a vision of 1960s political dissent as the very measure of authentic connection and directness of action; and as one who grew up with the mediated condition that Raymond Williams poignantly called, during the Falkland Islands conflict, "the culture of distance."[111] And most especially, as one writing under the presence—or the distance—of yet another war.

The aesthetic of concurrence in Rainer's performance of this period worked through—it caused the viewer to perform—a spectatorship that acknowledges distance. This is rather different from the Brechtian resistance to empathic absorption usually associated with distancing in the theater. Very simply, this aesthetic of distance *insisted on the ongoing existence of events outside one's immediate, situated experience.* I'm not sure that it could be said that the work turned distance into a form of involvement.[112] Nor does Rainer's distance-awareness necessarily activate the viewer's critical thinking, as the Brechtian model of distancing would, at least in theory. But it does suggest that the acknowledgment of distance could be an ethical as well as aesthetic act. And this in turn means rethinking Rainer's injunction that "responsible audience participation is okay,"[113] as well as her deradicalizing of audience involvement into mere sitting and looking in *Audience Piece.* Are there times, her more political work causes us to ask, when a "responsible" form of participation might be spectatorship itself? When uninvolved, even distanced watching has an urgency of its own? In the context of a

war waged elsewhere in one's name, and brought home as one of the choices arrayed in a *TV Guide,* the mode of spectatorship Rainer invented in this period is freighted with ideological weight. Just like *Street Action,* which mourned what was elsewhere right in the middle of a neighborhood celebrating the immediate, situated surround; just like the Washington banner, with its question about the war literally hanging over artistic proceedings, this is less an art of conscience than one of consciousness, and even of consciousness split.

Whether presence constitutes the essence of performance's aesthetic and political potential might remain a significant philosophical question. One thing Rainer's work of this period shows, however, is that from the perspective of art history it is possible to say that the "seeing difficulty" of performance presence dissolved under specific, historical conditions. In 1970, the *there*-and-now had become at least as pressing as the *here.* Further, if Rainer's qualified liberation of the audience in her multi-channel performances rhymes a bit too well with the spectatorial modes of television, then we now have a different way of understanding why. It is both a registration, in Rainer's avant-gardist, live performance, of conditions of spectatorship in dominant, mass-media experience, and—insofar as televisual spectatorship can be understood as a mode of multiplicity, of holding presence and absence together in one's mind—it might also suggest that media-conditioned experience is not always a terrible thing. That mere watching—choosing *not* to not watch—could be, oddly enough, a form of responsibility. As the artist Hermine Freed would write in 1975, discussing Rainer's films among other art, "The simple act of changing channels causes us to be aware of multiple events occurring simultaneously."[114]

At the time of this writing, Rainer's split awareness has for me another meaning as well. But this requires one more brief section.

A FINAL NOTE

My research for this chapter has turned up more than the usual ambiguity about the events and artworks discussed. Rainer recorded in her 1974 book *Work 1961–73* that the sign hung during her Washington session read "Why are we

in Vietnam?," and the choreographer Maida Withers, who helped organize and participated in the workshop, remembers this wording, too. The only photograph of the workshop that I have been able to discover, accompanying a review of the final performance in the *Washington Post,* seems to show a fragment of the banner behind the performers (figure 5.22).[115] But it is both hard to make out, and hard to make read "Why are we in Vietnam?" There seems to be an *S* in the banner, and the spacing seems wrong for inscription of the question as Rainer and others remember it. Maybe this is an illusion, maybe a different sign appeared in the picture, maybe (as Rainer admits is possible) the sign actually read "Why are we *still* in Vietnam?"[116] A book with this title (and with the word "still" printed above the line, as if inserted after the fact) appeared that same year. Implying both delay and stasis, the word would have contrasted with the dancers' presence and energetic movement. But what about the fact that, while Rainer remembers folding up the sign on the way to the Ellipse (thus distinguishing the group's walk from a procession or demonstration), Withers remembers walking with the banner proudly unfurled and facing the street? Why does Rainer remember taking the sign down when asked to do so by police, while Withers says that they defiantly danced on, to a chorus of contempt from the lined-up White House tourists, which Rainer also does not recall? Why does Rainer's 1974 account insist that *WAR* was always enacted in spaces separate from simultaneous performances by Grand Union, so that she was never able to see the performances, while *WAR* participant Nina Yankowitz is sure she remembers Rainer improvising with her during one of the performances? Why does no one, until I show them certain frames from the documentarians' contact sheets, seem to recall the moments when *WAR* participants carrying their flags crossed from their space to Grand Union's and briefly rushed around and interrupted the improvising performers?[117]

Memories are imperfect, of course, and someday these problems may be resolved. Maybe further photographs can be found, more recollections mined. But meanwhile these inconsistencies have heightened what is, for me, an inability to forget the distance between the historical interpreter and the historical object, and I think I would be remiss—I would have a bad conscience—if I did

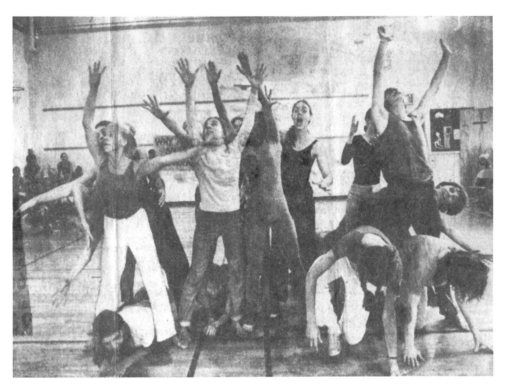

5.22 Performance by members of Yvonne Rainer's summer workshop, George Washington University, 2 July 1970. Photo by Charles Del Vecchio, as published in the *Washington Post,* 3 July 1970. Research Library, The Getty Research Institute, Los Angeles (2006. M24).

not bring them to your attention, too. Moreover, I find these difficulties in seeing the past to be strangely appropriate to the subject matter. It is as if the distance Rainer both insisted on and tried to activate between here and there—between contemporaneous but spatially distant realities of her world and the war—finds a way of returning as a temporal distance between the now of interpretation and the then of performance. In the 2006 Whitney Biennial, the artist Josephine Meckseper exhibited a work in which two demonstrations against the current war in Iraq were filmed on 1960s-vintage Super 8 film stock, then transferred to video and projected on a miniature minimalist cube (figure 5.23). It is a potent image for the way response to this war has been mediated and somehow mitigated by a now-nostalgic image of the 1960s. And it makes me wonder whether the gulf between present and past, like Rainer's treatment of the gap between near and far, could be made an active absence, a spur to thinking and feeling. And that is the question with which I would like to end.

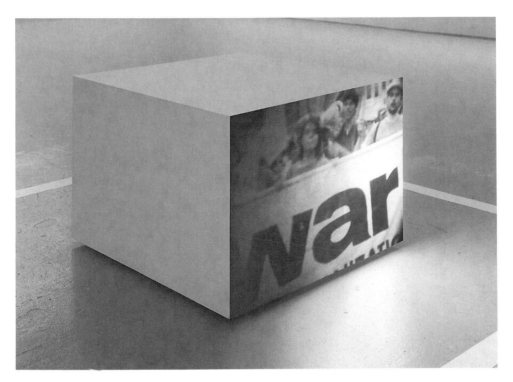

5.23 Josephine Meckseper, *Untitled (March on Washington to End the War on Iraq, 9/24/05),* 2005. Photo: Tom Powel. Courtesy of the artist and Elizabeth Dee Gallery.

Conclusion: Taking Sides

The Bodily Side

Midway through Rainer's 1972 film *Lives of Performers,* Shirley Soffer begins a narrative: "I had a dream about a wall."[1] "It's the kind of wall that I would like to climb rather than walk through a ready-made door," she continues in voiceover, while we watch slow-motion footage of a little girl in a bare loft space, bouncing and catching a small rubber ball (figure C.1).

> I do climb the wall, and it feels terrific. I'm stretching my body as I climb, feeling the pull on my legs and arms as I reach the top and climb over. I enjoy going down the other side. What I like about this wall is that I have no fear of being locked out or locked in. I can always get in or out by climbing, by my own physical nimbleness and agility.
>
> On the other side I find that I am in a schoolyard.... There are no children in the schoolyard on this day, although it is a beautiful spring day. I run around freely, the wind blowing in my hair. I am happy, bouncing a large volleyball. I bounce it up and down against a brick side wall. It feels good just to run around and be free and have

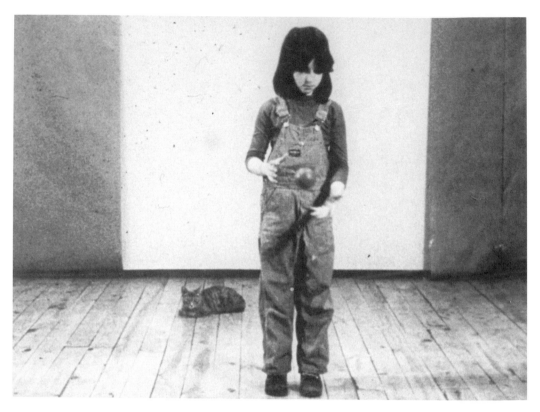

C.1 Yvonne Rainer, still from *Lives of Performers,* 1972. 16 mm black-and-white film, sound, 90 min. Cinematographer: Babette Mangolte. Pictured: Sarah Soffer.

all that space to myself. I feel my body stretching and I am running around the yard very fast, but I am full of energy, not at all tired. I have an enormous sense of great physical well-being, of a stretching and toning up of all my limbs and the back of my neck. When I wake up I am really happy. I remember that I have caught a glimpse of something alive and free within me.[2]

The type of pure, energetic physicality evoked by this three-minute sequence would have been immediately familiar to viewers of *Lives of Performers* acquainted with Rainer's work in dance. Certain images are right out of the Rainer image bank: the bouncing volleyball recalls the many balls held, rolled, and thrown in her work, from the 1963 *Terrain* to the 1967 film *Volleyball* to improvisation exercises with students in the early 1970s; the description of energetic "running around the yard very fast" evokes her fondness for forms of jogging, rushing, running, and swarming in works from *We Shall Run* and parts of *Terrain* in 1963 to sections of *Northeast Passing* and *Continuous Project—Altered Daily*, circa 1970 (figure C.2). But the dream sequence evokes her performance work of the prior decade above all with its representation of the pleasure and value of straightforward bodily action. Shirley's narrative and the image of the playing child together express precisely the "unenhanced physicality"[3] that Rainer's 1960s work in dance has been understood to disclose.

The dream recounted in *Lives of Performers* was one of Soffer's own, written down and given to Rainer as part of an exercise when she was participating in classes at the choreographer's loft around 1970.[4] She knew then that it was a direct expression of her encounter with Rainer's work. The discovery of her own muscular activity and agility, the physical freedom and consequent feelings of well-being: these were all aspects of the transformative engagement Soffer had been having with Rainer's art, beginning with her experience as a viewer of *The Mind Is a Muscle* in 1968 and deepening with her participation in the dance *WAR*, in the classes Rainer conducted in 1970–1971 at her studio and in an improvisation group called Stupendous Tremendous organized by some of Rainer's

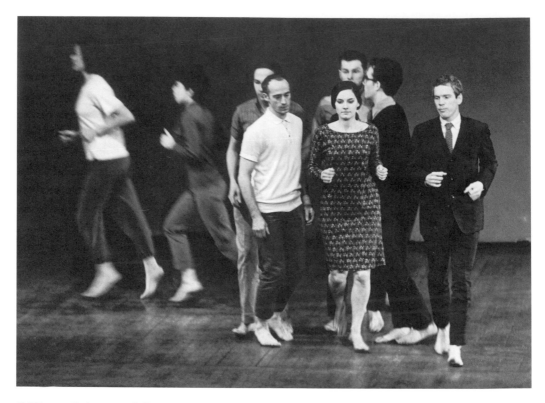

C.2 Yvonne Rainer, *We Shall Run,* 1963. Wadsworth Atheneum, Hartford, Connecticut, 7 March 1965. Pictured: Yvonne Rainer, Deborah Hay, Robert Rauschenberg, Robert Morris, Sally Gross, Joseph Schlichter, Tony Holder, Alex Hay. Photo: Peter Moore. © Estate of Peter Moore/VAGA, New York, NY.

students to continue their investigations outside the studio.[5] Soffer's experience of Rainer's dance was paradigmatic for one type of politics built into the artist's work with the body, as is also suggested in Soffer's account of her dream. The aftereffect she experiences upon awakening—her discovery of "something alive and free within me"—expresses the profoundly liberating promise of Rainer's 1960s choreography; a promise as bare-boned and as beautiful as the accompanying footage of the little girl in overalls, whose unself-conscious concentration on her serious play the camera reveals in luscious slow motion.

Lives of Performers, Rainer's first full-length, stand-alone film project, thus includes what may be the artist's most eloquent commentary on the unmannered, tasklike form of physicality her work in dance had produced. Yet this vision of a transformative way of being in the body is not the end of the story. To say so is not to imply that such physicality was not real, or not central to Rainer's artistic endeavor. It is only to say that, this being the work of Yvonne Rainer, we will always have to climb back and forth over that schoolyard wall. The dream of pure physicality will always have another side.

The Side of Spectatorship

To me this multiplicity seems embodied in the shot itself, in the slowed image of the ball-bouncing child (in fact, Soffer's young daughter, Sarah), which continues in silence for several minutes after Shirley's narration ends. This slow-motion footage—a literal version of the filmlike slowing so often used in Judson-era performance a decade earlier—gives the spectator a chance to see just *how* the girl catches or fails to catch the ball, how her body bobs or weaves slightly as she walks about or fumbles for a missed catch. It even reveals how elegantly coordinated is the movement of the cat who sits on the floor behind the girl for most of the shot, then gets up, scratches herself, and languidly leaves the frame halfway through. This luxuriantly detailed view of physical activity comes to us, however, by means of a technological trick that draws attention to the means of the representation, signaled also by the only prop in the otherwise bare space: a blank

white screen on the wall behind the child. As a special and specifically filmic effect, the same slow motion that brings the viewer so much more access to the experience of physicality described and depicted also *removes* the spectator from bodiliness—a doubling that perhaps explains why slow motion seems always to cast a nostalgic shadow over the moving image, leaving us longing.

The spectatorial side of Rainer's physicality is even more directly thematized in the companion piece to Shirley's dream, which is surely what we must consider the dance performed by Valda Setterfield toward the end of *Lives of Performers* to be. This scene starts when Valda tells Fernando Torm, playing her lover, that she wants to show him something. Actually—as is typical for a film in which speech is almost never synchronized with images, and most of the activity is narrated by characters speaking off-screen while watching themselves perform (so that they too are on the side of spectatorship)—what happens is that we hear Fernando's voice telling us that Valda says that she wants to show him something.[6] An intertitle then flashes: "Valda shows Fernando her solo." When it is removed, we are in a sleeker, cleaner room than the loft in which the rest of the film is enacted, although this elegant space (a gallery at the Whitney Museum) is also unfurnished and bare-walled. Wearing a velvet evening gown, Valda performs a slow-paced solo (figure C.3). For a dance by Rainer, it is an oddly mannered piece. Illuminated by a dramatic follow spot, Valda's movements are sinuous, stylized, and theatrical; inspired, Rainer has said, by Alla Nazimova's performance in the 1923 film *Salome*.[7] The drama is only somewhat undercut by the fact that throughout the solo, even as she maintains a haughty, temptress-behooving demeanor, Valda manipulates a child's rubber ball, rolling it down her arms, drawing it across her body, and holding it, just as elegantly as possible, beneath her chin.

Shirley's dream sequence is the baby version of Valda's solo; the solo, the grown-up form of the dream. In this ball-borne connection across the film, the dream of a dance that could evade what Rainer in 1966 called "the 'problem' of performance"[8] is revealed to be bound up with the dynamics, and politics, of display. "Valda *shows* Fernando her dance": with this announcement we are already placed in a social, dialogical, and specifically presentational space quite foreign

C.3 Yvonne Rainer, still from *Lives of Performers,* 1972. 16 mm black-and-white film, sound, 90 min. Cinematographer: Babette Mangolte. Pictured: Valda Setterfield.

from the abandoned schoolyard of Shirley's physicality-affirming romp; with the dance's arty self-consciousness we are on the other side of the fence she joyously scaled. The museum setting further undermines the chance of anything other than what Rainer once called "exhibitionlike presentation,"[9] while the follow spot literally highlights, as it thoroughly theatricalizes, questions of spectatorship. Modified by the focusing attention of eye, camera, and projector, dance takes on, rather than tries to overcome, the distinction between doing and viewing. Valda's solo leaves us with the body *seen*.

THE SOCIAL SIDE

As if to emphasize this shift comes Fernando's response to the dance he—and we—have been shown. His voice explains: "Fernando is saying to her why did she show him that, that he has seen it a hundred times. Then she says that she does it differently now, that she understands it better. But he says that it looks the same to him." She does it differently; to him it looks the same. With this we find ourselves back in the problematic of *Trio A,* working through the difference between internal and external knowledge of a dance—facing the gap between spectatorship and lived experience, spectacle and the body, that other endeavors of the 1960s, from Fluxus and Happenings to The Performance Group, tried so hard to overcome. Not so Rainer. What she feels does not correspond to what he sees.

But: what *she* feels does not correspond to what *he* sees. With this gendering of its terms, the spectator-performer problematic of earlier work like *Trio A* is suddenly and powerfully inflected.[10] In the terms of the feminist film theory that emerged just a few years after *Lives of Performers,* Valda has offered herself as object of the gaze—classically, to the male character and the viewer of the film at the same time.[11] As Laura Mulvey saw it in 1975, such objectification both gives pleasure to the male-positioned viewer and, through the vision of woman as difference and lack, causes him to experience the fear of castration: "the woman as icon, displayed for the gaze and enjoyment of men, the active controllers of the look, always threatens to evoke the anxiety it originally signified."[12] In Hol-

lywood films, Mulvey argued, the male character typically responds to this bind either by investigating and inculpating the woman or by overvaluing her, turning her into a cult object or fetish. *Lives of Performers* is no Hollywood film, but with its subtitle ("A Melodrama") and its subject matter (it is a narratively scrambled but nevertheless discernible story of a heterosexual love triangle), Rainer's film is itself an essay on the operations of such movies. Mulvey insisted that the patterns she identified were only the filmic expression of the power imbalances of patriarchy—film was not the problem but the symptom. And yet it seems crucial that it was in exploring cinema that Rainer gendered and thus made explicitly social the dynamics of display and desire that contaminate "unenhanced physicality"; that it was in a medium that was recorded and multiply distributable, as well as ideologically powerful, that the immediacy and situatedness of performance—the fact that "dance is hard to see"—became proto-political.[13] Rainer's move from performance to cinema, like any artistic or personal turn, is overdetermined, and much has been written about why she did it and what it signifies. Let me add only that, looking back at an artist working with the politics of spectatorship in a media-soaked modernity, what I find surprising is that it took so long before she found herself the maker of movies.

There is no way out for Fernando and Valda—for a woman who wants to be seen in the way she experiences her own physicality and a man who cannot see what remains on the other side of spectatorship. What they are locked into, however, may in itself be a provisional answer to the bind of bodies felt and seen—not the opposite of but an alternative to the fenced yard where the dreaming Shirley so blissfully played. For, in their briefly sketched struggle, the inability to reconcile the "'problem' of performance" is rendered social and proto-political. And in being so rendered, it is, in an odd way, resolved. In investigating spectatorial modes, Rainer, like so many artists of this moment, was engaging social and political realities, though usually on a level other than that of conscious intention. In *Lives of Performers,* however, seeing difficulties are shifted into a new register. As Rainer moves from live performance to film, and as she comes into a feminist awareness, she discovers a space of spectacle that *is* the space of sociality—ideological, sometimes pathological, but thoroughly real.

THE MEDIATED SIDE

If physicality unburdened of the social and historical conundrums of spectacle becomes a dream in *Lives of Performers,* this is not, or is not only, a loss. After a 1973 screening of the film, critic Nan Piene asked Rainer about the transition away from performance it represented for her. Thinking about it later, Rainer wrote an often-quoted paragraph:

> Dance is ipso facto about *me* (the so-called kinesthetic response of the spectator notwithstanding, it only rarely transcends that narcissistic-voyeuristic duality of doer and looker); whereas the area of the emotions must necessarily directly concern both of us. This is what allowed me permission to start manipulating what at first seemed like blatantly personal and private material. But the more I get into it the more I see how such things as rage, terror, desire, conflict, et al., are not unique to my experience the way my body and its functioning are. I now—as a consequence—feel much more connection to my audience, and that gives me great comfort.[14]

This passage is sometimes used to illustrate the shift in Rainer's work from physicality and the body to a different realm, one of emotion and social relationships.[15] It is less frequently noted that it is a statement both about subject matter *and* about "seeing difficulties"—problems of spectatorship. Perhaps this is because what Rainer is saying—that dance remains solipsistic, based in a performer-spectator, doing-watching divide, while her work in meta-melodramatic and quasi-autobiographical film allows a new connectedness to her audience—flies in the face of two discourses that have been exceedingly well developed in the thirty years since her statement: one that reserves live performance as the site of present-tense, intersubjective experience, and one that critiques film as the realm of voyeurism and false, ideological experiences of connection.[16] Yet it makes perfect if paradoxical sense, given the ways we have seen Rainer's work take on the problems (which she revealed as always interconnected) of physical

being and of spectatorship. If the investigations of this book have demonstrated anything, it should be that literal, physical copresence was not a simple desideratum in the 1960s; it was always a problem to be approached, poked at, experimented with, worked through. And if insistence on such presence is understood as compensatory in an age of increased and increasingly powerful experiences of mediation, perhaps it makes a bit more sense that the virtual but nonetheless social connectivity Rainer found through *film* dealing with emotional, personal material was so satisfying. The fact that film—and melodrama in particular—so powerfully expresses and reproduces social imbalances of power is precisely what makes it the realm of intersubjectivity Rainer's work demanded. As she switched mediums Rainer turned the problem of performance presence inside out, finding in the recorded, edited, and cliché-rich film medium a paradoxical publicity; an intersubjective experience fostered despite the unavailability there of the live.

In the remarkable series of thirty-five images that closes *Lives of Performers,* actors arrange themselves in dramatic tableaux vivants. A woman perches coquettishly on a man's lap; a man collapses at the feet of a woman holding a pistol; a woman swoons in the arms of a man; a man in close-up tries to keep his eyes unblinkingly open (figures C.5, C.7). Each time, the shot begins with the actors holding the pose. The camera stays still and focused on them as they try not to move. The effect is nearly photographic, but not quite: as they pose for a duration the clock says is twenty seconds but which seems far longer, eyes shift, breath moves, muscles twitch. Still, they hold the position. And hold it, until finally they begin to disassemble. As they do, the shot cuts—as palpable a reprieve for the viewer as for the performers—only to open on another tableau.

From a preceding intertitle, the spectator knows the sequence is called "Final Performance / LULU in 35 shots." Viewers familiar with the 1928 Louise Brooks classic *Pandora's Box* (with its lead character, Lulu) might recognize the tableaux as quotations from that film—or, more accurately, as reenactments of production stills, a large selection of which appeared in the 1971 edition of Georg Pabst's film script (figures C.4, C.6).[17] Of course, even in the context of such a book the stills alone do not convey the silent film's melodramatic

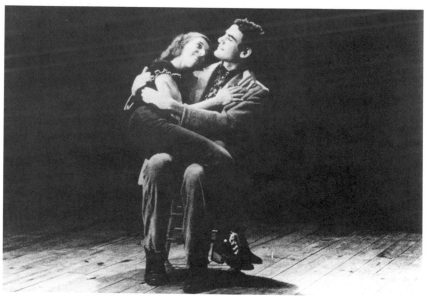

C.4 Georg Pabst, still from *Pandora's Box*, 1929. Pictured: Louise Brooks, Carl Götz.

C.5 Yvonne Rainer, still from *Lives of Performers*, 1972. 16 mm black-and-white film, sound, 90 min. Cinematographer: Babette Mangolte. Pictured: Shirley Soffer and John Erdman.

C.6 Georg Pabst, still from *Pandora's Box,* 1929. Pictured: Gustav Diessel.

C.7 Yvonne Rainer, still from *Lives of Performers,* 1972. 16 mm black-and-white film, sound, 90 min. Cinematographer: Babette Mangolte. Pictured: John Erdman.

narrative, and when Rainer's cast reenacts the images, plot and character re-cede still further. This in turn affects the images' emotional impact. As Shelly Green has said of this sequence, "the spectator cannot relate to the characters objectified in this way but can only admire the style and form of the presenta-tion."[18] Noël Carroll similarly suggests that in subjecting the melodrama's im-ages to this treatment, Rainer "has arrested their contagious powers," so that the tableaux provoke "contemplation rather than empathy, kinetic or otherwise."[19] Certainly *Lives of Performers* as a whole fairly bristles with Brechtian devices that disrupt the normal operations of filmic identification (beginning with the use of offscreen narration rather than synchronized speech), and the *Pandora's Box* poses fit into this tendency as the most mediated scenes imaginable: ac-tors on film recreating photographic images published in a book taken from a movie.

Yet I am not convinced that the viewer therefore sits at a cool remove from the action onscreen—or lack thereof. It is not incidental that the long sequence of still poses is a remarkably uncomfortable movie experience. The twenty-second duration of each tableau seems geared to the exact limit of both the performers' endurance and the viewer's attention. To watch each shot is to experience the perceptual equivalent of a muscular cramp, which finds marvel-ous expression within the sequence when the bug-eyed effort of John Erd-man to maintain his expression without blinking becomes a synecdoche for the tableaux's overall effect on the viewer: it takes effort to keep the eyes on these long-posing bodies, overexposed to our sight. And so, while the cavalcade of mediations strips away the narrative meaning of the depicted scenes and fore-closes the possibility of understanding the characters as people with whom one could emotionally engage, *by these very means* the physicality of the performers is brought nearer to the activity of the viewer—the seeing difficulty of perfor-mance intersubjectivity is more nearly resolved—than anywhere else in Rainer's work of the period this book has studied.

In a discussion of kinetic art that moves in extreme slow motion, Yve-Alain Bois describes the uncanny effect that comes from the brief moments of prerational seeing such work provides, in which the boundaries we have

come to accept between animate and inanimate, dead and living, are fleetingly disturbed.[20] He quotes Freud on the uncanny, a feeling that arises when there is a conflict of judgment—call it a seeing difficulty—"as to whether things which have been 'surmounted' and are regarded as incredible may not, after all be possible."[21] This is precisely what happens as we experience the barely-there movement and extended duration of the *Pandora's Box* stills at the end of *Lives of Performers*—as we experience this most not-live performance. We could not be more distant from these hypermediated figures, and yet, with their physical effort calibrated to our attentive struggle, something remarkable happens, something that typifies the telling paradoxes and generous contradictions of Rainer's investigation of spectatorship.

We feel for them.

NOTES

PREFACE: CAMERA, ACTION

1. Rainer performed *Dance Lecture* (1962), *Ordinary Dance* (1962), *Three Satie Spoons* (1961), and *The Bells* (1961). The photos with the camera show her during *Ordinary Dance*. Jepson and Rainer met in San Francisco, most likely when she came back to her native city from New York in 1960 to attend Ann Halprin's summer workshop, where Jepson was an accompanist (Warner Jepson, e-mail to author, 12 April 2007 and 25 May 2007; Yvonne Rainer, telephone interview with author, 28 May 2007). Several of Jepson's photographs from this session have been published as illustrations of Rainer's early dances, but to my knowledge the images with the television camera were never printed from the negatives except on Jepson's contact sheets, and have not been previously published. The frame numbers on the contact sheet indicate the order of the two images: first crouching, then standing.

INTRODUCTION: SEEING DIFFICULTIES

1. Yvonne Rainer, "Rreeppeettiioonn iinn Mmyy Wwoorrkk," unpublished essay, May 1965, typescript in Rainer's files, folder labeled "Writing." During the research for this book I was lucky enough to be able to access Rainer's files, notes, and archive of images and ephemera in her studio. These materials were transferred to the Getty Research Institute in 2006. As this book went to press, the archive was still being processed at the Getty, where it will fortunately

be available to all researchers in the future. My citations of Rainer's archival materials are thus identified throughout using references to the folders or binders in which they were located when the archive was in her studio, and not according to the Getty's file numbering system. Having worked with other archives at the GRI, however, I feel confident that the curators' careful description of file contents will make it possible for researchers to find the materials I refer to here using titles or dates.

2. Yvonne Rainer, "A Quasi Survey of Some 'Minimalist' Tendencies in the Quantitatively Minimal Dance Activity Midst the Plethora, or an Analysis of *Trio A*" (1966), in Rainer, *Work 1961–73* (Halifax: Press of the Nova Scotia College of Art and Design, 1974). One of the few critical studies to take seriously this resistance to vision is Ramsay Burt's essay "Genealogy and Dance History: Foucault, Rainer, Bausch, and de Keersmaeker," in *Of the Presence of the Body: Essays on Dance and Performance Theory,* ed. André Lepecki (Middletown, Conn.: Wesleyan University Press, 2004), 29–44.

3. An important study of the emphasis on ephemerality in the literature on dance in the West, and the concomitant intertwining of dancing and forms of inscription, is provided by André Lepecki, "Inscribing Dance," in Lepecki, *Of the Presence of the Body,* 124–139.

4. Rainer's influence has, of course, extended beyond national boundaries. On the cross-fertilization of American and European dance in the 1960s, see Ramsay Burt, *Judson Dance Theater: Performative Traces* (London: Routledge, 2006).

5. In this regard, my approach to Rainer's performance relates to that of several scholars who have emphasized the dialogical or spectatorial side of postmodern dance, over and above its treatment of the body per se. See Nick Kaye, *Postmodernism and Performance* (London: Palgrave and St. Martin's Press, 1994); Burt, "Genealogy and Dance History"; Mark Franko, "Some Notes on Yvonne Rainer, Modernism, Politics, Emotion, Performance, and the Aftermath," in *Meaning in Motion: New Cultural Studies of Dance,* ed. Jane C. Desmond (Durham: Duke University Press, 1997). Henry Sayre discusses a turn toward the audience rather than the performer as the site of artistic work, but dates this shift to the 1970s in *The Object of Performance: The American Avant-Garde since 1970* (Chicago: University of Chicago Press, 1992). Mark Franko argues for and performs a shift toward the theory of reception and spectatorship in dance in *Dancing Modernism / Performing Politics* (Bloomington: Indiana University Press, 1995).

6. Yvonne Rainer, letter to Steve Paxton and Barbara Dilley (1969), in Rainer, *Work 1961–73,* 146.

7. Richard Serra, interview by Lynn Cook and Michael Govan, in *Richard Serra: Torqued Ellipses* (New York: Dia Center for the Arts, 1997), 28. Serra was specifically discussing Rainer's 1969 piece *Rose Fractions.* Serra has also cited the influence of Rainer's earliest work in film on his own exploration of that medium, mentioning especially her *Hand Movie* (1966), discussed in chapter 4 above. See Annette Michelson, "The Films of Richard Serra: An Interview" (1979), in *Richard Serra,* ed. Hal Foster with Gordon Hughes (Cambridge: MIT Press, 2000), 21–57.

8. Sally Banes, *Terpsichore in Sneakers: Post-Modern Dance,* 2d ed. (Hanover, N.H.: University Press of New England, 1987), 49.

9. Yvonne Rainer, "Statement" (1968), program for *The Mind Is a Muscle,* Anderson Theater, New York, April 1968, reprinted in Rainer, *Work 1961–73,* 71.

10. Bertolt Brecht, "The Literalization of the Theatre (Notes to the *Threepenny Opera*)" (1931), in *Brecht on Theatre,* ed. and trans. John Willet (New York: Hill and Wang, 1964), 143–147.

11. Mark Franko commented on this paradoxical aspect of Rainer's practice in his discussion of *Trio A:* "Rainer's body desires not to appear, yet it appears" (Franko, "Some Notes," 298). Peggy Phelan has clarified that there are two aims in Rainer's work in dance (she is specifically discussing the early 1960s): one of opening up the kind of movement and bodies involved in dancing, and the other of revamping the relationship between spectator and performer; see Phelan, "Yvonne Rainer: From Dance to Film," in Yvonne Rainer, *A Woman Who . . . : Essays, Interviews, Scripts* (Baltimore: Johns Hopkins University Press, 1999), 5. The complexity of the relation between these two aims is in part what I am after in this study.

12. Rainer, "A Quasi Survey," 67.

13. Roger Copeland, "Towards a Sexual Politics of Contemporary Dance," *Contact Quarterly* 7, no. 3–4 (Spring-Summer 1982): 46.

14. When addressing the politics of this refusal of spectacle, critics typically have been interested in metaphorically extending Rainer's treatment of the dancer's body presented to the spectator to the relationship between female body and male gaze in patriarchy. This is an important line of inquiry, signaled early in Rainer's career with the *Duet Section* of *Terrain* (1963), which specifically linked the exhibitionism of dance performance to pinups and burlesque (discussed in chapter 3). However, as most commentators in this vein acknowledge, *Trio A* was performed as often by men as by women, and Rainer dates her own feminist awakening later, to the early 1970s. Nevertheless, the fact that structures of power are addressed in her earlier works' treatment of spectatorship is undeniable. Particularly clear on this point is Jonathan Walley, "From Objecthood to Subject Matter: Yvonne Rainer's Transition from Dance to Film," *Senses of Cinema,* no. 18 (January–February 2002), at http://www.sensesofcinema.com/contents/01/18/rainer.html. Other texts providing a feminist reading of the aversion of the gaze in *Trio A* are Sally Banes, *Dancing Women: Female Bodies on Stage* (London: Routledge, 1998), 222–225; Franko, "Some Notes"; and Copeland, "Towards a Sexual Politics of Contemporary Dance." The most provocative interpretation is Peggy Phelan's in "Yvonne Rainer: From Dance to Film," 6–7, discussed below.

15. Rainer remembers bristling at the implication that the dance seemed improvised rather than carefully planned. Rainer to the author, October 2006.

16. Annette Michelson, "Yvonne Rainer, Part 1: The Dancer and the Dance," *Artforum* (January 1974), 58. Michelson then focuses on Rainer's revision of the "performing self" in relation to dominant models of artistic subjectivity. Among the other important contributions of this essay is Michelson's treatment of time in Rainer's work, which I will discuss in chapter 2.

17. Ann Kisselgoff, "Casual Nude Scene Dropped into Dance by Rainer Company," *New York Times,* 16 December 1970, 51.

18. Rainer, "A Quasi Survey," 67.

19. Kaye, *Postmodernism and Performance.* Kaye's central argument as it relates to Rainer and postmodern dance is that this art, like minimalist sculpture, recognized the profound contingency of art—the fact that convention, location, and conditions of presentation rather than anything intrinsic to the type of behavior are what makes something dance rather than mere movement.

20. Don McDonagh, "Miss Rainer Offers 'Mind Is a Muscle,'" *New York Times,* April 12, 1968, 40; Frances Herridge, "The Avant-Garde Is At It Again," *New York Post,* 7 February 1969, reprinted in Rainer, *Work 1961–73,* 155.

21. Yvonne Rainer, "Don't Give the Game Away," *Arts Magazine* (April 1967): 47.

22. This is as paraphrased by Rainer, interviewed by Chrissie Isles, in "Life Class," *Frieze* 100 (June-August 2006): 229. Rainer cites the question in "A Quasi Survey," 65, and in numerous interviews and lectures. I believe the actual quotation she refers to is from George Jackson's essay "Naked in Its Native Beauty," *Dance Magazine* 38 (April 1964): 37: "Why do these people want to be themselves so badly that they practice doing it in public?"

23. Rainer, interviewed by Isles, 229.

24. Alan Solomon, "Is There a New Theater?," *New York Times,* 27 June 1965, X12.

25. Roland Barthes, "The Death of the Author," trans. Richard Howard, *Aspen* 5–6 (Fall–Winter 1967).

26. Wolfgang Kemp, "The Work of Art and Its Beholder: The Methodology of the Aesthetic of Reception," in *The Subjects of Art History: Historical Objects in Contemporary Perspectives,* ed. Mark A. Cheetham, Michael Ann Holly, Keith Moxey (Cambridge: Cambridge University Press, 1998), 181. Reception aesthetics proper was largely developed in the 1970s and 1980s within the study of literature, but as Kemp points out, the approach dovetails with tendencies in aesthetics and art history reaching back to Hegel and Riegl, respectively, that look to "the function of the beholder prescribed in the work of art" (183–184). While reception aesthetics can be a historical approach, insofar as it seeks a work's historicity precisely in the relation to the beholder it assumes, a strict definition would distinguish this study of the work's implicit beholder from reception history, or research directed at the historical record of actual acts of spectatorship. For me, however, the approaches are both theoretically interpenetrable (because the texts and documents of "actual" reception themselves must be understood as creative acts, requiring active interpretation and thus recognition of *their* implicit beholders) and, in the case of the study of past performance, practically intertwined (since the "work of art" itself is accessible to us only through documents of reception, ranging from the artist's own documents to

those produced by photographers and critics and to the reminiscences solicited in interviews and other forms of primary reception history research). Neither approach alone would provide sufficient information; together, they offer a way of identifying and understanding historically Rainer's work with spectatorship.

27. Michael Baxandall, *Painting and Experience in Fifteenth-Century Italy: A Primer in the Social History of Pictorial Style,* 2d ed. (Oxford: Oxford University Press, 1988).

28. Clive Barnes, "Far Out Five," *New York Times,* 12 June 1966, 45; Allen Hughes, "Dance Programs Have Premiere," *New York Times,* 17 March 1964, 30; Saul Goodman, "Yvonne Rainer: Brief Biographies: A Monthly Series about Dancers You Should Know," *Dance Magazine* 39 (December 1965): 110.

29. Phelan, "Yvonne Rainer: From Dance to Film," 3–17.

30. Ibid., 6–7.

31. Yvonne Rainer to Don McDonagh, 29 December 1969, in Rainer's files, folder "Correspondence 1971."

32. Allan Kaprow, *Assemblage, Environments and Happenings* (New York: H. N. Abrams, 1966).

33. Yvonne Rainer, "Some Retrospective Notes on a Dance for 10 People and 12 Mattresses Called *Parts of Some Sextets,* Performed at the Wadsworth Atheneum, Hartford, Connecticut, and Judson Memorial Church, New York, in March, 1965," *Tulane Drama Review* 10, no. 2 (Winter 1965), reprinted in Rainer, *Work 1961–73,* 51. The famous paragraph, often referred to as her manifesto, is but one paragraph in a substantial essay, though this fact is rarely noted. The essay and the dance that is its subject will be discussed in chapter 2.

34. Yvonne Rainer to Batya Zamir, 21 December 1969, in Rainer's files, folder "Correspondence 1969."

35. Rainer herself has done this magnificently in her writing over several decades, and in her recent memoir *Feelings Are Facts: A Life* (Cambridge: MIT Press, 2006).

36. Amelia Jones's insistence that performance art disallows the normal stance of scholarly objectivity, due to its inherent intersubjectivity as well as its reliance on traces, has been of great importance (*Body Art: Performing the Subject* [Minneapolis: University of Minnesota Press, 1998]. Kathy O'Dell's *Contract with the Skin: Masochism, Performance Art, and the 1970's* (Minneapolis: University of Minnesota Press, 1998) suggestively foregrounds these traces, exploring the experience of the documents of painful performance art and linking it to the context of the Vietnam War's mediatization. In *What the Body Cost: Desire, History, and Performance* (Minneapolis: University of Minnesota Press, 2004), Jane Blocker reflects on this scholarship, arguing that a concern with "the body" and its special genre, writing on body art, corresponds to a postmodern desire for that about which one is skeptical. Whether that desire drives this study as well I leave to the reader to decide.

37. Leo Steinberg, "Objectivity and the Shrinking Self" (1967), in Steinberg, *Other Criteria: Confrontations with Twentieth-Century* Art (New York: Oxford University Press, 1972), 317.

38. Ibid., 318.

1 Judson Dance Theater in Hindsight

1. The flashlights were in *Rafladan* by Alex and Deborah Hay, discussed toward the end of this chapter; a pear was eaten in Steve Paxton's *Proxy;* and David Gordon did the singing in *Mannequin Dance.*

2. Steve Paxton, e-mails to author, 2 June and 4 June 2005. Paxton stressed to me the nonhierarchical organization of the list of names in the poster. Dance historian Sally Banes mentions in passing the poster's "hint of repetition and reversal," in Banes, *Democracy's Body: Judson Dance Theater 1962–1964,* 2d ed. (Durham: Duke University Press, 1993), 39; hereafter cited within the text as *DB.* A similar positive-negative reversal was used five years later on the cover of an issue of *Ballet Review* devoted to Judson (vol. 1, no. 6, 1967).

3. The film, *Overture,* was credited to the three filmmakers along with W. C. Fields, bits of whose films were spliced into the chance-structured collage. See Banes, *Democracy's Body,* 40–41.

4. Yvonne Rainer, *Work 1961–73* (Halifax: Press of the Nova Scotia College of Art and Design, 1974), vii.

5. Ibid.

6. Rainer, e-mail to author, 6 July 2006. She particularly recalls spending hours between dance classes at the Coliseum Book Store on 57th and Broadway.

7. Guy Debord, *The Society of the Spectacle* (1967), trans. Donald Nicholson-Smith (New York: Zone Books, 1995), 114.

8. Thomas Heyd, "The Real and the Hyperreal: Dance and Simulacra," *Journal of Aesthetic Education* 34, no. 2 (Summer 2000): 15.

9. Erving Goffman, *Behavior in Public Places: Notes on the Social Organization of Gatherings* (New York: Free Press, 1963); Students for a Democratic Society and Tom Hayden, "The Port Huron Statement" (1962), available at www.tomhayden.com/porthuron.htm.

10. Sally Banes, "Will the Real . . . Please Stand Up? An Introduction to the Issue," *TDR* 34, no. 4 (Winter 1990): 23.

11. Thomas Crow, *The Rise of the Sixties: American and European Art in the Era of Dissent* (New York: Harry N. Abrams, 1996), 128.

12. While most of the works discussed here were presented under the rubric of Judson Dance Theater, the phenomena under investigation are somewhat broader than the term allows. The phrase "Judson dance," referring to the artistic project rather than the sociological entity, expresses this wider sense of the new type of dance-based performance developed in New York at this time and embraces art that the narrower term would exclude, such as the choreography done in workshops that preceded the concerts at the church, and the performances of Simone Forti, who participated in the early workshops and often collaborated with members of Judson Dance Theater but did not participate in its concerts.

13. This is not meant to disprove the arguments of Banes and others: nowhere am I saying that this work *wasn't* exemplary in its collaborative spirit, brave in its rejection of convention, and innovative in its embrace both of new materials for dance performance and new ways of organizing them. As this book was in final preparations, a new treatment of Judson Dance

Theater was published by Ramsay Burt, who also respectfully takes issue with Banes's vision, contrasting his view of Judson dance as an anarchic, critical avant-garde with what he reads as her "affirmative" vision of the group and its project. See Burt, *Judson Dance Theater: Performative Traces* (London: Routledge, 2006). In contrast to both of these important arguments, I want to show the complexities and ambiguities in the ideological work performed by Judson dance.

14. Fluxus, Happenings, and Judson dance intersected in a number of ways during the early 1960s in New York. There was some tension between participants in the various endeavors (with one partial casualty being the loss of Simone Forti—though she did brilliant, influential dance work elsewhere in the early 1960s, her relationship with her then-husband, Happenings-maker Robert Whitman, and his resistance to Judson kept her from participating in the collaborative concerts at the church). But there was also tremendous interaction and cross-fertilization. Forti presented work in Happening and Fluxus contexts, with Rainer and Robert Morris performing her *See-Saw* in a Happenings event; several of her works were published in the Fluxus compilation *An Anthology.* Rainer and Trisha Brown performed at the Fluxus Yam Day. Al Hansen presented a Happening called *Parasol 4 Marisol* at the Judson "Concert of Dance 12" (held at the Gramercy Arts Theater); Steve Paxton collaborated with curator Alan Solomon to bring together Happenings makers Claes Oldenburg, Jim Dine, and Whitman with Judson dancers in a series of events they organized in May 1965 as the New York Theater Rally.

15. Though performance itself may be a transhistorical and transcultural phenomenon, the concept of *live* performance depends on the existence of an alternative—performance experienced at a temporal remove (as in recording) or spatial remove (as in radio or television broadcasting). This is a central argument of Philip Auslander's *Liveness: Performance in a Mediatized Culture* (London: Routledge, 1999).

16. Hannah Higgins, *The Fluxus Experience* (Berkeley: University of California Press, 2002). Higgins describes the specifically "apprehensive, hesitant" approach to Ay-O's *Finger Boxes,* for there is an instinctive carefulness involved in sticking one's finger into the unknown interior. It matters that it is a slightly scary as well as pleasurable experience, for this means that the viewer encounters the boxes as a careful explorer rather than willful grasper (38–40).

17. Ibid., 67. The foam-filled *Finger Box* intervened in the archival environment not only by contrasting with the visual, textual means by which knowledge was busily being produced at

the other workstations in the Reading Room, but also by suggesting how tactile a learning activity such research actually is: those archival bolsters for the books, pads for the table: all made of foam rubber. And all there so that people might access the information embodied in singular boxes, books, and binders encountered in physical space.

18. Owen Smith, *Fluxus: The History of an Attitude* (San Diego: San Diego State University Press, 1998), 147–148.

19. Lee Heflin, "First Performance," in *The Fluxus Performance Workbook, a Special Issue of El Djarida,* ed. Ken Friedman (Trondheim, Norway: Gutthorm Nordo, 1990), 22. The piece is undated in the *Fluxus Performance Workbook,* which indicates it is from the early 1960s.

20. See Emmett Williams, *My Life in Flux—and Vice Versa* (London: Thames and Hudson, 1992), 50–51.

21. Tomas Schmit, "Sanitas No. 165," in Friedman, *Fluxus Performance Workbook,* 45.

22. Ken Friedman, "Fluxus Instant Theater," in Friedman, *Fluxus Performance Workbook,* 19. There are any number of other examples whose individual effects and underlying ideas deserve more discussion: Ben Patterson, in his *Lick Piece,* invited the audience to lick off the whipped cream covering Letty Eisenhauer's body, and in *Seminar I* paired off audience members and had them interact—for example, "one person slapping the other and asking a question, the second person returning the slap and the question." Ay-O had several audience members tie their feet to a long board and walk around the room together (see Smith, *Fluxus: The History of an Attitude,* 148–149). And in the most famous instance, Yoko Ono had the audience come onstage to cut off pieces of her clothing with scissors in *Cut Piece,* 1965.

23. Liz Kotz has provided the most significant account of the event-score, historicizing its emergence via the reception of experimental music by artists like Brecht and LaMonte Young in New York in the late 1950s. She also theorizes its differences from Cage's precedent and from the more generalized Barthian "return of the reader" in art and culture of the 1960s (to the endlessness and circularity of which the materiality and specificity of the event-score acts as a corrective). Kotz, "Post-Cagean Aesthetics and the 'Event' Score," *October* 95 (Winter 2001): 55–89.

———

24. Ken Friedman, "Working with Event Scores: A Personal History," *Performance Research* 7, no. 3 (2002): 125. This form led to the odd situation in which an artist can say, "there are pieces of mine that I have never seen" (ibid., 126).

25. Per Hovdenakk, preface to *The Fluxus Performance Workbook,* 4.

26. And of course this is one of many ways that Fluxus refigures Dada. A sense of Dada as an international network and as invested in questions of mass media is newly apparent in the Dada exhibition and accompanying publications organized in 2005 by Leah Dickerman and Laurent LeBon at the National Gallery of Art, Washington and the Centre Pompidou, Paris. See *Dada: Zurich, Berlin, Hannover, Cologne, New York, Paris,* ed. Leah Dickerman (Washington, D.C.: National Gallery of Art in association with D.A.P./Distributed Art Publishers, 2005).

27. The *Finger Boxes* were on display at the Fluxshop during the weeks of the first U.S. Fluxus performance festivals, 11 April–23 May 1964. See Smith, *Fluxus: The History of an Attitude,* 147.

28. Ina Blom, "Hiding in the Woods," in Friedman, *Fluxus Performance Workbook,* 59.

29. Rosalind E. Krauss, "In the Name of Picasso," in Krauss, *The Originality of the Avant-Garde and Other Modernist Myths* (Cambridge, MIT Press, 1985), 28.

30. Ben Vautier, "Police," in Friedman, *Fluxus Performance Workbook,* 50.

31. Ben Vautier, "Shower II," in Friedman, *Fluxus Performance Workbook,* 51.

32. Susan Sontag, "Happenings: An Art of Radical Juxtaposition" (1962), in Sontag, *Against Interpretation, and Other Essays* (1966; repr., New York: Anchor Books/Doubleday, 1990), 265.

33. Allan Kaprow, "Happenings in the New York Scene," *Art News* 60, no. 3 (May 1961): 37.

34. Alan Solomon, "Is There a New Theater?," *New York Times,* 27 June 1965, X12.

35. Joanna Drucker, "Collaboration without Object(s) in the Early Happenings," *Art Journal* 52, no. 4 (1993): 54.

36. Ibid. The most thoughtful and provocative response to Drucker's sympathetic view of the Happenings is Judith Rodenbeck's essay "Madness and Method: Before Theatricality" (*Grey Room* 13 [Fall 2003]: 54–79), which attends to the objectified treatment of the human subject in Happenings by way of undercutting what she demonstrates has been an overdetermined (and underhistoricized) distinction between the Happenings and theater.

37. Kaprow, quoted in Drucker, "Collaboration without Object(s)," 56.

38. Simone Forti notes this range in her commentary on *Flower,* relating it to both the speed with which we have learned to "read" images and to the frustrating feeling of needing a little more time to properly see them, in our ever-accelerating image culture. In Robert Whitman, *Performances from the 1960s,* DVD (Artpix, 2003).

39. Gavin Butt, "Happenings in History, or, The Epistemology of the Memoir," *Oxford Art Journal* 24, no. 2 (2001): 113–126.

40. Specifically, Butt links the effect Delany describes to postmodern historical discourse, with its emphasis on multiple, contingent views and voices. This is proposed by Delany himself, who uses his experience of Kaprow's Happening as a metaphor for the condition of writing history—and particularly of writing the history of sexuality. Kaprow's event provides the logic for writing a queer history of the early 1960s in New York that is different from the predominant model of outing: "he does not attempt to make good that absence by filling it with a gay presence" (Butt, "Happenings in History," 122). And from this, Butt extracts yet another lesson: "the idea that history writing—whether the history of art or the history of the subject—might address itself to its own inevitable inadequacies, to its lapses of memory, exclusions, and obfuscations *as an important part of its very enterprise*" (122).

41. See Allan Kaprow, "Pinpointing Happenings," in *Essays on the Blurring of Art and Life,* ed. Jeff Kelley (Berkeley: University of California Press, 1993), 84.

42. Kaprow, "Happenings in the New York Scene," 37. Some dimension of the same problem may have extended to Judson Dance Theater. Though this group never achieved the widespread notoriety of the Happenings, within mainstream contemporary dance criticism its work was consistently placed in a ready-made category of the "fringe" or "far out" that shares in

the assimilation of the avant-garde to which Happenings and other underground forms were subject. See, among many examples, Allen Hughes, "Dancing in Summer in Manhattan," *New York Times,* 16 June 1963, 98; Hughes, "Dancers Explore Wild New Ideas," *New York Times,* 9 February 1963, 5; and Cecily Dell, "Far beyond the Far Out: Some Experimental Choreographers," *Dance Scope* (Winter 1965): 13–18. Lynn Tornabene commented in her 1965 profile of Judson minister Howard Moody that "the church has been called 'far out' so often that one might wonder if it is on the moon" ("Way-Out Minister of Washington Square," *New York Times,* 6 June 1965, SM116).

43. The text of the tape used at a second performance of *Street Dance,* at Robert Rauschenberg's Broadway loft, was published in Childs's "Lucinda Childs: A Portfolio," *Artforum* 11, no. 6 (February 1973): 52.

44. Childs in "Lucinda Childs," transcript of interview with Lucinda Childs edited by Anne Livet, in *Contemporary Dance: An Anthology of Lectures, Interviews and Essays with Many of the Most Important Contemporary American Choreographers, Scholars and Critics,* ed. Livet (New York: Abbeville Press, 1978), 61.

45. There is no record of exactly what the objects pointed to were in the first, 1964 performance at the Dunn loft (Rainer recalls sheets in a shop window). The examples and quotations I've given are from the transcript of the tape Childs made for a 1965 performance of *Street Dance* at Robert Rauschenberg's studio at Broadway and 11th Street, in "Lucinda Childs: A Portfolio."

46. Rainer, telephone interview with author, 18 May 2005.

47. Nick Kaye, *Postmodernism and Performance* (London: Palgrave and St. Martin's Press, 1994), 108.

48. Rainer, telephone interview, 18 May 2005. Kaye's argument is opposed to earlier writings on the group by Sally Banes, discussed here as well, in which Judson dance is understood to have at its heart a question about its own medium.

49. Hal Foster, "The Crux of Minimalism," in *The Return of the Real: The Avant-Garde at the End of the Century* (Cambridge: MIT Press, 1996), 35–69.

50. Arlene Croce, "After Five Years," introduction to special issue on Judson Dance Theater, *Ballet Review* 1, no. 6 (1967): 3.

51. Jill Johnston wrote that at Judson dancers and artists worked together to project "dance into what I call the Theatre of Action." Johnston, "Judson 1964: End of an Era," reprinted in *Ballet Review* 1, no. 6 (1967): 11.

52. Robert Dunn, "Notes, 30 March 1980," 6–7; quoted in Banes, *Democracy's Body,* 208–209.

53. Childs, "Lucinda Childs: A Portfolio," 53.

54. Lucinda Childs, "Notes: '64–'74," *The Drama Review: TDR* 19, no. 1 (1975): 33.

55. Childs, "Lucinda Childs: A Portfolio," 53.

56. Samuel Weber, "Television: Set and Screen," in *Mass Mediauras: Form, Technics, Media,* ed. Alan Cholodenko (Stanford: Stanford University Press, 1996), 115.

57. Diane di Prima, "A Concert of Dance—Judson Memorial Church, Friday, 6 July 1962," *The Floating Bear* 21 (1962): n.p.

58. Childs, in "Lucinda Childs," interview in *Contemporary Dance,* 61.

59. Sally Banes, *Terpsichore in Sneakers: Post-Modern Dance,* 2d ed. (Hanover, N.H.: University Press of New England, 1987), 29.

60. At the time, Barbara Dilley was using the surname Lloyd, which she took during her first marriage. She has used Dilley since the mid 1970s. In keeping with her preference and to avoid confusion, I will refer to her as Barbara Dilley throughout this book.

61. Don McDonagh, *The Rise and Fall and Rise of Modern Dance* (New York: Outerbridge and Dienstfrey, 1970), 139.

62. Sally Banes documents and describes the workshop in the first chapter of *Democracy's Body,* while Mary Edsall provides a view from Dunn's perspective in "Reading and Writing Robert Ellis Dunn as a Democratic Artist in a Postmodern World: Locating Content through Context in Dance Biography" (Ph.D. dissertation, Temple University, 2003).

63. The program for the first concert indicated that *The Daily Wake* had a special "structure" that was "realized" by its dancers; perhaps to further specify the structure's source, at the second concert the title was changed to *Newspaper Dance.* Newspapers made another appearance in Judson Dance Theater when, in a kind of Dionysian rite of media consumption, Carolee Schneeman had dancers leap through, run over, and toss about piles of papers in her 1963 *Newspaper Event.* Newspapers were also a staple of Happenings and Environments in the late 1950s and early 1960s.

64. This description is drawn from Elaine Summers, telephone interview with author, 5 October 2001, and from Banes's description and quotes from her 1980 interview with Summers (*Democracy's Body,* 53–54). The use of the newspaper to generate the dances' images, movement, and structure—which amounts to imagining dancing as a novel and complex form of reading—is an extreme case of a procedure that was foundational for Judson dance. In part because of Dunn's interest in trying Cage's musical composition methods in movement performance, using scores as an alternative to more intuitive methods of dance composition was an essential Judson operation (see Banes, *Democracy's Body,* ch. 1). Scoring soon became the norm for dance construction in the workshop. The use of scores has been linked to the nonhierarchical and inclusive aspects of Judson dance. Banes describes scores as crucial "in order to objectify the composition process, both by creating nonintuitive choices and by viewing the total range of possibilities for the dance" (*Democracy's Body,* 7). Moreover, scores allowed performers to take on creative responsibility— they were not simply obeying instructions that had been handed down to them from choreographers, but asked to participate in deciding how the scores should be interpreted. But the use of scores in this way also fits with recent dance theory, often inspired by Jacques Derrida, that has emphasized representation's entry into the presence of performance (see note 81 below).

65. Summers, telephone interview, 5 October 2001.

66. Leo Steinberg, "Other Criteria," in Steinberg, *Other Criteria: Confrontations with Twentieth-Century Art* (New York: Oxford University Press, 1972), 90.

67. Clive Barnes used an interestingly horizontal and Rauschenberg-appropriate metaphor in 1965 when he called Judson Dance Theater the "warm-bed of dance protestantism situated in the odd." See Barnes, "Dance: At Judson Theater," *New York Times,* 23 November 1965, 53.

68. Paxton was Rauschenberg's partner for several years, and photographs of him appear in many of the painter's early 1960s silkscreens.

69. Steve Paxton and Yvonne Rainer, interview with author, Los Angeles, 26 May 2005. Paxton and Rainer recall that this was in 1965, as part of a private performance for Joan Miró, who was visiting New York and had expressed interest in the dance work of the Judson circle to a Museum of Modern Art curator who then arranged an impromptu concert. Paxton performed his *Section of a New Unfinished Work,* Rainer presented an in-progress version of *Trio A,* and Childs and Holder did Childs's *Street Dance* outside the studio.

70. Steinberg, "Other Criteria," 55.

71. Rainer notes that this object, originally painted yellow, was actually created for her dance *The Bells* (1961) by her friend George Sugarman, and was left behind at the Living Theater after the James Waring concert of 31 July 1961, at which she performed the piece as her public choreographic debut. Rainer to the author, November 2001; further discussed in her memoir *Feelings Are Facts: A Life* (Cambridge: MIT Press, 2006), 235.

72. See Robert Morris, "Notes on Dance," *Tulane Drama Review* 10, no. 2 (Winter 1965): 183.

73. Sally Banes discusses *Take Your Alligator with You* (*Democracy's Body,* 145), but doesn't mention that the still poses came from advertising. Rainer recalled this detail (Rainer to the author, November 2001). A precedent for the use of stillness by Judson dancers is Paul Taylor's 1957 work *7 New Dances,* in which he both struck a series of still poses and included a four-minute tableau vivant. Stillness and near-stillness were of course exploited in experimental film of this period as well, most notably in Andy Warhol's early films, such as *Empire* and the screen tests.

74. John Cage, "45' for a Speaker," lecture given at Composers' Concourse, London, October 1954, in Cage, *Silence: Lectures and Writings* (Middletown, Conn.: Wesleyan University Press, 1961), 191.

75. Rainer, e-mail to author, 6 July 2006.

76. Roland Barthes, *Camera Lucida: Reflections on Photography,* trans. Richard Howard (New York: Hill and Wang, 1981), 77.

77. Peggy Phelan, *Unmarked: The Politics of Performance* (London: Routledge, 1993), 146.

78. Robyn Brentano, "Outside the Frame: Performance, Art, and Life," in *Outside the Frame: Performance and the Object: A Survey History of Performance Art in the USA since 1950,* exh. cat. (Cleveland: Cleveland Center for Contemporary Art, 1994).

79. Susan Sontag, *On Photography* (New York: Farrar, Straus and Giroux, 1977), 155.

80. Phelan, *Unmarked,* 146.

81. More precisely, Phelan argues that performance can thus serve as a model for a type of representation that is not reproduction—that does not try to render the Other as the Same (*Unmarked,* 3). Phelan's argument was made at the beginning of a line of thinking in performance and dance studies that reverses the long disparagement of performance, especially dance, in Western culture because of its inaccessibility to language and its ephemerality, instead valorizing it and finding in it important models precisely because of its lack of fixity and constant vanishing. As André Lepecki and Mark Franko have argued, this turn is in part a response to the influence in the humanities of Jacques Derrida's critique of the metaphysics of presence. See André Lepecki, "Inscribing Dance," in *Of the Presence of the Body: Essays on Dance and Performance Theory,* ed. Lepecki (Middletown, Conn.: Wesleyan University Press, 2004), 124–139; Franko, *Dancing Modernism;* and Mark Franko, "Mimique," in *Bodies of the Text: Dance as Theater, Literature as Dance,* ed. E. W. Goellner and J. S. Murphy (New Brunswick, N.J.: Rutgers University Press, 1995). See also Heidi Gilpin, "Lifelessness in Movement, or How Do the Dead Move? Tracing Displacement and Disappearance for Movement Performance," in *Corporealities: Dancing, Knowledge, Culture, and Power,* ed. Susan Leigh Foster (London: Routledge, 1996), 106–128. Most in line with the current investigation, Philip Auslander challenges the priority on presence in performance studies in his book *Liveness,* arguing that under the conditions of a mass-media-oriented culture, and particularly a television-dominated one, the live is always already, in Jameson's term, "mediatized." In addition to the

concern with negotiations of media culture (which he tends to refer, however, to the 1980s and not the earlier period with which I am concerned), Auslander's approach is important for inserting a question of historicity in the discussion of performance presence and absence. As Lepecki notes, much of the theory cited here tends instead toward a generalized view of performance.

82. Peggy Phelan in "E-mail Correspondence between Sabine Folie and Peggy Phelan from the Catalog for the Exhibition *A Baroque Party*" (Kunsthalle Wien, 2001), in *Yvonne Rainer: Radical Juxtapositions 1961–2002,* ed. Sid Sachs, exh. cat. (Philadelphia: University of the Arts, 2003), 14.

83. Banes, *Democracy's Body,* 53; Summers, telephone interview, 5 October 2001.

84. But not a mournful one: drawing on the traditions of the Irish side of her family, she meant the idea of the wake to be "jolly . . . a summation of everything that happened just before, and it has died and we're burying it." Summers, telephone interview, 5 October 2001.

85. This was my experience as a viewer, when Paxton performed *Flat* in the concert "Danspace Project Silver Series: Steve Paxton," Danspace Project, St. Mark's Church, New York, 21–23 May 2001.

86. Robert Morris in 1965 suggested a slightly different effect of stillness—he claimed it was "not used as punctuations for the movement but in the attempt to make duration itself palpable" ("Notes on Dance," 183).

87. Banes describes the procedure as performing the gestures "made minuscule and thereby unrecognizable" (*Terpsichore in Sneakers,* 79), but from the versions I have seen on film (BAM performance, 1996, on *Trisha Brown: Early Works 1966–1979* [Artpix, 2004]) and in live performance (by Mikhail Baryshnikov in the White Oak Dance Project concert "Past Forward," 2000), I am not convinced "miniaturization" is precisely the right term, though there is an overall reduction, a smoothing, slowing, and scaling down. The effect however is, as Banes says, to make the gestures unrecognizable, but just barely (one or two, like a short sequence of tap dancing, are legible, which increases the sense that the others would be recognizable if only they were performed in a different manner).

88. See Banes, *Terpsichore in Sneakers,* 79.

89. Recreated and taped for the Judson Dance Theater revival concerts in 1982, video available at the Dance Collection, New York Public Library for the Performing Arts. The *Pop* performances are also described by Sally Banes, *Democracy's Body,* 160.

90. This is a different way of framing the effect that Henry Sayre identifies as the Derridean aspect of Brown's work from this period. He explains that in her work the possibility of presence, of a thing being in and for itself, is foreclosed by the dynamics of repetition, in a way that makes her work comparable to the logic of the trace in Derrida. Sayre, *The Object of Performance: The American Avant-Garde since 1970* (Chicago: University of Chicago Press, 1992).

91. Steve Paxton, Bennington Judson Project Interview by Nancy Stark Smith with Wendy Perron, 1983. Typescript in Dance Collection, New York Library for the Performing Arts, p. 3.

92. Rainer, Notebook, quoted in Banes, *Democracy's Body,* 15. It is important to note here that the repetition Rainer is talking about is literal and exact. The difference between this kind of repetition and the type of replay available through conventional dance's recurring themes and variations is comparable to the distinction Rosalind Krauss makes between the multiple identical castings in Rodin's work, for example the thrice-repeated figure atop his *Gates of Hell,* and the repetition of *similar* forms in classical sculpture. See Rosalind E. Krauss, *Passages in Modern Sculpture* (Cambridge: MIT Press, 1977), 18–21.

93. Yvonne Rainer, "Rreeppeettiioonn iinn Mmyy Wwoorrkk," unpublished essay, May 1965, typescript in Rainer's files, folder labeled "Writing." Here Rainer considers all of her uses of repetition, and comes to the conclusion that it has a different function every time it is used. Interestingly, she suggests that by 1965, when repetition played a key role in *Parts of Some Sextets* (because in this dance a chance-based process called for certain chunks of movement material to recur repeatedly), she had found a very different effect from the programmatic use of pure repetition in *The Bells* and *Three Satie Spoons*—not to make an image linger and become more visible for the audience, by the mid 1960s, but to diffuse attention so that it would be difficult to stay involved with the image at all. This is clearly a step toward the decision in *Trio A* of 1966 to forgo any and all repetition, which as she would write in her essay about that dance, was in a sense the flip side of her earlier concern with "the seeing difficulty": her

strategy in the mid 1960s was not to try to make dance easier to see, but to exaggerate the difficulty.

94. Lepecki, "Inscribing Dance," 130–133.

95. Pamela M. Lee, *Chronophobia: On Time in the Art of the 1960s* (Cambridge: MIT Press, 2004), xii.

96. Described in Rainer, "Rreeppeettiioonn iinn Mmyy Wwoorrkk"; also in Rainer, *Work 1961–73,* 285, and Banes, *Democracy's Body,* 18.

97. Lillian Moore, "Yvonne Rainer, Fred Herko Present Dance Offerings," *New York Herald Tribune,* 6 March 1962, 12.

98. Simone Forti, interviewed by Louise Sunshine, tape recording and transcript, 8 May 1994, Dance Collection, New York Public Library. Quote is on transcript page 40. See also *Simone Forti: From Dance Construction to Logomotion,* produced and directed by Charles Dennis, 28 min., UCLA National Dance/Media Project, Los Angeles, in association with Loisaida Arts, Inc., 1999, videocassette.

99. Robert Morris, "Notes on Sculpture, Part Two," *Artforum* 5, no. 2 (October 1966): 20–23.

100. Paxton, Bennington Judson Project Interview, 12–13.

101. Paxton, interview with author and Yvonne Rainer, Los Angeles, 26 May 2005.

102. She would repeat this kind of shifting from pose to pose in *Act,* a section of the later work *The Mind Is a Muscle,* to which I will return in the following chapters.

103. Jill Johnston, "Judson Speedlimits," *Village Voice,* 25 July 1965, reprinted in Johnston, *Marmalade Me,* 2d ed. (Hanover, N.H.: University Press of New England, 1998), 41.

104. See Banes, *Terpsichore in Sneakers,* 78.

105. Given the use of repetition in Judson dance, it is significant that Gordon's original conception called for the piece to be performed ten times in an evening, interrupted by brief intermissions (Banes, *Democracy's Body,* 54).

106. Walter Benjamin, "The Work of Art in the Age of Mechanical Reproduction," in *Illuminations: Essays and Reflections,* ed. Hannah Arendt, trans. Harry Zohn (New York: Schocken Books, 1969), 237.

107. The difference from Bergsonian views of perception in time can be considered symptomatic. Significantly, Pamela M. Lee shows how the extreme slowness in the contemporaneous kinetic sculptures of the Belgian artist Pol Bury was specifically opposed to Bergson's view of a seamless and flowing duration, correlating instead with the discontinuous, ruptured understanding of time provided by Gaston Bachelard. See Lee, *Choronophobia,* chapter 2.

108. Phelan, *Unmarked,* 146.

109. Paxton, Bennington Judson Project Interview, 16.

110. Paxton, e-mail to author, 11 June 2005. The relevance of Muybridge for this generation of artists is discussed further in chapter 2 of this book.

111. Paxton and Rainer, interview with author, 26 May 2005.

112. Rainer, "Rreeppeettiioonn iinn Mmyy Wwoorrkk."

113. Bertolt Brecht, "The Literalization of the Theatre (Notes to the *Threepenny Opera*)" (1931), in *Brecht on Theatre,* ed. and trans. John Willet (New York: Hill and Wang, 1964), 144.

114. Yvonne Rainer, "Some Retrospective Notes on a Dance for 10 People and 12 Mattresses Called *Parts of Some Sextets,* Performed at the Wadsworth Atheneum, Hartford, Connecticut, and Judson Memorial Church, New York, in March, 1965," *Tulane Drama Review* 10, no. 2 (Winter 1965), reprinted in Rainer, *Work 1961–73,* 47.

115. André Lepecki, introduction to *Of the Presence of the Body,* ed. Lepecki, 4.

116. Don McDonagh, "Change Sets Pace in Dance Festival," *New York Times,* 21 July 1969, 39.

117. See chapter 5 of this book. Such experiments both made performances more spontaneous and emphasized the careful preparation dance normally requires.

118. Don McDonagh, "Films Are Backdrop for Robust Dances of Yvonne Rainer," *New York Times,* 1 April 1970, 38.

119. Anselm Jappe, *Guy Debord,* trans. Donald Nicholson-Smith (Berkeley: University of California Press, 1999), 142.

120. Rainer was not alone in this choice. Richard Schechner remembers Open Theater and other 1960s groups sometimes having performers who weren't in a given scene sit on the side of the action. They sat "in a quiet, almost formal manner, and then rose to join the scene—something like athletes coming into the game from the bench." He would experiment with a similar situation in his mid-1970s production of *Mother Courage* with The Performance Group, which had a small space separated from the main stage but visible to the audience in which the actors could drop out of character and relax between scenes. Richard Schechner, "Selective Inattention," in *Performance Theory,* rev. ed. (London: Routledge, 2003), 227.

121. Johnston, "Judson Speedlimits," 42.

122. Anne M. Wagner, "Performance, Video, and the Rhetoric of Presence," *October* 91 (Winter 2000): 74.

123. Debord, *The Society of the Spectacle,* 26.

124. Catterson learned *Trio A* from Becky Arnold and Barbara Dilley, dancers who had worked with Rainer in the 1960s, and who were thus fulfilling a tacit contract attached to *Trio A* by Rainer herself: that anyone who wanted to learn *Trio A,* or teach it to someone else, could do so (thus assuring its endless reproducibility—see chapter 3 of this book). Around 1970 Cat-

terson taught herself the dance in retrograde. For the recent performance, Rainer worked with Catterson to perfect the backward version. See my interview with Rainer, "Contents under Pressure: A Conversation with Yvonne Rainer," *Documents* 18 (Fall 1999): 6–16.

125. As I discussed in the introduction, Rainer gave special choreography for the head, such that the dancer is never able to make eye contact with the audience while performing. An in-depth analysis of *Trio A* is the subject of chapter 3.

126. *Trio A Pressured,* in this debut performance, consisted of Patterson's retrograded version, followed by Rainer and Patterson doing *Trio A* in the forward direction; Rainer was next joined by Colin Beatty in a new version of *Trio A* in which she performed the dance while he moved around her trying constantly to meet her always-moving gaze. Rainer then performed *Trio A* alone, after which she was joined in a final version by Steve Paxton and Douglas Dunn. Mikhail Baryshnikov was in the audience at Judson Church that night and later invited Rainer to participate in a Judson Dance Theater reconstruction/homage called *PASTForward,* which his White Oak Dance Company performed on tour in 2000. Ramsay Burt discusses *Trio A Pressured* in his *Judson Dance Theater: Performative Traces,* 197–199.

2 SECTIONS AND CHUNKS: SERIAL TIME

1. Ronald Argelander, "Photo-Documentation: (And an Interview with Peter Moore)," *The Drama Review: TDR* 18, no. 3 (September 1974): 51.

2. The New York University Graduate Department of Drama became the Department of Performance Studies in 1980. Scholars generally agree that the field had been in development for nearly two decades prior, with its intellectual foundations worked out in the journal *TDR*. The dance *Parts of Some Sextets* has a particular relation to this history since it was at the invitation of then-editor of *TDR* Michael Kirby that Rainer wrote her essay "Some Retrospective Notes on a Dance for 10 People and 12 Mattresses Called *Parts of Some Sextets,* Performed at the Wadsworth Atheneum, Hartford, Connecticut, and Judson Memorial Church, New York, in March, 1965," *Tulane Drama Review* 10, no. 2 (Winter 1965), reprinted in Yvonne Rainer, *Work 1961–73* (Halifax: Press of the Nova Scotia College of Art and Design, 1974), 45–51.

3. Argelander, "Photo-Documentation," 51.

4. Like most discussions of performance documentation, it also participates in what André Lepecki, following Derrida, calls the photology of dance or performance studies: its commitment to a metaphysics of light or visibility to counter the self-erasure of ephemeral performance. Lepecki also calls this the "documental tradition." See André Lepecki, "Inscribing Dance," in *Of the Presence of the Body: Essays on Dance and Performance Theory,* ed. Lepecki (Middletown, Conn.: Wesleyan University Press, 2004), 130.

5. Major works in this genre are Stephen Kern, *The Culture of Time and Space, 1880–1918* (Cambridge: Harvard University Press, 1983), and Anson Rabinbach, *The Human Motor: Energy, Fatigue, and the Origins of Modernity* (Los Angeles: University of California Press, 1992).

6. Mary Ann Doane, *The Emergence of Cinematic Time: Modernity, Contingency, the Archive* (Cambridge: Harvard University Press, 2002).

7. Ibid., 230 (emphasis mine).

8. Charles Baudelaire, *The Painter of Modern Life and Other Essays,* trans. and ed. Jonathan Mayne (New York: De Capo, 1964), 16; cited in Doane, *Emergence of Cinematic Time,* 11–12.

9. Doane, *Emergence of Cinematic Time,* 230. She argues that the ideological function of cinema as a medium is precisely to depict and manage the contingent.

10. As I will discuss further on, in this way my research on Rainer confirms and extends in different directions Pamela Lee's exploration of how and why time came to be such a crucial area of investigation for artists, critics, philosophers, and others in Europe and the United States in the 1960s. See Pamela M. Lee, *Chronophobia: On Time in the Art of the 1960s* (Cambridge: MIT Press, 2004).

11. Quotes are from "Some Retrospective Notes," 47, 48.

12. These terms were used by the film scholar P. Adams Sitney, who attended the Wadsworth premiere in 1965 (interview with author, Los Angeles, 31 March 2005). Steve Paxton also described it as "well orchestrated" (e-mail to author, 17 April 2005).

13. Rainer has said she particularly values the image for this reason. Rainer, e-mail to author, 28 February 2005.

14. When the performance began, the mattresses were in a pile, behind which was a red box of objects, including paper and rope, that were used in some of the choreographed sequences. Rather than leave the stage, dancers who had "nothing to do" at a given moment in the dance sat behind the box. Rainer to the author, October 2006.

15. Rainer, "Some Retrospective Notes," 46.

16. Robert Morris, "Dance," *The Village Voice,* 10 February 1966, 15.

17. Rainer, "Some Retrospective Notes," 46.

18. Yvonne Rainer, quoted in Saul Goodman, "Yvonne Rainer," *Dance Magazine* 39 (December 1965): 110.

19. Rainer, "Some Retrospective Notes," 45.

20. Michael Kirby, "Objective Dance," in *The Art of Time: Essays on the Avant-Garde* (New York: E. P. Dutton, 1969), 111.

21. Yvonne Rainer, "A Quasi Survey of Some 'Minimalist' Tendencies in the Quantitatively Minimal Dance Activity Midst the Plethora, or an Analysis of *Trio A*" (1966), in Rainer, *Work 1961–73,* 67.

22. Annette Michelson, "Robert Morris: An Aesthetics of Transgression," in *Robert Morris,* exh. cat. (Washington, D.C:. Corcoran Gallery of Art, 1969), 55.

23. Ibid., 55, 57, emphasis in the original. See also Sally Banes, who wrote that in postmodern dance from *Huddle* to *Trio A* "time was flattened and detheatricalized, stripped of the dynamics of phrasing typical of modern dance and ballet: preparation, climax, recovery." Banes, introduction to the Wesleyan Paperback Edition, *Terpsichore in Sneakers,* 2d ed. (Hanover, N.H.: University Press of New England, 1987), xvii.

———

24. Rosalind E. Krauss, *Passages in Modern Sculpture* (Cambridge: MIT Press, 1977), 146.

25. Recent scholarship has complicated this opposition. James Meyer has shown how Michelson's linking of Fried's "presentness" to the logocentric self-presence critiqued by Derrida overlooks a built-in sense of lack and deferral in the modernist critic's term, which Meyer argues was intended to signify a specifically fleeting and compensatory form of communicatory experience, bound up with its lack under the normal conditions of language and culture. See Meyer, *Minimalism: Art and Polemics in the Sixties* (New Haven: Yale University Press, 2001). Pamela Lee has contributed another dimension to the discussion: reading Fried in part through Smithson, she stresses the *endlessness* of time in literalist (or minimalist) art (*Chronophobia,* 44–45), linking it to the logics of recursion (a circular, temporal process of self-reference in which a thing is tested and defined by the repeated application to it of a set of rules or conditions) and autopoesis (self-production) as found in systems theory. Lee shows that time in much art of the 1960s, including minimalism, is "understood as a system, recursive and shuddering like an echo, the time of an expanding new media and the articulation of its logic within and by art" (*Chronophobia,* 39). Work with temporality in this period's art can thus be understood as the link between a wide range of 1960s art and the discourses of and around technology. Lee's argument has particular resonance with my discussion in the later part of this chapter of the value to 1960s artists of obsolete and mechanical representations of time.

26. E. P. Thompson, "Time, Work-Discipline, and Industrial Capitalism," *Past and Present* 38 (1967): 56–97. Task-oriented temporality overlaps with but is not identical to the idea of agricultural time (cycles are not as relevant and, as the examples given suggest, shorter time spans than those of growth and harvest are typically at issue). Thompson was only one of a number of thinkers in this period concerned with how, in Marshall McLuhan's words, "not only work, but also eating and sleeping, came to accommodate themselves to the clock rather than to organic needs" (McLuhan, *Understanding Media: The Extensions of Man* [1964; repr., Cambridge: MIT Press, 1997], 146). Thompson cites Pierre Bordieu's similar comments in "The Attitude of the Algerian Peasant toward Time," *Mediterranean Countrymen,* ed. Julian Pitt-Rivers (Paris; Mouton, 1963); Henri Lefebvre, *Critique de la vie quotidienne* (Paris: L'Arche, 1958); Stanley Udy, *Organization of Work* (New Haven: HRAF Press, 1959); and Wilbert Moore, *Industrialization and Labor* (1951; repr., New York: Russell & Russell, 1965). See also Guy Debord's chapter on time in *Society of the Spectacle* (1967), trans. Donald Nicholson-Smith (New York: Zone Books, 1995); McLuhan's entire chapter on the clock in *Understanding Media;* and Sebastian de Grazia, *Of Time, Work and Leisure* (New York: Twentieth Century Fund, 1962).

27. Thompson, "Time, Work-Discipline, and Industrial Capitalism," 95.

28. Catherine Wood makes a case for a reading along these lines of Rainer's slightly later work *The Mind Is a Muscle,* in reference to ideas about work from Guy Debord, the Situationist International, and youth movements of the late 1960s. See Catherine Wood, *Yvonne Rainer: The Mind Is a Muscle* (Cambridge: MIT Press, 2007).

29. Rainer, "Some Retrospective Notes," 47.

30. P. Adams Sitney, e-mail to author, 20 April 2005.

31. Steve Paxton, e-mail to author, 17 April 2005.

32. Jill Johnston, "Waring—Rainer," *Village Voice,* 6 May 1965, reprinted in Johnston, *Marmalade Me,* 2d ed. (Hanover, N.H.: University Press of New England, 1998), 52.

33. McLuhan, *Understanding Media,* 145–146.

34. Debord, *The Society of the Spectacle,* 27.

35. Liz Kotz, *Words to Be Looked At: Language in 1960s Art* (Cambridge: MIT Press, 2007); "Composing with Cage: From Durational Structures to Indeterminacy," Duration Workshop presentation, Los Angeles, Getty Research Institute, 7 February 2005; and "Post-Cagean Aesthetics and the 'Event' Score," *October* 95 (Winter 2001): 55–89. Cage began working with "time structures" as the basis of composition in the late 1930s. These were metrical time until the early 1950s, when he switched to clock time; during the same period, he also began to work with magnetic tape, and thus to think of time measured in spatial rather than temporal lengths.

36. McLuhan, *Understanding Media,* 153.

37. Mary E. Edsall, "Reading and Writing Robert Ellis Dunn as a Democratic Artist in a Postmodern World: Locating Content through Context in Dance Biography" (Ph.D. dissertation, Temple University, 2003), 71.

38. Quoted in Sally Banes, *Democracy's Body: Judson Dance Theater 1962–1964,* 2d ed. (Durham: Duke University Press, 1993), 10.

39. The press release and performance program for *Parts of Some Sextets* indicated the source of the text, although infelicitous phrasing in the press release gave the impression that it was the Reverend Bentley himself who would be doing the reading. This mistake was repeated in several preperformance announcements in the Connecticut press.

40. For example, in her dance *Nonesuch* (1965), performed at Judson Memorial Church. Sally Gross, conversation with author, 25 March 2005.

41. Doane, *Emergence of Cinematic Time,* 11.

42. Again, I don't mean to imply that it was obvious to the audience that the dancers were responding to cues at thirty-second intervals. Johnston had to ask Rainer what the system was, but did so only because she was aware that there was something static and regular about the dance's structure that was in tension—that strangled or suffocated, to use her terms—the movement material.

43. McLuhan, *Understanding Media,* 153.

44. De Grazia, *Of Time, Work and Leisure,* 63.

45. Ibid., 312.

46. Thompson, "Time, Work-Discipline, and Industrial Capitalism," 95.

47. C. Wright Mills, "The Unity of Work and Leisure," in *Power, Politics and People: The Collected Essays of C. Wright Mills,* ed. Irving Louis Horowitz (New York: Oxford University Press, 1963), 349. He goes on: "As people have more time on their hands, most of it is taken away from them by the debilitating quality of their work, by the pace of their everyday routine, and by the ever-present media of mass distraction."

48. Rainer, "Some Retrospective Notes," 47.

49. Yvonne Rainer, "Skew(er)ing McLuhan: A Techno-Hysteric Enters the Fray," typescript of unpublished lecture presented at the conference "Mediators: Medium and Its Messages," organized by Caroline Jones, Boston University and the Isabella Stewart Gardner Museum, Boston, 7–8 March 2003.

50. Rainer, "Some Retrospective Notes," 47.

51. Another factor to consider—and this is a line of thought that will recur in the following sections—is that ruptures in the mechanical model were perfectly appropriate to a postindustrial age. McLuhan: "Now in the electric age of decentralized power and information we begin to chafe under the uniformity of clock-time." McLuhan, *Understanding Media,* 149.

52. Donald Judd, "Specific Objects," *Arts Yearbook* 8 (1965), reprinted in Judd, *Complete Writings 1959–1975* (Halifax: Press of the Nova Scotia College of Art and Design; New York: New York University Press, 1975), 184.

53. Rainer, "Some Retrospective Notes," 47.

54. Johnston, "Waring—Rainer," 53.

55. Though he does not discuss *Parts of Some Sextets,* Douglas Crimp has provided a sustained look at Rainer's use of music and sound in "Yvonne Rainer, Muciz Lover," *Grey Room* 22 (Winter 2006): 48–67.

56. Herbert A. Kenny, "Speaking of Books," *New York Times,* 1 September 1963, BR2.

57. William Bentley, *The Diary of William Bentley D.D., Pastor of the East Church, Salem, Massachusetts* (Gloucester, Mass.: P. Smith, 1962), vol. 2, 337–338.

58. Johnston, "Waring—Rainer," 52.

59. Ibid.

60. The equation of ordinary motion and egalitarianism—which I don't mean to debunk here, only complicate—is especially clear in Sally Banes, *Greenwich Village 1963: Avant-Garde*

Performance and the Effervescent Body (Durham: Duke University Press, 1993), see p. 122. It is also apparent in other writings including her most extended treatment of ordinary movement, the essay "Gulliver's Hamburger: Defamiliarization and the Ordinary in the 1960s Avant-Garde," in *Reinventing Dance in the 1960s,* ed. Sally Banes with Andrea Harris (Madison: University of Wisconsin Press, 2003), 3–23.

61. Yvonne Rainer, "Statement" (1968), program for *The Mind Is a Muscle,* Anderson Theater, New York, April 1968, reprinted in Rainer, *Work 1961–73,* 71.

62. Nöel Carroll, "Yvonne Rainer and the Recuperation of Everyday Life," in *Yvonne Rainer: Radical Juxtapositions 1961–2002,* ed. Sid Sachs, exh. cat. (Philadelphia: University of the Arts, 2003), 74.

63. Rainer, "Some Retrospective Notes," 51.

64. Johnston, "Waring—Rainer," 51.

65. Bentley, *The Diary of William Bentley,* quoted by Rainer in *Work 1961–73,* 58. Punctuation and spelling are as in Rainer's quotation. This passage was reproduced in the *New York Times Book Review* article on Bentley that first brought the diary to Rainer's attention (Kenny, "Speaking of Books"), but the last two lines in Rainer's citation were not reproduced in the *Times.*

66. Jack Anderson, "Yvonne Rainer: The Puritan as Hedonist," *Ballet Review* 2, no. 5 (1969): 32.

67. Robert C. Stewart, "Reading Dr. Bentley: A Literary Historical Approach." *Essex Institute Historical Collections* 113, no. 3 (1977): 161.

68. Yvonne Rainer in Jerry Tallmer, "Rebellion in the Arts. 4. The Advanced Dance," *New York Post,* 4 August 1966, Magazine, 1.

69. Ibid.

70. See Yvonne Rainer, "Profile: Interview by Lyn Blumenthal" (1984), in Rainer, *A Woman Who . . . : Essays, Interviews, Scripts* (Baltimore: Johns Hopkins University Press, 1999), 62–63.

71. Rainer, "Some Retrospective Notes," 46.

72. Johnston, "Waring—Rainer," 49.

73. Ibid., 52.

74. Ibid., 51.

75. Ibid.

76. Doane, *Emergence of Cinematic Time,* 68.

77. Rainer, "Some Retrospective Notes," 47. The film scholar P. Adams Sitney, who attended a Wadsworth performance of *Parts of Some Sextets,* recalls that its "pleasure principle" lay in its use of recurrence—the way a movement element would return, time after time, often embodied by a different performer in each instance (Sitney, interview with author, Los Angeles, 25 March 2005). This is a mode very different from the pleasure of rapidly juxtaposed cuts Johnston describes. As we saw in the previous chapter, the pleasing aspect of recurrence in live art is the way it puts the brakes on performance ephemerality, giving the viewer extra chances to view a particular action.

78. Jill Johnston, "Photoplay," *Village Voice,* 1 February 1968, reprinted in Johnston, *Marmalade Me,* 143.

79. Simone Forti, comments in "BAMdialogue" series panel discussion accompanying the *PASTForward* concerts by the White Oak Dance Project, moderated by Jayme Koszyn, Brooklyn Academy of Music, 6 June 2001. From notes taken by author.

80. Ibid.

81. Yvonne Rainer, interview with author and Barbara Moore, New York, 2 February 2001.

82. Gary Garrels, "Sol LeWitt: An Introduction," in *Sol LeWitt: A Retrospective,* ed. Garrels, exh. cat. (San Francisco: San Francisco Museum of Modern Art, 2000), 25.

83. William I. Homer and John Talbot, "Eakins, Muybridge and the Motion Picture Process," *Art Quarterly* 26, no. 2 (Summer 1963). Thanks to Sarah Gordon for bringing this article to my attention.

84. In 1971 Rainer played with the idea of "a lay-out of movement sequences vis-à-vis Muybridge" as a limited-edition poster to help fund her work (Yvonne Rainer to Stanley Grinstein, 1 October 1971, Rainer's files, folder "Correspondence 1971"). Later she would explore a related form in the "photo-romanza" *Kristina (For a . . . Opera)* that she produced in 1975 along with Benjamin Buchloh for the German conceptual art magazine *Interfunktionen,* of which he was then editor; and she referred to a special set of images of her dance *Stairs,* described below, as her "Muybridge slides" in "Dance and Lecture Demonstration (ideas)," c.1969, page in a notebook recently labeled by Rainer "Misc., Rose Fractions, Performance Fractions for the West Coast, 1969."

85. Though Muybridge offered his images as both scientific (especially medical) and artistic aids, research in recent years has established how thoroughly unscientific his own procedures often were. See Marta Braun, *Picturing Time: The Work of Etienne-Jules Marey (1830–1904)* (Chicago: University of Chicago Press, 1992). Tom Gunning, in reflecting on the many reasons Eadweard Muybridge had such appeal to film artists in the 1970s, cites this false or failed rationality. See Gunning, "Never Seen This Picture Before: Muybridge in Multiplicity," in *Time Stands Still: Muybridge and the Instantaneous Photography Movement,* ed. Phillip Prodger (Oxford: Oxford University Press, 2003), 222–270, esp. 263–270.

86. Henri Bergson, *Creative Evolution* (1907), trans. Arthur Mitchell (Mineola, N.Y.: Dover, 1998), 308.

87. On Bergson and the modernization of temporal experiences, see Kern, *The Culture of Time and Space;* Rabinbach, *The Human Motor;* and Gilles Deleuze, *Cinema 1: The Movement-Image* (Minneapolis: University of Minnesota Press, 1986).

88. On this aspect of Bergson, see Rabinbach, *The Human Motor,* especially 108–119.

89. See Deleuze, *Cinema 1.*

90. Jonathan Crary, *Suspensions of Perception: Attention, Spectacle, and Modern Culture* (Cambridge: MIT Press, 1999), 142. Samuel Weber makes an interestingly similar argument about television, which I discuss in the next chapter.

91. Ibid., 147.

92. Dan Graham, "Muybridge Moments," *Arts* 41, no. 4 (February 1967): 23–24. A copy of this article is in Rainer's files along with other 1960s ephemera (folder "Articles").

93. A recreation of the dance is preserved in a film by Babette Mangolte, *Four Pieces by Morris,* 1993, 16mm, 94 min., color.

94. Robert Morris, "Notes on Dance," *Tulane Drama Review* 10, no. 2 (Winter 1965): 183.

95. Don McDonagh, "Dance and Pictures Mingle in Program," *New York Times,* 12 December 1968, 61. On the documental tradition, see Lepecki, "Inscribing Dance," 130.

96. Johnston, "Photoplay," 124. It should be noted that the first performance was in 1964.

97. Lee, *Chronophobia,* ch. 5.

98. Rainer, "Some Retrospective Notes," 51.

99. Ibid.

100. Thanks to Alison Matthews David for pointing out to me this metaphorical extension of Rainer's truck.

101. Lee, *Chronophobia,* xiii.

102. Yvonne Rainer has made clear her resistance to McLuhan both in the mid 1960s, "when nearly everyone I knew in the music and dance worlds was reading and quoting Marshall McLuhan and Buckminster Fuller," and today. The reasons for her distaste include the need to

fight her own "weakness for the sweeping revelations of great men" (a line from the 1972 film *Lives of Performers*), and a distrust of the particularly totalizing nature of McLuhan's thought. From a current vantage point, she sees his work as "utopian rationalizations" for injustices and international hegemony in the age of the supposed "global village" (Rainer, "Skew(er)ing McLuhan," 1). She also takes issue with McLuhan's foundational idea that media shape consciousness and thinking. As she says of beginning to work with computers and other new technologies introduced during her lifetime: "these technological innovations have had no more profound effect than the changes brought about by other personal and historical circumstances, like coming out, aging, and the election of George W. Bush. And as far as my art work goes, I will make one concession to McLu's 'The medium is the message,' and that is: sometimes it is and sometimes it ain't" (Rainer, "Skew(er)ing McLuhan," 9).

103. McLuhan, *Understanding Media*. McLuhan thought this involvement was due to the technical nature of the medium—particularly its low-definition image relative to film: "The TV image requires each instant that we 'close' the spaces in the mesh by a convulsive sensuous participation that is profoundly kinetic and tactile" (*Understanding Media,* 314). McLuhan also noted the temporality of the image: "The TV image is . . . not a photo in any sense, but a ceaselessly forming contour of things limned by the scanning-finger" (*Understanding Media,* 313). This difference between the photographic still and the TV image, which is always coming into being, would later be linked explicitly to Bergson's antimechanical terms by Herbert Zettl, who suggests how what Bergson hated could have served as a critical tool in the postmechanical age: "Contrary to the static, discrete film image, the television image is always in motion even if it displays an object which is not in motion. It relies on the constantly moving electron beam for its existence. . . . The projected television image is, like Bergson's arrow, never at rest at any given moment. It is in a continuous state of change. . . . It represents, as Bergson would say, an interpenetration of the before and after. Contrary to the basic structural unit of film, the frame, which is a concrete static image, the basic structural unit of television is a continual flow, an image in flux, a process." Herbert Zettl, *Sight, Sound, Motion: Applied Media Aesthetics* (Belmont, Calif.: Wadsworth, 1973), 253. We have seen in chapter 1 how that interpenetration of temporal flow was highlighted, disrupted, and otherwise troubled in Judson dance.

104. Yvonne Rainer, notebook, Rainer's files. This notebook was recently dated by Rainer as being from 1963–1965.

105. In her published description of the project in *Work 1961–73,* Rainer says the interval between images was twenty seconds. The slides are lost, but in 2001 Rainer together with Peter Moore's widow, Barbara Moore, looked over the contact sheets in relation to Rainer's written notes for *Stairs,* and the two concluded that the interval was somewhere between two and five seconds (Yvonne Rainer to the author, 25 May 2001; conversation with Moore and Rainer, New York, 2 February 2001). Barbara Moore explained to me that there were contact sheets related to the set of slides in this case (slides don't typically go through the negative phase) because the images were first shot on regular 35mm film and then transferred to slides (conversation with Moore and Rainer, New York, 2 February 2001).

106. Rainer, "Dance and Lecture Demonstration (ideas)."

107. This breakdown has a parallel in John Cage's experience in producing *Williams Mix* (1952), in which hyperdetailed manipulation of fragments of magnetic tape nevertheless produced unpredictable effects since measurements tended to vary and synchronization to deteriorate. Liz Kotz argues convincingly that this experience was at the origin of Cage's exploration of indeterminacy. See chapter 1 of Kotz, *Words to Be Looked At.*

108. Conversation with Moore and Rainer, 2 February 2001. Coincidentally, Jill Johnston made the same mistake in the context of her 1965 review of *Parts of Some Sextets,* in which she stated that the structural unit of the dance was three seconds long, rather than thirty.

109. See Braun, *Picturing Time.*

3 MEDIATING *TRIO A*

1. Many unpublished images of the dance are significantly more awkward, showing the body in transitional, torqued, or contorted postures—in addition to the previously unpublished image of Rainer performing *Trio A* in her studio as a work in progress in 1965 (figure I.2), see those of her and Steve Paxton performing *Trio A with Flags* in 1970 (figures 5.4, 5.5). An instructive comparison is between these unpublished images and the poised, near-balletic photo of David Gordon in *Flag* (figure 3.11), which Rainer did choose to publish in her book *Work 1961–73* (Halifax: Press of the Nova Scotia College of Art and Design, 1974). Rainer has

commented on the reasons for this apparent selectivity in the published record, which returns *Trio A* to conventions of spectacular dance and dance photography. See note 96 below.

2. Yvonne Rainer, "Some Retrospective Notes on a Dance for 10 People and 12 Mattresses Called *Parts of Some Sextets,* Performed at the Wadsworth Atheneum, Hartford, Connecticut, and Judson Memorial Church, New York, in March, 1965," *Tulane Drama Review* 10, no. 2 (Winter 1965), reprinted in Rainer, *Work 1961–73,* 51.

3. *Trio A (The Mind Is a Muscle, Part 1),* produced by Sally Banes, 1978, silent, black-and-white film, 10 min. 20 sec. In recent years the film has been shown as a video in visual art contexts, for example in the Whitney Museum's "American Century" exhibition and in the Vienna Kunsthalle's "Eine Baroque Party."

4. "Blissfully boring dance number" is Clive Barnes's phrase, from his review of the concert that included the debut of *Trio A* (*New York Times,* 11 January 1966); Don McDonagh called *Trio A* the most stultifying dance he'd ever seen in "Rainer Troupe Seen in 'Rose Fractions,'" (*New York Times,* 7 February 1969). The phrase "a sort of boring continuum" is Jerry Tallmer's quotation of Jill Johnston in conversation after the first performance of *The Mind Is a Muscle* in 1966 (Jerry Tallmer, "Rebellion in the Arts. 4. The Advanced Dance," *New York Post,* 4 August 1966, Magazine, 25). "Woolen underwear" is from Jill Johnston, "Rainer's Muscle" (1968), in Johnston, *Marmalade Me,* 2d ed. (Hanover, N.H.: University Press of New England, 1998), 65.

5. Mark Franko, "Some Notes on Yvonne Rainer, Modernism, Politics, Emotion, Performance, and the Aftermath," in *Meaning in Motion: New Cultural Studies of Dance,* ed. Jane C. Desmond (Durham: Duke University Press, 1997), 296.

6. Sally Banes, *Terpsichore in Sneakers: Post-Modern Dance* (Hanover, N.H.: University Press of New England, 1987), 49.

7. The question of the postmodern in dance is a vexed one. Sally Banes has done the most to put forward this term for the kind of movement performance Rainer developed with her cohorts in the 1960s, and there is no other accepted terminology. (Though I have used it in a general way, "Judson dance" technically excludes those, like Simone Forti, who did not present work at Judson Memorial Church, and in any case a number of the choreographers discussed

here, including Rainer, had stopped performing in Judson Dance Theater concerts by 1965. The term "New Dance" used by Annette Michelson in two 1974 articles on Rainer is confusing because of its associations with the 1930s generation of modern dancers.) Mark Franko in "Some Notes" points out that many of the qualities of this work that Banes identifies—chiefly, the exploration of what is dance and what is not—are properly modernist concerns, and don't relate in a strong way to the term "postmodern." Rainer comments: "'What is dance and what is not' was the critics' concern, not ours. We called it dance from the getgo. . . . I called it P[ost] M[odern] to differentiate it from / mark a break with previous dance long before Baudrillard and Lyotard were on the horizon with their art historical scrambling" (Rainer to the author, November 2001).

8. Catherine Wood treats *The Mind Is a Muscle* as a whole, in terms somewhat different from but largely complementary to the arguments provided here, in her *Yvonne Rainer: The Mind Is a Muscle* (Cambridge: MIT Press, 2007).

9. William Ewing, *The Fugitive Gesture: Masterpieces of Dance Photography* (London: Thames and Hudson, 1987), 27. Similar differences are discussed in Owen Edwards, foreword to Howard Schatz and Beverly Ornstein, *Passion and Line: Photographs of Dancers by Howard Schatz* (New York: Graphis Press, 1997), 6. Lois Greenfield, whose dance photographs are made in improvised collaboration with dancers, makes the assumed incompatibilities central to her practice.

10. Rainer, Notebook, quoted in Sally Banes, *Democracy's Body: Judson Dance Theater 1962–1964,* 2d ed. (Durham: Duke University Press, 1993), 15. Emphasis mine.

11. Rainer, "A Quasi Survey of Some 'Minimalist' Tendencies in the Quantitatively Minimal Dance Activity Midst the Plethora, or an Analysis of *Trio A*" (1966), in Rainer, *Work 1961–73,* 65. All quotations in this paragraph are from this page of the essay, and all italics are mine.

12. Susan Leigh Foster, *Reading Dancing: Bodies and Subjects in Contemporary American Dance* (Berkeley: University of California Press, 1986), 89.

13. Jean Nuchtern, "An Yvonne Rainer Collage," *Soho Weekly News,* 4 November 1976, 17.

14. Johnston, "Rainer's Muscle," 38.

15. Rainer, "A Quasi Survey," 67.

16. Jill Johnston, "Which Way the Avant-Garde?," *New York Times,* 11 August 1968, reprinted in Johnston, *Marmalade Me,* 116.

17. See Rosalind E. Krauss, "Grids," in Krauss, *The Originality of the Avant-Garde and Other Modernist Myths* (Cambridge: MIT Press, 1985), 8–22. In addition to recalling nonhierarchical composition in painting and sculpture, the grid backdrop is reminiscent of the theatrical set design of the Russian avant-garde (for instance, Rodchenko's gridded screens for *The Doll with Millions*). A connection to constructivism has, of course, been an issue for minimalism generally. One issue of particular interest here is the fact that constructivist design work done for the theater is known primarily through photographs.

18. Ann Daly, "Dance History and Feminist Theory: Reconsidering Isadora Duncan and the Male Gaze," in *Gender in Performance: The Presentation of Difference in the Performing Arts,* ed. Laurence Senelick (University Press of New England, 1992), 249.

19. Despite, or perhaps because of, her bare legs and sheer costumes, Duncan went to great lengths to distinguish her performances from bawdier counterparts, performing only in select, "legitimate" theaters and creating tasteful and classicizing décor. But of course her care in this direction indicates how prone she was to being grouped among the less artistically ambitious performers. She would be dismayed to find her own photographs among those of the burlesque-star pinups in the section on the early twentieth century in Jessica Glasscock, *Striptease: From Gaslight to Spotlight* (New York: Abrams, 2003).

20. Roger Copeland has compared Isadora Duncan's dance innovations with Rainer's in the context of a discussion of dance and feminism, arguing that Duncan's liberated, uncorseted body and movement corresponds to her moment in feminist thought, while Rainer's "puritanical" dance, typified in *Trio A,* correlates with her generation's suspect regard for sexual liberation as another kind of oppression. See Roger Copeland, "Towards a Sexual Politics of Contemporary Dance," *Contact Quarterly* 7, no. 3–4 (Spring-Summer 1982): 45–50. Highly suggestive, Copeland's argument nevertheless falters for me insofar as it depends on a one-dimensional reading of *Trio A* as "cold, uninflected, almost 'unperformed,'" and "coolly oblivi-

ous to those watching" (46). This approach misses an opportunity to explore the way Rainer's work can be thought of as reinventing rather than rejecting visual pleasure, eroticism, and the display of physicality, as Sally Banes and Annette Michelson have each in their own way proposed. Moreover, this view of Rainer's work as unequivocally antispectacular contrasts with the one I am trying to produce here of Rainer's work dancing a dialectic between the spectacular and the resistant, the image and the body.

21. In the feminist critiques of classical dance that would emerge with the discipline of dance studies in the 1980s, the public secret of ballet's regressive gender politics was a common theme. Its authors proceeded not only by decoding the obvious symbolism of passively sleeping princesses and unattainable sylphs, and by interpreting the formal attributes of a dance style built on frontal exposure of the lower body via the dancer's turnout, or outward rotation of the legs from the pelvis; but also by bringing to bear the theory of representation of the female body as object of the gaze that had by then emerged in feminist discourse on film. Among the most significant texts in elaborating this critique since the 1980s are Marianne Goldberg, "Ballerinas and Ball Passing," *Women and Performance* 3, no. 2 (1987/88), 7–31; Elizabeth Dempster, "Women Writing the Body: Let's Watch a Little How She Dances," in *Grafts: Feminist Cultural Criticism,* ed. Susan Sheridan (London: Verso, 1988), 35–54; Janet Wolff, "Reinstating Corporeality: Feminism and Body Politics," in *Feminine Sentences: Essays on Women and Culture* (Berkeley: University of California Press, 1990); Ann Daly, "Dance History and Feminist Theory" and "Classical Ballet: A Discourse of Difference," *Women and Performance* 3, no. 2 (1987–1988), 57–66; Roger Copeland, "Dance, Feminism, and the Critique of the Visual," in *Dance, Gender and Culture,* ed. Helen Thomas (New York: St. Martin's Press, 1993), 139–150; Susan Leigh Foster, "The Ballerina's Phallic Point," in *Corporealities: Dancing Knowledge, Culture, and Power,* ed. Foster (London: Routledge, 1996), 1–24; Susan Manning, "The Female Dancer and the Male Gaze: Feminist Critiques of Early Modern Dance," in Desmond, *Meaning in Motion,* 153–166. Alexandra Carter offers a review and strong critique of the feminist literature specific to ballet in "Dying Swans or Sitting Ducks? A Critical Reflection on Feminist Gazes at Ballet," *Performance Research* 4, no. 3 (1999): 91–98.

22. Yvone Rainer, "Terrain," in Rainer, *Work 1961–73,* 30–31.

23. Ibid., 16. See Tony Crawley, *Screen Dreams: The Hollywood Pin-Up* (New York: Putnam, 1984).

24. Interview with David Parsons for *Egg: The Arts Show* (PBS, 2002–2003) at http://www.pbs .org/wnet/egg/203/caught/, accessed 4 January 2005.

25. Annie Leibovitz, *Dancers* (Washington, D.C.: Smithsonian Institution Press, 1992), 12. The studio session Leibovitz describes was for an advertisement for The Gap.

26. See Craig Owens's meditations from the mid 1980s on the tropes of immobility and masquerade in feminist art: "The Medusa Effect, or, The Spectacular Ruse," *Art in America* (January 1984): 97–105; and "Posing," in *"Difference": On Representation as Sexuality,* exh. cat., ed. Kate Linker and Jane Weinstock (New York: New Museum of Contemporary Art, 1984); both reprinted in Owens, *Beyond Recognition: Representation, Power, and Culture* (Berkeley: University of California Press, 1992).

27. *Trio A* has been retrospectively read in terms of gender, by making a metaphorical connection between its treatment of the performer presented to the spectator's view and the female body presented to the male gaze. While this is partially supported by Rainer's intervention in *Duet Section*, it seems to me better to understand the feminist potential of *Trio A* as latent, part of a more general investigation of the dynamics of spectatorship—one that I am arguing makes sense within period concerns about media and mediation—which only later becomes explicitly politicized and gendered (see chapters 4, 5, and conclusion). See Sally Banes, *Dancing Women: Female Bodies on Stage* (London: Routledge, 1998), 222–225; Franko, "Some Notes"; Copeland, "Towards a Sexual Politics of Contemporary Dance." The most provocative interpretation is Peggy Phelan's in "Yvonne Rainer: From Dance to Film," in Yvonne Rainer, *A Woman Who . . . : Essays, Interviews, Scripts* (Baltimore: Johns Hopkins University Press, 1999). Also see my discussion of these arguments in the introduction.

28. Tallmer, "Rebellion in the Arts. 4," 25.

29. Jerry Tallmer, "Rebellion in the Arts. 1. It Began with the Living Theater . . . ," *New York Post,* 1 August 1966, 25.

30. Jill Johnston, "Rainer's 'Mind Is a Muscle,'" *Village Voice,* 2 June 1966, 13.

31. Yvonne Rainer, "Some Non-Chronological Recollections of *The Mind Is a Muscle,*" in Rainer, *Work 1961–73,* 75.

32. Author's notes, rehearsal of *Trio A,* University of the Arts, Philadelphia, 8 November 2001.

33. Tallmer, "Rebellion in the Arts. 4," 25. And as we've seen, Rainer began the explorations of newly quirky and nonexpressive movement that would lead to *Parts of Some Sextets* and culminate in *Trio A* in a desolate Düsseldorf studio, where her view of activity in the city below was of "an intricate mechanized toy [going] thru its paces" (Rainer, *Work 1961–73,* 46).

34. It should be remembered that *Trio A* was usually performed as part of another, longer, dance work, and has thus had dozens of distinct incarnations, from this first performance, when only its title indicated it was part of a larger work in progress (the multi-part *The Mind Is a Muscle,* itself first shown in May of 1966; new sections were added in performances over the subsequent two years), through its use in later 1960s performances when *Trio A* was taught onstage or performed by untrained dancers (see chapter 5 of this book), and culminating in Rainer's first dance work after more than two decades working exclusively in film, the 1999 piece *Trio A Pressured* (see chapter 1). Preserved on film, worked into this host of subsequent performances, and designed to be taught by and to anyone interested, *Trio A* is Yvonne Rainer's most reproduced and reproducible dance.

35. Rainer, "Some Non-Chronological Recollections of *The Mind Is a Muscle,*" 75. While Rainer saw the dance and falling slats as alike in their monotonous rhythm, Clive Barnes claimed to have found the relentless "plomp, plomp" of the slats more interesting than the "blissfully boring dance number" they accompanied ("Village Disaster: Concert of Old and New Works at Judson Church Unveils Just One Minor Talent," *New York Times,* 11 January 1966, 20).

36. Author's notes, rehearsal of *Trio A,* 8 November 2001.

37. Annette Michelson, "Yvonne Rainer, Part 1: The Dancer and the Dance," *Artforum* (January 1974): 59.

38. Johnston, "Rainer's Muscle," 66–67.

39. Donald Judd, "Specific Objects," in *Complete Writings 1959–1975* (Halifax: Nova Scotia College of Art and Design; New York: New York University Press, 1975), 184.

———

40. Yvonne Rainer, interviewed by Liza Bear and Willoughby Sharp, "The Performer as Persona: An Interview with Yvonne Rainer," *Avalanche* 5 (Summer 1972): 54.

41. Many critics have found ways of describing this aspect of the dance. Sally Banes wrote that it "unrolls smoothly and seamlessly, even when the seams are showing" (*Terpsichore in Sneakers,* 51).

42. Questions about the meaning of the parallels between minimal art and industrial production recurred recently at the Getty Research Institute's symposium, "Structures and Systems: Minimal Art in the United States," 1 May 2004, and were addressed most directly on that occasion in Alex Potts's paper, "Minimalism and Junk," and the discussion it engendered. Two earlier texts are crucial in this regard: Hal Foster's "The Crux of Minimalism," in *The Return of the Real: The Avant-Garde at the End of the Century* (Cambridge: MIT Press, 1996), and Rosalind E. Krauss, "The Cultural Logic of the Late Capitalist Museum," *October* 54 (Fall 1990): 3–17.

43. Marshall McLuhan, *Understanding Media: The Extensions of Man* (1964; repr., Cambridge: MIT Press, 1997), 116.

44. Ibid., 12.

45. Rainer spoke of her disinterest in McLuhan in the 1960s and her current critique of his thinking in "Skew(er)ing McLuhan: A Techno-Hysteric Enters the Fray," text of unpublished lecture presented at the conference "Mediators: Medium and Its Messages," organized by Caroline Jones, Boston University and the Isabella Stewart Gardner Museum, Boston, 7–8 March 2003.

46. Rainer suffered a severe intestinal blockage caused by adhesions from a childhood appendectomy and had emergency surgery in October 1966, immediately after the first of the "Nine Evenings" events at the New York Armory organized by the Experiments in Art and Technology initiative, to which she contributed the work *Carriage Discreteness.* She had already been working on extending *The Mind Is a Muscle,* with a performance of a forty-minute version at the Now Festival in Washington, D.C., 29 April 1966, and at Judson Memorial Church in late May of that year. The intestinal condition recurred in 1967, not long after which Rainer performed *Trio A* as *Convalescent Dance.* That summer, a short version of *The Mind Is a Muscle*

was performed in Spoleto, Italy; and in New York, *Mat,* another section of the work, was performed, preceded by a reading of a surgeon's letter about her illness. The full-length *Mind Is a Muscle* (including the sections *Mat, Stairs,* and *Film*) was first performed at Brandeis University, Waltham, Massachusetts, in January 1968. For a detailed timeline of these years, see "Chronology," in *Yvonne Rainer: Radical Juxtapositions 1961–2002,* ed. Sid Sachs, exh. cat. (Philadelphia: University of the Arts, 2003).

47. Yvonne Rainer, "Statement," from program for *The Mind Is a Muscle,* Anderson Theater, New York, April 1968, reprinted in Rainer, *Work 1961–73,* 71.

48. Ibid. This second paragraph runs through a list of some of the formal concerns of *The Mind Is a Muscle*'s various sections: "Details executed in a context of a continuum of energy (*Trio A, Mat*); phrases and combinations done in unison (*Trio B*) … "

49. Annette Michelson, "Robert Morris: An Aesthetics of Transgression," in *Robert Morris,* exh. cat. (Washington, D.C.: Corcoran Gallery of Art, 1969), 55–59.

50. Rainer, "Statement," 71.

51. Sally Banes writes about the "human materiality" that Rainer "was committed to installing center stage," presenting this return to physicality as a negation of conventional dance's idealization of the body; see Banes, *Greenwich Village 1963: Avant-Garde Performance and the Effervescent Body* (Durham: Duke University Press, 1993), 190–191. While there's no question that Rainer contested specialized dancer physique and the transcendence of base materiality it implied, I am suggesting that her notion of physicality in dance was also constituted in relation to another opposite. The "enduring reality" of Rainer's own, known, experiential body was opposed to what Guy Debord, in these very years, was calling the "pseudo world apart" produced by the operations of spectacle culture; see *The Society of the Spectacle* (1967), trans. Donald Nicholson-Smith (New York: Zone Books, 1995). Intentionally or not, Rainer suggests as much by contrasting her own bodily materiality not to world events per se, but to those events as seen on TV.

In an important essay on poststructuralism, performance, and politics, dance historian Ramsay Burt has written about Rainer's 1968 "Statement." However, he takes Rainer at her word more than I do, arguing that through her deconstruction of modes of dance performance

———

and presence, she was asserting the need to remain outside of historical and ideological realities, albeit as a mode of critical resistance to them. Burt sees Rainer's *Trio A* and her writing about it, in counterdistinction to attitudes of choreographers in later decades, as representing a moment of certainty or confidence about the artist's—or any subject's—ability to resist ideological forces. To me the statement is, instead, steeped in anxiety about the possibility of any separation of art from ideology or from history, and is evidence of a widespread and increasing discomfort in the late 1960s with the lack of overt political commitment in the avant-garde forms she and others had been developing, which I explore in chapter 5. See Ramsay Burt, "Genealogy and Dance History," in *Of the Presence of the Body: Essays on Dance and Performance Theory,* ed. André Lepecki (Middletown, Conn.: Wesleyan University Press, 2004), 29–44, especially 36–38, 40–41; see also Ramsay Burt, *Judson Dance Theater: Performative Traces* (London: Routledge, 2006).

52. Rainer recalls that her intention was to refer to the Vietnam War as a whole: "it was meant as horror at that particular war moment." Rainer to the author, October 2006.

53. In a chilling example of the oft-noted linguistic connection between camera and gun, Eddie Adams later recalled, "As Loan's hand holding the pistol came up so did my camera . . . I just shot by instinct." Quoted in Clarence R. Wyatt, *Paper Soldiers: The American Press and the Vietnam War* (New York: W. W. Norton, 1993), 166.

54. The figure of twenty million viewers is cited in Don Oberdorfer, *Tet!* (1971; repr., New York: Da Capo Press, 1984), 170. Distributed by the AP, the photograph appeared on the front pages of New York's *Times, Daily News,* and *Post,* as well as on the covers of papers across the country. It won Adams not only the Pulitzer for Spot News Photography in 1969 but also the Grand Prize for Spot News of the World Press Photo Contest, the Overseas Press Club Award for Best Photographic Reporting from Abroad, and numerous other major awards. The shooting was filmed for television most successfully by Vo Suu, working for NBC. The shooting and its dissemination are discussed by Clarence Wyatt in *Paper Soldiers* and by Don Oberdorfer in *Tet!* (161–171); on NBC's coverage, see George A. Baily and Lawrence W. Lichty, "Rough Justice on a Saigon Street: A Gatekeeper Study of NBC's Tet Execution Film," in *Big Story: How the American Press and Television Reported and Interpreted the Crisis of Tet 1968 in Vietnam and Washington,* ed. Peter Braestrup, vol. 2 (Boulder: Westview Press, 1977), 266–281. David Culbert also discusses the television coverage of the incident in "Television's Visual Impact on

Decision-Making in the USA, 1968: The Tet Offensive and Chicago's Democratic National Convention," *Journal of Contemporary History* 33, no. 3 (July 1998): 419–449.

Besides its still shocking impact and the questions about violence, media, and sensationalism that the picture raises, the specifics of this incident and its dissemination may have more to tell us about the period, photography, and television. It's interesting, for instance—and especially in the context of a discussion of Rainer—that the shooting appeared on television on 1 February 1968 as *stills,* before the film footage was available the following day. Television and still photography are thus blurred and combined in the image's dissemination, impact, and history in interesting ways; Culbert discusses conflicting opinions as to whether it was the still image or the event's televisual dissemination that had the more profound impact. Also strange is that the still photograph's drama comes in part from a distortion—the muzzle of the gun was actually not inches from the prisoner's head when Loan fired (Adams's wide-angle lens caused the effect)—and that the TV footage of the shooting does not actually show the instant of the shot. ABC's film ended before the shooting and picked up again with the prisoner on the ground (the cameraman having backed away), while NBC's complete footage of the event has a brief blind spot, as a figure steps between the camera and its subjects for a split second just as the shot is fired. The interruption is so brief as to be almost unnoticeable, and was not discussed at the time (see Oberdorfer, *Tet!,* 171; Culbert, "Television's Visual Impact," 422–423). On the one hand we find an exaggeration, on the other a lacuna—photography, with its reputation for truthfulness, distorting; television, with its reputation for immediacy, interrupting. To me, these media failures underscore that what is finally most moving about the photographs and the film is not the power but the limits of the experience they provide; ultimately, the unbridgeable distance they establish from the bodily facts they bring home.

55. On the Tet offensive as such a turning point, see David W. Levy, *The Debate over Vietnam* (Baltimore: Johns Hopkins University Press, 1991), 144–145. For reconsiderations of the relation between the press, public opinion, and the government, see Daniel C. Hallin, *The "Uncensored War": The Media and Vietnam* (New York: Oxford University Press, 1986); Wyatt, *Paper Soldiers;* and sections of Levy's *The Debate over Vietnam.* Given my interests here, it is important to realize that, as Hallin argues (e.g., *The "Uncensored War,"* 4–5), and as the Nixon quotation that follows in the text clearly indicates, the opinion that the press turned the tide against the war was largely held by conservatives who blame the media for the negative outcome of the war. Since the 1980s, several historians have questioned this view, arguing that the oppositional role of the press in this period is largely mythic. Hallin and Wyatt argue that by blaming the

press, rather than questioning the motives of the government and military, and by minimizing attention to the effect of ongoing antiwar activism, the myth of the oppositional press serves conservative interests. They point out that while they were putatively—and famously—uncensored, journalists in Vietnam nevertheless depended on accreditation from the military to get their firsthand view of the war, and on official briefings for their information on its progress. Wyatt argues compellingly that for the most part the press did little more than reiterate official government statements on Vietnam until very late in the war. Moreover, both retrospectively and in the 1960s, the impact of the news stories that showed actual combat or its casualties far exceeds their number; in fact, reports from Vietnam were more often reports of briefings or human interest stories about the soldiers.

56. Richard Nixon, *The Memoirs* (New York: Grosset and Dulap, 1978), 350; quoted in Hallin, *The "Uncensored War,"* 3.

57. Quoted by Oberdorfer in *Tet!,* 170. The quotation continues: "I don't know why, to win a Pulitzer Prize, people have to go probing for the things that one can bitch about when there are two thousand stories in the same day about things that are more constructive in character."

58. I don't mean to imply that these bodies were uncoded. The fact that these were Asian bodies no doubt mattered greatly in the reception of the image.

59. Shana Alexander, "What Is the Truth of the Picture?," *Life* 64, no. 2 (1 March 1968): 19.

60. The format of the daily, half-hour, national news broadcast was established in 1963. By 1970 television would become the primary news source for Americans; in 1968 the leading evening news program, NBC's *Huntley-Brinkley Report* (on which the Saigon execction footage was broadcast), commanded a viewership of 20 million. See Culbert, "Television's Visual Impact," 420.

61. Samuel Weber, "Television: Set and Screen," in *Mass Mediauras: Form, Technics, Media,* ed. Alan Cholodenko (Stanford: Stanford University Press, 1996), 117.

62. Michael J. Arlen, *Living-Room War* (New York: Viking Press, 1969), 8.

63. Brian Wallis rightly notes that there is a class argument in the photomontages as well, as the homes are specifically upper-middle-class, the same privileged class that Rosler elsewhere indicts for its paternalistic relation through documentary photography itself to the impoverished or injured. See Andrew Ross, "Living Room War," *Art in America* 80 (February 1992): 105–107.

64. Of course the effect is not limited to scenes from Vietnam. The images from urban riots in the summers of 1966 and 1967 would also contribute to this aspect of Rainer's understanding of her relation to the "world-in-crisis."

65. This detachment, the ability to walk away, might be understood to correlate problematically with the kind of free spectatorship Rainer would encourage in her work in 1968–1970, discussed in chapter 5.

66. Alexander, "What Is the Truth of the Picture?," 19.

67. When she wrote the "Statement," Rainer was unlikely to have known that the realities of war were being experienced like "a bad Western" not only by viewers but also by participants. In his book *Dispatches,* journalist (later screenwriter) Michael Herr both uses and reports on soldiers who used the tropes of the movie Western to filter their real-life experience of the Vietnam war. See, for example, Michael Herr, *Dispatches* (1977; repr., New York: Avon, 1980), 46.

68. The mutual constitution of the live and the mediated is at the heart of Phillip Auslander's *Liveness: Performance in a Mediatized Culture* (London: Routledge, 1999). As exemplified by the fact that the *Oxford English Dictionary*'s first entry for the word "live" in the context of performance comes from the mid 1930s, and thus against the backdrop of recording technologies and/or broadcasting (radio), Auslander argues that "the historical relation of liveness and mediatization must be seen as a relation of dependence and imbrication rather than opposition" (53). His examples, however, all come from what might be called the era of high mediatization, the 1980s.

69. Samuel Weber, quoted in "Deus ex Media: Interview of Samuel Weber by Cassi Plate on Arts National's Weekly Film, Video, and Television Program *SCREEN,* Broadcast 16 July

1992 on Radio National, the Australian Broadcasting Corporation," in Cholodenko, *Mass Mediauras,* 164.

70. Television spectators are offered vision ready-made, replete with perspectives impossible from their own, situated selves. Also, television "takes place" simultaneously in multiple locations (the places where the sounds and images are recorded or electrically encoded, the places where they are received, and the in-between places through which they are transmitted). Thus Weber argues that television upsets what we normally mean by "place" itself (Weber, "Television: Set and Screen," 117).

71. Vito Acconci, quoted in Doug Hall and Sally Jo Fifer, "Introduction: Complexities of an Art Form," in *Illuminating Video: An Essential Guide to Video Art,* ed. Hall and Fifer (New York: Aperture, 1990), 27.

72. Yvonne Rainer, quoted in Bear and Sharp, "The Performer as Persona," 52. Rainer further adds here that the idea of task "wasn't primarily about organization. The organizational battle had been fought for the most part by Cunningham and Cage, as far as I was concerned."

73. Michelson, "Yvonne Rainer, Part 1," 58.

74. This is one of Ramsay Burt's arguments about *Trio A* in *Judson Dance Theater: Performative Traces,* 79–83. While I agree with his assessment in part, I want to restore the dialectical aspects of Rainer's thinking and of her work around these issues.

75. Rainer indicated this to me in a conversation of 3 June 1998. Susan Leigh Foster notes the appearance of these shapes in the dance and even suggests that its smooth continuity is reminiscent of the organic flow of expressionist dance (Foster, *Reading Dancing,* 175–176). Banes suggests that such allusions make the dance a dialectic between the classical and the tasklike or objectlike, linking this to Heidegger on the artwork and the thing in the world (Banes, *Terpsichore in Sneakers,* 44).

76. Michelson notes the effects of texts read aloud during a later Rainer project, *Continuous Project—Altered Daily* (1969): "readings of assigned texts, mostly reminiscences of performers in film's silent period, superimposed the dimension of reference to past, completed performance

upon a present, evolving one" ("Yvonne Rainer, Part 1," 61). The fact that descriptions of filmed performance were what created this effect is of particular interest.

77. Rainer, "A Quasi Survey," 67.

78. Ibid.; Rainer, quoted in Bear and Sharp, "The Performer as Persona," 50.

79. In this, Rainer might find an interesting kindred spirit in Donna Haraway, who, in an interview with Thyrza Nichols Goodeve, had this to say about her own method: "My instincts are always to do the same thing. It's to insist on the join between materiality and semiosis." Donna J. Haraway and Thyrza Nichols Goodeve, *How Like a Leaf* (London: Routledge, 2000), 86.

80. Mechanical forces and models of mechanical reproduction would come together in another interesting way in Robert Morris's 1970 installation at the Whitney Museum, entitled *Continuous Project Altered Daily.* The museum was transformed into a work site, specifically engaging ideas of lever and pulley—the museum's elevator was used as an enormous counterweight to hoist wood, steel, and cement—while viewers became documentarians, using tape recorders, still cameras, and movie cameras to record the event. Rainer would borrow Morris's title for her own extended performance project at the Whitney in 1970. For more on both projects, see Michelson, "Yvonne Rainer, Part 1," and Annette Michelson, "Three Notes on an Exhibition as a Work," *Artforum* 8, no. 10 (June 1970): 62; for an incisive historical study of the politics and meaning of Morris's Whitney show, see Julia Bryan-Wilson, "Hard Hats and Art Strikes: Robert Morris in 1970," *Art Bulletin* 89, no. 2 (June 2007): 333–359.

81. Rosalind E. Krauss, "Notes on the Index: Part 1," and "Notes on the Index: Part 2," both in Krauss, *The Originality of the Avant-Garde,* 196–220. Part 2 first appeared in *October* 4 (Fall 1977).

82. Krauss, "Notes on the Index, Part 2," 211.

83. For an extended discussion of semiotics applied to dance, see Susan Leigh Foster's *Reading Dancing.* It is arguable, of course, whether dance other than pantomime can even be understood to operate as a signifying system, and for advocates of such a position—for whom dance manifests rather than represents its meaning—the work of artists like Hay and Rainer is exemplary.

See, for example, David Michael Levin, "The Embodiment of Performance," *Salmagundi,* no. 31–32 (1975–1976), 120–142; and Banes, *Terpsichore in Sneakers.* However, I want to propose that such manifestation or presentation was a desideratum but not, entirely, an achievement of Rainer's most famous dance.

84. Krauss's thinking on the index in these essays is based in the writings of Charles Sanders Peirce. To my knowledge, the first use of Peirce in American art criticism is by Annette Michelson in "Robert Morris: An Aesthetics of Transgression," 17–23, 49–50. Michelson engages Peirce's category of "firstness" in comparison to Michael Fried's writing on "presentness" to elaborate the metaphysical stakes of this version of modernism, and to distinguish from this complex Morris's resolutely secular investigation of temporality as the condition of aesthetic perception. Importantly for tracing the appearance of the index in art theory, she also takes up indexical versus iconic modes in discussion of Morris's work with casting, impression, and his EEG self-portrait.

85. Charles Sanders Peirce, "Logic as Semiotic: The Theory of Signs," in *Philosophical Writings of Peirce,* ed. Justus Buchler (New York: Dover, 1955), 102.

86. Deborah Hay, quoted in Banes, *Terpsichore in Sneakers,* 126.

87. Rainer, "A Quasi Survey," 67.

88. Here, besides dealing with the gender-, race-, and desire-neutral body of minimalist phenomenology, we are also dealing with a body underwritten by a model of mechanical neutrality. It is possible to see, in this mechanical body, the faint shadow cast by an old model of corporeality. In *The Human Motor: Energy, Fatigue, and the Origins of Modernity* (Los Angeles: University of California Press, 1992), Anson Rabinbach traces the nineteenth-century European preoccupation with labor through its favorite metaphor for the worker's body. Following developments in thermodynamics, social scientists began to apply theories of energy conservation to the bodies of animals and of working people. Taylor's infamous attempts to rationalize the motions of industrial workers in the interest of time and energy efficiency were the American outcome of this Continental science of work. The critic who compared *Trio A* to a museum of science and technology thus got it exactly right: Rainer's employment of the mechanical body model is an act of historical preservation (Tallmer, "Rebellion in the Arts. 4," 25). Unconsciously resonat-

ing with this model of the human motor, Rainer's body mechanics perhaps represent what Raymond Williams calls a "residual formation"—a mode that continues or takes up practices considered out of date by the dominant culture. (See Williams, *Marxism and Literature* [Oxford: Oxford University Press, 1977].) Rabinbach argues that the model of the human motor finally fell out of favor as automation practices advanced in the mid-twentieth century, and popular and sociological thinking about work gave up the image of physical labor in favor of a preoccupation with the exchange of information. Rainer said that in *Trio A* the "desired effect was a worklike rather than an exhibitionlike presentation" ("A Quasi Survey," 67). However, I will suggest that insofar as the indexical model imports into this "geared" body a mode intrinsic to the new image culture, any opposition that *Trio A*'s machine-age body might offer must remain one pole in a thoroughly dialectical formation.

89. The very title of *Trio A* might be understood to signal this reading of its indexical structure. Philosopher Charles Sanders Peirce frequently mentioned the labeling letters used by lawyers or mathematicians as examples of indices. (These are indexical in the sense of a shifter, like the pronouns "I" or "you"; see Rosalind E. Krauss, "Notes on the Index: Part 1," in her *Originality of the Avant-Garde*.) Rainer often used letters or numbers to refer to dances or sections of a dance. It should be noted that in my analysis of the indexical structure of *Trio A,* I am diverging from Michelson, who uses Peircean terms in a different way in a section on dance in her essay on Robert Morris. She suggests that dance offered Morris the possibility of a "total coincidence of work and process" not available to him in traditional visual arts. "Neither icon (such as the *I-Box*)," she writes, "nor index (electrode-encephalogramme) could afford that totality of fusion" (Michelson, "Robert Morris: An Aesthetics of Transgression," 57). The indexical structure of *Trio A* evokes but also drives a wedge into that image of dance as total fusion; as beyond or outside the contradictions and discontinuities of image- or object-making.

90. Roland Barthes, "The Photographic Message" (1961), in Barthes, *Image, Music, Text,* trans. Stephen Heath (New York: Hill and Wang, 1977), 17.

91. Ibid. (italics mine).

92. Denis Hollier, "Surrealist Precipitates," trans. Rosalind Krauss, *October* 69 (Summer 1994): 126. Discussing the effect of André Breton's inclusion of photographs in *Nadja,* Hollier is interested in the performative realism of the photograph in contrast to the descriptive realism of texts.

93. More recently Rainer has imposed restrictions on the dance's dissemination. As of 2006, there are four individuals authorized to teach *Trio A*. Rainer to the author, October 2006.

94. Rainer says this in the voiceover of a video by Charles Atlas and David Gordon projected during the White Oak Dance Project program of Judson choreography, called *PASTForward*, presented in various locations in 2000 and at the Brooklyn Academy of Music in June 2001. *Trio A* was discussed in the "Beyond the Mainstream" episode of WNET/Thirteen's *Dance in America*, 1980.

95. Frederick Castle, "Occurrences," *Art News* 67 (Summer 1968): 34–35, 71.

96. The 1970 performance in which David Gordon is pictured here was Rainer's contribution to the "People's Flag Show" at Judson Memorial Church, a demonstration against flag desecration laws. It will be discussed in chapter 5.

Rainer's response to my comments on the dancerly look of *Trio A*'s documentation: "The dance photographer is conditioned to watch for those moments of suspension that will best 'register like a photograph.' *Trio A* is obviously full of those moments. However much I intended to abort a jump, blur a transition, erase a rhythm, the dance inevitably could not be amorphous, simply because the body is constantly making shapes, whether or not it 'dances.' And what about my own selection of all those photos you showed from Peter Moore's contact sheets? Do you think I looked for the most 'shapeless' and amorphous and least dancelike (whatever that means)? Not on your life. I chose the most dramatic and 'dancerly' ones I could find. Which does not disprove your thesis, necessarily, but maybe you should take the roles of photographer and dancer's vanity into account as further markers in the production of meaning" (Rainer to the author, 20 October 1998). All I will add to this is that a "dancer's vanity" might also be interpreted socially: that is, as this instance would seem to bear out, those photographs which are most pleasing to the ego are those which most closely reproduce the ideals produced in hosts of other images. "Dancer's vanity" understood in this way is another manifestation of the role of a culture of images in the production of this dance and its legacy.

97. Merce Cunningham, quoted in Barbara Rose, "ABC Art," *Art in America* (October–November 1965), reprinted in *Minimal Art: A Critical Anthology*, ed. Gregory Battcock (New York: E. P. Dutton, 1968), 280. Rainer credited Rose's essay in a panel discussion with Peggy

Phelan at the University of the Arts, Philadelphia, 8 November 2001, and in an interview with author, 14 July 1999.

98. Johnston, "Which Way the Avant-Garde?," 116.

99. Yvonne Rainer, "The Mind Is a Muscle," introduction to "A Quasi Survey," in Rainer, *A Woman Who . . .* , 27.

4 OTHER SOLUTIONS

1. Yvonne Rainer, "Miscellaneous Notes," in Yvonne Rainer, *Work 1961–73* (Halifax: Press of the Nova Scotia College of Art and Design, 1974), 106. These were retrospective notes written sometime in the years 1969–1971 (Rainer, e-mail to author, 9 May 2003). The spelling is per the original.

2. Rainer, "Miscellaneous Notes," 106.

3. Yvonne Rainer, "Statement," from program for *The Mind Is a Muscle,* Anderson Theater, New York, April 1968, reprinted in Rainer, *Work 1961–73, 71.*

4. Yvonne Rainer, "Out of a Corner of the Sixties," author's notes on lecture, Whitney Museum of American Art Independent Study Program, New York, 7 October 1997.

5. Yvonne Rainer, "Films," in Rainer, *Work 1961–73, 211.*

6. Yvonne Rainer, interviewed by Liza Bear and Willoughby Sharp, "The Performer as Persona: An Interview with Yvonne Rainer," *Avalanche* (Summer 1972): 50. Rainer was discussing her interests circa 1966–1968, as expressed in *Trio A* and her essay about it. The full quotation is: "Another part of that statement had to do with my rage at the narcissism of traditional dancing. It seemed very appropriate for me at that time to use a whole other point of view about the body—that it could be handled like an object, picked up and carried and that objects and bodies could be interchangeable. I'd explored this previously in the mattress dance, *Parts of Some Sextets.* . . ."

7. Rainer, "Out of a Corner."

8. This took place in a performance of the improvisational dance troupe Grand Union in 1972.

9. Yvonne Rainer, "The Mind Is a Muscle," in Rainer, *Work 1961–73,* 75. This instruction was the alternative Rainer offered when David Gordon told her that in doing a particular section of *Trio A* he was thinking of himself as a faun.

10. Herbert Marcuse, *One-Dimensional Man: Studies in the Ideology of Advanced Industrial Society* (Boston: Beacon Press, 1964), 57. Maurice Berger has detailed the significance of Marcuse for Robert Morris, with whom Rainer was living during this time, in *Labyrinths: Robert Morris, Minimalism, and the 1960s* (New York: Harper & Row, 1989).

11. Frank Stella, quoted in "Questions to Stella and Judd," interview with Bruce Glaser, in *Minimal Art: A Critical Anthology,* ed. Gregory Battcock (New York: E. P. Dutton, 1968), 157–158. Transcript of an interview by Bruce Glaser of Stella and Donald Judd, conducted 15 February 1964, broadcast on WBAI-FM, New York, as "New Nihilism or New Art" on 24 March 1964, and edited by Lucy Lippard and published in *Art News* 65, no. 5 (September 1966). For discussion of this interview, see James Meyer, *Minimalism: Art and Polemics in the Sixties* (New Haven: Yale University Press, 2001), 87–93.

12. Susan Sontag, "Against Interpretation," *Evergreen Review* (1964), in Sontag, *Against Interpretation, and Other Essays* (1966; repr., New York: Anchor Books/Doubleday, 1990), 14.

13. Sally Banes, *Democracy's Body: Judson Dance Theater 1962–1964,* 2d ed. (Durham: Duke University Press, 1993), 40.

14. Rosalind E. Krauss, "Allusion and Illusion in Donald Judd," *Artforum* 10, no. 9 (May 1966): 24–26; Krauss, *Passages in Modern Sculpture* (Cambridge: MIT Press, 1977).

15. Brian O'Doherty, "Frank Stella and a Crisis of Nothingness," *New York Times,* 19 January 1964, X21.

16. Leonard B. Meyer, "The End of the Renaissance? Notes on the Radical Empiricism of the Avant-Garde," *Hudson Review* 16, no. 2 (Summer 1963). As Irving Sandler noted, Warhol cited

the article just a few months after its publication, in his famous 1963 interview with Gene Swenson for "What Is Pop Art?" (*Art News* 62, no. 7 [November 1963]); see Sandler, *American Art of the 1960s* (New York: Harper & Row, 1988), 84, n. 20. Sandler recalled the Meyer article being much discussed among artists at this time (63–64).

17. Meyer, "The End of the Renaissance?," 186. Italics in the original.

18. M. [Mel] Bochner, "Primary Structures," *Arts Magazine* 40, no. 8 (June 1966): 34.

19. Sontag, "Against Interpretation," 8.

20. Annette Michelson, "Robert Morris: An Aesthetics of Transgression," in *Robert Morris,* exh. cat. (Washington, D.C.: Corcoran Gallery of Art, 1969), 13–17.

21. The artists Gregg Bordowitz and Mark Dion borrowed the films and screened them privately while participants in the Whitney Independent Study Program in 1985. Bordowitz, e-mail to author, 15 September 2003.

22. The title originated with Igor Stravinsky's 1916–1917 set of piano compositions for his children. However, Rainer borrowed it from the movie starring Jack Nicholson (1970, directed by Bob Rafelson, screenplay by Adrien Joyce). Rainer, e-mails to author, 9 May 2003 and 5 June 2004.

23. It is, however, a light-skinned hand. The lack of race consciousness by white artists during most of the 1960s, which would have allowed whiteness to go unmarked in cases like this, points to the blind spot of the period's focus on the body as a neutral, phenomenological entity rather than a socially defined one. Rainer would explore the cultural coding of bodies in her later career as a filmmaker, but I will argue in this chapter that neutrality was already internally compromised—though not addressed in terms of race—in Rainer's work of the 1960s.

24. Yvonne Rainer to the author, May 2003.

25. Since O'Doherty, in his perceptive review two years earlier of the antihumanism of Frank Stella's paintings ("Frank Stella and a Crisis of Nothingness"), had cause to call the painter

"the Oblomov of art," it also seems worth noting here the more than superficial (or specifically superficial) resemblance between the character in Ivan Goncharov's story and Morris's sculpture: not only was Oblomov's face "neither reddy nor dull nor pale, but of an indefinite hue," but for Oblomov, "lying in bed was neither a necessity (as in the case of an invalid or of a man who stands badly in need of sleep) nor an accident (as in the case of a man who is feeling worn out) nor a gratification (as in the case of a man who is purely lazy). Rather, it represented his normal condition." Ivan Aleksandrovich Goncharov, *Oblomov,* trans C. J. Hogarth (New York: Macmillan, 1915), available from Eldritch Press at www.ibiblio.org/eldritch.

26. Yvonne Rainer, "Don't Give the Game Away," *Arts Magazine* (April 1967): 44–47. Rainer's quotations come from Alain Robbe-Grillet's essay "Nature, Humanism, Tragedy," in *For a New Novel: Essays on Fiction,* trans. Richard Howard (1965; repr., Evanston: Northwestern University Press, 1989). Her comment about *For a New Novel* is from an interview with the author, 23 February 2003. Rainer's 1967 essay deserves more recognition in the historical literature. Though it does not focus exclusively on minimalism, in it Rainer identifies many of the attributes that have become central to historical analysis of this art: not only its anthropomorphism, but also its literalness ("It occupies space differently from other sculpture. One might say sculpture didn't take up room until this sculpture. It doesn't 'aspire'; it squats."); its relation to the viewer ("It includes me in its space, but defies all attempts to know any more about it than what a single glance can offer"); and its temporal and relational character ("Your sense of time is affected. . . . Do it and I share the same time? Does it exist without my presence?"). Moreover, in making connections between her experience of Morris's work and of Warhol's films, this essay suggests new avenues for thinking across the art of the 1960s.

27. Bochner, "Primary Structures," 32.

28. Rainer, "Don't Give the Game Away," 47. To propose the kind of reading of the hand and its behavior that I have is precisely this type of complicity, but Rainer is going further, arguing that even to discuss the work's *nonsignification*—as when Bochner, in scare quotes, calls the work "dumb"—is to engage in projection.

29. Briony Fer discusses this issue in her essay "Objects beyond Objecthood," *Oxford Art Journal* 22, no. 2 (1999), 25–36. She distinguishes between the "superficial anthropomorphism" (31) resisted by so many artists in the 1960s and a model taken from surrealist Roger Caillois, in

which the human is absorbed into the environment, much like a camouflaged insect, rather than occupying it. The latter, she argues, is evident in the work of Louise Bourgeois and others whose work was exhibited in the 1960s under Lucy Lippard's rubric of "eccentric abstraction" (the title of the exhibition she curated at the Fischbach Gallery in 1966).

30. Rainer, "Miscellaneous Notes," 106.

31. Rainer was far from alone in this recognition, though her focus on the body as object renders the tension most telling. For others it was a matter of meaning in matter: Lippard acknowledged retrospectively "the way this obdurately 'meaningless' art hid so many multi-leveled meanings." Lucy R. Lippard, "Skärningspunkter/Intersections," in *Flyktpunkter=Vanishing Points,* ed. Olle Granath and Margareta Helleberg, exh. cat. (Stockholm: Moderna Museet, 1984), 15.

32. Yvonne Rainer, "Continuous Project—Altered Daily," in Rainer, *Work 1961–73,* 134.

33. Robbe-Grillet, "Nature, Humanism, Tragedy," 52, 72.

34. See Krauss, "Allusion and Illusion in Donald Judd." Beginning in the early 1970s, she would make plain what is only implied in the 1966 essay's recourse to Merleau-Ponty: that as objects coming into being in perception, these were works based on an antihumanist self: not the model of private ineffable self-within-a-body—for this reason, too, no more music of the soul—but an open, publicly produced, embodied subject.

35. Yvonne Rainer, interview by author, 14 July 1999.

36. Rainer and Morris would have been familiar with works like this one, if not from international art magazines, then from a six-week residency in the fall of 1964 in Düsseldorf, where Beuys was a professor at the Kunstakademie and acted as stage manager for a performance by the two Americans. See "Chronology," in *Yvonne Rainer: Radical Juxtapositions 1961–2002,* ed. Sid Sachs, exh. cat. (Philadelphia: University of the Arts, 2003), 137. Rainer describes visiting Beuys's home in *Feelings are Facts,* 256.

37. Annette Michelson wrote about this effect of *Untitled (Corner Piece)* in "Robert Morris: An Aesthetic of Transgression," 37–39.

38. See the comparison of Morris and Beuys in Benjamin H. D. Buchloh, "Beuys: The Twilight of the Idol," in *Neo-Avantgarde and Culture Industry: Essays on European and American Art from 1955 to 1975* (Cambridge: MIT Press, 2000), 54–57. Circa 1990, at least two enormously important corner pieces reworked the dynamics of these earlier sculptures in a social register—Adrian Piper's video installation *Cornered* (1988) and Felix Gonzalez-Torres's *Untitled (Portrait of Ross in L.A.)* (1991).

39. Yvonne Rainer, "Three Distributions," *Aspen,* no. 8 (Fall–Winter 1970–71), n.p.

40. Ibid.

41. Rainer, "Films," 209.

42. Yvonne Rainer, "A Quasi Survey of Some 'Minimalist' Tendencies in the Quantitatively Minimal Dance Activity Midst the Plethora, or an Analysis of *Trio A*" (1966), in Rainer, *Work 1961–73,* 67.

43. Clive Barnes, "Dance: Workshop Season," *New York Times,* 19 October 1968, 30.

44. Rainer, "Films," 209.

45. James Meyer's history of minimalism illuminates this aspect of its trajectory; see *Minimalism: Art and Polemics in the Sixties.*

46. Lippard, "Skärningspunkter/Intersections," 12. On Virginia Dwan, see Suzaan Boettger, "Behind the Earth Movers," *Art in America* (April 2004), 55–63.

47. Yvonne Rainer, "Some Retrospective Notes on a Dance for 10 People and 12 Mattresses Called *Parts of Some Sextets,* Performed at the Wadsworth Atheneum, Hartford, Connecticut, and Judson Memorial Church, New York, in March, 1965," *Tulane Drama Review* 10, no. 2 (Winter 1965), reprinted in Rainer, *Work 1961–73,* 46.

48. Rainer, "Films," 210.

49. Carl Andre, letter to Rainer, 13 February 1969, reproduced in Rainer, *Work 1961–73,* 158.

50. As such, it is a reminder that *Five Easy Pieces* is, among other things, a filmic sampler. Each piece works through a different aspect of the medium: *Hand Movie* and *Volleyball* explore the use and meaning of the frame; *Rhode Island Red,* film's fundamentally visual character, as we become aware in their conspicuous absence of the sound and odor of the coop. Each of them is in some way also filmic by opposition, in the sense that each produces effects impossible in live performance. For instance, while there are kinds of dance in which hand movement is far more articulated and important than in Western dance—traditional Indian and Balinese styles are obvious examples—the dance of a hand alone and as such is something only camera and projector will allow. Likewise, *Rhode Island Red*'s spatial dissolve is a matter of the light's effect on the lens and emulsion, on filmic chemistry and optics. Rainer specifically played with the contrast of film and performance when *Volleyball* was projected on a raised screen placed center stage during *The Mind Is a Muscle* in 1967–1968. When the choreography brought the dancers directly behind the screen, the audience would see only their lower bodies, cropped like the legs in the film. Rainer thus created a situation in which a film itself performed an act of framing on live, performing bodies.

51. The ball was actually a bead on a string attached to a motor that slowly reeled it in.

52. Rainer, "Films," 211.

53. Hal Foster, "The Crux of Minimalism," in *The Return of the Real: The Avant-Garde at the End of the Century* (Cambridge: MIT Press, 1996). *Line* raises the very questions of the displayed female body that feminist film theory, and Rainer's own work, would explore in such depth in the following decade. This is an issue in many of Rainer's films, but is particularly stressed in *The Man Who Envied Women* (1985), in which the female protagonist is an off-camera voice who never appears on screen. For an in-depth discussion of this aspect of the film and of the implications of visibility and invisibility, see the chapter on Rainer in Peggy Phelan's *Unmarked: The Politics of Performance* (London: Routledge, 1993).

54. "The Port Huron Statement of the Students for a Democratic Society" (New York: Students for a Democratic Society, 1962), 4, available at www.tomhayden.com/porthuron.htm.

55. For example, see "189 Arrested as Police and Demonstrators Clash throughout Capital," *Santiago Times,* 22 November 2004, at Institute for Global Justice, http://www.globaljust.org/news_detail.php?catagori=&id=11.

56. George W. Bush, speech at Hershey Lodge and Convention Center, Hershey, Pa., 19 April 2004. Full text available via the White House press release "President Bush Calls for Renewing the USA Patriot Act," http://www.whitehouse.gov/news/releases/2004/04/20040419-4 .html.

57. See for example Caroline Jones, *Machine in the Studio: Constructing the Postwar American Artist* (Chicago: University of Chicago Press, 1996).

5 PERFORMANCE DEMONSTRATION

1. My account of the episode of the banner is drawn from Rainer's description in "Judson Flag Show," in Yvonne Rainer, *Work 1961–73* (Halifax: Press of the Nova Scotia College of Art and Design, 1974), 171, and Yvonne Rainer, e-mails to author, 12 November 2004 and 21 May 2006, supplemented by a telephone interview with Maida Withers, 22 May 2006, and Withers, e-mail to author, 20 May 2006. As I will discuss later in the chapter, there are some complications in writing the history of this particular intervention.

2. This list of movements in the "war games" is drawn from the section of Rainer's teaching notes labeled "Ellipse classes," in Rainer's files, folder "Washington 6–70." The only notes in this section are for "war games." The section reads: "harass one or 2 people (running & missing) passing & jostling; line (crawl, roll, walk); clump; converge & disperse (2 versions: milling & circle); dying; running toward each other from great distance, tumbling over)." A bit more of a sense of what these activities involved can be gathered from the notes for and documentation of the dance *WAR,* which Rainer was in part preparing with these exercises (in *Work 1961–73,* 161–169).

3. Withers, e-mail to author, 20 May 2006.

4. See Paul Valentine, "New Limits Studied for Demonstrations in White House Area," *Washington Post, Times Herald,* 23 April 1970; David E. Rosenbaum, "Administration Will Permit

Rally Today at Ellipse, South of the White House," *New York Times,* 9 May 1970; John Herbers, "Big Capital Rally Asks U.S. Pullout in Southeast Asia," *New York Times,* 10 May 1970. The administration eventually proposed preserving rights to protest in the Ellipse but limiting protest in the other areas abutting the White House. See "Rally Rule Asked for White House," *New York Times,* 14 July 1970.

5. Withers, e-mail to author, 20 May 2006.

6. Rainer, e-mail to author, 12 November 2004. As the organizer of Rainer's teaching stint at George Washington, Withers had to argue with the physical education director over whether Rainer should be allowed to hang the sign in the university gym. As she recalls, the question form gave her particular grounds: "as an academic institution was it not our job to teach how to ask questions?" Withers, e-mail to author, 20 May 2006; telephone interview, 22 May 2006.

7. The question "Why are we in Vietnam?" as well as the rhetorical strategy of the interrogative mode would have had particular currency in this context. In April 1965, the question had been the title of a section of a speech given by President Lyndon Johnson to lay out his justification and vision for U.S. policy in southeast Asia. See Lyndon B. Johnson, "Peace without Conquest," Johns Hopkins University, 7 April 1965, from the website of the Lyndon Baines Johnson Library and Museum, www.lbjlib.utexas.edu/johnson/archives.hom/speeches.hom/650407 .asp. Within the speech Johnson posed the question as "Why are we in South Viet-Nam?" and of course answered it within the logic of cold war ideology. The question had been published in a slightly different form in February and March of 1965 in an open letter to Johnson signed by over a thousand faculty members from East Coast colleges and universities and paid for by the Ad Hoc Committee for Open Letter on Vietnam (*New York Times,* 16 February, 1 March, and 28 March 1965), along with a litany of other questions: "We have widened the war—how wide will it become? . . . What are our goals in Vietnam? Are they just? Can they be accomplished? Are they truly worth what they are bound to cost in dollars and human lives? . . ." and so on. The question *Why Are We in Vietnam?* was also the title of a 1967 novel by Norman Mailer (New York: Putnum, 1967). In the same year as Rainer's intervention, Mayor John V. Lindsay answered the title question of the book *Why Are We Still in Vietnam?* (the "still" in the title set off with an insertion mark) by saying that the antiwar movement had not been effective enough; until policy-makers understood that they could not be elected unless they stopped hostilities, "all of us will continue to share responsibility for the Vietnam War" (John V.

Lindsay, introduction to *Why Are We Still in Vietnam?* ed. Sam Brown and Len Ackland (New York: Random House, 1970). This sense of responsibility, carried by the second-person plural pronoun, is crucial to Rainer's strategy as well.

8. Ramsay Burt treats the relation between dance and radical politics—and political disappointments—of this period in chapter 5 of *Judson Dance Theater: Performative Traces* (London: Routledge, 2006).

9. Yvonne Rainer, "Performance Demonstration," in Rainer, *Work 1961–73,* 109.

10. Yvonne Rainer to Jan Stockman, 23 October 1968, copy of letter in Rainer's files, in the folder "Correspondence 1969" (because it was about a performance that would take place 8 May 1969).

11. Yvonne Rainer to Maida [Withers], 29 September 1970, copy in Rainer's files, folder "Smithsonian." Emphasis in the original. This letter was part of the process of planning what would be simultaneous performances by Grand Union and a group of Washington, D.C., dancers doing Rainer's dance *WAR* in two areas of the Smithsonian's Museum of History and Technology, 19 and 20 November 1970 (discussed below).

12. Another piece, *Northeast Passing,* was developed at Goddard College in Vermont and shares the titling strategy of the "format" works, but it was a separate piece with its own choreography, incorporated as a whole into *Rose Fractions.*

13. Some of these moments, occurring in *Performance Demonstration* (1969), are illustrated in chapter 3 of this book.

14. These two slide sets were either Peter Moore's automated photographs of *Stairs,* as discussed and illustrated in chapter 2, or slides of people performing a section of *Northeast Passing* called *Tracks* (which consisted of configurations like "mill," "huddle," and "swarm") in a winter landscape.

15. Michael Fajans, *Connecticut Rehearsal,* 16mm, silent, black and white, 32 minutes. Shot during the American Dance Festival, Connecticut College, New London, Conn., 1969. Choreog-

raphy: Yvonne Rainer. Performers: Rainer, Barbara Dilley, Becky Arnold, David Gordon, and Douglas Dunn. A copy of the film can be viewed at the Dance Collection, New York Public Library for the Performing Arts. Sally Banes provides a description of parts of the film, with commentary by Rainer, in Banes, *Terpsichore in Sneakers: Post-Modern Dance,* 2d ed. (Hanover, N.H.: University Press of New England, 1987), 205–206.

16. "Yvonne Rainer at the Whitney," press release, 12 March 1970, in the Francis Mulhall Achilles Library, Archives, Whitney Museum of American Art, New York. The fact that the writers of the press release put the word "materials" in quotation marks indicates how unusual this way of thinking about performance would have seemed.

17. Rainer to Withers, 29 September 1970.

18. Yvonne Rainer, "1968–1970," in Rainer, *Work 1961–73,* 128.

19. Ibid.

20. Hay's *26 Variations on 8 Activities for 13 People Plus Beginning and Ending.*

21. Rainer, letter to Steve Paxton and Barbara Dilley (intended to be shared with other performers in *Continuous Project—Altered Daily*), 19 November 1969, published in Rainer, *Work 1961–73,* 149. Emphasis in the original.

22. Rainer, "1968–1970," 128.

23. Yvonne Rainer, "California Dreaming: News, Reflections, and Reveries from Vacation Village, Laguna Beach" (letter to performers), 28 January 1970, in Rainer, *Work 1961–73,* 153.

24. Steve Paxton linked the transition in part to a structural problem: the choreographer-dancers involved were not often all available to rehearse in time for the performance dates Rainer had accepted; thus, the "format" idea and allowing rehearsal processes to happen in and as performance were practical as well as aesthetically productive innovations. Steve Paxton, "The Grand Union," *The Drama Review* 16, no. 3 (September 1972): 128–134.

25. The Grand Union continued until 1976. In addition to the performers of *Continuous Project—Altered Daily,* the group included Lincoln Scott, Nancy Green, and Trisha Brown. See Margaret Hupp Ramsay, "Grand Union (1970–1976), an Improvisational Performance Group" (Ph.D. dissertation, New York University, 1986).

26. Not coincidentally, during this period art museums were beginning to recognize the vitality and relevance of performance and other time-based arts. Barbara Rose would note in 1972 that in the past several years every major New York museum aside from the Metropolitan had sponsored or produced avant-garde theater, dance, performance, film, music, and media. See Barbara Rose, "Museum as Theater," *New York,* 15 May 1972, 76.

27. Robert Morris was also trying to act on the social organization of artistic production in these years, as was demonstrated, spectacularly if ambiguously, in his 1970 exhibition at the Whitney Museum of American Art. The complexities of this gesture in historical context are brilliantly explored by Julia Bryan-Wilson in "Hard Hats and Art Strikes: Robert Morris in 1970," *Art Bulletin* 89, no. 2 (June 2007). It seems significant that the change in Rainer's conception of performance—from dances and concerts to the "format" that would evolve into Grand Union—required rethinking the financial terms of performance organization. Thus, in arranging the May 1969 performance at the University of Illinois that would wind up being the debut of *Continuous Project—Altered Daily,* Rainer had to come up with an alternative to fees arranged in terms of the duration of individual dances or concerts. This was a model that set value based on the choreographer's contribution; Rainer instead wanted payment keyed to how many dancers would be involved and in need of transportation and lodging. (She asked for $1000 plus transportation and lodging for a single performance by three or four dancers.) Rainer to Jan Stockman, 23 October 1968.

28. Susan Buck-Morss, "What Is Political Art?," in *Private Time in Public Space: InSite97,* ed. Sally Yard (San Diego: Installation Gallery, 1998), 16. Emphasis mine.

29. The real danger for such art, argues Buck-Morss, is that it might become institutionalized as yet another artistic genre.

30. Buck-Morss, "What Is Political Art?," 22. Italics in the original.

31. Ibid. This example is of course problematic—it is as inadequate to the politics of Presley's use of and profit from African-American music and performance modes to view them as unproblematically antiracist as it would be to view them *only* as theft.

32. Marcia Siegel, "Smut and Other Diversions," *New York,* 24 March 1969.

33. Jack Andersen, "Yvonne Rainer: The Puritan as Hedonist," *Ballet Review* 2, no. 5 (1969): 36–37.

34. Frances Barth to Yvonne Rainer, 1 August 1969, in Rainer's files, folder "Correspondence 1969."

35. Rainer had already been working with two American flags in her dance *WAR,* where, she explained, they functioned as objects while also supporting the theme of nationalist conflict in that work (*WAR* will be discussed further below). She wanted to charge the flag more politically in the "Flag Show," and so, knowing well how inflammatory nudity in dance—and in a church—could be from her experience with *Waterman Switch* in 1965, she decided to combine an unorthodox treatment of the flag with "the other area in theater that still carries an emotional 'load' in its assault on taboos, viz., public nudity" (Rainer, "Judson Flag Show," 172). Though they ran into no trouble in the context of the Judson exhibition, the extent to which this gesture tested contemporary mores became evident later that month, when Rainer and Grand Union proposed to have Steve Paxton perform the nude-flag *Trio A* at the Smithsonian Institution. A Smithsonian official interrupted the performance. See Jean Battey Lewis, "Nudity Barred, Dance Censored," *Washington Post,* 20 November 1970; and Rainer's account, along with a reminiscence by Steve Paxton, in Rainer's *Feelings Are Facts: A Life* (Cambridge: MIT Press, 2006), 346–349. When this version of *Trio A* was performed the next month in New York within a Grand Union concert, it received blasé treatment by critic Ann Kisselgoff ("Casual Nude Scene Dropped into Dance by Rainer Company," *New York Times,* 16 December 1970, 51).

36. This performance of 22 April 1999 was part of "No Limits: A Celebration of Freedom and Art to Benefit Judson Memorial Church," 19–24 April 1999. The work was taught to a new group of performers by Rainer and Clarinda Mac Low.

37. Deborah Jowitt, "Dear Jane: May I Explain?," *New York Times,* 23 August 1970, D12.

38. What Jowitt did not address, however, was the axis between performer and viewer in such work. I will discuss below how watching Rainer's late-1960s performances related critically and otherwise to television spectatorship.

39. These practices should be at least partially distinguished from the blurring of conventionally separate phases of performance production as described by Richard Schechner in the case of his work with The Performance Group around the same time: "We begin in workshops. Somewhere along the way, when an audience becomes necessary for our work, we invite them to 'open rehearsals,' . . . after perhaps several months, the production is a unity. It 'opens.' But it is not finished. Work on the show does not stop until . . . it is withdrawn from the repertory. There is a constant give-and-take between the audience, and the changing social situation out of which all performances come" (Schechner, "Want to Watch? Or Act," *New York Times,* 12 January 1969, D1, 7). In Rainer's case the movement of rehearsal into performance involved teaching and practicing in view of the audience, but very much within something understandable as a performance proper, not an open rehearsal; like Schechner, however, she was interested in a project changing over time rather than ever being finished or set.

40. Rainer mentions some viewers of the 1968 version of *The Mind Is a Muscle* saying this (*Work 1961–73,* 89). In her retrospective catalog Adrian Piper mentions that she went three nights in a row to see *The Mind Is a Muscle* in 1968, giving a tantalizing sense of the intensity of the experience for some viewers. Adrian Piper, "Personal Chronology," in *Adrian Piper: A Retrospective,* ed. Maurice Berger (Baltimore: Fine Arts Gallery, University of Maryland, 1999).

41. Soffer was in the performance pieces *WAR,* 1970, discussed below; *Grand Union Dreams,* 1971; *Performance,* 1972; and *This Is the Story of a Woman Who . . . ,* 1974. She performed in the films *Lives of Performers,* 1972; *This Is a Film about a Woman Who . . . ,* 1974; *and Kristina Talking Pictures,* 1976.

42. Shirley Soffer, interview with author, New York City, 26 May 2006. Soffer worked with Rainer during the era when women's consciousness-raising groups played a similarly transformative role in the lives of many women of her generation. Attending one meeting of such a

group, Soffer, while sensing its importance, found it pale in comparison with the combination of camaraderie and physicality in the world of avant-garde performance she had recently entered. A sense of the personal/political importance of working with Rainer and also the special demands of that collaboration can be seen in a fascinating published conversation: Shirley Soffer, "'You Gave Me So Much Room': A Reminiscence with Yvonne Rainer," *Helicon Nine: The Journal of Women's Arts and Letters,* no. 20 (1989), 93–106. Soffer lists the works she did with Rainer and briefly discusses the mode of performing without traditional acting craft in Rainer's later performances and films in an unpublished statement of February 1974 (personal archive of Shirley Soffer, New York).

43. In the late 1970s Dunn stressed the utopian nature of Grand Union's endeavor to Sally Banes: "We made great strides developing a theatrical image-model of a possible ideal world, a viable heterogeneous social organism, one accommodating a wide range of individual rights, one knit together by a mutual search for appropriate levels of tacit contractual tolerance" (quoted in Banes, *Terpsichore in Sneakers,* 226). Dunn also concisely suggested some reasons for the disbanding of Grand Union in 1976 that are identical to those often given for the fading of 1960s-style countercultural politics in general by the mid 1970s: "war over / Dick out" (quoted in Banes, *Terpsichore in Sneakers,* 231). However, in a recent conversation, Dunn insisted that the work he had done with Rainer and Grand Union was only indirectly political (Douglas Dunn, interview with author, 16 June 2006). I believe this indirectness is reconcilable with the model of political art as "avant-garde experience" I am motivating here.

44. Paxton, "The Grand Union," 130–131. I cannot provide a full-scale account of Grand Union's aesthetics and politics here, but since this passage in Paxton's article is remarkably telling about both, I'll quote it in full:

> The weighty theatrical tradition of subjecting one's self to another person's aesthetic of time-space-effort manipulation is ignored in favor of the attempt to be emancipated without confining or restricting others.
>
> It has not been a clear path for some members. We are conditioned to voluntary slavery. In a democracy, dictators must demand that others be slaves; fortunately for the dictators, the American life produces slaves who are unaware of the mechanism of that production. The ties that bind are the ties that blind.

———

45. Barbara Dilley to Yvonne Rainer, no date, in Rainer's files, folder "Correspondence 1969."

46. Rainer, letter to Paxton and Dilley, 19 November 1969, in Rainer, *Work 1961–73,* 149. The existence of such a letter already exemplifies an optimistic system of social feedback closely tied to emerging modes of therapeutics and politics as well as artistic work in the later 1960s. Excerpts of this and a January 1970 letter to performers titled "California Dreaming" (in *Work 1961–73,* 150–154) were included in the program for *Continuous Project—Altered Daily* at the Whitney Museum. (Though the program is reproduced in facsimile in *Work 1961–73,* 129–131, this page was not included; a longer version of the letters to performers is reproduced instead.) The Whitney program along with Peter Moore's contact sheets from the performances and related materials are held at the Archives, Frances Mulhall Achilles Library, Whitney Museum of American Art, New York. Rainer chose to reproduce the Whitney *Continuous Project* program, along with a statement dated 11 May 1970 (which I will discuss further on in this chapter), in the catalog of Kynaston McShine's exhibition "Information" at the Museum of Modern Art in 1970 (this entry in the catalog was the totality of Rainer's contribution to the exhibition). See *Information,* ed. Kynaston L. McShine, exh. cat. (New York: Museum of Modern Art, 1970), 116.

47. Rainer on *Rose Fractions,* in Rainer, *Work 1961–73,* 114.

48. See Yvonne Rainer, "Flashback," in Rainer, *Work 1961–73,* 307.

49. Rainer to Jan Stockman, 23 October 1968, copy in Rainer's files, folder "Correspondence 1969."

50. Annette Michelson, Carrie Oyama, George Sugarman, Hollis Frampton, Lucinda Childs, Norma Fire, and Richard Foreman read passages mainly taken from Kevin Brownlow's *The Parade's Gone By* (New York: Knopf, 1968).

51. It was supposed to have been *The Incredible Shrinking Man,* but the Barbara Stanwyck film *The Night Walker* was used instead (Rainer, "1968–1970," 128).

52. In 1967 Rainer had commented on one of her favorite aspects of Andy Warhol's dual-projection film *Chelsea Girls:* the inside edge between the two images. Yvonne Rainer, "Don't Give the Game Away," *Arts Magazine* (April 1967): 45.

53. See Clive Barnes, "Theater: Development of the Environmental Experience and Audience Involvement of 'Dionysus in 69,'" *New York Times,* 19 November 1968, 52; Benjamin DeMott, "'Can't I Just Watch?'" *New York Times,* 2 March 1969, D1, 7; Walter Kerr, "Come Dance with Me. Who, Me?," *New York Times,* 16 June 1968, D1, 12; Elenore Lester, ". . . Or the Wave of the Future," *New York Times,* 30 June 1968, D1, 3; Schechner, "Want to Watch?," D1, 7; Richard F. Shepard, "Not on Marquee, but in Spotlight: The Audience," *New York Times,* 7 February 1969, 32; Dan Sullivan, "Theater: 'Bacchae' Updated in Garage: 'Dionysus in 69' Offered as an 'Environment,'" *New York Times,* 7 June 1968, 35. On *Changes,* see Bill Simmer and Robb Creese, "The Theatrical Style of Tom O'Horgan: 'The Architect and the Emperor of Assyria,'" *The Drama Review: TDR* 21, no. 2 (June 1977): 65–66.

54. Lester, ". . . Or the Wave of the Future," D1.

55. For instance, the link to the Happenings is mentioned by Ken Dewey, then director of program development for the New York State Council of the Arts, quoted by Richard Shepard in "Not on Marquee," 32; and by Lester, ". . . Or the Wave of the Future," 3.

56. Schechner, "Want to Watch?," D7.

57. Program for concert titled "Yvonne Rainer and The Grand Union," Rutgers University Concerts, Douglass College, 6 November 1970, collection of Shirley Soffer, New York.

58. Rainer, program for *Continuous Project— Altered Daily* at the Whitney Museum, reproduced in *Work 1961–73,* 129, and in *Information,* ed. McShine, 116.

59. Rainer, program for Connecticut Composite, Connecticut College, 19 July 1969.

60. Don McDonagh, "Films Are Backdrop for Robust Dances of Yvonne Rainer," *New York Times,* 1 April 1970, 38.

61. DeMott, "'Can't I Just Watch?,'" 7.

62. Alan M. Kriegsman, "Dance 'Priestess,'" *Washington Post,* 3 July 1970, C7.

63. Lester, ". . . Or the Wave of the Future," D3.

64. Schechner, "Want to Watch?," D7.

65. Robert Morris to Yvonne Rainer, 5 July 1967, Rainer's files, folder "Correspondence 1967."

66. John Rockwell, "Art Motivates Dance Star," *Oakland Tribune,* 25 April 1969, 40.

67. Yvonne Rainer to Don McDonagh, 29 December 1969, copy in Rainer's files, folder "Correspondence 1971."

68. Yvonne Rainer to Batya Zamir, 21 December 1969, in Rainer's files, folder "Correspondence 1969." Rainer was commenting on the concert "Choreography by Batya Zamir." A partial program is attached to the letter in her file, but without information regarding date or venue.

69. Shepard, "Not on Marquee," 32.

70. DeMott, "'Can't I Just Watch?'"

71. Quoted in Shepard, "Not on Marquee," 32.

72. DeMott, "'Can't I Just Watch?'" D1, 7.

73. Lester, ". . . Or the Wave of the Future," D1.

74. See for example, Richard Schechner's "From Ritual to Theater and Back" and "Selective Inattention" (1976), both in his *Performance Theory,* rev. ed. (London: Routledge, 2003); also Lester, ". . . Or the Wave of the Future." As Schechner insists, the "selective inattention" solicited by avant-garde theater—for which his example was the extreme duration of Robert Wilson's twelve-hour *The Life and Times of Joseph Stalin* (1973)—is comparable to the audience's behavior in other contexts and traditions. Significantly, he gives as an example a classical Carnatic music concert he attended in Madras in 1971. Rainer, too, would be in India in 1971, and

she too would comment on the varieties of audience involvement—or seeming noninvolvement—with the theatrical events she attended. See her "Indian Journal," in Rainer, *Work 1961–73,* 173–188.

75. See Judith Rodenbeck, "Madness and Method: Before Theatricality," *Grey Room* 13 (Fall 2003): 54–79.

76. Yvonne Rainer in "Interview by the Camera Obscura Collective," *Camera Obscura, A Journal of Feminism and Film Theory,* 1 (1976), reprinted in Rainer, *A Woman Who . . . : Essays, Interviews, Scripts* (Baltimore: Johns Hopkins University Press, 1999), 151.

77. Yvonne Rainer to Mr. Boyt, 13 March 1969, letter regarding preparations for performances at University of Illinois, Urbana-Champaign, copy in Rainer's files, folder labeled "Correspondence 1969."

78. Jowitt, "Dear Jane," D12.

79. Schechner, "Selective Inattention," 234.

80. On the differences between Weiner's *Traces* (1970) and Serra's Verb list, see Liz Kotz, "Language between Performance and Photography," *October* 111 (Winter 2005): 20.

81. In addition to the "war games" described in note 1 above, the teaching notes mention an exercise using "verbs from newspaper," indicating Rainer had begun developing *WAR* by this point. Yvonne Rainer, teaching notes, Rainer's files, folder "Washington 6-70."

82. There is some ambiguity in the record regarding colors of the flag borrowed from Judd: the single review of *WAR* I have located mentions a flag in green, orange, and black (Jean Battey Lewis, "Nudity Barred, Dance Censored," *Washington Post,* 20 November 1970), but Rainer remembered it in her 1974 account in *Work 1961–73* as green, orange, and white. The photographs are ambiguous on this, but Julie Finch, Judd's widow, believes there was only one flag made, and that it was green, orange, and black; and after consideration Rainer has agreed this must have been what was used (Rainer, e-mail to author, 11 October 2006). Now owned by their daughter Rainer Judd, the flag was exhibited in 2005 at the Nicole Klagsburn

Gallery in the exhibition "Interstate" curated by Adam McEwen. Jasper Johns had first used the complementary colors in a two-flag painting of 1965, in which the viewer's concentrated gaze at the miscolored flag could produce the official red, white, and blue as an optical illusion when the eyes moved down to a grey monochrome version below. He made prints based on similar images in 1966–1967, and then used the green, orange, and black version as a poster for a Vietnam Moratorium fundraiser in 1969.

83. Yvonne Rainer, e-mail to author, 13 May 2006.

84. Soffer, interview, 26 May 2006; Nina Yankowitz, telephone interview with author, 10 May 2006; Pat Catterson, undated letter to Yvonne Rainer (1970), archive of Pat Catterson; Pat Catterson, telephone interview, 23 May 2006.

85. Catterson, telephone interview, 23 May 2006.

86. Yvonne Rainer, "WAR," in Rainer, *Work 1961–73*, 162–164.

87. Catterson, telephone interview, 23 May 2006.

88. In early 1967 she had participated in dance performances that were part of "Angry Arts Week," proceeds from which supported the antiwar movement. But like most of the performances in the series, her presentation itself was not in any explicit way related to the war (recovering from surgery, she gave *Trio A* as *Convalescent Dance*). See also (though Rainer is not mentioned) Clive Barnes, "Dance: Recital Used to Protest War," *New York Times,* 31 January 1967, 52.

89. Yvonne Rainer, "Statement on May 11, 1970," in *Information,* ed. McShine, 116.

90. Grace Glueck, "Neighborhoods: Soho Is Artists' Last Resort," *New York Times,* 11 May 1970, 37.

91. For an attempt to historicize and theorize different modes of physicality in nonviolent political protest, from civil rights sit-ins to the 1999 protests aimed at the World Trade Organi-

zation meeting in Seattle, see Susan Leigh Foster, "Choreographies of Protest," *Theatre Journal* 55 (2003): 295–412.

92. Richard Schechner, "Guerrilla Theatre: May 1970," *The Drama Review: TDR,* 14, no. 3 (1970): 163–168. Schechner recalls the day the NYU class he was teaching on performance theory was interrupted by someone distributing leaflets announcing that students had been shot at Kent State. Gathering at Loeb Student Center, students and teachers immediately began planning actions, including guerrilla theater. The event described here was called "The Kent State Massacre," and was developed by students in collaboration with professors including Richard Schechner, Joan MacIntosh, and Ralph Ortiz, whose ideas formed the basis of the performance.

93. Described by Richard Schechner in "Guerrilla Theatre: May 1970."

94. Douglas Dunn, e-mail to author, 23 June 2006.

95. Sara Rudner, telephone interview with author, 15 May 2006.

96. Dunn, e-mail to author, 23 June 2006. Dunn also suggests that the down-turned gaze signified looking inward, questioning or trying to come to terms with what had happened.

97. Rainer, "Judson Flag Show," 171; and Rainer to the author, October 2006.

98. Rainer, e-mail to author, 13 May 2006.

99. Rainer, interview with author, 14 July 1999.

100. Described by audience member Richard Pilkinton, who had participated in Rainer's summer dance workshop the summer before. Pilkinton, telephone interview with author, 31 May 2006.

101. Pat Catterson to Yvonne Rainer, undated (from fall of 1970), personal archive of Pat Catterson, New York.

102. Rainer, e-mail to author, 13 May 2006.

103. Yankowitz, telephone interview, 10 May 2006.

104. Rainer, e-mail to author, 13 May 2006.

105. Rainer, *Feelings Are Facts,* 342.

106. This information about the gym is based on photographs in Rainer's files, and on the memories of Patricia Mayer of Rutgers University's Mason Gross School of the Arts, who was at Rutgers and attended the performance at Rutgers's Douglass College in 1970. Interestingly, while Mayer clearly recalls the event, she has no memory of the *WAR* performance, only of Grand Union. Based on the photographs, it appears that there were always many more audience members in the Grand Union space than in the gym watching *WAR,* and it is possible that any given audience member might not have visited *WAR* at all—the headliners, after all, were in the dance studio. This disparity may have been what caused Rainer to allow the "incursions" of *WAR* performers into Grand Union's space, as described below. Shirley Soffer considers these incursions a first step toward the investigation of star status in her work that Rainer would carry out in the performance piece *Grand Union Dreams,* in which Grand Union members played "Gods" while other performers were "Heroes" and "Mortals" (Soffer, interview, 26 May 2006).

107. Per the program notes for the Smithsonian event; at NYU the program similarly indicated that "the audience is invited to change position at any time." Both programs are in Rainer's files, folder "Programs, Fliers 1970–71."

108. Paxton, "The Grand Union," 130.

109. Program for concert titled "Yvonne Rainer and The Grand Union," Douglass College, 6 November 1970.

110. Yvonne Rainer, "Statement," from program for *The Mind Is a Muscle,* Anderson Theater, New York, April 1968, reprinted in Rainer, *Work 1961–73,* 71.

111. Raymond Williams, "Distance," originally in *London Review of Books*, 17–30 June 1982, reprinted in *Raymond Williams on Television: Selected Writings*, ed. Alan O'Connor (London: Routledge, 1989), 13–21.

112. Though of the 1969 Zamir concert, whose physical and psychological distance Rainer admired, she wrote that it was under these conditions that she was "able to really look, see, and get involved." Rainer to Zamir, 21 December 1969.

113. Thanks to Julia Bryan-Wilson, who encouraged me to think about what "responsible" (non)-participation might mean in the context of a television war.

114. Hermine Freed, "In Time, of Time," *Arts Magazine* 49 (June 1975): 82.

115. The photograph by Charles DelVecchio was published alongside Alan Kriegsman's "Dance 'Priestess,'" *Washington Post*, 3 July 1970. I have been unable to locate a print, negative, or other photographs taken at the same time.

116. *Why Are We Still in Vietnam?*, ed. Brown and Ackland, 1970.

117. Withers, telephone interview, 22 May 2006, and email, 20 May 2006. Nina Yankowitz, telephone interview, 10 May 2006. Peter Moore's contact sheets from the Loeb Student Center performances are in Rainer's archive, as are contact sheets and negatives by an unknown photographer (or photographers) who documented the Douglass College performance. The majority of the images in both sets show either the Grand Union or *WAR*, occasionally with one at the beginning of a roll of film and the other at the end, indicating that the photographer was going back and forth between the two spaces. But in both sets of images there are sequences that show at least part of the *WAR* group coming into the Grand Union performance space with their flags. At Douglass College the *WAR* group seems to have done some exercises at one end of the very large space in which Grand Union was performing and then milled in a circle around the Grand Union performers, holding and in one case wrapped in the U.S. flag. In the smaller space of the Loeb lobby, the group seems to come closer to the Grand Union performers. Holding hands in a line, they circle the group, and then do what looks like the "Wedge" formation. It isn't possible to tell where they went after the "incursion," but the contact sheets from Douglass College do show the *WAR* group entering from a hallway into Grand Union's performance space.

———

CONCLUSION: TAKING SIDES

1. The discussion of *Lives of Performers* here is related to my more extended study of the film in the essay "On Being Moved: Rainer and the Aesthetics of Empathy," in *Yvonne Rainer: Radical Juxtapositions 1961–2002,* ed. Sid Sachs, exh. cat. (Philadelphia: University of the Arts, 2003), 40–63; a revised version of this text appears as "Lives of Performers and the Trouble with Empathy," in *Masterpieces of Modernist Cinema,* ed. Ted Perry (Bloomington: Indiana University Press, 2006).

2. Shooting script of *Lives of Performers,* in "Lives of Performers," published in Yvonne Rainer, *Work 1961–73* (Halifax: Press of the Nova Scotia College of Art and Design, 1974), 227. Subsequent quotations from the film are also from this script.

3. Yvonne Rainer, "Statement," from program for *The Mind Is a Muscle,* Anderson Theater, New York, April 1968, reprinted in Rainer, *Work 1961–73,* 71.

4. Shirley Soffer, interview with author, 22 June 2006.

5. Stupendous Tremendous did improvisational performance exercises around the city of New York in the summer of 1971, including activities on the Staten Island Ferry and in Penn Station. These events brought some of the concerns of dance, visual art, and conceptual art of this period into public space in fascinating ways. The Penn Station piece, for example, involved each dancer picking a person in the station and imitating as closely as possible his or her physical actions. This was a last-minute substitute for a piece in which the dancers were to lie down on the floor and pretend it was a beach, spreading out towels and covering themselves with sunscreen, recalling a slogan of May 1968 in Paris: "under the cobblestones, the beach." Fittingly enough, the group's attempt to picture such a principle was stopped by police (Pat Catterson, telephone interview with author, 23 May 2006; Soffer, interview, 22 June 2006). I also discuss Soffer's experience of working with Rainer in chapter 4.

6. The offscreen voice is a favorite Rainer device, explored to greatest effect in her 1985 film *The Man Who Envied Women*. As Peggy Phelan points out, the fact that the main female character in this film is heard but never seen onscreen makes her "a spectator of her own film"

———

344

and "displaces her from filmic space into the spectator's psychic space" (*Unmarked: The Politics of Performance* [London: Routledge, 1993], 71, 73). Ann Cooper Albright provocatively connects the offscreen presence in *The Man Who Envied Women* to the "space-off" or "elsewhere" theorized as the potential site for female subjectivity in cinema by Teresa de Lauretis. For Albright, however, this is prelude to the discussion of modes of dance performance by artists such as Ann Carlson, Pooh Kaye, and Marie Chouinard that she argues overcome the problem of objectification of the female body by allowing the performers' subjectivities and experience of their own physicality *to be seen*. It is my argument here that the difference between the subjective experience of the performer's physicality and the spectator's view—including the gender imbalance often metaphorically and actually mapped onto that difference—is something Rainer's work does not set out to resolve, but to circle around and expose as a problem. See Ann Cooper Albright, "Mining the Dancefield: Spectacle, Moving Subjects and Feminist Theory," *Contact Quarterly* 15, no. 2 (Spring–Summer 1990): 32–40.

7. B. Ruby Rich, "Yvonne Rainer: An Introduction," in Rainer, *The Films of Yvonne Rainer* (Bloomington: Indiana University Press, 1989), 6.

8. Yvonne Rainer, "A Quasi Survey of Some 'Minimalist' Tendencies in the Quantitatively Minimal Dance Activity Midst the Plethora, or an Analysis of *Trio A*," (1966), in Rainer, *Work 1961–73*, 67.

9. Ibid.

10. Several commentators have suggested that Rainer's work against the conventional dynamics of the spectator-performer relationship was already feminist prior to her explicit engagement with gender critique. See introduction, note 14.

11. As Sally Banes has pointed out in lectures, *Lives of Performers* is an avant-gardist version of the backstage movie musical (Banes, "Yvonne Rainer's Intermediality," unpublished manuscript of a lecture given at the Women and Theatre Program conference, Toronto, Summer 1999 [n.p.]; and "Dance, Emotion, Film: The Case of Yvonne Rainer," lecture at New York University's Humanities Center Symposium on Yvonne Rainer in April 1999 [author's notes]). Of all the genres of classical Hollywood cinema, the backstage movie musical most perfectly coincides with the scopophilic imperatives of mainstream film, as Laura Mulvey suggests in

her famous essay when she notes that the character of the showgirl is a device that allows the gaze of the spectator and that of the main male character to be united without breaking the diagesis. See Laura Mulvey, "Visual Pleasure and Narrative Cinema," *Screen* 16, no. 3 (1975), reprinted in *Feminist Film Theory: A Reader,* ed. Sue Thornham (New York: New York University Press, 1999), 63.

12. Mulvey, "Visual Pleasure and Narrative Cinema," 65.

13. Fernando's response to Valda's dance might be understood as a laconic version of the first option Mulvey saw for the male character/viewer faced with the gratifying but also threatening female body on display, insofar as his dismissal of the performance she has offered him seems mean-spirited; either annoyed or insensitive, he has decided not to see. Perhaps one could argue that his refusal to see difference (the difference between this performance and previous ones) is also a disavowal of sexual difference, and thus castration. But this argument seems to force a psychoanalytic narrative onto the scene that seems inappropriate. More significant is that Fernando's inability or refusal to see the new aspects of Valda's performance injects a sense of emotional reality—of jealousy, of anger, of desire and its discontents, and thus of power imbalance and gender—into the problem of viewing dance. It thoroughly recasts the seeing difficulty.

14. Rainer, letter to Nan Piene, 27 January 1973; in Rainer, *Work 1961–73,* 238.

15. Mark Franko takes this up in "Some Notes on Yvonne Rainer."

16. Sally Banes has pointed out that it also challenges the old view of kinesthetic sympathy as the essence of dance spectatorship (Banes, *Dancing Women,* 226), something I discuss further in "On Being Moved." Rainer's statement also neatly challenges Brecht's famous proclamation that feelings, as opposed to reason, are "private and limited."

17. G. W. Pabst, *Pandora's Box (Lulu): A Film by G. W. Pabst,* trans. Christopher Holme (New York: Simon and Schuster, 1971). In developing this sequence (first used in Rainer's performance *In the College,* at Oberlin College, 21 January 1972), the cast worked from copies of the Simon and Schuster book. Shirley Soffer still has hers, marked with notes for the performance

and with a list denoting the various *Pandora's Box* poses ("me on John's lap," "revolver," "John, horror," etc.).

18. Shelly Green, *Radical Juxtaposition: The Films of Yvonne Rainer* (Metuchen, N.J.: Scarecrow Press, 1994), 27.

19. Noël Carroll, "Moving and Moving: From Minimalism to *Lives of Performers,*" *Millennium Film Journal* 35/36 (Fall 2000); italics mine. I treat the problem of empathy in this film at length in "On Being Moved."

20. Yve-Alain Bois, "Very Slow," in Bois and Rosalind E. Krauss, *Formless: A User's Guide* (New York: Zone Books, 1997), 202.

21. Sigmund Freud, "The Uncanny" (1919), in *The Standard Edition of the Complete Psychological Works of Sigmund Freud,* ed. James Strachey, vol. 17 (London: Hogarth Presss, 1955), 250; cited in Bois, "Very Slow," 202.

The Return of the Real: The Avant-Garde at the End of the Century, by Hal Foster

October: The Second Decade, 1986–1996, edited by Rosalind Krauss, Annette Michelson, Yve-Alain Bois, Benjamin H. D. Buchloh, Hal Foster, Denis Hollier, and Silvia Kolbowski

Infinite Regress: Marcel Duchamp 1910–1941, by David Joselit

Caravaggio's Secrets, by Leo Bersani and Ulysse Dutoit

Scenes in a Library: Reading the Photograph in the Book, 1843–1875, by Carol Armstrong

Bachelors, by Rosalind E. Krauss

Neo-Avantgarde and Culture Industry: Essays on European and American Art from 1955 to 1975, by Benjamin H. D. Buchloh

Suspensions of Perception: Attention, Spectacle, and Modern Culture, by Jonathan Crary

Leave Any Information at the Signal: Writings, Interviews, Bits, Pages, by Ed Ruscha

Guy Debord and the Situationist International: Texts and Documents, edited by Tom McDonough

Random Order: Robert Rauschenberg and the Neo-Avant-Garde, by Branden W. Joseph

Decoys and Disruptions: Selected Writings, 1975–2001, by Martha Rosler

Prosthetic Gods, by Hal Foster

Fantastic Reality: Louise Bourgeois and a Story of Modern Art, by Mignon Nixon

Women Artists at the Millennium, edited by Carol Armstrong and Catherine de Zegher

"The Beautiful Language of My Century": Reinventing the Language of Contestation in Postwar France, 1945–1968, by Tom McDonough

The Artwork Caught by the Tail: Francis Picabia and Dada in Paris, by George Baker

Being Watched: Yvonne Rainer and the 1960s, by Carrie Lambert-Beatty

Index